THE BRITISH MUSEUM BOOK OF

ANCIENT EGYPT

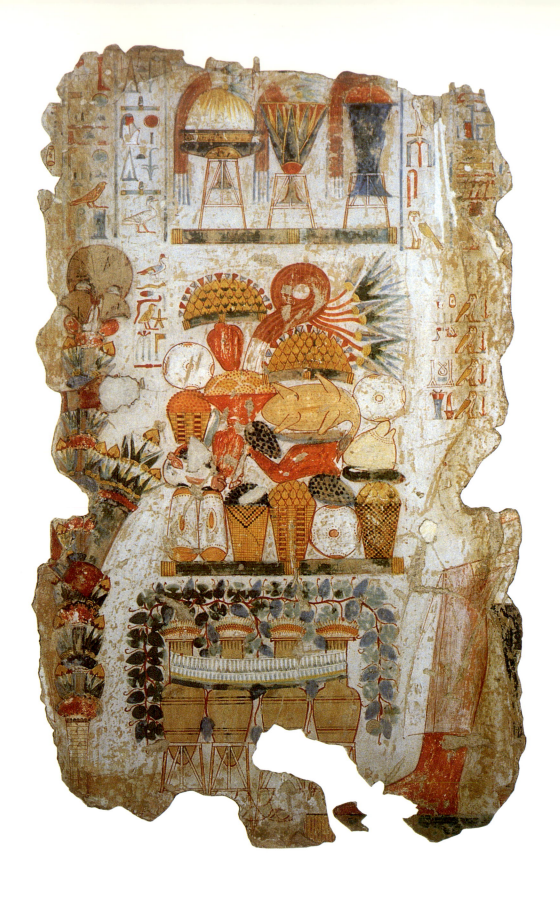

THE BRITISH MUSEUM BOOK OF
ANCIENT EGYPT

Edited by

Stephen Quirke and

Jeffrey Spencer

THAMES AND HUDSON

Library of Congress Catalog Card Number 92-80823

Designed by Behram Kapadia

Set in Ehrhardt by Selwood Systems, Midsomer Norton, Avon
and printed and bound in Great Britain
by Butler & Tanner Ltd, Frome, Somerset

Frontispiece Fragment of a wall-painting from the tomb of Nebamun
showing a richly laden offering table between Nebamun, seated, and
his son, offering clusters of flowers. Under the table are wine-jars,
cooled by fresh plants. 18th Dynasty, *c.* 1400 BC; from Thebes.
H.1.01m.

Front cover Head of the coffin lid of Pasenhor, a member of the Libyan
Meshwesh tribe who lived in Egypt. The Abydos-fetish, a symbol of
the god Osiris, is painted in the centre of the garland-collar. Late
Third Intermediate Period, *c.* 730-680 BC; painted wood, from
Thebes. H. 2.03m.

Back cover Remains of the Ptolemaic temple at Medamud, an
important centre of the god Montu, situated just north of Thebes.
Excavations at the site have revealed traces of earlier temples going
back to the Old Kingdom.

CONTENTS

ILLUSTRATION REFERENCES

Front cover EA 24906
Back cover A. J. Spencer
Frontispiece EA 37985

1. Drawn by Christine Barratt
2. EA 25360
3. A. J. Spencer
4. EA 691
5. EA 10470/8
6. EA 10470/35
7. EA 40915
8. EA 22900
9. EA 37978
10. EA 994
11. feline EA 15671, balls EA 46709–10, tops EA 34920–1
12. EA 2560
13. EA 9955
14. EA 5634
15. EA 1466
16. EA 61083
17. EA 10793/1
18. EA 117
19. EA 59648
20. EA 20791. The upper fragment is a cast of a piece in the Ashmolean Museum, Oxford
21. EA 55586
22. EA 35597
23. EA 1242
24. EA 1239
25. EA 1397
26. EA 44
27. EA 32191
28. EA 1131
29. EA 30448
30. EA 26
31. EA 64391
32. EA 32747
33. EA 17
34. Drawn by Christine Barratt
35. A. J. Spencer
36. Photograph from the Frith series, taken *c.* 1860s.
37. EA 9995/3
38. EA 65443
39. EA 21810
40. EA 35501
41. EA 27332

42. EA 9999/24
43. EA 63544
44. EA 9999/43
45. EA 76, 57, 62, 80
46. EA 12587
47. EA 35360
48. EA 67186
49. EA 16518
50. EA 37996
51. EA 67
52. EA 2
53. EA 54388
54. EA 10021/1
55. EA 60006
56. EA 43
57. EA 53799
58. EA 63631
59. EA 24426
60. EA 60958
61. EA 10470/37
62. EA 60308
63. EA 41549
64. EA 41603
65. EA 32751
66. EA 6697
67. EA 10470/5
68. EA 9562–5
69. A.J. Spencer
70. EA 22920
71. EA 6736
72. EA 20869
73. EA 7876
74. Clockwise from top left: EA 64656, 54412, 23092, 12235, 20639
75. EA 36188
76. EA 30839
77. EA 9980
78. EA 50704
79. EA 9919/3
80. EA 52887
81. EA 71620
82. EA 32051
83. EA 6652
84. EA 22940
85. EA 32
86. EA 65346
87. EA 30845
88. EA 5340

89. EA 1848
90. EA 32610
91. Drawn by Christine Barratt
92. Drawn by Christine Barratt
93. Drawn by Christine Barratt
94. EA 826
95. EA 9999/75
96. EA 10831
97. EA 12784
98. EA 14030
99. EA 19
100. From plates vol. of Belzoni's *Narrative*
101. EA 24
102. EA 10016
103. EA 10057/8
104. EA 581
105. EA 10508/7
106. EA 5645
107. EA 10274
108. EA 37984
109. EA 37982
110. EA 10026
111. EA 10864
112. EA 10419
113. EA 9901/5
114. EA 68512
115. EA 5061
116. EA 37977
117. L to R. From EA 1848, 162, 1368. Drawn by Richard Parkinson
118. EA 171
119. EA 1181
120. EA 24385
121. EA 480
122. EA 501
123. EA 947
124. Drawn by Christine Barratt
125. A. J. Spencer
126. EA 38
127. EA 42179
128. Drawn by Christine Barratt
129. EA 35571–2
130. EA 9901/3
131. EA 1147
132. EA 64564
133. Clockwise from top left: EA 14349, 4159, 36466, 2933,

37308, 65316, 49717; centre
14345

134. From inner to outer: EA 65279,
3081, 59418
135. EA 51178
136. EA 57323
137. EA 32237, 36337, 16010,
32676
138. EA 938
139. EA 5114
140. EA 59334
141. EA 12337
142. L to R. EA 24391, 47620, 2589,
55193, 4741
143. EA 6037, 6040, 6042, 6043,

6044, 6046, 6055, 6061, 22834,
30083, 30245, 36728

144. EA jarstand 2470, headrest
6526, linen 6639, bed 18196,
chest 24708
145. EA 55722
146. EA 5945
147. EA 30727
148. EA 43215
149. EA 43049
150. EA 59194
154. EA 64354
155. EA 73965
156. Drawn by Christine Barratt
157. EA 51211

158. EA 55424
159. EA 1834
160. EA 922
161. EA 1779
162. EA 24656
163. W. V. Davies
164. EA 55561
165. EA 719
166. EA 1587
167. L to R, back row EA 51619,
51617, 51641, 51616, 51516;
front row 51615, 51448, 51460
168. EA 606
169. EA 5807
170. EA 10063

PREFACE

The British Museum Book of Ancient Egypt replaces this Department's well known and much appreciated *An Introduction to Ancient Egypt* (second edition, edited by T. G. H. James, British Museum Publications, 1979). Like the latter, this is a collaborative effort, involving almost all the present members of the curatorial staff of the Department, Carol Andrews, Dr M. L. Bierbrier, Dr J. H. Taylor, Dr R. B. Parkinson, Dr A. J. Spencer and especially Dr S. G. J. Quirke who is the sole author of chapter 3 and has contributed to several of the others. Other participants include Hero Granger-Taylor, a special assistant in the Department, who wrote the section on Predynastic and dynastic textiles, the late Dr Martha Bell, who provided advice and information on Aegean connections, Professor K. Parlasca, who contributed comments for the sections on Roman and Coptic Egypt, Christine Barratt, Graphics Officer in this Department, who prepared the line drawings and maps, and Peter Hayman of the British Museum Photographic Service, who undertook the bulk of the photographic work.

The onerous task of general editing has been carried out by Drs Quirke and Spencer, while the production of the book has been the responsibility of Rachel Rogers and Susanna Friedman of British Museum Press.

W. V. Davies
Keeper of Egyptian Antiquities
British Museum

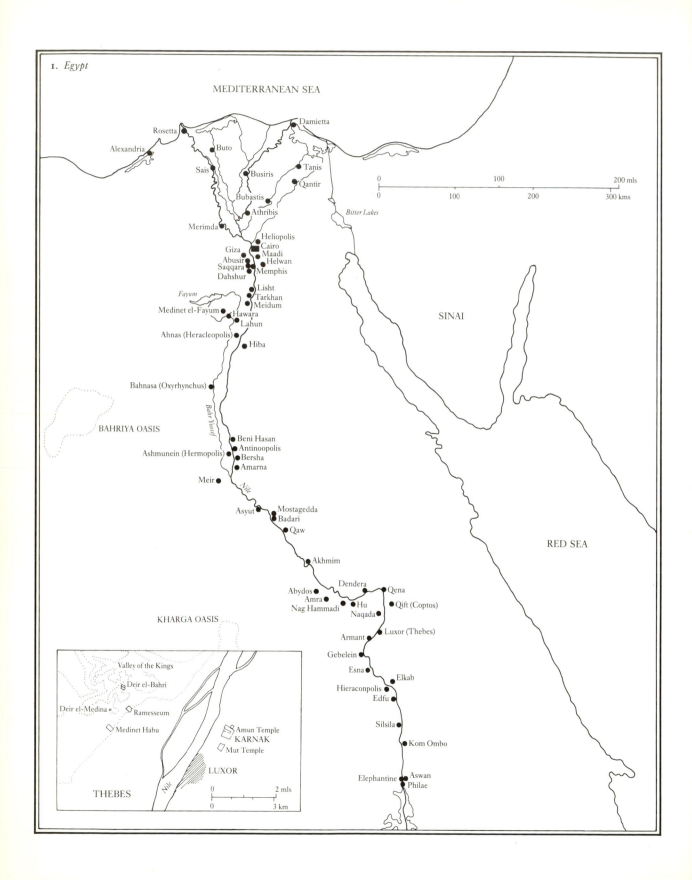

1. *Egypt*

MEDITERRANEAN SEA

Damietta

Rosetta

Alexandria

Buto

Sais

Busiris

Tanis

Qantir

Bubastis

Athribis

Bitter Lakes

Merimda

Heliopolis

Cairo

Giza

Maadi

Abusir

Helwan

Saqqara

Memphis

Dahshur

Lisht

Tarkhan

Fayum

Meidum

Medinet el-Fayum

Hawara

Lahun

Ahnas (Heracleopolis)

Hiba

SINAI

Bahnasa (Oxyrhynchus)

Bahr Yussef

BAHRIYA OASIS

Beni Hasan

Antinoopolis

Ashmunein (Hermopolis)

Bersha

Amarna

Meir

Nile

Asyut

Mostagedda

Badari

Qaw

RED SEA

Akhmim

Dendera

Abydos

Qena

Amra

Qift (Coptos)

Nag Hammadi

Hu

Naqada

KHARGA OASIS

Armant

Luxor (Thebes)

Gebelein

Esna

Elkab

Hieraconpolis

Edfu

Silsila

Kom Ombo

Elephantine

Aswan

Philae

THEBES

Valley of the Kings

Deir el-Bahri

Deir el-Medina

Ramesseum

Medinet Habu

KARNAK

Amun Temple

Mut Temple

LUXOR

Nile

0 2 mls

0 3 km

0 100 200 mls

0 100 200 300 kms

I

THE TWO LANDS

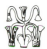

The River Nile

The modern land of Egypt occupies the north-eastern corner of Africa, bordered by the Mediterranean Sea to the north, the Red Sea and the south-western corner of Asia to the east, Libya to the west and the Sudan to the south. The sands and rocky mountains of the Sahara cover the country, as they do the rest of north Africa, to form the largest desert on earth. This Saharan wilderness is broken only by occasional oases and a single river, the Nile, flowing from the highlands of east Africa in the south northwards to the Mediterranean. The river is an artery providing fresh water to sustain plant, animal and human life on a scale impossible across the rest of the continent at this latitude. The verdant river valley and waterless desert form two opposing environments of life and death, which the ancient Egyptians called *Kemet* 'the black land', the rich silt soil of the Nile Valley, and *Deshret*, 'the red land', the dead sands of the Sahara desert. Only the larger oases and more importantly the river valley could support permanent human settlements. The ancient Egyptians called themselves the *remet-en-Kemet*, 'people of Egypt', and their language *medet-remet-en-Kemet*, 'speech of the people of Egypt'. Our words 'alchemy' and 'chemistry' probably derive from the word *Kemet* via the Arabs and before them the ancient Greeks, who greatly respected Egyptian knowledge of materials.

Egypt divides into two not only between the Nile and the desert to its east and west, but also between the narrow valley and broad Delta of the river. From the southern highlands the river flows in a single stream north to the vicinity of modern Cairo, after which it separates into different branches that veer north-east and north-west to the Mediterranean, creating a fertile triangular plain, named *delta* by the Greeks after their letter of the same shape. In the narrow valley the desert never lies far away and often imposes its presence as a line of mountains or cliffs; by contrast life in the Delta continues unaffected by the desert except at its very margins. The ancient government of Egypt divided the land into *ta-shema*, 'the land of the *shema*-reed', that is the valley or 'Upper Egypt', and *ta-mehu*, 'the land of the papyrus-plant', that is the Delta or 'Lower Egypt'. One of the king of Egypt's titles was 'lord of the two lands', echoed in the Biblical Hebrew name for Egypt, *Mizraim*, 'the two territories'.

In these paired opposites of desert and river, valley and Delta, the persistent element is the river, which provided Egypt with its unity in name and in being. In name, Egypt remained one land, despite the dualism; from the Middle Kingdom (*c.* 2000 BC) Egyptian texts refer to it as *ta-meri*, 'the cultivated (?) land', and the modern Arabic name for the country is *Misr*, 'the land'. More fundamentally, the river binds Egypt together and at all periods provided the possibility of unification; until the invention of the motor vehicle rivers and seas offered attractively swift and reliable transport and communication. The Nile gave Egypt both the water and mud needed for settled life, and the path from one community to another; the ease of contact was increased by the dominant northerly wind that assists travel moving against the south-north current. The hieroglyph

2 after the word *khenti*, 'to travel south', is a boat with sail, while the word *khed*, 'to travel north', takes the sign of a boat with sail down. From such words for travel it is clear that river transport provided the means of communication beyond simply walking, which explains why the Egyptians did not invent the wheel and made little use of wheeled vehicles even after their introduction from Western Asia. No highways other than the river are known to have existed; there does not even seem to be an ancient Egyptian word for 'bridge', with ferries being used instead to cross the Nile as is still common today. Ancient Egyptian also had no special name for the Nile, identified in texts simply as *iteru*, 'the river', or *iteru aa*, 'the great river'. It is not known where the Greeks found the word *Neilos* from which we derive our 'Nile', although it has been suggested that the Egyptians of the first millennium BC would have called the Nile Delta branches *na-iteru*, 'the rivers', and that this might have sounded to the Greeks like *nailu>Neilo*, the *s* being a common Greek word-ending.

Within the cultivated land, valley and Delta have their own internal divisions. The valley breaks into two principal sections: a narrower band of fields lies along the Nile as far north as Asyut, beyond which a branch of the Nile called the Bahr Yussef ('canal of Joseph') splits away and runs parallel to the main river down to Beni Suef where it veers west into the desert and drains into a depression as a lake, creating the area of fields called the Fayum. The section of the valley with two streams, Bahr Yussef and the main Nile, widens the cultivable plain at some points to about twenty miles, and is called Middle Egypt, distinct from the narrower valley of Upper Egypt. The Delta does not enjoy the same automatic unity as the valley, since each river-branch provides a competing line of communication: to travel from Sais on the western branch to Xois on the central branch or over to Tanis on the eastern branch a boat would need to pass south to the apex of the Delta and then north again by the other river-branch. This accounts in part for the loss of cohesion and unity after the New Kingdom, when the Delta became the economic heartland of the country and rival families from different

2. *Model of a boat with a sail and crew. Models were placed in early Middle Kingdom burials to create a wealthy estate for the afterlife; the inclusion of boats demonstrates the importance of river traffic. 12th Dynasty, c. 1900 BC; painted wood and linen, from Meir.* L. *1.13 m.*

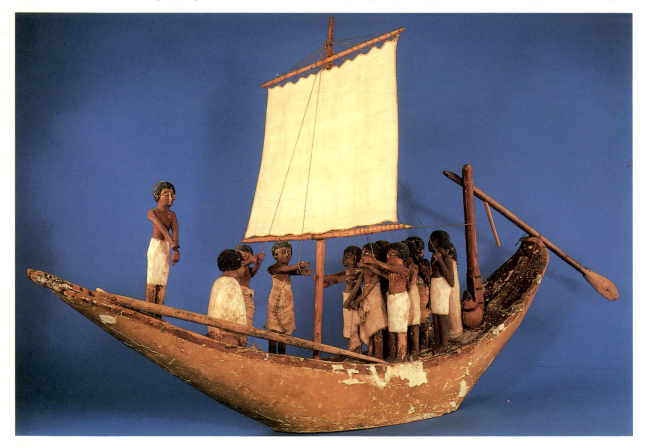

Delta cities aimed at dominance; only foreign troops could impose unity during this final millennium of Pharaonic history.

In earlier times the distances along the valley tended to pull against the centralised control afforded by the river; it would take over a week to reach the southern frontier at Aswan from the Old Kingdom capital city Memphis, south of modern Cairo, and this created an administrative lapse of a fortnight for exchanges of information. The course of ancient Egyptian history weaves in and out of the two strands of unity made possible by the river, promoting the growth of the first nation-state in history, and then allowing separate developments removed from the political centre, made possible by the time-lag in contacts between different parts of the country.

Valley and Delta can be controlled at the point where they meet, north of the modern capital Cairo. Before the foundation of that city in AD 969 the area immediately south of old Cairo provided the early Islamic rulers of the country with their military headquarters Fustat, close to the major Roman fortress known as Egyptian Babylon. This site may have been the ancient town of Kheraha, but the main Pharaonic city lay further south on the opposite bank of the river at Memphis. During the Old Kingdom, Memphis acted as capital of Egypt with the Residence of the king in or near the city. The Middle Kingdom Residence Itjtawy lay closer to the Fayum. Throughout the New Kingdom and Late Period the Memphite region remained the key to ruling Egypt, and this importance is expressed in names of Memphite districts such as Mekhattawy, 'balance of the two lands', or the name of the Memphite cemeteries, Ankhtawy, 'life of the two lands'. The three dominant institutions of the city well convey the kernel of Pharaonic civilisation: Inebhedj, 'the white wall' or fortifications, Hutnub, 'gold site' or royal workshops, and the Pernefer dockyards. The fortifications and workshops carry an importance readily appreciated, but the dockyards played no less crucial a role in the life of a country centred on a river. At the dockyards the state could gather the two lands together physically in manpower and material resources, as when the prince and future king Amenhotep II organised the shipyard preparations at the time of the Asiatic wars of his father Thutmose III. This work survives in records on papyrus now preserved in the British Museum and in the Hermitage in St Petersburg.

The Desert

The inhabitants of the Nile Valley were bound together by the lifeline of the river and cocooned from the outside world by a series of environments hostile to human settlement on a large scale. South of the First Cataract the valley provides only a thin margin of cultivable soil through the land of Nubia, now divided between the Sudan and Egypt. The northern Delta marshes and the Mediterranean Sea provide a barrier to populations approaching the other end of the country. However, the starkest and most dramatic frontier lay east and west of the valley, where the fertile fields confront the Sahara desert. The desert could be crossed by trading groups and might support nomadic peoples moving from one water source to the next; nevertheless, it was sufficiently uninhabitable to remove any threat of a population settling adjacent to the valley dwellers. Although the desert shielded the Egyptians from attack, it was at the same time home to nomads who might encroach on the margins of the valley and disturb the life of its inhabitants. In contrast to the river plain, the Sahara presents a waterless waste in which fixed settlements are unable to survive outside the few scattered oases; and yet it also holds the way to a wealth of luxury resources.

The desert provided routes for long-distance trade and it also had its own array of raw materials to attract the attention of Egyptian rulers. While the river supplied the Egyptians with their essential requirements for daily food and drink, and ordinary building materials such as mud and reeds, the produce that came from and across the desert served loftier, strictly inessential, ends, such as the making of ornaments and monuments. The presence of raw materials in the Sahara stems from the geological history of this corner of Africa. The oldest strata of the continent, the African Basement Complex, consist of granites and metamorphic rocks including veins of gold and diorite. Over these, sandstone accumulated from desert streams and coasts during the late Cretaceous period, about 130 to 65 million years ago. At some points volcanic rocks such as basalt lie over the sandstone, a reminder of the fault running along the east African rift-valley that is prone to movement of the earth's crust.

In the early Tertiary period, the warm waters of the Tethys Sea covered what is now Egypt before withdrawing to leave a coating of chalk, shale and limestone. The recent landscape of the area took shape in the late Tertiary period, about 18 to 5 million years ago, from the erosive activity of desert streams, including a forerunner of the modern Nile that gradually cut deeper into the stone to form the valley running from the Sudanese highlands to the Mediterranean. On its course through Nubia and as far north as the area of Esna in Upper Egypt the valley runs through the soft Nubian sandstone and the occasional veins of quartzite. The flow of the river is interrupted by rocky outcrops, or cataracts, that obstruct river traffic; these cataracts occur, six times in all, where the underbed of granite emerges from the sandstone. North of the sandstone bed of Nubia the early

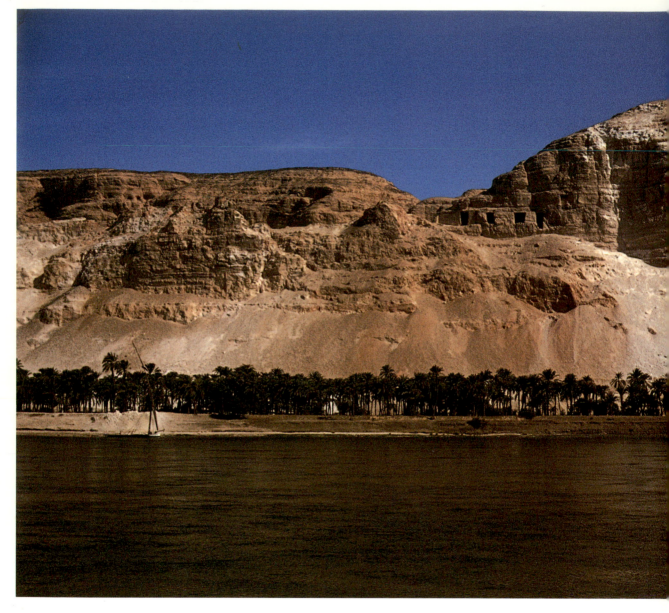

3. High limestone cliffs of the desert stand close to the Nile at Gebel Haridi in Upper Egypt.

Tertiary limestone rocks line the valley from the area south of Luxor to the region of Cairo, where sandstone and quartzite rocks with basalts return to the surface.

Over the last two million years the river has undergone alternate erosion and deposits of silt and gravel, lowering and raising the level of the river-bed and laying the sandy terraces that form a stretch of low desert between the floodplain and the high desert cliffs. A series of strong floods in about 15,000–10,000 BC carried gravel from the Sudanese valley down into southern Upper Egypt, with deposits of chalcedony, cornelian, jasper and agate. This completed the rich provisioning of the desert surface that allowed the Egyptians to procure soft and hard building stones, predominantly Nubian sandstone, Egyptian limestone and Aswan granite, as well as stones for statues, vessels and other artworks. For these they selected above all Egyptian calcite (the alabaster of Egypt), green and black basalts, diorite from Nubia and greywacke from the eastern desert between the Nile and the Red Sea. The semiprecious stones from the southern gravels were supplemented by materials from further afield, especially turquoise from Sinai and lapis lazuli

4. *King Sanakht smiting his enemies. 3rd Dynasty, c. 2680 BC; red sandstone, from Sinai.* H. *33 cm.*

of the first towns and states in fourth-millennium Upper Egypt. The history of Egypt in the New Kingdom mirrors the development and eventual exhaustion of the gold reserves in the desert with the supply first financing and then failing the military objectives of the Pharaonic state. At the same time that the south-east ceases to offer the most attractive prize of the desert, the dangers from the desert materialise in the north-west in the guise of nomadic or seminomadic peoples on the fringes of the Delta. Bronze Age Egypt finds in the Sahara much of its energy and of its undoing.

Flood, Crops and Animals

Human settlements need a reliable supply of food and water, and the Nile provided both by the most regular yearly cycle of all the great rivers of the world. The waters of the Nile flow from the lakes and mountain springs of eastern Africa. From Lake Victoria, and from Lakes Edward and George, the Kagera and the Semliki respectively thread north to merge and join other tributaries on their right bank and so form the White Nile. The level of this section of the river does not vary greatly through the year. At the modern city of Khartoum the White Nile joins the Blue Nile and further north the Atbara, both of which rise in the mountains of Ethiopia and are fed by summer rains which generally last from the end of May to the beginning of September. Before the Aswan High Dam was built in the 1960s, these summer rains would have swollen the volume of the river to create a flood that surged downstream north to the Mediterranean.

In southern Egypt the flood became visible at the end of May when the waters of the river turned muddy and started to rise appreciably. The Nile then rose quickly

that came on indirect long-distance trade routes from Afghanistan. Another semiprecious stone with a specific provenance is amethyst, obtained in ancient times from Wadi el-Hudi, south-east of Aswan. Other materials from the desert surrounds of Egypt include the desiccating agent natron from Wadi Natrun, west of the Delta, malachite from Sinai, rock-crystal from the western desert between the Farafra and Bahriya oases, and the common steatite or soapstone.

The eastern desert also provided copper and gold. The exploitation of gold veins in Egypt and Nubia gave the Pharaohs a resource coveted throughout the ancient Near East, and may have played a role in the formation

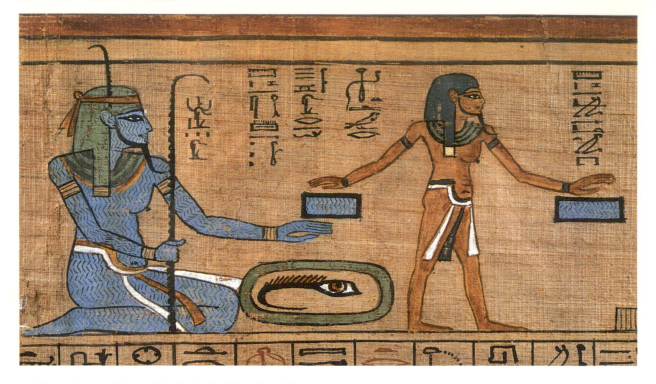

5. *Vignette from Any's* Book of the Dead. *The Nile, coloured blue and represented as a corpulent man, wears and carries the palm-rib hieroglyph for 'year', symbolising the annual flood. 19th Dynasty, c. 1250 BC; painted papyrus.* H. *10 cm.*

in July to reach its highest point at the start of September before dropping again sharply in October. The level continued to fall gently until May when the cycle began anew. In Lower Egypt the changes occurred about a fortnight later. According to Late Period texts an ideal flood reached sixteen cubits (*c.* 8.36 m) above the river level before the flood, and recent records concur with this, giving an average flood level of +8 to +10 m at Aswan and +6 to +8 m at Cairo. The precise height, timing and strength of the flood depended on the Ethiopian summer rains. Excessive rains caused catastrophic floods in which people and livestock perished and buildings were destroyed; in 1821 one such flood swept away Antaeopolis near Qaw with its ruined Ptolemaic temple. If the rains failed, the flood did not cover the fields long enough or at all, and famine ensued. A series of excessively high or low floods posed a challenge to central order but documentation is too scarce to assess any historical effects.

Each flood deposited a fresh layer of silt over the land, and this built up the rich fertile soil of the river floodplain. The desert begins exactly where the flood-waters ended, producing a demarcation line so strict that a person can stand with one foot on the desert and the other on the cultivable land. With annual blankets of silt and water, nature irrigated the valley for the Egyptians; artificial irrigation in Pharaonic times seems to have been limited to refining the natural network of waterways and their banks. Over the millennia canals and dykes would have slowly modified local agriculture in three important respects, by increasing the cultivable area, by fostering second or third crops within a year in small select plots, and by retaining water in basins to alleviate the effects of brief floods. The only tool for irrigation in Pharaonic times was the device known by its Arabic name *shaduf*, a well-sweep with a counterpoise; this can be used to water a small garden plot next to a canal, but is inefficient in water and labour. The first advance in irrigation technology came in Ptolemaic times with the waterwheel, *saqiya* in Arabic, which is worked by oxen rotating a wheel that in turn draws up vases of water from river to field level.

There is no evidence that central government took measures to improve agriculture; the upkeep and extension of field networks seems to have fallen exclusively to local manpower perhaps as communal work. From the late Middle Kingdom to the Ptolemaic Period figures called *shabtis* were placed in burials to carry out any such community labour in the afterlife: 'to make arable the fields, to irrigate the riverbank lands, to ferry the sand of the East to the West'. The text implies that people

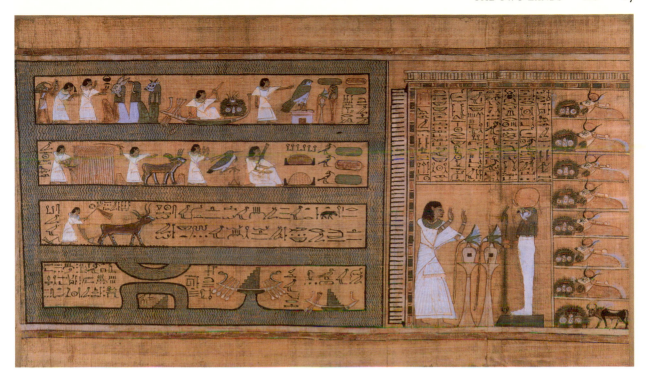

6. *Vignettes from Any's* Book of the Dead. *Any carries out various farming activities in the Egyptian Elysian Fields and worships Ra, the seven celestial cows and the bull of heaven, who provide sustenance. 19th Dynasty, c. 1250 BC; painted papyrus. H. 10 cm.*

were often summoned to carry out arduous tasks necessary to the well-being of the community, but it does not identify the summoning authority. The interest of central government in local affairs seems to have begun only with the collected produce; irrigation and agriculture appear to fall outside the direct concerns of the state.

The flood brought silt to fertilise the land but also changed the appearance and potential yield of each field; only boundary markers and accurate surveys could secure property and allow value to be assessed. The main cereal crops were barley and emmer, while wheat did not become prevalent until the Late Period when Egypt became the granary of Rome. The farming year followed the Nile cycle, with three seasons of four months each, the model for our own twelve-month calendar. The rise of the floodwaters marked the New Year, heralded in the skies by the rise of the dog-star Sirius in advance of the sun at dawn; for this reason New Year's Day was named 'emergence of Sepdet' (Sepdet being the personification of Sirius as a goddess). During the flood, farm work came to a halt, providing the state with a large reserve of manpower for building and other projects. This season was called *akhet*, perhaps meaning 'time of inundation', and lasted from July to October. When the floodwaters went down, farmers could plough the silt-covered fields and at the same time sow the grain along the ploughed furrows. The season of ploughing and sowing extended from November to February, and was known as *peret*,

'time of emergence', perhaps a reference to the land emerging from the draining floodwaters. The final season was *shemu*, a word that came to mean 'harvest', the principal event of the four months of March to June. No other event in the farming year required such intense labour as reaping, threshing, winnowing and bringing in the grain for storage. Here river traffic played a vital role in transporting grain over any distance. Once the crops were safely harvested the cycle came full circle and the next emergence of Sirius announced the next sequence of flood, sowing and harvest.

Grain was the main ingredient of the two staples of the diet, bread and beer, which appear on every offering prayer as the first two items desired of life. The most common type of beer was produced by straining the mash from fermented barley-bread into a beer-vat in a procedure similar to that now used in the Sudan to make a drink called *bouza*. Dates could be used as sweeteners. Different flavours of bread could be achieved, although it is difficult to determine from the names alone the differences between the dozens of types of bread and cake identified in texts. Bread and beer production involved

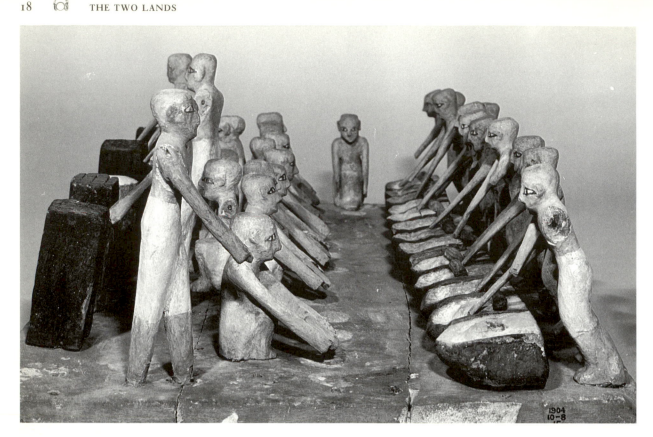

7. *Model of a bakery from the burial equipment of king Nebhepetra Mentuhotep. The four stages of production shown are grinding grain, sieving flour, mixing dough and stoking ovens; all are overseen by a foreman. 11th Dynasty, c. 2000 BC; painted wood, from Deir el-Bahri. L. 78.7 cm.*

substantially the same ingredients and, to the point of fermentation, the same procedure. For this reason, production took place in the same area; models placed in early Middle Kingdom tombs illustrate the stages in which the food and drink were prepared, such as grinding the grain, kneading the dough and, for beer, straining the mash.

As well as grain crops, the Egyptians cultivated garden produce such as beans, lentils, onions, leeks, cucumbers and lettuce. Fruits included dates, dom-palm fruit, figs, pomegranates, mandrakes and persea fruit. Vineyards existed in the Delta and in the larger oases of the western desert such as Kharga and Dakhla, and these areas produced wines for wealthy households and temples. Tomb-chapel wall reliefs and paintings depict the picking and treading of grapes; juice was wrung from the dregs by placing them in a sack tied to two poles and then pressing apart the poles. The most important sweeteners for food and drink were dates and honey. Egypt was

home to the first beekeeping, and bees and honey were regarded with respect, in contrast to the attitudes of other ancient cultures. The beehives were long cylinders placed in rows on the ground, and fires were lit to smoke out the bees when the time came to extract the honey. Apiculture may have been favoured because of the abundance of flowers that were themselves often cultivated to provide garlands and bouquets for banquets and rituals.

A further crucial ingredient in daily life was oil, procured from the nuts of the moringa tree as well as other plants such as flax, giving linseed oil, and in the Ptolemaic and Roman Periods olive oil was produced within Egypt. Oil of high quality ranked among the most valuable commodities; when robbers broke into the tomb of Tutankhamun shortly after it was sealed they stole not the gold but the silver and the precious oils. Oils were used for cooking and lighting as well as cosmetics, ointments and mummification.

Among the plants cultivated but not for human consumption papyrus and flax played the largest part in daily life. Papyrus is a flowering marsh reed with tough outer fibres that can serve as material to make rope, mats, reed boxes and sandals. The soft kernels of the stem were used for the Egyptian version of paper (see chapter 5). Flax provided the material from which linen was manufactured; a Middle Kingdom text at Bersha records

a harvest of flax in March, but the exact moment depended on the purpose for which the flax was required; young plants supplied a fine thread, while older tougher plants gave a coarse strong yarn (for linen see the textile section in chapter 7).

While agriculture made up one half of the economy, animal husbandry made up the other. Cattle, sheep, goats and pigs were reared, although herds of pigs tend not to be recorded because the pig was considered unclean for religious contexts. Cattle were divided by the Egyptians into longhorned and shorthorned, and into age-groups. In the New Kingdom a new humpbacked variety appears in tomb-chapel paintings, perhaps introduced from Western Asia in an attempt to improve breeding stock. If conditions in modern Egypt provide a guide, pastures would have been available throughout the valley, but most abundantly in the Delta, which may explain the use of cattle for nome-emblems (nomes are administrative areas) in Lower Egypt.

Animal herds change in size from one year to the next by the natural accident of birth and death, and this makes it necessary to count the herd every year or two in order to assess the value of an estate. The cattle count was an important event in the life of every herd-owning household and appears among early Middle Kingdom tomb models of estates. In the Old Kingdom the count was used to number the years of a king's reign, for example, 'year of first cattle count' = year 1, 'year after first cattle count' = year 2 etc.. In the late Old Kingdom the system was simplified to give simply 'year of the first occasion' = year 1, 'year of the second occasion' = year 2 etc., in which 'occasion' lost its link to the original cattle count.

The most spectacular wild animals on the ancient river were the hippopotami and crocodiles that threatened small boats and people on the riverbanks. Wolves and jackals haunted the desert fringes, and other unwelcome

8. *Detail of the interior of the coffin of the priest of Amun and scribe Djedhoriufankh. The dead man is shown making an offering of food to Ra-Horakhty-Atum and the baboon-headed Hapy, one of the four Sons of Horus. Late 21st or early 22nd Dynasty, c. 950–900 BC; plastered and painted wood, from Thebes. H. 2.09 m.*

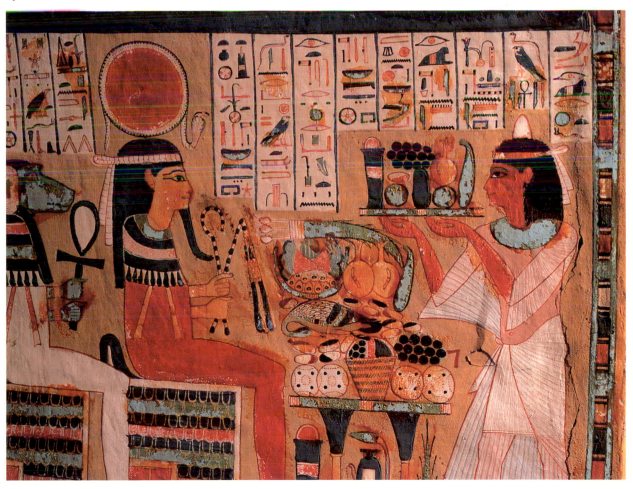

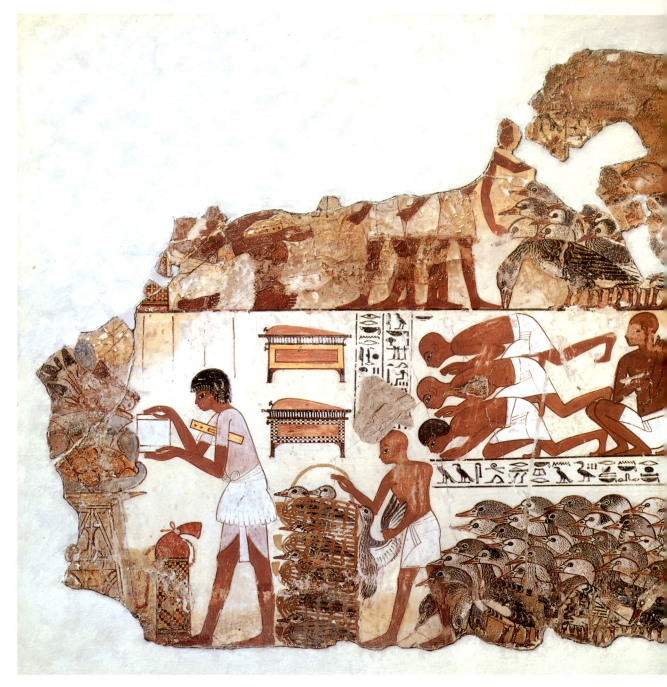

9. *Fragment of a wall-painting from the tomb-chapel of Nebamun,*
showing the counting of geese for the periodic assessment of wealth.
To the left a scribe reads out the numbers from his papyrus roll. 18th
Dynasty, c. 1400 BC; painted plaster, from Thebes. H. 71 cm.

neighbours were snakes, scorpions, mosquitoes and flies.
Another familiar and unproductive inhabitant of the
river environment was the frog; the tadpole appears in
hieroglyphs as the number 100,000. Spiders are not
attested in texts or illustrations, although webs were
noted in the burial chamber of the tomb of Tut-
ankhamun. Some Old Kingdom tomb-chapel reliefs
depict the force-feeding of hyenas, oryx and antelope,

range and nutritional value of the Egyptian diet. Many wild birds played no part in the economy, such as falcons, vultures, herons and ibis, all of which were used in religious iconography to depict various gods and goddesses. Other birds present in the hieroglyphic script and in tomb-chapel depictions include pelicans, cormorants, lapwing and owls, as well as the humbler swallows and martins.

Animals domesticated for purposes other than meat include the dog, used in hunting from Predynastic times and the only type of animal other than cattle to receive personal names in ancient Egypt. In addition to the slender hounds useful for the chase, stockier breeds are attested and were perhaps used to protect the home from rats; in the late Middle Kingdom town at Lahun virtually every house had rat tunnels that the inhabitants had tried to block with rubble and rubbish. The cat seems not to have been a pet before the New Kingdom, and not domesticated on a large scale until the Late Period; even pet cats seem to have been called simply 'cat'. In the Old and Middle Kingdoms the only common pet other than the dog in rich households was the monkey, which 169 retained its popularity in later times. New Kingdom tomb-chapel paintings depict the presentation of exotic African animals to the royal court, notably leopards, ostriches and giraffes; parts of animals were also delivered as luxury produce, in particular elephant tusks that gave larger pieces of ivory than hippopotamus teeth. Campaign texts of the New Kingdom also record Syrian bears and the African rhinoceros.

Oxen were used in ploughing and donkeys were used in transport across land, either the short distances between waterways in the valley or the long routes across the desert to oases and foreign lands. The camel is not attested in Egypt between Predynastic times and the Roman Period, when its domestication by nomadic tribes brought to an end the safety of the valley. Unlike previous beasts of burden camels can go without water for prolonged stretches and move as swiftly as horses, allowing the rider to attack and escape before any response can be organised. With the appearance of the domesticated camel in the Roman Period nomadic incursions into the valley margins became the permanent nightmare of settled population and authorities alike, and the threat did not fully subside until the industrial age.

Horses were first brought to Egypt from Western Asia in the Second Intermediate Period, when Lower Egypt was ruled by kings from Western Asia. In the New Kingdom the horse chariot became a symbol of royal and 109 aristocratic power, but within the Nile Valley the use of this luxury animal and vehicle remained ceremonial; the chariot did, however, play an important part in campaigns against enemies in Syria-Palestine where it could be used in attack across plains. Horses were only rarely

presumably as experiments in domestication; such attempts did not survive into the Middle Kingdom or later times, and the wild game of the desert fringe remained the object of hunting rather than farming. Wildfowl and fish also supplemented the meat ration 9 from animals on farms, and geese and ducks were successfully domesticated and included in the farming economy. The additional meat and eggs extended the

ridden bareback, and then only by scouts for the army. Until the Ptolemaic Period the king is shown in his chariot but never directly riding the horse. In daily life the horse never became cheap enough to play a significant role, and the donkey remained the predominant beast of burden.

Society

Egyptian life has been transformed since Pharaonic times in virtually every aspect. The Nile has not flooded since the building of the Aswan High Dam in the 1960s, and the fields of barley and emmer were replaced by wheat under the Ptolemies, and in the last century by the cash crops cotton, sugar and bananas. Transport is no longer by boat or by donkey; the camel arrived in Roman times, to be followed by railways in the nineteenth century and by roads and motor vehicles in the twentieth. Religion and social customs altered under foreign rulers from the Persians to the Europeans and Turks, and with conversions in antiquity first to Christianity and then to Islam. The distance in culture from any living society makes the ancient sources all the more crucial if we are to build up an accurate picture of the past. Many European preconceptions about ancient Egypt derive from the ancient Greeks, such as the idea that brothers married sisters, or from the encounter with the Islamic world, such as the idea that men had many wives. Often the sources do not answer specific questions; there is, for instance, no picture of an ancient Egyptian wedding. Nevertheless the combined evidence of texts, pictures and building remains permits us to piece together a general view of life in the Egyptian home, allowing for differences between one period and the next.

Marriage was the central institution of social life, but it seems never to have been a religious ceremony; the Egyptian term was simply 'to found a house', and a man and woman became 'married' by setting up house together, ideally in a new building separate from the parents of each. Although a man could marry more than one wife, very few examples have been documented, and even in the royal family monogamy seemed to be the rule; the large numbers of wives of Amenhotep III, Ramses II and Ramses III seem to reflect diplomatic necessities, when Semitic rather than Egyptian custom led foreign rulers to send their daughters to marry Pharaoh. Marriage existed for the task of engendering and rearing children, and this was fraught with danger in a world without antibiotics where mother and child were likely to die at the birth, and where even if it passed the obstacle of birth the child might not survive more than a few years. Children are depicted in art naked with a sidelock or plait of hair to one side, but this may be artistic convention. All children were considered offspring of

10

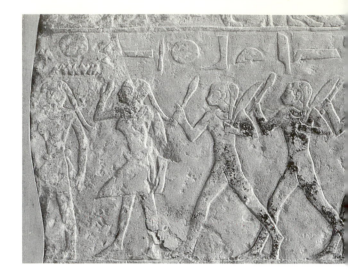

the natural mother and father; they could be adopted, but there was no concept of illegitimacy. Toys are rare before the Roman Period although wooden figures with moveable limbs occasionally survive; more common are gaming boards and pieces, the circular *mehen* serpent game-board of the Early Dynastic Period and the later rectangular boards with twenty or thirty squares.

11

At maturity boys and girls were expected to carry out different tasks, and differentiation by sex runs through the entire Egyptian outlook on existence; even deities, spirits and harmful animals are classified by sex in religious texts. In the human domain women did not take part in activities that involved wielding blades, such as reaping at harvest, presumably because this would threaten male dominance, the blade being both a direct weapon for attack and a metaphor for masculine sexuality. Women were also generally excluded from washing clothes, because crocodiles threatened the riverbanks. Apart from these two barriers to hard labour, women took part in backbreaking chores such as grinding of grain for flour, pressing fermented loaves in sieves for the mash to make beer, and weaving textiles in the dim halls in which estates had their clothes produced, the ancient feature nearest to modern industrial conditions.

Women enjoyed legal and economic equality with men; a woman called Senebtysy owned an estate including a textile factory in the Thirteenth Dynasty (c. 1750 BC), and another named Niutnakht was able to select which children to disinherit in the Twentieth Dynasty (c. 1200 BC). Nevertheless, women never enjoyed social equality with men, and this is most evident in the rules of kingship; only men could be king, perhaps theoretically because the king acted as sun-god on earth and the sun is male in the Egyptian language. Following from this rule, so strong that even queens ruling Egypt claimed to be not queen but king, royal power could not be delegated

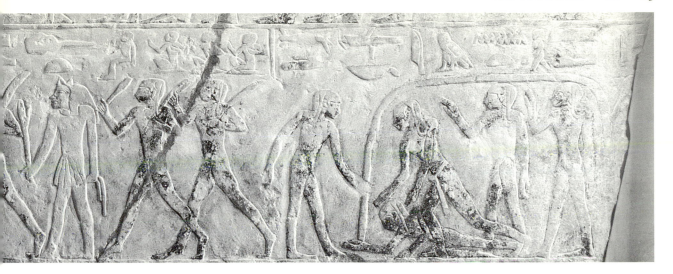

10. *Block from a tomb-chapel of five baton-wielding youths with sidelocks and a man who carries a stave, ending in the shape of a hand, and whose head has leonine features. The hieroglyphic text above describes the activity as 'dancing'. To the left is part of a 'musical troupe' of girls; to the right more youths with the speech in hieroglyphs: 'Rescue your one among (them), my companion'. 6th Dynasty, c. 2300 BC; painted limestone, from Giza. ll. 47 cm.*

11. *Children's toys: a feline with an articulated jaw, inlaid crystal eyes and bronze teeth, wood, from Thebes; painted balls, Roman Period, linen and reeds; spinning tops, Roman Period, glazed composition, from the Fayum. Tops are rare before the Roman Period and the animal figures with moveable parts have not been dated securely, though they are generally ascribed to the New Kingdom.*

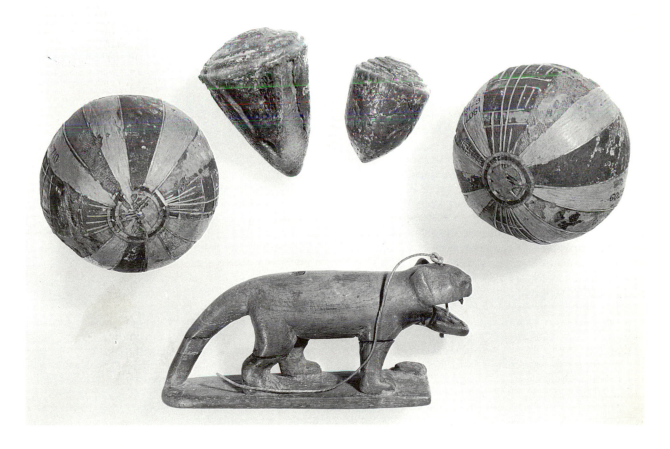

to women, and so men held all positions in the administration and in the temple hierarchies; after the Old Kingdom the only titles held by women concern the musical accompaniment to temple ritual. Exclusion from state office also meant exclusion from the considerable resources that supported each state office, and this would have left most women in a secondary economic position. In view of the unfavourable circumstances it is perhaps surprising that ancient Egyptian women retained equality in law, so that a wife could divorce a husband as easily as he might divorce her. Only in the Late Period, apparently under Greek influence, did the wife begin to lose her legal rights against the husband, for example in the amount of property she was allowed to keep in the event of divorce.

The Egyptian home, from humble dwellings to the royal palace, divided into three areas of activity, the private rooms for mother and children and bedrooms, the reception rooms where the man of the house might receive guests, and the production quarters where the food, drink and materials of the house were prepared. Even in a rich house furnishings were sparse by modern standards. Wooden beds with matted centrepieces were used, with headrests rather than pillows, which were often adorned with a motif that suited the shape, such as the desert hare, or that afforded amuletic protection. Chairs are found although the scribe at work wrote seated on the ground crosslegged; the rich sometimes travelled in a sedan-chair consisting of a platform upon which the owner sat crosslegged or knelt. Tables are rare, and some examples may be for offerings rather than for daily use, as in the table with the snake-goddess of fertility Renenutet painted on the top. More common are jarstands and the chests for keeping household items free of sand and dust.

During the Eighteenth Dynasty household items were decorated with artistic motifs more often than in other periods, and fortunately for us they were often included in the burial equipment of the owner. Cosmetic containers and sticks to apply eyepaint are frequently found, and cosmetic spoons and boxes in particular can be transformed into exquisite sculpture. Mirrors of shining reflecting metal often have ornamented handles with motifs connected with Hathor goddess of love, and wigs and wig-boxes also survive. Like jewellery cosmetic items might serve men as well as women. At banquets guests wore fine linen garments, jewellery and wigs upon which cones of sweet-smelling fats are often represented. Entertainment was provided by dancing girls and musicians; instruments include the harp, lyre and lute, and flute with one or two reeds, as well as pairs of clappers and, for temple service, the metal rattle or sistrum. Singing played a central role in Egyptian music, to judge from texts and depictions, but few types of song survive; religious hymns and praises to the king are known, and harpist

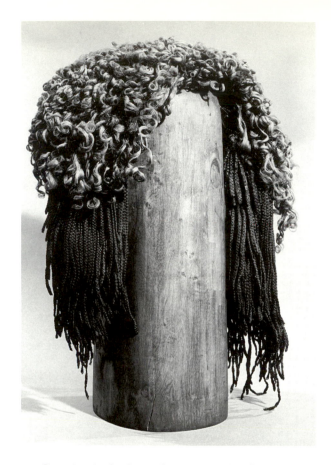

12. *Composite wig of curls over plaits, constructed to allow ventilation, as would be necessary in an Egyptian summer. New Kingdom; human hair, from Deir el-Medina.* H. *50.5 cm.*

songs of the Middle and New Kingdoms occur, and there are New Kingdom lovesongs, but none of the music for the words, or indeed for the instruments is known.

The production of food, drink and clothes is depicted on tomb-chapel walls, where the scenes were intended to reproduce the activities for eternity on behalf of the tomb-owner. The Old Kingdom and Late Period reliefs and the Middle and New Kingdom paintings on tomb-chapel walls illustrate life on the great estates of the land. Model estates of the early Middle Kingdom include, alongside the practical details of bakeries, butcheries, textile factories and different types of boats, a garden pool where a nobleman might hope to escape from the headaches of city life. New Kingdom lyrical texts echo this dream with praises of villas in the country. Great townhouses have been excavated but until now no archaeological work has uncovered a Pharaonic farm or any aspect of the Pharaonic countryside, leaving us dependant on texts and the pictorial record.

We have little information about the rights of an owner on his or her land; we do not know, for example, if many

or most farmers owned their own land, or rented it from large estates. The modern notion that Pharaoh owned all of Egypt is never found in ancient Egyptian texts, and seems in any case more a statement of the constitution, as it is in England, than a tenet of law. Crown estates were certainly extensive, as were temple lands, but we do not know what was expected of Crown or temple tenants. It does seem clear though that the temples never functioned independently of the state, but acted instead as departments of state, because Pharaoh was high priest of every deity; only Pharaoh is depicted offering to the gods in temples. New Kingdom literary and administrative texts refer to the collection of dues, either a percentage of the harvest or a number of goods, from large and small estates, including temples; unfortunately we do not know how often or on what basis these dues were collected. They may have been fixed annual amounts to be collected from tenants, like modern rent, or from all inhabitants, like modern tax, or they may have been varying sums collected only when the government needed funds for a special purpose such as building or fighting on a particular instance; ancient government probably involved a minute fraction of the concerns and expenditure of modern state bureaucracies.

Slavery seems to have been rare at all periods, and restricted largely to foreigners captured in war abroad. In the late New Kingdom defeated foreign peoples were settled on land in Egypt and seem to have been free to cultivate there; again, their rights and obligations are a matter for conjecture. Slaves were those who might be sold by one person to another; at another level of dependance a person might be bound to the estate that supported a particular title, for example, the estate of the mayor of a particular town. In the Middle Kingdom landbound servants were called 'agents of the king', presumably because the Crown decided how large the estate for each title should be. An official in the administration thus had two types of property, the land he inherited from his mother and from his father, and the land he owned by holding a position in the government.

The law did not become a specialised sector of its own. Local worthies or, in more important cases, high officials formed tribunals of very general scope in which any matter might be raised, administrative or legal; any official or landowner could be petitioned to settle a case, and from the New Kingdom on a plaintiff could take a case before an oracle. For serious charges a commission might be appointed to prosecute a case, as in the unique documents that record proceedings against the palace conspirators who poisoned Ramses III (see chapter 5).

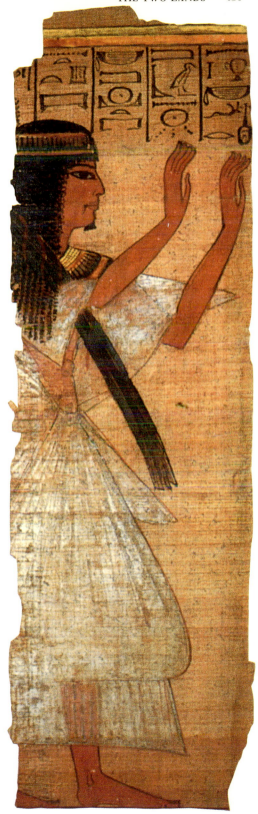

13. *The royal craftsman Pashedu from his* Book of the Dead, *showing him with his hands raised in adoration of the sun-god and with the text of a hymn to the sun in hieroglyphs. 19th Dynasty, c. 1250 BC; painted papyrus, from Deir el-Medina.* H. *38 cm.*

Punishment for crime included harsh physical measures, from beating for failure of duty to death for treason. If a person did not appear for communal work when summoned, he or she might be obliged to work for a state institution permanently, until a committee of review authorised release; if the person ran away and could not be caught, his family was taken instead. The flight from the settled valley to avoid hard labour is attested already in the Middle Kingdom, but became common in the Roman Period when the government imposed high dues on the population; early Christians also fled to the desert under persecution from the Roman authorities, and this practice gave rise to Christian monasticism when entire communities learnt to live in the desert free from the law and state religion of the Roman Empire. That change from refugee to monk provides an eloquent example of the way in which life in Egypt was transformed over time and yet retained continuity in its geographical confines of valley and desert.

Most textual evidence for New Kingdom daily life comes from the community who worked in the Valley of the Kings. Kings' tombs at that time had deep, decorated tunnels built by the permanent workforce of royal craftsmen, supporting workers and suppliers; with their families they settled at Deir el-Medina, behind the temples of Amenhotep III and Horemheb. The dry soil, lack of later habitation and presence from *c*. 1300-1100 BC of literate craftsmen has yielded hieroglyphic monuments, sculpture, tomb-chapels and many hieratic documents, mainly on flakes of limestone ('ostraca'), revealing details of life in an Egyptian community, from buying and selling goods to marriage and divorce to hymns and prayers.

16. OPPOSITE *Sculpted head of the type named 'ancestral heads' by Egyptologists, thought to belong principally in household niche-shrines. This example bears no name and may be intended to represent all previous family members. Late New Kingdom, c. 1200 BC; painted limestone, from Deir el-Medina. H. 24 cm.*

14. *Large ostracon recording the reasons for absenteeism in work on the tomb of Ramses II in his year 40. Such records could have been transferred to a papyrus roll for more formal storage in a reference archive. 19th Dynasty, c. 1250 BC; pigment on limestone, from Deir el-Medina. H. 38.5 cm.*

15. *Stela of the royal craftsman Penbuy, shown in adoration of Ptah, patron god of craftsmen. The raised arms at bottom left embody a prayer for offerings, and the ears behind the god represent the quality of hearing expected from the god. 19th Dynasty, c. 1250 BC; painted limestone, from Deir el-Medina. H. 38 cm.*

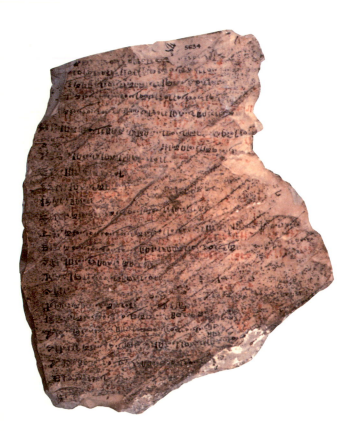

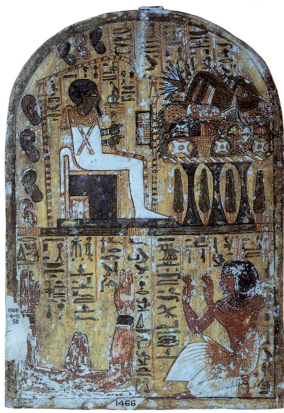

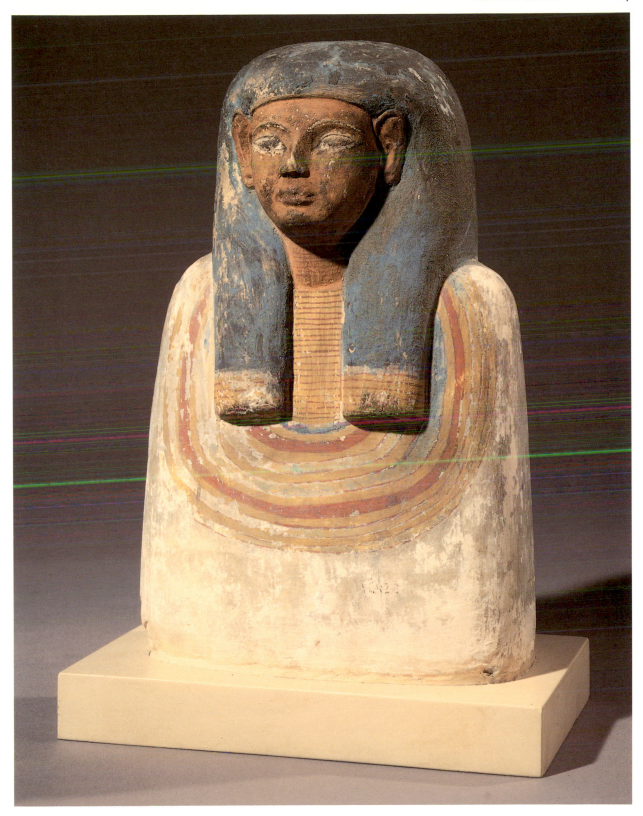

2

AN HISTORICAL OUTLINE

Chronology

Our ability to place features of Egyptian history in their correct relative place in time depends in part on exact modern dating techniques such as Carbon-14 testing, used to date organic material, and thermoluminescence, for dating pottery, and in part on ancient Egyptian texts relating to dates and the measurement of time. Systematic astronomical observation enabled the Egyptians to design star charts first attested on coffin lids of the First Intermediate Period, about 2100 BC; these give the names of the decans (stars that rose every ten days at the same time as the sun), of which there were thirty-six. The star chart thus enabled the deceased to tell the time of night or the date in the solar year. More elaborate star charts occur in the New Kingdom, first in the tomb of Senenmut, the minister of Hatshepsut, and then in the cenotaph of Sety I at Abydos; they are found later in the tombs of kings Ramses IV, VI and IX, where a seated man is shown next to a net of stars. On all these examples the chart is drawn on the ceiling of the chamber.

For measuring and recording time, the Egyptians devised a civil year of 360 days plus five days added at the end. The 360 days were divided into three seasons: *akhet*, time of flood; *peret*, time of sowing; and *shemu*, time of harvest. Each season had four months, numbered simply as 'first month of *akhet*' etc., though names were given to the months from the Ramesside Period on, derived from the principal festival near the start of each month. The month was divided in turn into thirty days,

sometimes grouped as three 'weeks' of ten days; each day had, by analogy with the months of the year, twelve hours of night and twelve of day which were not of precise or equal lengths. This civil year and its divisions gave the Egyptians a useful means of measuring time, but it did not coincide exactly with the solar year of $365\frac{1}{4}$ days; this discrepancy meant that every four years the civil year moved back a day by comparison with the solar year, and every 120 years it moved back a month, with the two coinciding again only after 1,460 years. This did not affect the usefulness of the civil year as a calculating device, and the Egyptians dated all events or business documents by reference to the civil year. Alongside this civil year the Egyptians obviously used the solar year for distinguishing the natural seasons of summer and winter and for the practical purposes of the agricultural cycle with its associated festivals such as harvest celebrations. Some religious events were held with reference to the lunar cycle, with certain festivals occurring at specific stages of the waxing and waning of the moon.

There is proof that at least one astronomical event was carefully monitored in relation to the civil calendar. This was the annual rising of the dog-star Sirius at the same

17. OPPOSITE *Vignette from Paynedjem's* Book of the Dead. *The High Priest of Amun, Paynedjem II, is making an offering to Osiris, who grasps the royal crook and flail, and a composite staff incorporating the symbols for 'life', 'dominion' and 'stability'. 21st Dynasty, c. 990–969 BC; painted papyrus, from Thebes.* H. *33 cm.*

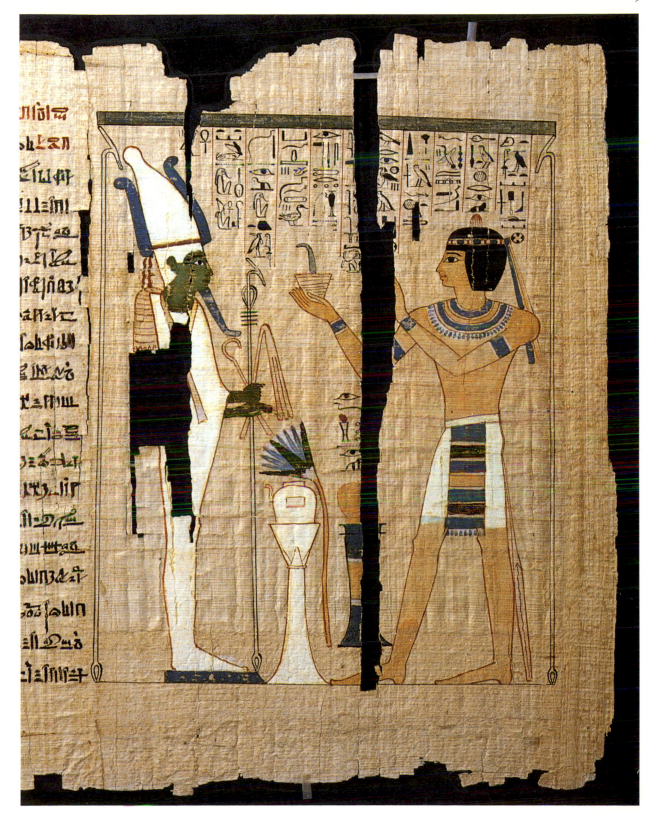

time as the sun (i.e. heliacally), on approximately 19 July of the Julian calendar. The Roman writer Censorinus mentions that a heliacal rising of Sirius on the first day of the civil year occurred in AD 139. As the discrepancy between the civil and astronomical calendars rights itself at the end of 1,460 years, but only for four years, it has been calculated that a similar coincidence of the rising of Sirius and the first day of the civil year would have occurred in the Pharaonic Period in 1321–1317 BC and 2781–2777 BC, assuming the calendar was in use that early. The period of time between these coincidences is termed a Sothic cycle by Egyptologists. By a fortunate chance, three texts have been preserved which record the date in the civil year on which Sirius rose heliacally in the reign of Senusret III, Amenhotep I and Thutmose III. However, because of the uncertainty of where the observations were made in Egypt, the determination of the exact dates in terms of the Julian calendar is debatable.

Neither the astronomical or civil calendar could be used successfully to determine the passage of time since neither began from a fixed point, as in later Greek or Roman calendars. The reigns of the kings provided the means to accomplish this dating, but the use of simple regnal years evolved slowly. In the early dynasties each year of a king's reign was named separately after some contemporaneous event. From the Old Kingdom the years of each king were dated by the biennial cattle count (discussed above) which could lead to uncertainty if the census years were changed. By the Middle Kingdom a simple system of regnal dating was in use. To avoid confusion with the civil year, the new king's first year,

no matter how short, would end on the first day of the next civil year when his second year would begin and henceforth the regnal and civil years would coincide. This synchronisation was abandoned in the New Kingdom when the full regnal year would date from the king's accession. By the Twenty-sixth Dynasty, the Egyptians had reverted to the Middle Kingdom system.

Dating by regnal years would have had no value unless the sequence of kings and their exact years of reign were known. Careful records were kept of these events, but a complete listing has not survived to this day. The survey documents which afford the greatest information are first the fragmentary Royal Annals (the so-called Palermo Stone and its congeners in the Egyptian Museum in Cairo and University College London) which record the kings and the principal event in each year of their reigns down to the Fifth Dynasty. Secondly, there is the mutilated Royal Canon of the Turin Museum, compiled in the Nineteenth Dynasty, which gives the names of the kings in chronological order, the length of their reigns and the total number of years occupied by each dynasty down to the Second Intermediate Period; the third source is the *History* of an Egyptian priest called Manetho (written in Greek in the third century BC and preserved only incompletely in the works of other writers) which

18. *Kinglist from the temple for the cult of Ramses II at Abydos but omitting the rulers not receiving offerings, notably kings of the Intermediate and Amarna Periods. The lower register repeats the phrase 'as the gift of king Ramses II', alternating his throne- and birth-names. 19th Dynasty, c. 1250 BC; painted limestone, from Abydos. H. 1.38 m.*

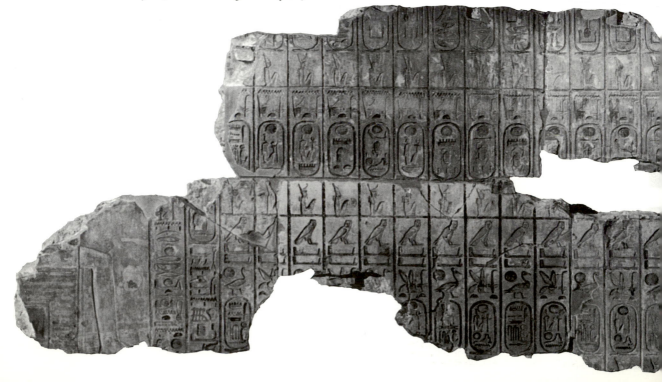

follows the same pattern as the Royal Canon of Turin. Lastly there are the innumerable inscriptions and papyri dated to such and such a year of a named king. Not only because of damage to the text, the Turin Canon must be used with caution for it does not indicate when certain kings were contemporaneous rather than consecutive and does not show co-regencies when there was a possible overlap in reigns. One error recently detected concerns the reigns of Senusret II and III: the Turin Canon gives them nineteen and thirty[six?] years respectively, but contemporary monuments give a maximum of six for Senusret II and nineteen for Senusret III. Apparently the dates have been interchanged and a mistake by a copyist has given Senusret II an extra thirteen years. Similarly the garbled tables of Manetho which survive in later classical authors are useful but by no means reliable. Second to them only in importance are the lists of kings arranged in chronological order found in the temples of Abydos and Karnak, and in a tomb at Saqqara. Though far from complete, these lists (one of which was found in the temple of Ramses II at Abydos and is now in the British Museum) contain many names which are missing from the documents previously mentioned, but they lack the details of the length of reigns and corruptions sometimes occur. By far the most complete and the best preserved is the famous list of king Sety I which still stands in his temple at Abydos.

18

An important check on the chronology of the various rulers of Egypt is provided by synchronisms with foreign kings who can be more firmly dated. This is particularly true of the New Kingdom when Egypt was in diplomatic contact with Babylonian, Assyrian and Hittite monarchs and the Late Period when Egypt faced invasions by Assyrian, Persian and Greek rulers. The narrowing of the possible dates of kings' rule enables astronomical observations recorded in individual reigns such as eclipses to be fixed more precisely in terms of the Julian calendar. While these facts enable the chronology of Egypt's dynasties to be determined with a reasonable degree of accuracy, many problems still remain.

The Stone Age and Predynastic cultures

Nile floods and river movement have obliterated all but scant traces of the most ancient human activity in the valley, but tools of Acheulean man are attested at one site of the early Palaeolithic period, about 200,000 BC, at Naga Ahmed el-Khalifa near Abydos. In the mid-Palaeolithic period, about 100,000 to 50,000 BC, only surface finds occur north of Asyut; sites between Asyut and Qena seem to be connected with flint mining. The Late Palaeolithic period, up to 21,000 BC, saw the first manufacture of blades at sites such as Nazlet Khater near Qaw where underground flint mining can be dated to about 33,000 BC, one of the earliest underground mine veins in the world. A hunting and fishing camp existed at Shuwikhat, near Edfu, with remains of bubalis, gazelle and catfish, dated to about 25,000 BC by thermoluminescence analysis of burnt silts at the site.

The final Palaeolithic period, about 21,000 to 12,000 BC, witnessed a wide variety of lifestyles in Upper Egypt at a time of extreme aridity; at Kubbaniya near Esna gathering plant foods seems to have played a major role, while at a seasonal camp at Makhadma near Qena fish-hooks, fish-bones and traces of fire were found. No human remains are known from the Nile Valley from about 11,000 to 8000 BC, a period marked by high floods. Only a few sites appear in the Epipalaeolithic period, about 8000 BC, with the Elkabian culture in southern Upper Egypt, and the Qarunian in the Fayum; sites are small and the lifestyle remains Palaeolithic, i.e. without pottery or farming. A seasonal community occupied a riverbranch beach at Elkab, fishing in shallow and deep waters, and hunting gazelle and oryx in the nearby wadi (river valley), where the early Holocene wet phase allowed savanna to replace sand and rock desert.

The Epipalaeolithic hunter-gatherers bear no obvious relation to the Neolithic farming and herding cultures that grew up two thousand years later in Upper and Lower Egypt. Between about 7000 and 4000 BC the Sahara remained a savanna rich in herds of wild animals; desert sites indicate a gradual shift to a mixed economy of hunter-gathering with increasing domestication of animals and plants. The late sixth millennium BC saw the emergence of farming communities with domesticated

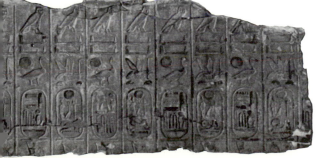

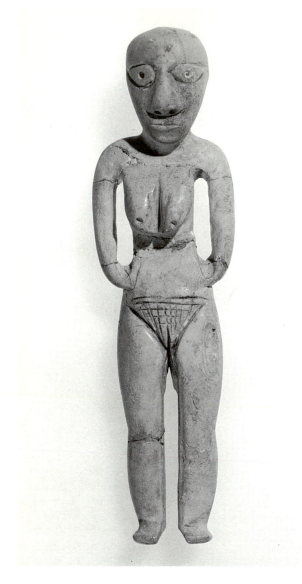

19. *Figurine of a naked woman from the Badarian or early Neolithic periods. Eyes, breasts and pubic triangle are emphasised. Badarian, c. 4000 BC; ivory.* H. *14 cm.*

and in the Fayum lived in a style similar to those at Gebel Tarif in the desert. The only site that shows no link to any other in the area, and so might indicate migration from distant regions, is Merimda.

Once these cultures were established they developed separately, but the Badarian seems to form the direct ancestor to Pharaonic civilisation. Egyptologists call the Neolithic in Egypt 'Predynastic', as precursor to Pharaonic Egypt with its dynasties of kings. In the Neolithic communities of Upper and Lower Egypt, emmer, barley and flax as well as fruit were cultivated, and sheep, pig and goats were domesticated, as was perhaps the dog at this time. Tomb size and equipment may reflect life in the society: in Lower Egypt tombs do not vary greatly in size and have few grave-goods, implying social equality, whereas Upper Egyptian tombs do vary greatly in size and contents. Both areas produce clay models, jewellery and pottery female figurines, but those of Upper Egypt tend to be of higher quality. Badarian grave-goods include black-topped red pottery and the earliest copper found in Egypt, small rings and beads that did not require advanced smelting of ore.

The next phase of the Upper Egyptian culture, about 4000 to 3500 BC, is called Amratian or Naqada I, after the sites of Amra and Naqada. Whereas the Badarian phase of the culture had been confined to the area of Asyut, Naqada I extended over most of southern Upper Egypt, with the domestication of donkey and cattle and the introduction of bricks, cosmetic palettes and war maces. Alongside the black-topped red ware, white incised pottery appears with hunting and other stylised scenes. Grave-goods include clay and ivory figures and stone vessels, principally of basalt. By the end of this phase of the Neolithic period, sprawling settlements of low density existed alongside the extensive cemeteries of Naqada and Hieraconpolis, which remained major sites up to the Early Dynastic Period. The record is biased in favour of southern Upper Egypt, because the floodplain has lost evidence for these periods in Middle and Lower Egypt; nevertheless Naqada and Hieraconpolis may have been sites of special importance because they lie opposite the desert valleys leading to goldmines and through to the Red Sea.

The final stage of the Upper Egyptian Predynastic Period, about 3500 to 3100 BC, is called Gerzean (after the site of Gerza), or Naqada II. The desert reached extreme aridity, and at Naqada and Hieraconpolis the settlements contracted from low density areas of houses to more tightly-packed towns. The culture reached north to the Fayum, and recent excavation at the north-east Delta site of Minshat Abu Omar revealed, astonishingly, the same lifestyle. By contrast Maadi, at the Delta apex, and Buto, in the western Delta, have yielded evidence only of a separate culture; the site at Maadi appears to

animals and pottery, which was crucial for moving and storing goods, in the south-western Delta at Merimda Beni-Salame and in the Fayum, and in southern Upper Egypt near Asyut at Tasa. The environment of the two areas varied and gave rise to two lifestyles, with different economies, pottery traditions and burial customs. In the late fifth millennium BC a culture closely related to that at Tasa appeared at Badari, and in Lower Egypt a community arose at Omari. The farmers at Omari, Badari

20. *Part of a ceremonial palette with relief decoration, showing, on the side illustrated here, a scene of captives and slain victims of battle; the latter are preyed upon by wild animals. The other side shows two long necked gazelles browsing on a date-palm. Late Predynastic to 1st Dynasty, c. 3100 BC; grey schist. H. 32.8 cm.*

have functioned as a trade emporium for working copper from Sinai. Naqada II grave-goods include animal-shaped slate palettes with inlaid shell-bead eyes, and vessels and pear-shaped maceheads made of hard stones. Pottery includes wavy-handled jars inspired by Palestinian models and a characteristic buff ware with motifs such as boats in purple paint. The finest work in flint occurs at this period, with rippled blades and carved handles in bone or ivory; the latest palettes and knife-handles bear relief scenes of hunting and war.

At Naqada and Hieraconpolis walls enclosed the towns, and the difference in size between the largest and smallest tombs grew ever greater at these two sites and at Abydos. The largest tombs were bricklined, and one at Hieraconpolis had walls painted with motifs of power such as a man holding two lions or vanquishing an opponent. These features in the late fourth millennium BC suggest the rise of warring kingdoms out of the larger towns. The unrecorded conflict and merger of these local kingdoms produced, in about 3100 BC, the earliest nation-state, the first time that the Nile Valley from southern Upper Egypt to the Delta was united under one ruler.

The Early Dynastic Period (Dynasties 1–3, *c*. 3100–2613 BC)

At Hieraconpolis and Naqada the series of great tombs came to an end at the same time that the separate Lower Egyptian culture disappeared, in about 3100 BC. Writing now appeared in Egypt, not long after its invention in Sumer; certain motifs in Egyptian art of the period also derive from Mesopotamian models, but it is not yet understood how features such as niched brick building facades, long-necked felines and the idea of writing itself came to Egypt without leaving any stronger impact on Egyptian culture, for all but writing disappeared within a century or two.

The first texts name the king, and only one king is attested for Egypt by the time that writing was in use. In the text, the king's name is written in a rectangular frame representing a niched brick palace facade, a type attested at Hieraconpolis. The frame is set under a falcon, later identified as Horus. Sometimes the falcon is identified specifically as 'Horus who is in the palace', but the tombs of these kings have been found not at Hieraconpolis but at Abydos. The earliest possible royal names have been identified in frames enclosing a pair of arms (read Ka or Sekhen), a scorpion, and catfish with chisel (read Narmer). Of the three only Narmer occurs clearly on well-carved objects, including the slate palette from Hieraconpolis where the king is shown on one side

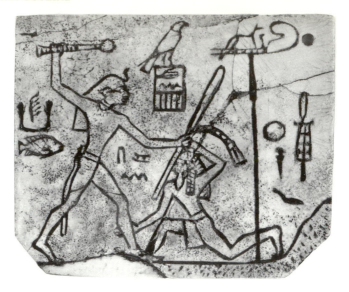

wearing the White Crown and on the other the Red Crown. It is often claimed that such symbols of kingship derived from the regalia of a kingdom of Upper Egypt and a kingdom of Lower Egypt, which would have been united to produce the Two Lands or united kingdom of Egypt; while the Delta and valley have different environments, and thus produce different lifestyles, there is no evidence that the Delta formed a united independent kingdom at any stage. The process of unification would have been complex, and each symbol of kingship might have come from any one centre in Upper, Middle or Lower Egypt. Pharaonic civilisation finds antecedents predominantly in the material culture of Upper Egypt, and even the Red Crown, said to be the crown of Lower Egypt, is first attested on a fragment of pottery from Naqada in Upper Egypt.

The third-century BC historian Manetho divided the kings of Egypt before Alexander the Great into thirty groups called dynasties (from the Greek word *dunamis*, 'power'). In the Late Period the deity of a town was deemed to guide its inhabitants, and Manetho allotted each group of kings to a town. Kings belonging to the same family might also be grouped separately. Modern historians retain the Manethonian scheme for convenience since on many points it accords with contemporary evidence for reigns. It is, however, important to remember that the scheme is a late product, and some of its divisions may result from misreadings of older kinglists. The thirty dynasties of Manetho are grouped today into broader periods; the criterion that marks off each period from adjacent periods is the unity or disunity of the country. Our history of Pharaonic Egypt is an outline of the state of unity or disunity of the country; the two main themes of records of its rulers are building and warfare, with little or no biographical information.

21. *Plaque with a scene showing king Den smiting an Asiatic enemy, accompanied by the inscription 'the first occasion of smiting the East'. The reverse of the plaque bears an incised picture of a pair of sandals, items of the king's funerary equipment to which the label was attached. 1st Dynasty,* c. *2950* BC; *ivory, from Abydos.* H. *4.5 cm.*

The First Dynasty comprises eight kings buried at Abydos; a seal impression found there in 1985 names the first five, beginning with Narmer and with the 'king's mother Merneit' in sixth place, and it confirms the sequence deduced from the layout of their tombs. The excavation of the cemetery at the turn of this century by Emile Amélineau (1850–1915) and then by Sir Flinders Petrie (1853–1942) produced the first mass of evidence for the earliest period of an Egypt united under one ruler. Finds included jewellery (now in the Egyptian Museum, Cairo) on an arm stuffed into a crevice by robbers, and an early masterpiece of hieroglyphic composition, the tombstone of king Djet (now in the Louvre, Paris). Since the work of Abydos, rich cemeteries have been found at Tarkhan, Helwan and Saqqara; the name Narmer occurs at Tarkhan, but the first king known at Saqqara is his successor Aha. Fine ivory carving and stonework illustrate the first phase of Pharaonic Egyptian art and writing. The great tombs at Saqqara are thought by some to be tombs of kings, but seem more likely to be for princely governors of the north because there is more than one per reign. Saqqara was the necropolis of Memphis, and its use implies that the city came into existence in the early First Dynasty; this concurs with the late tradition that the first king of all Egypt founded Memphis. The creation of Memphis, where valley meets Delta, underlines the role of the river in tying the two lands together through transport and communications, and it is no coincidence that Memphis came into existence at the same time that writing appeared in Egypt.

21,

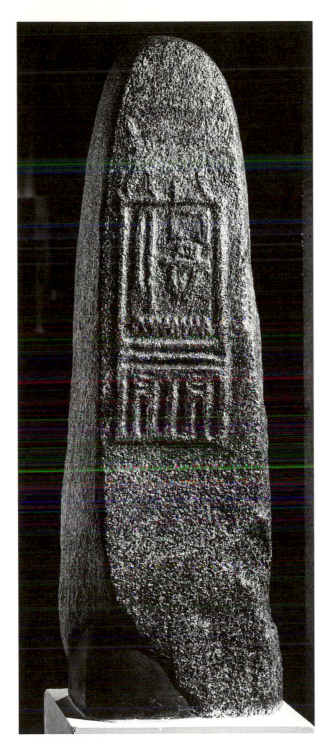

22. *Stela of Peribsen, one of a pair which stood at the king's tomb at Abydos. 2nd Dynasty, c. 2800 BC; granite. H. 1.13 m.*

The Second Dynasty consists of an unknown number of kings buried at Saqqara in galleries now beneath the monuments of the Old Kingdom, followed by two kings, Peribsen and Khasekhemwy, who were buried alongside the First Dynasty kings at Abydos. Peribsen is unique in taking above the frame for his name not the Horus falcon but the composite animal figure of Seth. His successor took two royal names, one with the falcon as Khasekhem ('the power is risen') and the second with both falcon and Seth animal as Khasekhemwy ('the two powers are risen'); the reason for these changes in title is not known. These are the last kings to be buried at Abydos. The tomb equipment of Khasekhemwy contains the first bronze vessels from Egypt; with these vessels we leave the Neolithic and Chalcolithic periods (the periods of farming and copper working respectively) and enter the early Bronze Age. Khasekhemwy is the first king for whom sculpture is known. Great brick enclosures of the Second Dynasty at Abydos and Hieraconpolis, once thought to be forts, have now been reinterpreted as temple enclosures for the cult of the king at the end of the Second Dynasty; they look forward to the Step Pyramid enclosure, the first use of stone on a colossal scale.

The Third Dynasty again consists of an unknown number of kings buried at Saqqara, now in tombs with massive superstructures of which the only completed and surviving example is the Step Pyramid of Netjerkhet, identified in New Kingdom graffiti as king Djoser. In the Step Pyramid substructure are found the first reliefs on a large scale of the king performing rites of kingship, and walls inlaid with faience tiles in motifs of columns and *djed*-pillars. The superstructure incorporates not only the first large scale use of stone, but also experiments in adapting the forms of wooden columns and doors to stone, though the columns are not yet monolithic or freestanding. On the base of one royal statue appear the name and titles of Imhotep, first minister of Netjerkhet; Imhotep was praised as a writer in later literature and identified in the Late Period with the Greek god of medicine Aesculapius as god of learning, perhaps because he was credited with the construction of the Step Pyramid. In the Third Dynasty, alongside the invention of the pyramid, the sun Ra is first found as a god; Netjerkhet occurs on the surviving fragments of the earliest reliefs found at the temple of Ra at Heliopolis. Other kings of the dynasty appear in reliefs at copper and turquoise mines in Sinai, the oldest known destination for expeditions to eastern frontier regions. This new range of pictorial and textual sources opens the first of four classic periods of Pharaonic history.

The Old Kingdom (Dynasties 4–8, *c.* 2613–2160 BC) and First Intermediate Period (Dynasties 9–11, *c.* 2160–2040 BC)

The surviving monuments of the Old Kingdom do not accord easily with the dynasties given by Manetho, and it may be safer to group the kings according to what and where they built, as follows:

Dynasty	Sites	Monument
Fourth	Meidum, Dahshur, Giza	pyramids
early Fifth	Abusir, Abu Gurab	pyramids, sun temples
Fifth–Eighth	Saqqara	pyramids with *Pyramid Texts*

The pyramids dominate the record; their construction transformed Pharaonic culture from the developmental forms of Early Dynastic art and writing into the system of harmonious proportions that guided craftsmen throughout the following three thousand years. The hieroglyphic monuments of Egypt represent the pinnacles of achievement and required for their planning and decoration exceptional precision combining organisation, a tradition of expertise and the artistic inspiration behind each individual monument. These monuments could be created only at moments of concentrated wealth and stability, and therefore reveal the pattern of historical development.

The Fourth Dynasty brought the construction at Giza of the largest pyramids with surrounding tombs of courtiers; at this time writing and formal art did not reach the provinces, although large undecorated rock-cut chapels in Upper Egypt may date to this period and be evidence of wealthy local nobility. A Fourth Dynasty town with metalworking was noted at Buhen in Nubia, and diorite-gneiss quarries in the desert north-west of Abu Simbel provided stone for one of the most celebrated Egyptian statues, of Khafra enthroned (now in the Egyptian Museum, Cairo). In the Middle Kingdom the royal court of Fourth Dynasty kings was used as the setting for

23, 24

23. *Relief slab from the offering chapel of the tomb of Rahotep at Meidum. 4th Dynasty, c. 2600 BC; limestone.* H. *79 cm.*

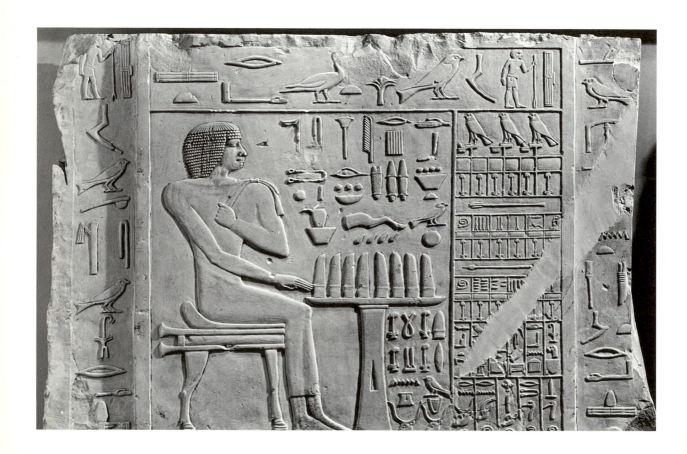

literary tales, perhaps partly because their pyramids make such a strong impression on an observer; it is difficult to assess the historical accuracy of information in such later texts. The last king to build a large pyramid of carefully assembled masonry was Menkaura; after his reign Giza no longer served as the royal burial place and the scale of the royal tomb complex was reduced. A group of kings constructed, in addition to their small pyramids at Abusir, shrines to the sun centred on a massive squat obelisk in an open courtyard. These kings, the early Fifth Dynasty of Manetho, were contemporary with the emergence of writing in the provinces, an event which could have strengthened royal power just as easily as it could have weakened it, by providing the central administration with local offices and staff. The pyramid complexes at Abusir are not large in comparison with Giza, but have left far more wall relief, all of the highest quality, some referring to foreign campaigns. The earliest archives of papyri come from the temple bureaucracy and record the maintenance of the cult into the Sixth Dynasty.

Under king Isesi of the mid Fifth Dynasty, the building of royal sun temples and all other construction work at Abusir ceased. The Saqqara pyramid of his successor Unas introduces a new type in which not only the temple outside but also the walls of the burial chamber and other rooms inside the pyramid were decorated. This type of pyramid was continued into the Sixth Dynasty; under these kings conflicts with southern and northern neighbours were recorded in the funerary monuments of provincial officials. Tomb-chapel texts of Fifth and Sixth Dynasty courtiers at Saqqara also include references to affairs of state, although their primary function was to secure a good afterlife for the owner; the king, court and military action are mentioned only where they might bolster the claim of an official to obtain the best life in the next world as in this. After Pepy II, from whose reign comes an unusual statue of the king as a child on the lap of his mother (now in The Brooklyn Museum, New York), the texts of provincial officials change their tone; they vaunt not their links to the throne but their own valour and independence. Already in the reign of Pepy II the royal necropolis for king and high officials had become a poor shadow of earlier court funerary monuments, implying a loss of control over resources; in southern Upper Egypt the texts now tell of open warfare, in particular texts in the tomb-chapel of Ankhtyfy, a magnate in the area between Thebes and Edfu. The tomb-chapel of Ankhtyfy's son contains no texts mentioning strife, but the neighbouring rulers of Thebes had by this time broken away from northern rule. Thebes had not been a great city in the Old Kingdom, but it became the capital of a new kingdom stretching over southern Upper Egypt.

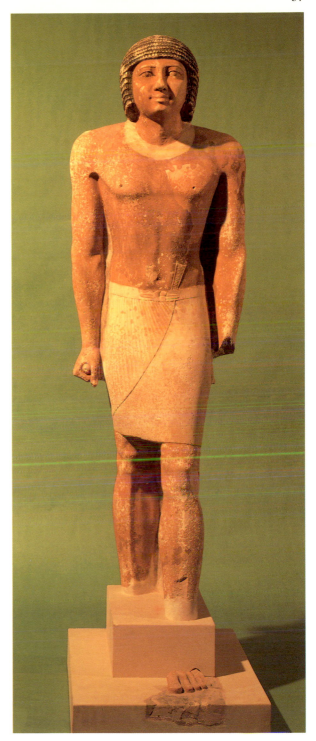

24. *Statue from the tomb of Nenkhefika, showing the nobleman in a striding pose, left foot forward, with his skin shown tanned red-brown. Proportions, costume and colour conform to the artistic rules established in the Old Kingdom. 5th Dynasty, c. 2400 BC; painted limestone, from Deshasha. H. 1.34 m.*

Manetho marks the end of the Old Kingdom with a Seventh Dynasty, perhaps a literary device to express collapse, followed by weak Memphite kings as the last successors to Old Kingdom tradition. The north was then controlled by kings from Heracleopolis, who may have resided there rather than at the Old Kingdom Residence city Memphis. For about a century Egypt was divided between these Heracleopolitan kings, the Ninth and Tenth Dynasties of Manetho (no reason for the division into two dynasties is known), and the Theban kings, the Eleventh Dynasty of Manetho, the First Intermediate Period. The provinces seem to have flourished in the disunity of the land, with hieroglyphic craftshops continuing from the Sixth Dynasty in many Upper and Middle Egyptian centres such as Asyut and Gebelein; in their funerary texts provincial nobles speak of loyal service, in the south to Thebes, in Asyut to the Heracleopolitan king, but all still stress their own active prowess.

The Middle Kingdom (Dynasties 11–13, *c.* 2040–1750 BC) **and Second Intermediate Period (Dynasties 13–17, *c.* 1750–1650 BC)**

Division ended under the Theban Nebhepetra Mentuhotep, who became sole king of Egypt. His funerary monument at Deir el-Bahri remained in the New Kingdom the most important and active creation of the Middle Kingdom at Thebes, and in later kinglists the king himself took the position of first ruler in the renewed central kingship. The reason for the disappearance of the Heracleopolitans is unknown; texts refer to warfare in the first years of the reign of Nebhepetra, as under

25. *Part of wall relief from the Theban temple for the cult of Nebhepetra Mentuhotep, showing the king wearing the Red Crown. 11th Dynasty, c. 2000 BC; painted limestone, from Deir el-Bahri.*

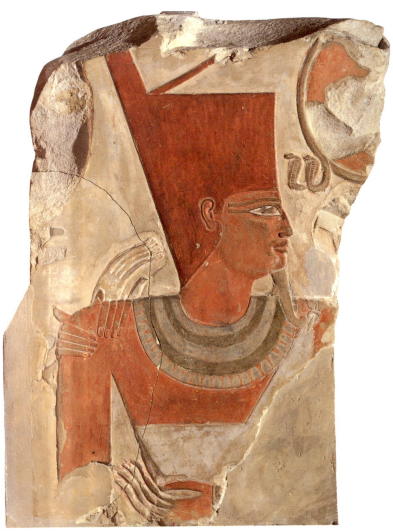

his predecessors, but the middle years of the reign are not well documented, and by the time the record resumes the land is already reunited. Despite the conflict in the early Eleventh Dynasty against Heracleopolis, late Eleventh and Twelfth Dynasty texts do not anathematise the city or its god, and it is possible that some peaceful arrangement, such as a dynastic marriage alliance, was concluded. The last two kings of the Eleventh Dynasty are known only from Theban texts, ending with a quarrying expedition to the eastern desert under the vizier Amenemhat, who had miraculous events recorded, including the birth of a gazelle on a block chosen for the king, Nebtawyra Mentuhotep.

A new line of kings (Twelfth Dynasty of Manetho) then opens with Amenemhat I, in whom some scholars see the vizier Amenemhat of the extraordinary quarrying expedition. Whatever his origins, Amenemhat I led a revival of the country, founding to the south of Memphis a Residence called Itjtawy (in full Itjtawyamenemhat, 'Amenemhat seizes the Two Lands'), and redefining boundaries between districts at the same time as launching campaigns against the south to annex Lower Nubia. Much of the dynamism may have come from his son Senusret I who followed the same policies and who created a far greater number of surviving temple buildings throughout the land. Literary works on papyrus mention tension in the court, and even an assassination attempt on Amenemhat I before he made Senusret I his co-regent, but it is simplistic to take these at face value without assessing their literary force; the word propaganda is often applied to these texts, but this is misleading, both because the precise date and audience are unknown, and particularly because the word propaganda was created in the world of counter-reformation and revolution within Europe. We can only say that the brilliant court creations of the Twelfth Dynasty range from sculpture and relief to the earliest written literary texts; the role of the king in the creation of any of these is not known in the absence of biographical sources.

The royal monuments of the early Twelfth Dynasty did not counteract the splendour of provincial courts; tomb-chapels of the governors at Beni Hasan, Bersha, Meir and Qaw in Middle Egypt and at Aswan in Upper Egypt seem all the more magnificent in the absence of comparable surviving court cemeteries near the Residence and the replacement of the solid stone pyramids of the Old Kingdom by cheaper building methods in the Middle Kingdom royal pyramids. A turning-point comes in the reign of Senusret III, splitting the Middle Kingdom into two distinct phases, early and late; the king launched a series of campaigns to annex more thoroughly the Second Cataract region, and strengthened the chain of fortresses controlling Lower Nubia. Most administrative posts were given extremely precisely

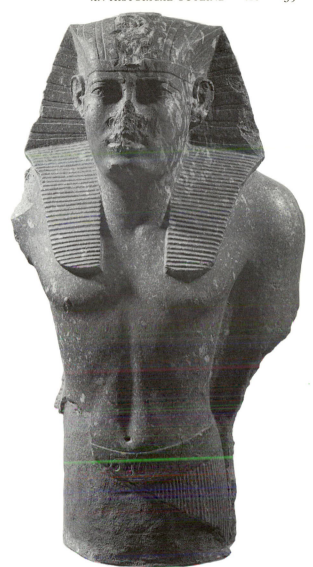

26. *Statue of Senusret* I *shown standing, wearing the* nemes *headcloth with uraeus and a* shendyt-kilt. *The throne-name of the king is inscribed on the belt. 12th Dynasty,* c. *1950* BC; *grey granite, from Karnak (?).* H. *76 cm.*

defined job descriptions, and some at least of the great provincial families seem to have been tied more closely to the Residence, with burial-places there instead of the local family necropolis. In sculpture Senusret III and his successors are shown with worn facial lines in striking contrast to the smooth youthful appearance of the king in art of other periods. By good fortune a number of items of jewellery survived the looting and destruction of the royal cemeteries, and testify to the unparalleled

mastery of materials at this time. The Twelfth Dynasty closes with Amenemhat III and two presumed relatives Amenemhat IV and, for perhaps the first time in Egypt, a queen reigning as king, Sobekneferu. However, the system established under Senusret III and the Residence founded by Amenemhat I at Itjtawy continued to function for another century or longer, under the many unrelated and short-reigning kings grouped by Manetho as the Thirteenth Dynasty.

Despite the continuity, the short reigns of Thirteenth Dynasty kings allowed no time for substantial royal initiative other than reduced temple and pyramid building and some spectacular statuary; the deepest repercussion came in the relaxation of the borders, which the Twelfth Dynasty kings had upheld by fortress chains and military strikes to counter potential aggressors. The change is most visible and dramatic at the north-eastern Delta site of Tell el-Daba, thought to be ancient Avaris, which turned from an Egyptian into a Western Asiatic city by the end of the Thirteenth Dynasty. The eastern Delta broke away from central control in the late Thirteenth Dynasty, apparently under a 'king's son' Nehesy who, with his barely attested successors, forms the Fourteenth Dynasty of Manetho as Delta kings contemporary with the last kings of the Thirteenth Dynasty at Itjtawy.

In about 1650 BC the minor rulers in the Delta were replaced by kings called in Egyptian *heqa-khasut*, 'rulers of hill-countries', foreign rulers called 'the Hyksos' by the later Greek historians; at about the same time the central line of kings moved from Itjtawy to Thebes. Later tradition alleged that the Hyksos sacked Memphis and destroyed order, but there is nothing in contemporary sources about their rise to power and the accompanying contraction of the Egyptian state to southern Upper Egypt. At first relations seem to have been stable between the foreign kings of the north (the Fifteenth Dynasty of Manetho, said to rule from Avaris) and the Theban kings (Seventeenth Dynasty); many scarabs name otherwise unknown rulers with Semitic names, either part of the Fifteenth Dynasty at Avaris or perhaps their vassals in other Delta or Palestinian cities (Sixteenth Dynasty of Hyksos in Manetho). The only Hyksos at this period to leave hieroglyphic monuments other than scarabs were Khyan and Apepi, both perhaps at the end of the Fifteenth Dynasty line when one might expect the foreign kings to be more Egyptianised. Under Apepi war broke out with the Theban king Seqenenra Taa; a late Egyptian tale describes the Theban court trying to ignore provocative letters from Apepi who was complaining of the noise from Theban hippopotami. Whatever the truth behind the tale, the skull of Seqenenra Taa bears the imprint of an axe of Western Asiatic type. The next Theban king, Kamose, of unknown origin, brought the fight to the gates of Avaris

itself, as vividly recounted on stelae set up by the king at Thebes; inscriptions in Nubia record the first moves to reconquer the area controlled by Egypt in the Middle Kingdom. After the short reign of Kamose, Ahmose I, son of Seqenenra Taa, completed the expulsion of the Hyksos from Egypt, but precisely when or how is not known.

The New Kingdom (Dynasties 18–20, *c.* 1550–1086 BC)

By regaining control of all Egypt Ahmose I inaugurated a new line (Eighteenth Dynasty of Manetho) and a new age of unity, the New Kingdom. He and his son Amenhotep I continued the reconquest of Nubia and took the northern war into Palestine, presumably to remove any threat of renewed foreign domination. The queen of Ahmose, Ahmose Nefertari, received a special position in his reign and the reign of his son, as the first to hold the title 'wife of the god' in the Amun temple. Whereas Ahmose I built a royal cult complex at Abydos, on the example set by late Middle Kingdom kings, Amenhotep I seems to have concentrated exclusively on Thebes. He extended the Amun temple at Karnak, restored the Nebhepetra Mentuhotep temple at Deir el-Bahri and apparently established the royal funerary workshops on the West Bank, leading to his posthumous role as patron deity, with his mother Ahmose Nefertari, of West Thebes. He was succeeded by a man of unknown origin, Thutmose I, who led the Egyptian armies further than any other Pharaoh, to the Euphrates in the north and to Kurgus in the south, an extraordinary extension of power that laid the ground for Egyptian occupation of Nubia and control of Western Asiatic cities for the next two centuries. Thutmose I was also the first king to have a deep rock-cut tomb made in the desert valley used as the royal burial-place to the end of the New Kingdom, and now called the Valley of the Kings.

Thutmose I was succeeded by a son Thutmose II, who married his half-sister Hatshepsut. After a few years, from which not many monuments survive, Thutmose II died and his son Thutmose III became king. Hatshepsut took the position of regent, perhaps because Thutmose III was too young to rule alone, and then in the second year of the new reign she became the first woman since Sobekneferu to be crowned king of Egypt. Her exceptional position in history is underwritten by the unique terraced temple that she had constructed for her cult at Deir el-Bahri next to that of Nebhepetra Mentuhotep, with reliefs showing the transport of obelisks and a voyage to the land of Punt for aromatic plants. Unusually explicit texts in that temple and on the great obelisks that she had erected in the Amun temple at Karnak emphasise her legitimacy. In her reign an artistic renaissance drew on Middle Kingdom work to produce a range

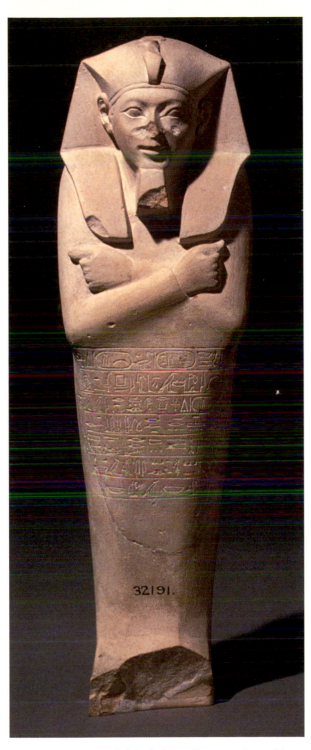

27. *The earliest known* shabti *of a king, Ahmose I, and one of the only sculptures of that monarch to be securely identified by an inscription on the piece itself. The king wears the* nemes-*headcloth and uraeus. On the mummiform body is written a variant of the* shabti-text. *18th Dynasty, c. 1550 BC; limestone.* H. *30 cm.*

of new types of sculpture, and the practice of writing funerary texts on papyrus (the *Book of the Dead*) began. The first minister of Hatshepsut was Senenmut, who was permitted to place his tomb at the side of the royal cult complex at Deir el-Bahri and to decorate it with unusual religious motifs such as an astronomical ceiling and texts, the *Litany of Ra* for example, otherwise reserved for the tomb of the king. During Hatshepsut's rule, Thutmose III seems to have reigned alongside, conducting campaigns and being cited as king in documents. Many innovations under Hatshepsut may derive from her claim to be not queen but king of Egypt; after her death the claim was gradually and systematically edited out of the hieroglyphic record by having her image and name as king erased on every monument, even in remote shrines and at the tips of obelisks. There is no evidence for the personal relations between Hatshepsut and Thutmose III, and the erasures reflect not personal revenge but an effort to set the record straight and remove the anomaly of a female Horus, a female king. It is not known what happened to Neferura, the daughter of Hatshepsut.

In his sole reign Thutmose III conducted campaigns against Near Eastern city-states that opposed Egyptian domination; the record of these campaigns was inscribed on the walls of the Amun temple at Karnak, a major beneficiary of each triumph. The first and most detailed account relates the siege of Megiddo following a decision by the king to lead his army through a dangerously narrow pass, against the advice of his courtiers and the expectations of his opponents. This historical moment coincided with the theory that the king is the defender of order and creation, and for this reason it was recorded in hieroglyphs on stone, giving a detail of past actions that hold importance for both ancient scribes and modern historians but for different reasons. Thutmose III brought children of foreign princes to Egypt as a guarantee of future subservience. Egyptian envoys were sent to strategic cities to report on local activity, and both in Asia and Nubia the appearance of Egyptian armies quelled sporadic opposition to Pharaonic control. Large-scale temple-building continued in Egypt and now spread to Nubia, and the control of Palestinian trade and Nubian goldmines brought accumulating prosperity to Egypt and led to the brilliant artistic and architectural achievements of the reign of Amenhotep III. He transformed Thebes with a series of new temple-buildings for Amun at Karnak and Luxor, and for his own cult on the West Bank, where there was also a royal palace at Malkata with a nearby chariot racetrack, the oldest known.

Amenhotep IV, the son of Amenhotep III, changed his name in his sixth year to Akhenaten, and cut all royal ties with (and presumably funding of) the Amun cult so that the sun alone was worshipped, in the new form of

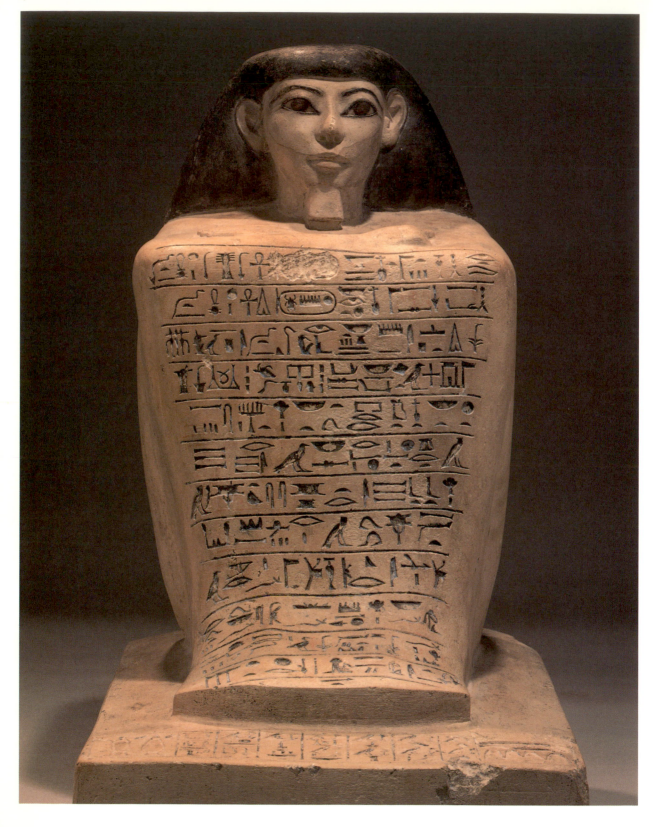

28. OPPOSITE *Block statue of Inebni, with incised hieroglyphic text painted blue to stand out against the white background. The black of the eyes and wig further emphasises the brightness of the stone body and base. The inscription contains the formulaic prayer for offerings, giving the name and titles of the official, a commander of infantry, and records in the first two lines that it was 'made by the favour' of the joint sovereigns Hatshepsut and Thutmose III. Hatshepsut's name is preceded by the phrase 'perfect goddess, lady of Two Lands', a feminine version of the titles of Pharaoh, but has been erased in the comprehensive official editing of monuments after her death. 18th Dynasty, c. 1450 BC; painted limestone, from Thebes. H. 51.5 cm.*

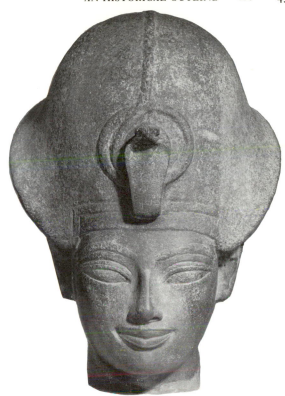

29. *Head from a statue of Amenhotep III, showing the king wearing the so-called Blue Crown; with a prominent coiled uraeus. 18th Dynasty, c. 1350 BC; quartzite. H. 22 cm.*

the sun-disk, or Aten. For the new cult he created a Residence city in Middle Egypt called Akhetaten, today known as Amarna, and from which is derived the term the Amarna Period to refer to the reigns of Akhenaten, Tutankhamun and Ay. The site lies along the desert edge, and consequently the layout of the city and its houses is preserved, providing a clear picture of the life of every class from those in the palace to worker quarters. The finds included a great number of clay tablets with inscriptions in the cuneiform script and Akkadian language dominant in Western Asia, and which contained diplomatic correspondence from Amenhotep III and his son to the rulers of Asiatic cities and kingdoms. The lack of response to many pleas for help was interpreted by earlier Egyptologists as evidence that Akhenaten allowed his power abroad to evaporate, but it is equally likely that the Egyptians received conflicting pleas for help from an array of foreign rulers, and had to tread carefully in the diplomatic minefield of Western Asiatic city-state rivalry.

Akhenaten's reign ended with the enigmatic Neferneferuaten, followed by the child Tutankhaten, of uncertain parentage but of the same family. Under the boy

ruler the Amun cult was re-established and the king's name changed to Tutankhamun. The royal workshops undertook a vast programme of restoration to statues and inscriptions damaged by agents of Akhenaten, and the general Horemheb led troops against enemies in Western Asia. Tutankhamun died when he was only sixteen or seventeen, and was succeeded first by an elderly courtier Ay and then by the general Horemheb, who abandoned his magnificent tomb-chapel at Saqqara and took a rock-cut royal tomb in the Valley of the Kings for his burial place. Horemheb was regarded by later generations as the legitimate successor of Amenhotep III, and the years of Akhenaten, Tutankhamun and Ay were allotted to the reign of Horemheb; Akhetaten was dismantled and any presence of Akhenaten, his queen Nefertiti and their image of the sun as a disk was erased.

Horemheb was followed on the throne by an elderly courtier Ramses I, who was himself succeeded by his son Sety I. The new line of kings forms the Nineteenth Dynasty of Manetho, and was characterised by a fresh struggle against foreign peoples. The major power opposing Egypt in the reign of Sety I and his son Ramses II was the Hittite Empire based in Anatolia; the conflict

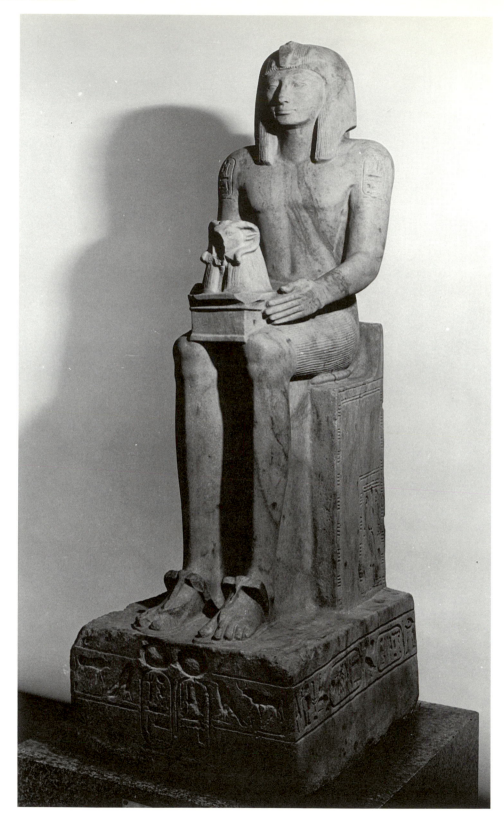

30. *Life-size statue of Sety* II, *enthroned. The king wears a plain plaited wig upon which is coiled a uraeus, and proffers on his lap a votive object consisting of a pedestal with the head of a ram, emblematic animal of Amun. 19th Dynasty, c. 1200 BC; quartzite, from Thebes.* H. *1.43 m.*

reached a head at the battle of Qadesh where the Hittite armies were prevented from routing the Egyptians only by the escape of Ramses II and his immediate retinue from their encirclement. The battle was not a military victory, and left a stalemate that led eventually to the first international peace treaty, surviving on both sides. Yet, as with Thutmose III at Megiddo, it saw the king fulfilling his role as defender of creation, and therefore it was described and portrayed in most original style on the walls of the greatest buildings of the reign, and the text copied on papyri. Ramses II left more monuments than any other Pharaoh, surpassing even Amenhotep III, although the quality in this tremendous output varies from outstanding to mediocre. Like Amenemhat I and Akhenaten he founded a Residence city, this time in Per-Ramses, 'Domain of Ramses', in the eastern Delta at or near the Hyksos capital Avaris, a position that indicates the pull of the Delta and Asiatic trade to the detriment of Nubia and Thebes.

Part of this shift may be due to the exhaustion of goldmines which is reflected in inscriptions of Sety I and Ramses II, but it may also reflect the rise of the Delta over the valley to become, as now, the economic heart of the country. The Delta was vulnerable to attack from the north and west as well as the east, and Ramses II and his son and successor Merenptah both had to repel nomadic incursions from the western desert. A victory inscription of Merenptah on northern triumphs is the only Egyptian text to mention Israel, one of a series of peoples said to have been crushed.

After Merenptah there is confusion in the evidence over the exact royal succession. Sety II left some remarkably fine royal sculpture, but the period of his reign is overshadowed by conflicting claims, with erasures and counter-erasures of names, under Saptah and the queen Tausret (who followed Sobekneferu and Hatshepsut in claiming kingship). The period of confusion ends with Setnakht, of unknown origin, who with his successors forms the Twentieth Dynasty of Manetho. The only substantial monuments surviving from this family of kings are a side-temple at the fore of the Amun temple at Karnak built by Ramses III, the temple for the cult of the same king on the West Bank at Thebes, and the great rock-cut royal tombs in the Valley of the Kings. The mortuary temple of Ramses III bears on its outer walls scenes of battles on water and land against the new northern and western enemies of Egypt that had begun to threaten order in the reign of Ramses II. In his fifth, eighth and eleventh years, Ramses III had to fight Libu and Meshwesh, thought to be nomadic tribes of the western desert, and with other peoples of unknown origin, often thought to be from Anatolia and the Aegean, such as the Tjeker and Peleshet (the Sea Peoples); the details of weaponry, armour and clothing on the reliefs

has not yet been matched from archaeological finds that would identify the exact homeland and destination of these peoples, but disruption of Western Asiatic sites at this time suggests that the population there was supplanted by the newcomers. With the arrival of new peoples, Egypt's hold on her neighbours slackened, and the internal economy seems to have faltered at the same time. Ramses III was assassinated and his successors failed to establish strong central authority in the face of internal and external strife attested in Theban texts (see chapter 5). Under the last king of the dynasty, Ramses XI, the viceroy Panehesy seems to have been at the centre of Theban disturbances in which Amenhotep, the high priest of Amun, temporarily lost his position; the general Payankh was sent to fight Panehesy and the outcome of the conflict is not known, but northern rulers had lost interest in Thebes and Nubia. Nubia ceased to be occupied by Egyptian forces and the last royal link with Thebes was the burial place of the kings; with the death of Ramses XI, whose tomb was unfinished and whose burial has not been found, the link was severed and the authorities in the north and south came to a new arrangement, effectively dividing the country and thus ending the New Kingdom.

The Third Intermediate Period (Dynasties 21–25, c. 1086–661 BC)

At the death of Ramses XI the kingship was taken up by a man called Smendes who resided at Tanis, north of Per-Ramses; the area from Aswan to Hiba in Middle Egypt was administered by the general Payankh. According to the literary *Report of Wenamun*, this arrangement already existed in the last years of Ramses XI, with the general Herihor at Thebes, and was called the 'repeating of births', or renaissance, as if marking a renewal of order after the disorder in the second half of the Twentieth Dynasty. Herihor legitimated his rule by placing his name in a cartouche and taking as second royal name the title High Priest of Amun. The Theban nobility probably continued to operate as before, but now claimed their income from estates not through the Crown but through priestly service of Amun, giving the impression of a 'theocratic state'. Oracles could be used to pass decrees and legal decisions, as already in the New Kingdom; the most striking difference lay in the new style of burial, without tomb-chapels and with two papyri including one drawn from previously kingly texts.

In the north, the kings of the new line (Twenty-first Dynasty of Manetho) embellished Tanis with monuments from Per-Ramses, and seem to have maintained good relations and even family ties with the authorities ruling Upper Egypt from the Amun temple. Few high

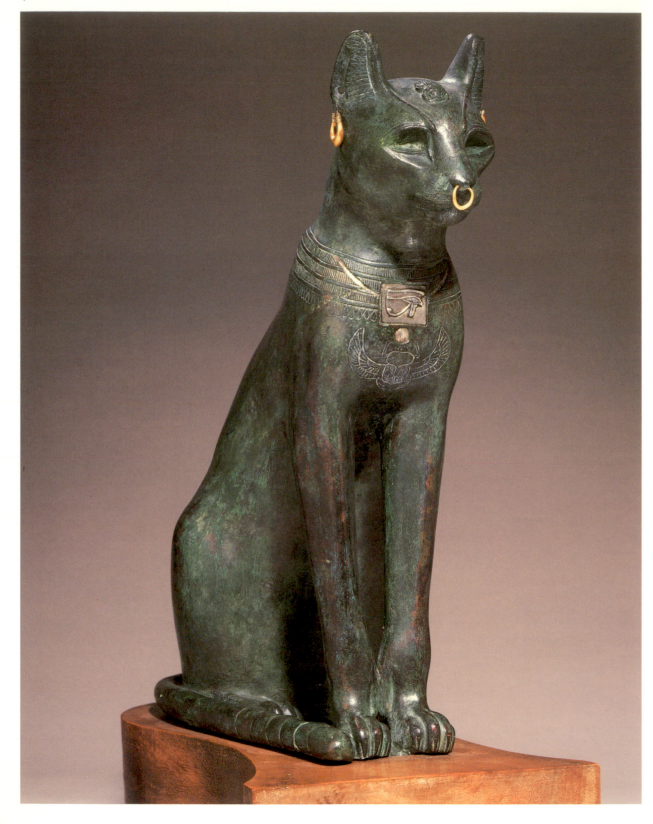

priests of Amun claimed kingly position, and many documents in the south were dated by regnal year of the northern king, but the executive authority in Thebes seems to have been the men holding the higher priestly titles. Many of the leading noblemen of the time in both halves of the country came from Libu or Meshwesh stock, and one such man in Bubastis became Sheshonq I, first king of a new line, the Twenty-second Dynasty of Manetho. The new kings, often called the Libyan or Bubastite Dynasty, restored royal authority at Thebes and took Egyptian armies abroad. The Old Testament Book of Kings (I, xiv. 25–6) records the seizure of Jerusalem temple equipment by a king Shishak (one reading of hieroglyphic forms of this non-Egyptian name), and Sheshonq I recorded his Asiatic victories on the walls of Karnak temple in New Kingdom style. Although Tanis continued to serve as Residence and royal burial-place, the kings moved much of the stonework to Bubastis, the cult-centre of the feline goddess, and Osorkon II had a monumental granite hall constructed there for the celebration of his *sed*, or kingship festival. The popularity of the cat and Bastet starts from this period of royal patronage of her cult and city.

Despite the strength of royal projects, texts indicate continued strife under Takelot II and his successors, ending in the fragmentation of the country into small kingdoms, with the central line at Tanis (late Twenty-second Dynasty) and rivals at cities such as Thebes, Heracleopolis and Sais (these may be grouped together for convenience under the label 'Twenty-third Dynasty' in the absence of any single clear opposing line). Sais, in the western Delta, provided the strongest move toward reuniting the land under its ruler Tefnakht, perhaps of western nomadic stock like the Bubastite kings (Tefnakht and perhaps other rulers of Sais form the Twenty-fourth dynasty of Manetho). The success of Tefnakht alerted a new powerful neighbour to the south, the king Piy (often written Piankhi in the ancient texts) of Napata. A long line of local rulers at Napata had come to dominate Nubia, and this southern realm was in a position under Piy to challenge Tefnakht for dominion of Egypt. A great hieroglyphic stela set up at the temple beneath the sacred mountain Gebel Barkal in Upper Nubia paints a dramatic picture of the progress of Piy with his armies through the valley, down to the final submission of Tefnakht (the stela is now in the Egyptian Museum, Cairo). Piy returned to Nubia but at Thebes he left as 'divine adoratrice', high priestess of Amun, Amenirdis, the daughter

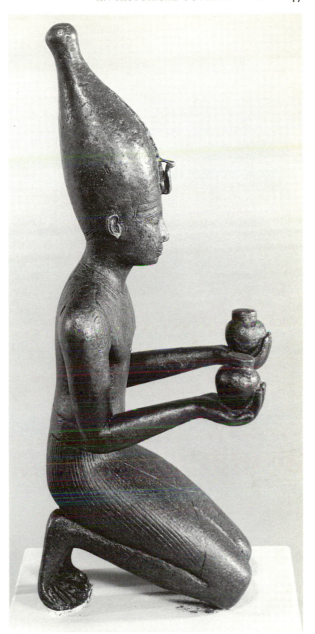

32. *Figure of king Pimay kneeling to present a pair of vases, probably part of a group-sculpture representing the king offering to a god. He wears the crown of Upper Egypt, and cartouches containing his names are engraved on the shoulders and in the centre of the belt. 22nd Dynasty, c. 773–767 BC; bronze. H. 25.5 cm.*

31. OPPOSITE *Figure of a cat, the sacred representation of the goddess Bastet. The protective eye-amulet at the neck is silvered and the eyes were originally inlaid. Late Period, after 600 BC; bronze with gold rings. H. 38 cm.*

of his predecessor Kashta. Documents in Thebes were now dated by regnal year of the Napatan king, and perhaps the Thebans used their distant southern ruler as shield against more immediate domination by the Delta. Piy's successor Shabako finally conquered the

Delta, and both he and another Napatan king Taharqo left numerous Egyptian monuments favouring both Amun and other Egyptian deities. One of the most famous religious texts from Egypt is an account of the creation carved on a slab of basalt, now in the British Museum, at the command of Shabako and purporting to be a copy of a wormeaten ancient book. The Shabako Stone epitomises the revival in ancient traditions under the Napatan kings in Egypt, particularly strong in works of art of the period.

Napatan rule over Egypt amounted to the largest ancient kingdom in Africa, far exceeding the reach of the New Kingdom. Yet it did not change the balance of power at local level, where descendants of rulers of the old petty kingdoms continued to hold the titles of their forefathers throughout the fifty years of Napatan domination. In 671 BC the Assyrian king Esarhaddon broke the grip of the Napatan kings with invasion and the capture of Memphis. Although Taharqo restored his rule after the Assyrian troops had left, they returned in 667 BC under the new Assyrian king Ashurbanipal to occupy Lower Egypt and remove to Nineveh the Delta princes suspected of opposing Assyrian rule. When the Napatan king Tanutamani came to the throne in 664 BC he launched a campaign to regain Egypt, and succeeded in killing Nekau the governor of Sais. Ashurbanipal crushed the attempt by reinvading and this time sacking Thebes; Tanutamani withdrew to Nubia, and the Assyrians made Psamtek, son of Nekau, governor of Lower Egypt.

The Late Period (Dynasties 26–30, 661–332 BC)

The Assyrians seem to have left Psamtek to govern Lower Egypt in their interest; in Thebes documents continued to be dated after the Napatan king, but executive power lay in the hands of the mayor Mentuemhat, whose tomb-chapel was one of the grandest non-royal Pharaonic structures, while the Napatan divine adoratrice Shepenwepet II continued in office. In 656 BC Psamtek came to a new arrangement with the Theban authorities by confirming them in office in exchange for having his own daughter Nitiqret (Nitocris in Greek) adopted by Shepenwepet II, as the next divine adoratrice, as recorded on a stela (now in the Egyptian Museum, Cairo). With this adoption, Psamtek became ruler of all Egypt, first of a line of Saite kings (the Twenty-sixth Dynasty of Manetho, commonly referred to as the Saite Period), fulfilling the ambitions of his forerunner Tefnakht. The Assyrians took no measures against their erstwhile vassal, and themselves fell prey to their Babylonian subjects toward the end of the reign of Psamtek I in Egypt. The Saite dynasty owed its security in large part to Lydian and Carian mercenaries and fostered good

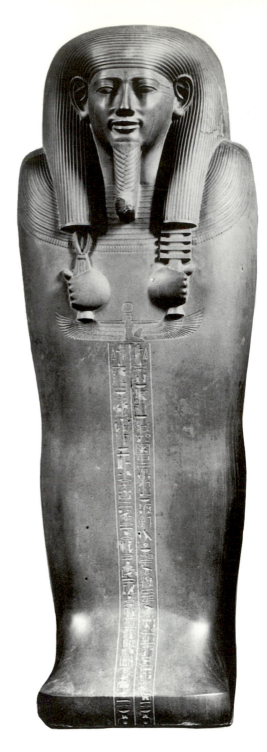

33. *Lid of the mummiform sarcophagus of Sasobek, Memphite vizier during the reign of Psamtek I. 26th Dynasty, c. 630 BC; basalt.* H. *2.23 m.*

relations with the densely populated Greek city-states; a Greek city was even permitted on Egyptian soil at Naucratis in the Delta, to channel the benefits of Mediterranean trade into the country.

Military concerns dominated the century of Saite rule; the effort of king Nekau to conquer Syria-Palestine failed when his armies were defeated in 605 BC at Carchemish by the Babylonians under Nebuchadnezzar, and war with Napata broke out under Psamtek II who led his troops deep into Nubia, perhaps causing directly the transfer of the Nubian capital from Napata farther south to Meroe, heralding the start of the Meroitic Period in Nubia. Despite the high military profile, the period built strongly on the Napatan renaissance in art and texts; the feats of the Late Period are often overlooked because their patronage was concentrated on Lower Egypt, where most sites have been despoiled of their stone and so of their hieroglyphic and sculpted monuments, but the surviving works testify to the vitality of the period. The central state imposed demotic as the standard cursive script, and the funerary corpus of texts (the *Book of the Dead*) was revived in a fixed sequence of striking regularity. The Egyptian kingdom was extinguished by the same fate that befell Babylon, the expansion of the Persian Empire, and Psamtek III was defeated at Pelusium by Cambyses in 525 BC.

Persian rule brought the Iron Age more fully into Egypt with a new administrative language and script, Aramaic, but some Persian rulers cultivated Egyptian tradition in religion and art. The First Persian Period is acknowledged in the list of Manetho as the Twenty-seventh Dynasty, and Darius I conferred stability on the country and built an Egyptian temple to Amun in Kharga oasis. However, the defeat of his army at Marathon in 490 BC opened the way for aspiring rebels; an immediate revolt was put down by his successor Xerxes upon his succession in 486 BC, and another uprising in the Delta greeted the accession of Artaxerxes I in 465 BC, when a local prince, called Inaros by the Greeks, was able to control the Delta, though not Memphis, until his defeat and execution in 454 BC. At the death of Darius II in 405 BC more successful opposition began, under a local prince named in the Greek histories as Amyrtaeus and present in Manetho as sole king of the Twenty-eighth Dynasty. Whatever his fate he left Egypt united and independent for the following sixty years, with kings from two Delta cities, first Mendes (Twenty-ninth Dynasty) and then from Sebennytos (Thirtieth Dynasty). The kings of the Thirtieth Dynasty left particularly impressive monuments, forming yet another renaissance in the resilient traditions of the land, this time drawing on the inspiration of the Twenty-sixth Dynasty. The last king of this group was Nakhthorheb, whose reign ended with the Persian reconquest of Egypt in 343 BC; it is not known

where he ended his days, or how his magnificent sarcophagus came to rest in Alexandria. Persian rule of Egypt lasted another decade, with an interlude when a certain Khababash apparently took control of parts of the country. Alexander the Great arrived as the new conqueror in 332 BC and opened the period when Egypt was ruled by Macedonians (332–30 BC) and administered in Greek (332 BC–AD 641).

The Ptolemaic Period (332–30 BC)

The conquest of Egypt by Alexander the Great opened an era lasting almost a thousand years during which Greek was the language of state in Egypt. Alexander made Egypt a province of the Macedonian empire, accepting the oracle of Ammon at the Siwa oasis that declared him son of the sun-god and so rightful ruler of Egypt. When Alexander died suddenly in 323 BC his generals took control of the various parts of the empire, although first they recognised Philip Arrhidaeus and the son of Alexander, Alexander IV of Macedon. The general governing Egypt was the Macedonian Ptolemy, who in 305 BC declared himself king with the epithet Soter, 'saviour'; as Ptolemy I he stands at the head of a dynasty that proved the most splendid and long-lived of the Hellenistic kingdoms to emerge from the break-up of the empire of Alexander. During the third century the throne passed from father to son in orderly succession, and the Ptolemies turned Alexandria into the most brilliant metropolis of the Greek-speaking world. Ptolemy I and II created the monuments for which the city remains famous, the lighthouse that stood from c.290–80 BC until an earthquake in 1362, and the library and museion ('house of muses', more akin to an academy than to the modern concept of museum); an example of the flourishing literature and scholarship of the age is the history of the Pharaohs compiled by the Egyptian Manetho (see the section on Chronology in chapter 2). Ptolemy II also instituted a new version of the Pharaonic cult of the ruler; he married his sister Arsinoe II and had her deified, a move that was followed by every succeeding Ptolemy and which enjoyed favour among Greek and Egyptian alike, to judge from the number of people named after Ptolemaic queens Arsinoe, Berenice and Cleopatra. Whereas Ptolemy I had entombed the body of Alexander at Memphis, Ptolemy II moved it to Alexandria to join the tomb and cult for his own parents, and the state cult of rulers continued to accumulate each successive Ptolemy and his wife to the end of the dynasty. Ptolemaic ruler cult differed from previous worship of the reigning king by including both wife and all previous kings and queens of the dynasty. A second innovation of the dynasty was the priestly decree whereby priests instead of the king issued decrees affecting the temples;

34. *The Delta.*

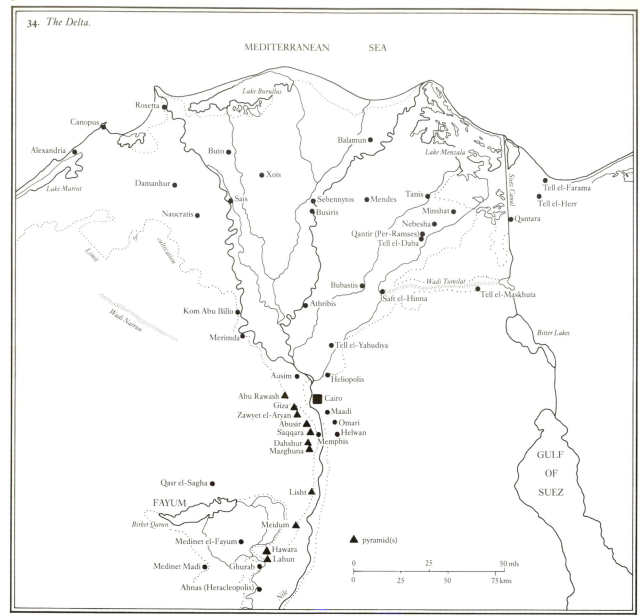

an early example is the decree of Canopus issued in 239–8 BC to deify Berenice as a goddess in all temples and to reform the calendar, an early but never enacted move to create a leap year. The priestly decrees were promulgated on stelae in three scripts, Greek as the language of the administration, demotic as the native script for daily purposes, and hieroglyphic as the writing appropriate to temples and eternity, and so they provided early nineteenth-century scholars with their first realistic hope of deciphering ancient Egyptian scripts from Greek parallel texts (see the section on Decipherment in chapter 5).

The prosperity of the third century is reflected in the Zeno archive, a mass of Greek documents on the business affairs of one Zeno and his administrative superior Apollonius, a minister of finance who owned a Levantine trading fleet. The Hellenistic celebration of life in luxury, crowned in lavish ceremonies of state under Ptolemy II, was not interrupted by the continual warfare between the Hellenistic kingdoms, notably a series of Syrian Wars between the Ptolemies and their Hellenistic rivals in Syria, the Seleucid dynasty. In 217 BC Ptolemy IV won the battle of Raphia against the Seleucid forces, in part by arming large numbers of Egyptians. Although similar arming of Egyptians for the battle of Gaza in 312 BC produced no known effects, it is thought to be no coincidence that the following decade saw a series of uprisings,

35. *The site of Buto was once the cult-centre of the goddess Wadjyt, adopted in Early Dynastic times as national patron. Recent German and Egyptian excavation has begun to reveal the Predynastic history and New Kingdom temple structure, the latter visible in this view. The site continued in importance into the Late Period.*

and led in 206 BC to the creation of a separate Egyptian state in Upper Egypt under the indigenous Pharaoh Horwennefer. Ptolemy IV left to his child successor Ptolemy V a kingdom torn by intrigue in Alexandria, revolts in the Delta and the outright secession of Upper Egypt under its native king. The Macedonian and Greek troops succeeded in the reconquest of Egypt during the next two decades, and the decree on the Rosetta Stone records the first stage in the fight, defeat of Delta rebels and installation of the boy-king as a god in all temples of Egypt. Nevertheless they failed to recapture the Ptolemaic territories in the Aegean and the family never regained the stability it enjoyed in the third century. The last two centuries of Ptolemaic rule were marked by internecine strife; Ptolemy V was poisoned by his wife Cleopatra I in 180 BC, and the second century BC was dominated by a power struggle between his sons Ptolemy VI (reigned 180–164 BC, reinstated 163–145 BC) and Ptolemy VIII (reigned 170–163 BC and 145–116 BC), the latter of whom murdered his nephew Ptolemy VII before he had reigned a year. In the next generation the sons of Ptolemy VIII vied for the throne (Ptolemy IX 116–107 BC and 88–80 BC; Ptolemy X 107–88 BC), but these Alexandrian feuds were already overshadowed by the might of Rome; in 168 BC the Roman legate Popilius Laenas forced Antiochus IV to withdraw from Egypt in the Sixth Syrian War, and the dictator Sulla placed a son of Ptolemy X on the throne as Ptolemy XI in 80 BC. An Alexandrian mob murdered Ptolemy XI after three weeks for murdering his stepmother, and chose as king Ptolemy XII, son of Ptolemy IX, who in turn courted the Romans for practical reasons. The family expired in typically dramatic style with the children of Ptolemy XII, his sons Ptolemies XIII and XIV and his famous daughter Cleopatra VII. Although ruling with first one then the next brother, Cleopatra VII established her own power through her alliance with Julius Caesar from 48 to 44 BC, and then with Mark Antony from 41 to 30 BC. Her ambitions for her son by Caesar, the infant Ptolemy Caesarion, were foiled only by the military triumph of Octavian over Mark Antony at the battle of Actium in 31 BC; the following year Octavian arrived victorious in Egypt to the suicide of the last Ptolemaic queen.

36. *Edfu temple, seen from the front before the removal of the closest houses of the modern town. The massive pylon extends to 36 m in height and is decorated with scenes of Ptolemy XII smiting the enemies of order; completed in 57 BC.*

Beyond the bewildering intrigues of Alexandria, a city of mixed Jewish and Greek as well as Egyptian population, the kingdom of the Ptolemies witnessed a unique forging of cultures in the combination of native Egyptian and imported Greek and, to a far lesser extent, Macedonian traditions. In becoming part of the Hellenistic world Egypt was compelled to undergo radical changes, above all in the administration which Ptolemy III restructured along Greek lines, making Greek the official language. Any Egyptian hoping to participate in the ruling elite needed not only to become bilingual but also to Hellenise.

In art new ideas were introduced from the Greek world which profoundly affected age-old Egyptian traditions, perhaps the most noticeable is the development of true portraiture. In military affairs the army was fully reorganised on Macedonian lines and turned into an efficient fighting machine. Yet it was the discontent of native soldiers which lay at the heart of the serious revolts in

the reigns of Ptolemy IV, V and VIII when rebel native Pharaohs were set up in opposition to their Greek overlords. Texts from Egyptian literature exemplified by the Greek-transmitted *Oracle of the Potter* show just how much they were hated.

In religious matters, however, the Ptolemies were careful not to offend the scruples of the native population. Although many strange gods, both Greek and Asiatic, were introduced into Egypt at this time and Ptolemy I created a new god intended to appeal to Greek and Egyptian alike when he Hellenised the composite Osiris-Apis as Serapis, the principal deities of the Egyptian pantheon were assiduously cultivated. Some of the greatest temples were constructed during the Ptolemaic Period. The most completely preserved is that of Horus at Edfu which was begun under Ptolemy III in 237 BC and which was given its final decoration by Ptolemy XII 180 years later. The great temple of Isis at Philae, recently saved by world-wide cooperation from the fluctuating waters of the Nile and rebuilt on a neighbouring island, was Ptolemaic in construction and decoration. The magnificent temple of Hathor at Dendera and the unique double temple of Sebek and Horus at Kom Ombo were both constructed under the Ptolemies and largely decorated during the same period. The reliefs in these

temples regularly depict the Ptolemies as kings in the ancient Egyptian manner but there is little reason to believe they did in fact attempt to behave as such unless it was in their own interests. The text of the Rosetta Stone (196 BC) provides a good example of the occasional royal need to gain the support of the Egyptian priesthood. In it Ptolemy V grants numerous benefactions and privileges to them and remits or reduces various fiscal burdens in order to secure the establishment of the royal cult throughout the country as a first step to reasserting royal control.

Although the Ptolemies adopted Egyptian royal titles and wrote their names in hieroglyphs it is not without significance that only Cleopatra VII took the trouble to learn the Egyptian language. For the most part they lived as Greek princes in their new capital at Alexandria kept apart from the Egyptian subjects by the Greek bureaucratic elite which they had deliberately created. Translation and study of demotic texts is now revealing this native substructure which until recently was reconstructed and viewed almost exclusively from the Greek side.

So unpromising a source as demotic legal texts allows the compilation of extensive family trees which provide useful information on the social structure of the native population. The marriage of close relatives, for example, so beloved of the Ptolemaic rulers as a means of maintaining stability, is virtually unknown. Life expectancy can be deduced; some rare texts provide a thumbnail sketch of the contractors giving not only their age but a description of their appearance. Information on the patterns of inheritance can be gleaned. It is clear that women continued to enjoy considerable legal rights and high social standing.

The method of defining geographically the properties which were the subject of legal transactions has allowed in the case of Thebes the mapping out of a whole district of the ancient city comprising more than thirty houses with ajoining roads and streets and following the changes they underwent over a period of 130 years. Excavation of the area is not feasible so the information would be otherwise unknown. The houses themselves were built cheek-by-jowl terrace-fashion as in Pharaonic times with nowhere to expand but upwards: they had more than one storey, stairs up to the roof allowed it to serve as an extra floor, rooms were set aside for the women of the household and there were light wells, windows, courtyards and outhouses used for storage or as workshops.

Although demotic ostraca with tax receipts and lists of commodities are the main source for an insight into the Egyptian economy under the Ptolemies, some demotic papyri have allowed the value of houses or pieces of land at a particular time to be deduced or have given an indication of income from the amount of money loaned which a borrower felt able to repay within a year at fifty per cent interest. Marriage contracts which list the woman's dowry with its value not only provide information on material property of the Ptolemaic period but alllow the rate of inflation to be closely followed.

Documents regulating the priesthoods, self-dedication texts, addresses to the gods and funerary texts reveal Egyptian religious life from the native viewpoint rather than that of the Greeks. The Pharaonic tradition was also maintained in mathematical and pseudo-medical texts and in literary works such as the *Instructions of Ankhsheshonqy*, the *Setne Khaemwaset cycle*, the *Oracle of the Potter* and the *Demotic Chronicle*.

Roman and Byzantine Egypt (30 BC–AD 642)

Although Greek continued to be the language of government in Egypt, the country was transformed by its absorption into the Roman Empire under Octavian, the future Augustus, in 30 BC. On certain points the Emperors adopted a Pharaonic stance, as in the additions and repairs to existing temple buildings; for example, Augustus and Tiberius built around the Mut temple at Karnak a new enclosure wall, work celebrated in four traditional Egyptian stelae of which one is in the British Museum. Large-scale temple works of the Ptolemies were completed, and to this end cartouches were devised for many Emperors of the first to third centuries AD; yet the five-fold titulary of the Pharaohs was generally reduced to the Horus name and two cartouches, and few Emperors visited or showed great interest in Egypt. In most respects Augustus, and his successors, adopted a hostile and suspicious attitude to his wealthiest acquisition, appointing a prefect from the equestrian order to rule on his behalf, forbidding senators to enter Egypt, excluding native Egyptians from administration, and introducing Roman law to the land. The most striking exception to the prevailing negative attitude was the Emperor Hadrian who toured Egypt in AD 130–1, and created the only Roman foundation in the country, at the site where his lover Antinous drowned, Antinoopolis. In conjunction with the personal interest of Hadrian, second-century AD hieroglyphic monuments seem more accurate products than the often garbled Egyptian works of the early first century AD found in Italy, and a general resurgence in native traditions saw the temples at Esna and Kom Ombo embellished, with new texts devised and new methods of writing hieroglyphic texts elaborated, culminating *c.* AD 200 at the time of the Emperors Septimius Severus and Caracalla. The second and third centuries also saw an increase in the number and quality of papyri in Egyptian scripts, for example those from Tebtunis in the Fayum, a principal source for surviving manuscripts. On the other hand the Egyptian tradition of placing funerary papyri with the body seems restricted to Thebes, where it died out in the second century AD;

37

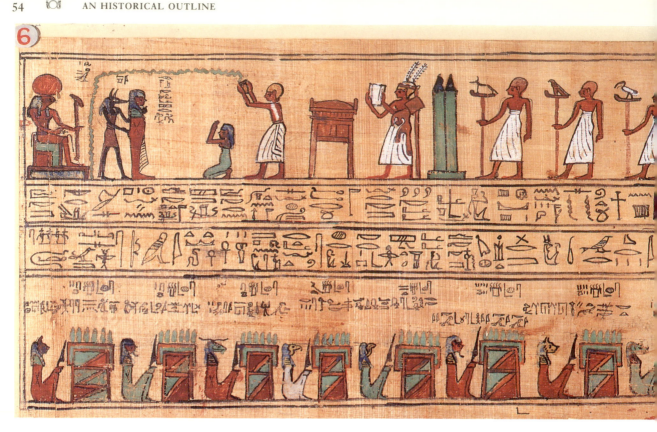

37. *Vignette from the papyrus of Kerasher. In the upper register, Kerasher's mummy is drawn along on a boat-shaped bier, accompanied by a statue and attended by priests bearing standards. They approach obelisks which mark the burial place where the mummy is lustrated before Ra-Horakhty. In the lower register, Anubis embalms the body beside twelve guardians of the Underworld's Portals. Ptolemaic Period, 1st century* BC; *painted papyrus.* H. *23.5 cm.*

the fortunes of native traditions evidently varied from one type of product to another, and from region to region. One group of outstanding papyri, including hieroglyphic manuscripts, survived at Tanis in carbonised form; they attest to the late flowering of Pharaonic traditions in the hostile setting of Roman rule, but are also evidence for the burning of Tanis, perhaps in political and military conflicts. The years of Roman rule saw repeated strife, amongst which may be noted the messianic Jewish revolt of AD 115–17 that flared throughout the Near East, the enigmatic 'revolt of the herdsmen' in the Delta in AD 172, and the invasion of Egypt by Zenobia, queen of Palmyra, in AD 268.

Objects in iron are known from ritual contexts in earlier periods, for example in the tomb of Tutankhamun, and iron tools and weapons of *c.* 700 BC have been found at Nebesha in the Delta and Ashmunein in Middle Egypt. Nevertheless, in material culture the Romans wrought the greatest revolution in Egypt since the Second Intermediate Period had brought the Bronze Age fully into the way of life in the Nile Valley; the domestic environment was changed not only by the spread in use of iron tools and weapons but also by the introduction of clear glass vessels, terracotta lamps, and specific artefacts such as the lathe, the reed pen with split nib and the key. Such humble utensils may have cleared the path for the general change in lifestyle to replace Pharaonic traditions in costume, jewellery, writing and methods of representation in art. The period probably also saw the spread in agricultural improvements such as the *saqiya*, a waterwheel driven by an ox, and the *noraq*, a wheeled sledge drawn over the threshing-floor to extract the grain from the ears. Egypt became the granary of Rome, and was relentlessly and mechanically exploited to secure the maximum return; in response many labourers fled to the desert as their forefathers had fled heavy impositions in Pharaonic times. Most of the demotic ostraca from Roman Egypt are tax receipts written on limestone flakes or pottery sherds, another echo of native burdens expressed directly in the demotic and Greek literary texts that foretell the coming of a saviour native dynasty (see the Literature

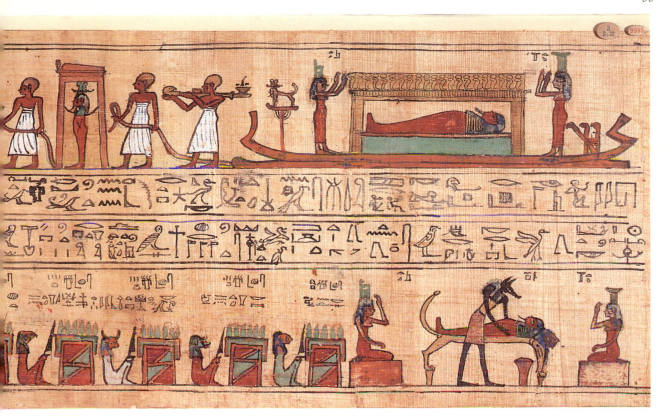

section in Chapter 5). It is difficult to determine from products of the merging Egyptian and Greek traditions exactly how many inhabitants of Egypt were of Egyptian rather than foreign origin, mainly Greek or Jewish.

39 Funerary customs show the inextricable mixture most clearly, and devotion to Greek and Egyptian deities also indicates the shared ground for much of the populace whatever their roots; Egyptian deities could now be represented in Greek style, such as a falcon-headed Horus in the armour of a Roman soldier seated on a horse and spearing a crocodile, as well as being given a classical Greek identity, as in the established Hellenistic tradition of bronze ex-votos, for example of Isis in the guise of Demeter, or translations of names such as *per-Djehuty*, 'domain of Thoth', into Hermopolis, 'city of Hermes'. Alexandria remained capital of Egypt, and continued to be home to the great Hellenistic institutions, but it now lacked the weight of a resident sovereign. Greek papyri unearthed in vast rubbish-heaps at Oxyrhynchus document the Greek-speaking and - writing audience in provincial capitals, as Hellenised as anywhere in first the Hellenistic world and then the Roman Empire.

From the third century Egypt shared in a change that was affecting the whole Empire, the spread of Christianity. Although the Christian Church in Egypt was already in the fourth century AD claimed as the oldest, founded by the apostle Mark in AD 70, there is little evidence for Christian conversion in Egypt before the third century AD outside a small Jewish and Greek-speaking circle in Alexandria. Determined persecution of Christians was unleashed by Diocletian, whose accession in AD 284 is still marked by the Coptic Church of Egypt as the start of its Era of Martyrs. Diocletian probably contributed to the demise of the Pharaonic gods more fundamentally through his land-reforms in which the temples and native priests would have lost much of their autonomy. The fourth century brought in addition to the official adoption of Christianity two far-reaching innovations, the foundation of Constantinople as capital of the eastern Roman Empire in AD 330, and the establishment of monasticism. The latter took shape in Egypt, in the footsteps of lone refugees from persecution who escaped into the desert like labourers in preceeding centuries avoiding state impositions; the traditional founder of the monastic way of life is Saint Antony, who was born *c.* AD 251, an idealised biography of whom was written by Athanasius, patriarch of Alexandria AD 328–73. In AD 320 the ideal of solitary desert hermit was adapted to communal life by another Egyptian, Pachom, who devised rules reminiscent of Roman military regulations to found a monastery at Tabennisi near Dendera.

The new monastic life became characteristic of Egyptian Christianity, and it is no coincidence that the principal author in Coptic is the abbot Shenute of the fifth century AD. Conversion and the monastic life required new use of the native language for written communication, both to translate the Bible and to conduct business affairs, but the old hieroglyphic script and its cursive offshoots hieratic and demotic were all tainted with the smear of paganism, being based on the same principles of representation that the Egyptians had used to represent gods and goddesses. The new Church used instead the Greek alphabet, which had no such specific link to an alien system of belief, and which had been used in the previous two centuries to represent vowel-sounds accurately for the purposes of incantations. The resulting alphabet added to the Greek letters a small number of adapted demotic signs to cover Egyptian sounds not found in Greek. From the fourth to the ninth centuries the new script was employed by the new church to create a last outlet of literary production for the Egyptian language; script, church and stage of the language are all known as Coptic, conferring a unity that echoes the Pharaonic unity of culture in writing, art, religion and kingship.

98

The emergence of the Coptic Church took place against a background of bitter doctrinal disputes that reflected deeper antagonism between Constantinople and its provinces. From the fifth century the relative unity of Coptic can be seen in the dialects found in manuscripts, reduced from six to three with a favoured standard form known as Sahidic ('Upper Egyptian', but of unknown original localisation, possibly the area of ancient Memphis and modern Cairo). In AD 451 the Church council of Chalcedon declared that Christ was two persons in one, Man and God; the Coptic Church was among those supporting a monophysite view, that Christ was entirely divine, and the hostility between the two camps did nothing to support order in the land. Order was a critical question in the days following the conversion to Christianity; nomads on camels raided from the north-western and south-eastern deserts, and put an end to the security of the valley. Conversion of some nomads in the sixth century marked a formal end to paganism, with the official closure of the temple of Isis at Philae under Justinian in AD 536. Nevertheless, peace was not accomplished in external wars, and in AD 618–28 the Persians occupied Egypt; their withdrawal did little to restore Byzantine rule, which ceded rapidly to the attack of the Arab armies, inspired by Islam, and the last Byzantine troops were evacuated from Egypt in AD 642. Under Islamic rule the number of Christians dwindled to become a minority by the twelfth century, and Coptic literature seems not to have survived the ninth century, the last known dateable author being Mark III patriarch of Alexandria from AD 799 to 819; the disappearance of the language is reflected in translations of Church texts from Coptic to Arabic from the tenth century on, and in the appearance of Arabic-Coptic grammars and vocabularies. Any distinctive Coptic tradition disappeared under Islamic influence, in stone sculpture by the tenth century and in crafts such as textile production by the twelfth; thereafter only the presence of a cross or Coptic inscription identifies objects as specifically Christian. By the seventeenth century the Coptic language had ceased to be spoken even in the remoter Upper Egyptian villages, and that last solid link to the world of the ancient Egyptians had been severed.

38. OPPOSITE LEFT *Standing naophorous (shrine-bearing) statue of a man in traditional Egyptian posture with realistic facial features. The shrine he proffers contains a figure of the god Atum represented as a standing man with the Double Crown. Roman Period, 1st century* AD; *basalt.* H. *46 cm.*

39. OPPOSITE RIGHT *Painted and gilded mummy case with an epitaph in Greek naming Artemidorus and incorporating an encaustic portrait of the deceased in Hellenistic style. The funerary scenes are purely Egyptian. Roman Period, early 2nd century* AD; *stucco, from Hawara.* H. *1.67 m.*

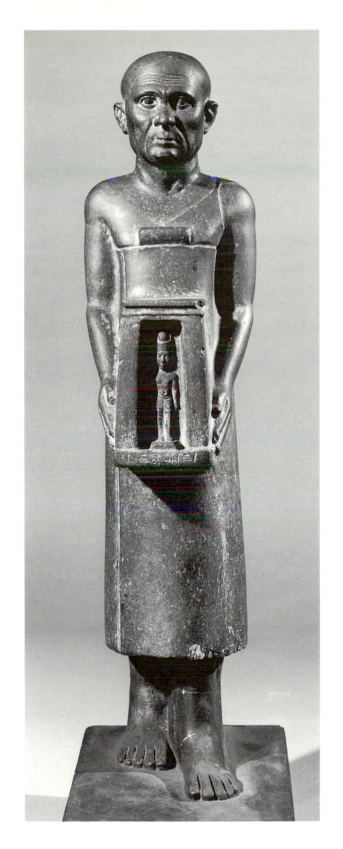

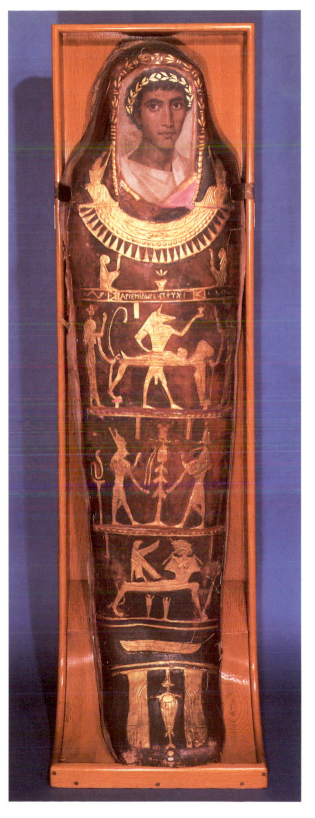

3

RELIGION

Our sources for religious belief in Egypt before the old Kingdom are sparse in the extreme. Figurines of naked men and women are found in Naqada I burials, but no religious structures have been identified, and the funerary figurines may have a specialised purpose confined for example to regenerating the deceased for life after death. Early dynastic images contain much that is recognisable from later periods, such as kingship apparel and festivals, and several deities appear in images, such as Horus, Seth and Ptah, or in personal names, such as Khnum. However, it is only with the increase in written and pictorial sources in the Third Dynasty that we find substantial evidence for religious belief and practice; from that moment until the rise of Christianity, texts and images concentrate on belief in the sun as creator, and this chapter examines the main sources for religion over this period of almost three thousand years. Throughout, the task of Egyptian religious practice lay predominantly in keeping the divine order in motion and in defending life and order from the agents of chaos.

Creation

Egyptian religion presents a bewildering array of gods and goddesses, and these stand in various grades of importance. The role of a deity may change from one period to another, but the religion presents a remarkable constancy from the early Old Kingdom until the arrival of Christianity in the Roman Period. Our knowledge of the Egyptian deities comes principally from fragmented

40. *Ceremonial palette with schematic birds' heads at the top, one of which is broken, and a relief incorporating the emblem later associated with the god Min. Late Predynastic, c. 3100 BC; schist, from Amra.* H. *29.5 cm.*

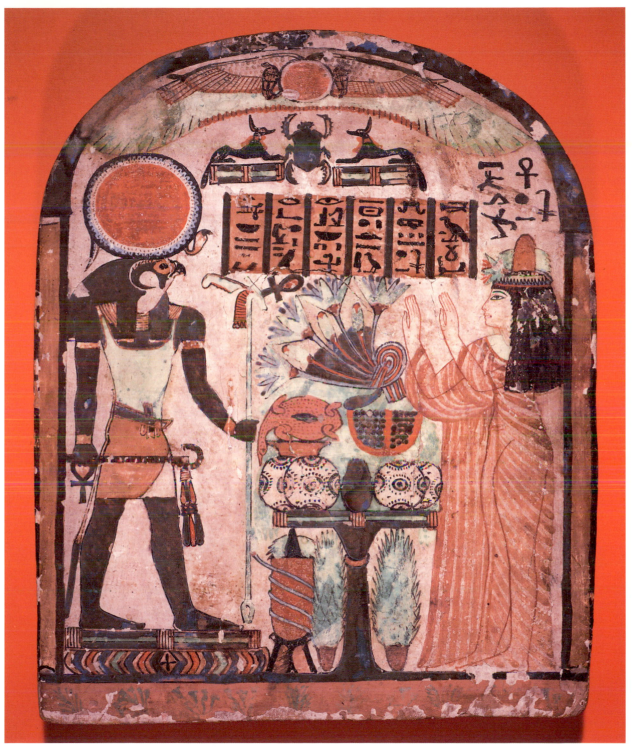

41. *Funerary stela of Deniuenkhons. The deceased, standing by a heaped offering table, raises her hands in adoration before the sun-god, who is identified in the inscription as Ra–Horakhty–Atum. The falcon-headed god grasps royal and divine sceptres and stands on a mat which in turn rests upon the hieroglyph for 'festival'. The scene is framed by stylised door-leaves which support the 'sky'-hieroglyph; beneath this the sun is again represented both as a winged disc and as a scarab beetle flanked by jackals. 22nd Dynasty, c. 945–715 BC; painted sycamore wood. H. 33 cm.*

references in rituals and texts to defend the individual in life (the so-called 'magical' texts) and after death ('funerary' texts). The scattered data from these various texts is supplemented by the even more fragmentary information, from personal names and labels to painting, sculpture and iconography, and builds up a case history for each deity across the centuries.

Tales about the gods are rare in Egyptian texts, and occur in religious settings only in the Graeco-Roman Period. Earlier only episodes concerning Horus and Seth were woven into a continuous narrative, but in a literary satire on social mores rather than as a record of religious beliefs. Otherwise there are no more than single episodes at most, and more often just allusions, that allow us to place one deity in relation to another. From these texts it becomes clear that Egyptian deities could split into separate aspects of a central figure (such as Khons-in-Thebes and Khons-the-child) or merge together to form a compound deity (syncretism, as in Amun-Ra or Ptah-Sokar-Osiris). In these gods and goddesses, and in their splits and mergers, we discover which aspects of life the Egyptians bound together, and which themes pre-occupied the Egyptians at different periods.

Above all the gods from the early Old Kingdom onward, there looms the role of the creator, identified under various names but most frequently in the most powerful source of life, the sun. The dominant Egyptian model of expressing the moment of creation mirrors an annual event in the Nile cycle, the emergence of the land covered with fresh silt after each flood. In Egyptian terms the events of the present are an echo, that never captures the perfection, of a 'first time'; the 'first moment' of all occurred in the emergence of the first ground from the primeval waters of nothingness. From that solid ground, the primeval mound, there arose the life-giving force of the sun from which the rest of creation issued. The principal temple of the sun was in Heliopolis, today a mere suburb of Cairo, and housed a sacred stone named the *benben*, a miniature angular mound roughly in the shape of a mini-pyramid. The name *benbenet* was given to the shining gilded capstones of pyramids and tips of obelisks, and to the pyramidia set above chapels. One of the forms in which the sun appeared or was borne aloft was the *benu*, a bird similar to a heron and also given a shrine at Heliopolis and echoed in the classical legend of the Arabian phoenix. These words belong to a group in the Egyptian language centring on the verb *weben*, 'to shine', underlining the focal place of the sun in Egyptian beliefs concerning creation. Although the primeval waters and the sun as creator are constant features, the mystery of the creation could be expressed in various ways, each with its own poetic vividness. In addition to the flight of a bird from the first solid ground after the flood, the Egyptians wrote of the appearance of the

creator-god as a youth out of a lotus-flower, that being the strongest and sweetest of scents used to bring the breath of life. The sun, *ra* in Egyptian, as the god Ra dominates the religious texts as the supreme embodiment of power, and is represented above all in the shape of the falcon, the perfect symbol of power in the sunlit skies of Egypt.

At his principal sanctuary Heliopolis, the sun-god took the name Atum 'the All', meaning the unbroken completeness of matter, to signify the pre-eminence of the god over the rest of creation. The Egyptians expressed the sovereignty of Atum over creation by representing him as Pharaoh, in human form wearing the Double Crown of the Two Lands. Atum was male, as all future sovereigns were required to be, but he engendered from himself the next generation of deities, Shu the preserving force of dry air and light, and Tefnut the corrosive force of moisture. The fissioning of creation into more than one entity is as much a mystery as creation itself, and was likewise expressed in a variety of ways. Atum is said to produce the pair of himself by masturbation, or from a mysterious creative force, sometimes said to be a female complement to the creator known as Iusaas, 'She comes and grows great', sometimes identified as Heka, 'magical power'. Iusaas appears at Heliopolis as the consort of Atum, and was known as Nebethetepet, 'mistress of Hetepet', a Heliopolitan sanctuary. In the New Kingdom the two identities became separate enough to receive separate worship and be represented side by side. From Shu and Tefnut appeared the third divine generation, now more tangible in the form of the earth Geb and the sky Nut. After Geb and Nut produced two further pairs of gods and goddesses they were separated by the air Shu, as portrayed on coffins and papyri of the Twenty-first Dynasty. The latest generation comprised the gods Osiris and Seth and their respective wives Isis and Nephthys. The Egyptians left numerous stories about these deities, and about Horus the son of Isis and Osiris, and these are described in brief in the next section. The first nine deities, from Atum to the children of Geb and Nut, constituted the Ennead, or Nine of Heliopolis, and dominate Egyptian religious literature from the *Pyramid Texts* of the Old Kingdom until the Roman Period.

The Ennead of Heliopolis concerns the first successors of the creator, in the aftermath of creation. Another set of beliefs concentrates instead on the forces present before the emergence of the creator. This set of beliefs revolves around pairs of deities usually said to form the Ogdoad or Eight, and connected with the city Khmun, 'the Eight', modern Ashmunein, also known as the city of Thoth, Greek Hermopolis, in Middle Egypt. The Eight were the beings existing at the appearance of the primeval mound, and at the earliest full listing, in the

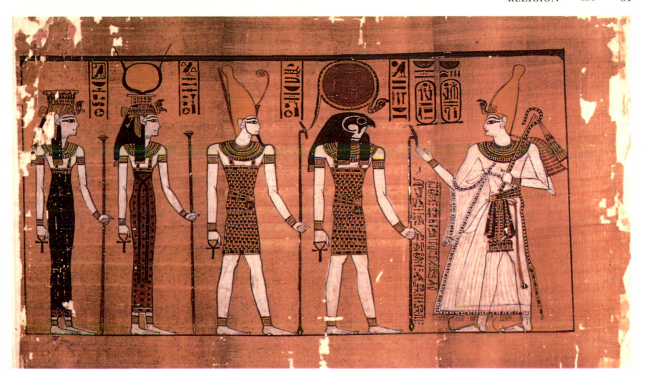

42. *Second of the three illustrations in the Great Harris Papyrus, a record of donations by Ramses* III *to temples. This vignette shows Ramses* III *wearing the White Crown, in front of Ra-Horakhty, Atum, Iusaas and Hathor Nebethetepet, the deities of Iunu (Heliopolis).* 20th *Dynasty, c. 1150* BC; *painted papyrus, from Thebes.* H. *42.5 cm.*

Middle Kingdom, consisted of four pairs of gods and goddesses: Nun and Nunet, the god and goddess of the primeval waters; Heh and Hehet, god and goddess of eternity; Kek and Keket, god and goddess of darkness; and Tenem and Tenemet, god and goddess of twilight. Out of these eight Atum created himself. The names of the beings within the Ogdoad vary, and often only single pairs of the primeval beings are given. One pair attested in the *Pyramid Texts* consists of Amun and Amunet, god and goddess of hiddenness. The fourth section of this chapter covers the spectacular transformation of Amun at the beginning of the Middle Kingdom into the god of universal power as Amun-Ra.

In order to fashion matter out of nothingness the creator employed three forces which then remained in action to ensure the continuing existence of the creation. First of these forces was Heka, the magical creativity which made life possible and as magic defended the universe, the sun-god and mankind from the forces of annihilation. Heka became active when the sun-god used Sia, 'perception', to determine a goal, and the act of creation attained material fulfilment through the third facet of creation, Hu, 'the divine word'.

In addition to the perception of the sun as creator of life, the Egyptians recognised creativity under other guises. Creativity in the guise of male potency was worshipped in the form of Min, a god represented mummiform with backward raised arm lifting aloft a flail, his phallus erect, and upon his head a crown with two tall plumes. As a symbol of masculine fertility Min provided a prototype for depictions of the god Amun when that deity came to be venerated as the creator. In the animal world the bull provided the perfect embodiment of male potency. The creativity of the earth was evident in two spheres of work, pottery and metalwork. The ramheaded Khnum was considered the god that fashioned mankind on the potter's wheel, according to the concept of 'ashes to ashes, dust to dust'. His main temple stood on the island of Elephantine near the southern boundary of Egypt, the first point to be reached by the annual Nile flood. Khnum became the god responsible for the fertility brought by the silt from which pottery was made and out of which the crops grew. Elephantine also housed a temple to the goddess Satet, found by recent excavation to lie on the site of a predynastic shrine next to a hollow in the rock where the floodwaters would have been heard immediately before their visible arrival. Satet came to be regarded as the wife of Khnum, and another local deity, the gazelle huntress Anuket, joined the pair to form a local triad. This pattern of local temple triads is typical of Egyptian religion from the New Kingdom to the

Roman Period. Khnum also received a cult at Esna, where a different pair of local goddesses joined him to form a distinct triad. At Esna, unlike Elephantine, part of the latest temple structure survives from Roman times, and the wall-texts include poetic hymns in praise of Khnum as creator and source of fertility and thus of life itself.

For the second craft, metalwork, the god Ptah represented the source of power. The Egyptians depicted Ptah as a man with mummiform body, wearing a blue skullcap and holding a sceptre of power. The main cult centre of the god lay at Memphis, the Old Kingdom capital, where the royal workshops were concentrated. Creation with metalwork included not only the production of metal objects but perhaps more importantly production involving metal tools, in other words the great architectural projects in which metal tools enabled craftsmen to cut squared building-blocks, fashion sculpture and create texts and images in relief on walls. Ptah acted as patron of arts and crafts, and could be seen in these terms as an original creative force. The most elaborate surviving account of Ptah as creator is a text inscribed by order of the Kushite Pharaoh Shabako on a slab of basalt, after the king, according to the heading to the text, found the temple manuscript with the original text in poor condition. Scholars continue to debate the date of composition of the text, and it is currently thought that the nearest parallels to its contents date it to the late New Kingdom. The text describes how Ptah brings the world into being by giving names, thereby dividing land from water, light from darkness, heaven from earth, and so forth.

43. *Fragment of a wall relief bearing a representation of the god Khnum as a man with the head of a ram with horns projecting horizontally from the head. New Kingdom, c. 1300 BC; sandstone.* H. *45 cm.*

At Memphis two aspects of creation joined Ptah to form the local 'holy family' or triad. Nefertem, the life-giving scent of the lotus at the emergence of creation, became the child in the triad, while the wife of Ptah was the lioness-headed Sekhmet, 'the mighty one'. Sekhmet introduces us to the dual character shared by virtually all Egyptian goddesses, a feature which allows them to exchange places and iconography with alarming ease. The goddess at once defends the sovereign of creation and attacks his enemies; she is love and hatred combined. The goddess most widely worshipped in temples across Egypt was Hathor, subject of a powerful narrative first recorded on the outermost gilded shrine in the burial chamber of Tutankhamun. In the myth the sun-god Ra sends out his eye as his daughter Hathor to destroy mankind in revenge for disrespect. When he relents after the initial slaughter, Hathor can only be enticed away from human blood by a lake of blood-coloured wine, which intoxicates her into loving sweetness. Hathor incorporates both motherly love and the fury of the lioness defending her children, as well as the power of female sexuality. For the love of the mother the Egyptians used the metaphor of the cow tending her calf, whereas for sensuality they represented the goddess in the appropriate form of a beautiful woman. As fury the goddess could best take the guise of a lioness.

44

61,
127,
148

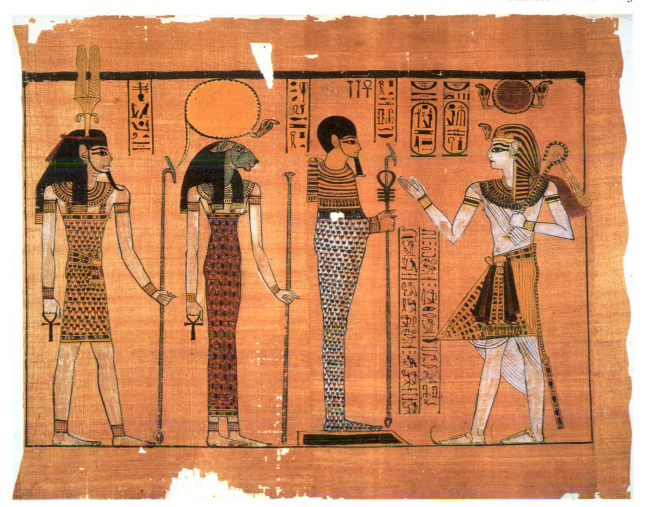

44. *The third illustration from the Great Harris Papyrus showing Ramses* III *wearing the* nemes-*headcloth beneath a sun-disk and facing the principal deities of Memphis, Ptah, his consort Sekhmet and the younger god Nefertem, whose plumed headdress breaks the enclosing frame. 20th Dynasty,* c. *1150* BC; *painted papyrus, from Thebes.* H. *42.5 cm.*

Various goddesses place the emphasis on different corners of this triangle. Sekhmet is the leonine fury that needs to be appeased, and manifests itself in plague, known in Egypt as the 'year of Sekhmet'. Mut 'the mother' represents motherhood incarnate, most often in the appropriate human guise but also familiar from the hundreds of lioness-headed statues created by Amenhotep III for his temple in Western Thebes and for the Mut temple at Karnak. The danger of the desert fostered a cult of the raging lioness Pakhet 'the mauler' at Beni Hasan where craftsmen needed to brave the desert edge to quarry limestone, and of Mafdet 'the panther'. Bastet, the goddess of the *bas* or ointment-jar, acted like the ointment itself as means of protection, and was wor-

shipped as a feline. Her city Bubastis in the Delta was home to a line of Libyan kings of Egypt, the Twenty-second Dynasty, and from that time her cult in cat-form attained national status, and her main festival became one of the annual highlights in the national calendar, as witnessed by Herodotus. The history of Isis follows another path of development and is discussed in the next section of this chapter in the company of her spouse Osiris and their son Horus.

The voyage of the sun-god through creation might be portrayed as the flight of a winged sun-disk or in typically Egyptian fashion as a boat journey across air as if on the waters of the Nile. Every hour of the day and night the sun must move forward and this mysterious progress, necessary to the continuation of life, demanded protection from all possible sources. The most critical moment, because it was the darkest, came during the journey through the night skies. In the depths of the underworld the sun underwent a physical resurrection conferring the energy that would motor him through

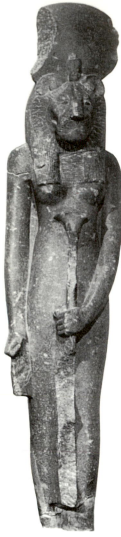
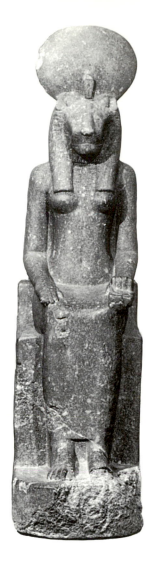
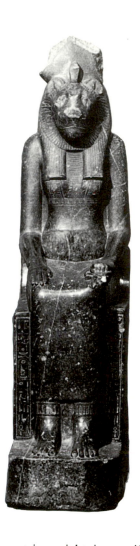
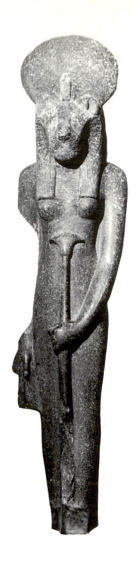

45. *Two seated and two standing statues of the lioness-headed goddess from the building programmes of Amenhotep III. Many of the hundreds of such images bear inscriptions referring to Sekhmet, but a large number were found at the temple of Mut, principal Theban embodiment of divine fury. 18th Dynasty, c. 1350 BC; black granite, from Thebes. H. (left to right), 2.36, 2.06, 2.18, 2.28 m.*

the next twenty-four hours. The dangers and ultimate triumph of these passages are described in the most intricate detail in various compositions known in Egyptology as the royal *Underworld Books*. In the unfailing morning sunrise the Egyptians sought a guarantee of their own rising after death, and in the daily circuit of the sun they saw the never-ending task of maintaining the order of the universe. On both fields, in life and in death, the sun held central place.

Other natural phenomena failed to capture the attention of the Egyptians in the same manner. Trees and

mountains might in specific instances be considered sacred, but only as secondary manifestations of the holiness of other deities. For example, the temple of the sun-god housed a sacred tree called *ished*, upon the leaves of which the names of the king were written. Similarly trees might be regarded as manifestations of the goddess of the sky Nut or of the goddess Isis, providing a person or soul with sustenance. The trees were not themselves deities. Even the Nile was not a deity, and was called simply *iteru*, 'the river'; by contrast the mysterious rise of the river waters at the annual flood was deified as Hapy, 'Inundation', and given offerings to ensure a favourable level of flooding for the crops. The stars were regarded as divine beings, but they play a secondary role next to the sun and Osiris in Egyptian hopes of resurrection. In the *Pyramid Texts* the dead join the 'stars that know no perishing', in other words the circumpolar

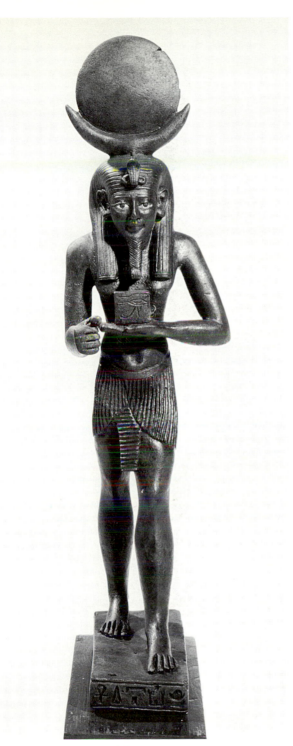

stars, in order to remain in existence just as those stars remain visible in the night sky whatever the time of year. The Egyptians did deify the moon under various names, the most widespread of which was Thoth. Thoth was 71, 72, represented as an ibis or baboon, crowned with the 126 crescent moon and lunar disk; since the moon provides a basis for calculating time and fractions Thoth became the god of knowledge, above all of written knowledge, and his role as god of the moon was taken up by a god of childbirth Khons, perhaps the placenta or afterbirth. In the Late Period there was a cult of Iah, 'the moon', assimilated to Osiris, presumably to acknowledge again 46 the separate significance of the moon as an entity that renews itself as mystically as, if more slowly and less spectacularly than, the sun.

Within the divine order the Egyptians considered the human being to be an organism made up of separable spiritual elements that should be kept in harmony to ensure a good life and afterlife. In the New Kingdom and later these elements are occasionally listed in prayers for offerings. Recurrent items are the lifespan, the destiny and the birth of a person, with his or her shadow and, crucial to identity and existence, name. These aspects of life activated into personality by the *ka*, soul of sustenance, and from the Middle Kingdom by the *ba*, soul of mobility (prior to the Middle Kingdom only the king and the gods were said in texts to have a *ba*). The gods too had souls of sustenance, *ka*s, and mobility, *ba*s. After death the person who kept together all elements of the personality became a transfigured being or *akh*, 'enlightened spirit'; the person who failed to achieve transfiguration was condemned to a condition of eternal death as a *mut*, 'dead person'. In Egyptian religious texts classifying all active beings the types are gods, goddesses, *akh*-spirits, *mut*-dead, and finally living people.

Horus and Osiris

The most extensive series of episodes found in Egyptian religion concern the gods Horus and Osiris, whose names pervade funerary texts, 'magical' formulae and inscriptions of kings alike. Horus appears at the outset of Pharaonic history as the primary god of kingship, represented by the most striking symbol of power in the skies, the falcon. The first recorded names of the kings of Egypt were each introduced by the name Horus in the manner of a title, as 'the Horus Narmer', 'the Horus Aha' etc.. The king was thus a manifestation of the god of heavenly power, or conversely the god of the skies provided the most suitable image for power on earth. Throughout Egyptian history Horus stands in opposition to the god Seth, depicted as a composite creature made 47 up of extraordinary, and therefore disorderly or anarchic, features: a curved tapering snout, a forked tail, a pair

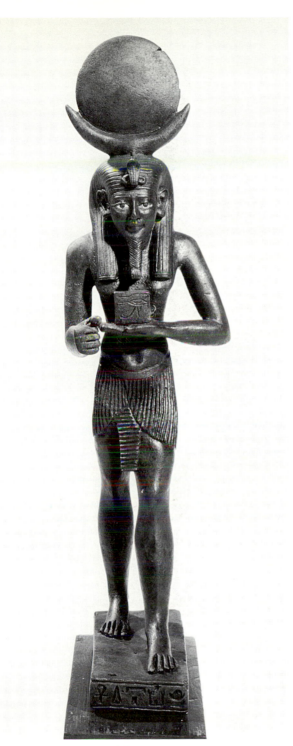

46. *Figure of Iah 'the moon', here represented in human form with a crescent moon and disk on the head and a long divine beard. In one hand he holds a plaque marked with the eye of Horus. Late Period, c. 600 BC; bronze.* H. *22 cm.*

of tall straight-topped ears. Seth embodied disorder, constantly at work against the order championed by Horus, and the king of Egypt had to incorporate both principles of life in order to exercise his rule. On a celestial plane, Horus represented the good order inherited from the sun-god, but the energy of Seth was needed to fight off the enemies attacking the solar boat. Until late in Egyptian history Seth presented the threat of trouble rather than total annihilation.

As life involved a constant struggle between forces of order and anarchy, rituals evoked the conflict between Horus and Seth in the effort to preserve the balance of power. The continual battle centred around the falcon-eye of Horus, the *wedjat*, which was torn out by Seth and had to be made whole (*wedja*) by Thoth. In the offering ritual for the dead, first made explicit in the *Pyramid Texts*, each item is identified with the eye that, once made whole again, becomes a more potent symbol of perfection than any object that had not been through the natural procedure of damage and the mystical procedure of being made whole. In this way every item in an offering attained a supernatural level of perfection. As the symbol of completeness, the *wedjat* became one of the most common amulets, particularly for the protection of the mummified body after death. Another strand of belief expressed the restoration of order as the return of the eye of the sun-god; the eye took the form of a raging goddess, left Egypt and had to be coaxed back to Egypt by a god, sometimes expressed as Inheret, 'he who brings back the distant goddess'.

The end of the Old Kingdom witnessed the emergence of Osiris as the god of the dead and ruler of the underworld, with his principal cult-centres at Abydos in Upper Egypt and Busiris in Lower Egypt. Abydos as the royal necropolis of the First Dynasty had housed the cult of a god called Khentamentiu, 'Foremost of the Westerners' (i.e. the dead). When Osiris became the main deity for the afterlife, he absorbed the name and cult of Khentamentiu at Abydos. By the Middle Kingdom the tomb of king Djer of the First Dynasty in the Abydene desert had been identified as the resting-place of Osiris, and each year the story of the god was re-enacted dramatically in a procession between the temple and the supposed tomb of the god. Egyptian texts contain many allusions to the episodes revolving around the person of Osiris, but the story is fully woven together only in the account by the Greek writer Plutarch. Although Plutarch was recording the story secondhand and in the first century AD, his version is corroborated at many points by Egyptian sources, and it is worth presenting a summary here, on the understanding that it postdates the first rise to importance of the god by more than two thousand years.

After the sun-god Ra had withdrawn from direct rule over his creation, first his son Shu, and then grandson

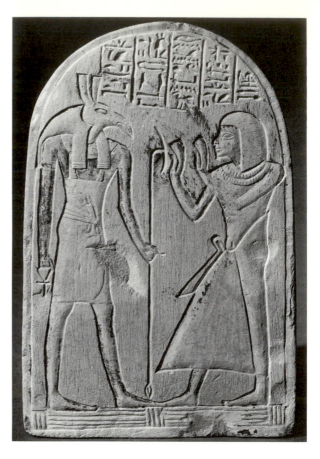

47. *Stela of the royal craftsman Aapehty, shown adoring the god Seth. In the Ramesside Period Seth became prominent alongside Amun, Ra and Ptah as a patron of Egypt; the phrase* aa-pehty, *'great of strength', is a common epithet of the god. 19th Dynasty, c. 1200 BC; limestone, from Thebes.* H. 21.2 cm.

Geb inherited sovereignty. The kingship was then taken up by Osiris, one of the four children of Geb by the sky-goddess Nut. The kingship of Osiris inspired the jealousy of his brother Seth, who prepared a scheme to usurp power. He invited Osiris among many others to a banquet at which he revealed a coffin so magnificent that anyone would wish to possess it for their funeral. Seth promised it to the person who most closely fitted the coffin; when Osiris lay inside the trunk, he fitted perfectly, and Seth slammed shut the lid and cast the coffin into the river. Isis, the sister-wife of Osiris, went in search of the body, and found it in the valley of the cedar, presumed by Egyptologists to be the forests of Lebanon, encased in the living trunk. Through her magical powers she was able to resurrect her dead husband and bring him back to Egypt. Seth now resorted to butchery, cutting the body of his brother into small pieces and again hurling them into the river, which carried them to each of the

nomes of Egypt. Isis recovered each piece, with the help of her sister Nephthys the wife of Seth, and reassembled the body from which she magically revived enough energy to conceive a son. From this moment Osiris descended to rule over the Underworld, leaving Isis to hide with the rightful heir Horus the child in the marshes. During his infancy Horus was open to the attacks of venomous snakes, scorpions and all manner of disease, from which only the magical powers of Isis could defend him and provide cures.

When Horus reached the age for action he embarked upon a struggle with Seth over the right to inherit the sovereignty inherited by Osiris from Geb, and ultimately from Ra himself. In these fights the opponents assumed a wide range of forms, most characteristically of river animals in conflict, and at one peak in the hostilities Horus became a harpooner to defeat Seth who had taken the form of a hippopotamus. Overtures for peace and appeals to the gods, above all to Ra, interrupt the conflict, as does a notorious incident in which Seth seduces Horus and is then himself tricked into public humiliation through the magic of Isis. Finally, the tribunal of the gods decreed a compromise by which Horus should rule the settled land of Egypt, while Seth should be given dominion over the deserts and foreign lands, and should take the role of defender of Ra from evil in the solar boat. In this settlement a truce is reached, but Seth as foreigner became a Satanic figure in the eyes of the Egyptians in the Late Period, when the loss of geographical isolation brought Egypt recurrently the experience of harsh foreign occupations.

The various stages, characters and episodes each express acute dramas in the life of every Egyptian. Horus and Seth remained the gods of kingship, but they became the central actors in the life and death drama of each individual on a mythic plane. At death each Egyptian sought resurrection both in the daily cycle of the sun and in the story of Osiris. Whereas the sun brought resurrection from above, Osiris represented resurrection of the body, from below; Osiris brought the renewal of plant life each year, the fertility of the earth for the crops, and the promise of new life even after dismemberment, the most dramatic form of death. Similarly the power of Isis to revivify Osiris and to protect the child Horus from harm became the solution to the human predicament of death and disease. In the Late Period Isis received her own cult-centres at Behbeit el-Hagar in the Delta and on the island of Philae at the southern borders of Egypt, which was the last temple to be closed by the early Christian Church in Egypt on the orders of the Byzantine emperor Justinian. The protecting power of the goddess could be harnessed by use of a symbol known in Egyptian as *tit* and in Egyptology as the Girdle of Isis, an amulet similar to the *ankh* sign of life and apparently depicting

a knot of cloth. For Osiris the most characteristic amulet was equally stylised, and interpretations range from tree-trunk to backbone; the Egyptian name of this pillar was *djed*, 'stability', and it represented the quality of enduring survival. These two signs, *tit* and *djed*, are among the most common motifs in Egyptian art and amulets, further testifying to the strength of belief in the god and goddess as guarantors of life and afterlife.

Since each person sought identity with Osiris at death, to ensure resurrection, Abydos and Busiris became religious centres of national importance from the Middle Kingdom. Anyone living nearby or passing on official commission participated in the ritual enactment of the death, burial and resurrection of the god at Abydos. If an official had the resources, he would pay for a stela or offering-chapel to be set up along the processional way in order to participate in the festivals, and their offerings, for all eternity. In scenes on tomb-chapel walls at Thebes and elsewhere the dead is often shown being taken to Busiris and Abydos, and this funerary scene has led to mistaken beliefs in an ancient pilgrimage on the model of Judaic, Christian and Islamic practice. There is no evidence that ancient Egyptians ever set out from their hometown to travel to Abydos specifically to take part in religious events there; instead it seems that they joined festivals if they happened to be in the vicinity. The scenes in tomb-chapels should be understood on the religious level as spiritual voyages to the cities sacred to certain gods, in order to benefit from the offerings to those gods. In the same spirit the *Book of the Dead* mentions as part of the journey of the soul visits to or knowledge of the cities Heliopolis, sacred to the sun-god, Memphis, sacred to Ptah, its necropolis Resetjau, Hermopolis, sacred to Thoth, Hieraconpolis and Buto, ancient centres of Upper and Lower Egypt, and indeed Abydos and Busiris, the sacred cities of Osiris. When the Egyptians mentioned these places in connection with the afterlife, their interest lay in the resident deities and the offerings provided there, rather than in physical visits to the actual sites.

The importance of Abydos from the Middle Kingdom to the Roman Period can be seen in the numerous offering-chapels set up by individuals throughout those two millennia to enable their souls to partake of the food and drink offered to Osiris in the temple and to share in his triumph over death at the great annual festivals. In the Middle and New Kingdoms a number of kings built their own temples at Abydos, separate from the cult sanctuary of Osiris which stood to the north. Of the Middle Kingdom structures little remains, although enough survives to show that each complex acted as a cenotaph or second tomb for the dead king to identify him the more fully with Osiris. The early New Kingdom complex of Ahmose has also largely disappeared, but

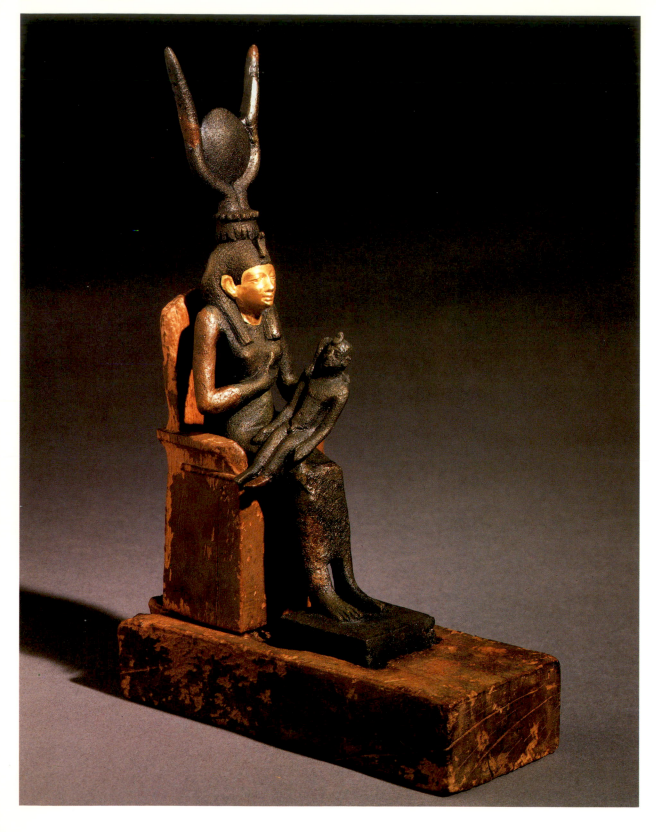

its Nineteenth Dynasty successors, built by Sety I and Ramses II, still stand. Both of the surviving temples included sanctuaries for various deities, notably Osiris and the king himself, and both contained a kinglist in which the king recorded the names of all previous kings who were still receiving offerings. Here the king acts as the living Horus for every deceased king, that is to say every previous earthly form of his father Osiris. In these lists the sense of time as a long line of successive phases comes closer to our concept of history, although the dominant belief remains focused on the two deities Osiris and Horus.

Kingship

The role of the king is central to Egyptian belief in order and remains, until the arrival of Christianity, one of the four inseparable core strands of Pharaonic civilisation, together with art, writing and religion. From the earliest written sources the king stands at the centre of his country as a divine force, identified in his first name and title as a manifestation of the god of power in the skies, Horus the falcon. The name was written inside a panel representing the palace, to represent the king as Horus present and alive in the palace. The palace itself became a convenient way to refer to the person of the king in a deferential manner, from the New Kingdom as *per-aa*, 'the great house' or 'palace', from which is derived through the Bible the word Pharaoh. The king took five titled names, in a titulary developed during the course of the third millennium BC. After the Horus name, the title of the second name was *nebty*, 'He of the Two Ladies', placing the king under the protection of the cobra-goddess Wadjyt of Buto and Lower Egypt and of the vulture-goddess Nekhbet of Hieraconpolis and Upper Egypt. The third title in the series was 'Horus of Gold' in which the word gold may have referred originally to the sunlit sky, and was reinterpreted by the Ptolemaic Period as the god of the 'Golden City' Ombos, Seth defeated by Horus. In the Fourth Dynasty a fourth name was added to these three, and was enclosed in a cartouche, an oval signifying the circuit of the sun around the universe and implying dominion over it. In the Fifth Dynasty a second cartouche was given to the king, completing the series of five titled names. The first cartouche, fourth titled name in the series, was given a mysterious and ancient title *nesut bity*, 'He of the Sedge and the Bee', interpreted in Ptolemaic times in Greek

48. OPPOSITE *Isis enthroned suckling the infant Horus. The wooden chair and pedestal are original and the face of the goddess is gilt. Late Period, after 600 BC; bronze, gilt and wood, from North Saqqara. H. 23 cm.*

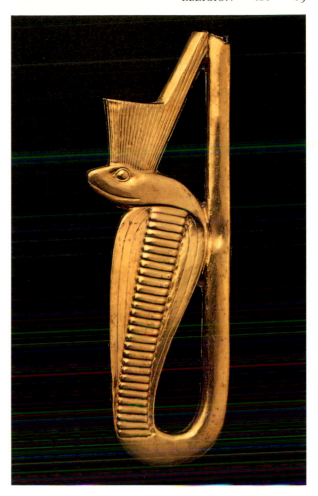

49. *Gold sheet shaped to the form of a rising cobra wearing the Red Crown, unusually here with vertical striations. The image would have been part of a larger object, perhaps a wooden statue or item of furniture. Late Period (?), after 600 BC; gold. H. 15 cm.*

translation as 'ruler of the upper and lower regions', and aligned from at least New Kingdom times with the dualistic symbolism opposing Upper to Lower Egypt. The second cartouche, fifth titled name, was given the title, 'son of Ra', first attested in the Fourth Dynasty. The title 'son of Ra' points to a theory of kingship that replaced the Early Dynastic emphasis on Horus and Seth, and expressed the dominance of the sun in Egyptian belief from the early Old Kingdom to the Roman Period.

The coronation was called the *kha*, 'appearance' of the king, a term applied to the appearance of the sun at dawn. Every subsequent occasion at which the king left the seclusion of the inner palace was also called *kha*, as were the crowns in which the king appeared. In addition to the ceremonies at the start of each reign, the king

ideally celebrated a festival of renewal called the *sed*. In this representatives of the nomes of Egypt brought the sacred images of their local deities to the Residence and witnessed the regeneration of royal power in a series of ritual performances. The king was required to run a circuit bounded by markers, and was confirmed in his rule seated in a pavilion, wearing a knee-length cloak and the White Crown and, in a parallel rite, the Red Crown. The combined performances were designed to maintain and strengthen the reign, and took place at an optimum interval of thirty years, being three times ten, three for plurality and ten for a length of time sufficiently extended without being implausible for mortal lifespan (under the Egyptian decimal numbering system, the next 'plurality of years' would have to be 3 x 100 = 300).

According to the belief in solar creation and rule the king was the bodily and unique son of the sun-god, and ruled earth in the place of Ra just as Shu, Geb, Osiris and Horus had ruled creation. The idea was developed in written form in the tale of the divine birth of the king, recorded in a literary text of the Second Intermediate Period in about 1600 BC and then upon temple walls in the New Kingdom. The story describes the desire of the creator Ra or Amun-Ra to produce a son to rule earth in the next generation, and his choice of a married earthly woman to bear the child. He visits the woman in the form of her earthly husband, and Thoth announces the impending birth of the divine child to her. The birth is assisted by deities of magic such as Isis and of childbirth such as Meskhenet, the birthbrick upon which the mother squatted to give birth, and Renenutet, the pro-

tective snake-goddess. Khnum fashions both the child and its soul on his potter's wheel at the command of the creator. In this tale the earthly woman acts only as receptacle for the divine seed and the child is entirely of the substance of his divine father the creator. The child was revealed as king when he was crowned and appeared as ruler of Egypt. In theory any person could be revealed as the next king upon the death of the old; only secular social convention dictated that the eldest son inherited the position of the father. Accordingly royal texts legitimate the rule of the reigning king by claiming the sun-god as his father, not by pointing to a family relationship with the previous ruler. By these beliefs it was not possible to usurp power after the death of the king; usurpation could only happen during the reign of a king accepted as the son of the sun-god. The sum of the ideas concerning the divine birth of the king lay in his role as the creator upon earth, in an ideally perfect reflection of the sun in the sky. For this reason the sun-god is often called the great (i.e. elder) god, while the king is called the perfect (i.e. younger) god, forming a partnership of order in the fight against chaos.

Following from the perception of the king as a god, the palace and the progress of the king on earth assumed a mantle of divinity with all the necessary ritual and amuletic protection. One designation of the palace was *setep-sa*, 'protection of the back', a phrase often inscribed behind representations of the king in relief on temple walls. In such images the king receives the protection of the vulture-goddess Nekhbet flying overhead, and the *iaret*, 'rearing cobra' or uraeus, is coiled at his brow ready to spit her fiery venom at any opponent. The separate nature of the king is expressed in the clothing and crowns that only the king could wear. The striped *nemes*-headcloth is among the most common items of royal headgear, and a plainer version called the *khat* is also common. Most characteristic of the crowns were the Red Crown, with a tall thin back and protruding coil, and the White Crown, in conical form with a bulbous tip. The original significance of the two crowns is not known, and the symbolism of the colours is rich and complex; red is the colour of blood and danger, but also a solar colour of energy, while white represents purity. The Red Crown first appears on a Predynastic pot from Naqada, and is later aligned to the royal title 'He of the Bee', and is also worn by the goddess Neith of Sais, while the White Crown became aligned to the title most often translated 'king', 'He of the Sedge', and when adorned with two plumes became the attribute of Osiris. In the overriding dualistic symbolism of the two lands the Red Crown is associated with the north, with Lower Egypt, and the White Crown with the south, with Upper Egypt. It is not certain that this interpretation of the crowns antedates the Middle Kingdom. From the Eighteenth Dynasty

50. *Figure of an unidentified king wearing the crown of Upper Egypt and the cloak associated with the royal jubilee. 1st Dynasty, c. 2900 BC; ivory, from Abydos.* H. *8.8 cm.*

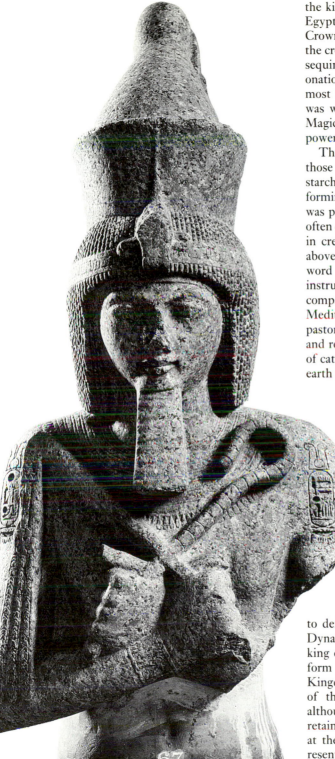

the king is often shown wearing the *khepresh*, known in Egyptology as the Blue Crown, or incorrectly the War Crown, partly because it often appears in scenes of battle; the crown is in fact not a helmet but a cloth with circular sequins, and is also worn by the king in scenes of coronation. In the Egyptian perception the uraeus was the most important element on the head of the king, and was worshipped as the goddess Werethekau, 'Great of Magic'; hymns to the royal crowns in fact address this power rather than any particular form of headgear. 49

The kilts worn by the king were also distinct from those worn by ordinary mortals, characteristically with a starched and ornate front apron, or starched plaits forming the *shendyt*-kilt. The *shesmet*, 'girdle', of the king was personified as a goddess Shesmetet, and the king is often depicted wearing a bull tail to underline his potency in creation. The sceptres wielded by the king include 51 above all the crook of the shepherd, used to write the word *heqa*, 'ruler', and the three-pronged flail, not an instrument of punishment but a tool of soft material comparable to those used by shepherds in the eastern Mediterranean to collect laudanum from bushes. The pastoral role of the king is emphasised in certain literary and religious texts in which mankind is seen as the herd of cattle to be tended by the creator and by his issue on earth the king. The king also held an armoury of weapons

51. *Ramses* II *wearing the Double Crown and carrying the crook and flail, the insignia of royalty. Over his short wig he wears a diadem with block-decoration; a broad collar ending in teardrop-shaped pendants lies on his chest; on one wrist is a heavy bracelet which incorporates a* wedjat *eye as decoration. 19th Dynasty, c. 1250* BC; *granite, from the temple of Khnum, Elephantine.* H. *1.43 m.*

to defend creation and smite its enemies; in the Early Dynastic Period the usual weapon was the mace, and the king continued to be shown attacking with the original form into the Graeco-Roman Period. From the New Kingdom the scimitar from Western Asia entered scenes of the king destroying rebels against the sun-god, although the traditional postures of the composition were retained as they had first appeared on the Narmer Palette at the start of the First Dynasty. Early Dynastic representations of the king also portray him wearing a false beard, a long rectangular plait of hair attached to the chin by a cloth strap; only the king wore the royal beard,

although honoured courtiers were allowed to wear a very short beard on the chin. Another type of beard was the long tubular example ending in an upturned curl, as worn by the gods and, by extension, the king.

The items and texts created to express and perpetuate kingship were strictly reserved for the reigning king, and yet times of central weakness see ordinary mortals usurping these royal prerogatives, a process known in Egyptology by terms such as 'democratisation' or 'privatisation'. Certainly the kings kept their distinct nature by reserving symbols of power for themselves, and in certain cases suppressed the non-royal use of royal texts; for example, in the Twenty-first Dynasty Theban priests copied the royal texts of the underworld for use in their own burials, but this practice dies out after the Twenty-second Dynasty rulers reasserted strong central control over Upper Egypt. Nevertheless, it is inaccurate to speak of 'democracy' or a loss of royal prestige, for the very adoption of royal prerogatives demonstrates a belief in the efficacious nature of kingship. Even when kingship

became politically inactive or ineffective, no alternative view of the world arose to replace it, perhaps because it was so inextricably intertwined with the mainstays of the Pharaonic culture, namely art, writing and religion.

Equipped with this magically protective apparel that distinguished him from gods and mankind alike, the king could fulfil his role as lieutenant for the sun-god on earth. All peoples were subject to the king, and could be represented as the nine bows beneath his feet; as in the Ennead or nine gods, nine here represents three times three, a graphic device to signify plurality of plurality, in other words totality. The bow indicates the hostile intent of those trampled underfoot, but it should be noted that the peoples classified as potential opponents of the divinely ordained order included the Egyptians as well as foreigners. Royal texts of conflict refer to both possibilities, of internal sedition as well as external threat of invasion, but the language of these texts always removes the events from the mundane political plane to the heights of a fight between order and chaos, good and evil. The second concern of the king beside defending order through his military action rested in his activity as pious son of the gods, building for them and endowing their cults with offerings. Any donation in permanent form, from a tiny image to an entire temple, could be designated a 'monument', and the ideal king had to

52. *In front of his temple at Soleb Amenhotep* III *installed two images of himself as a reclining lion, one with the inscription 'lion great of strength', a remarkable projection of the divinity of the reigning king. It bears a dedicatory-text of Tutankhamun and a much later inscription of the Meroitic ruler Amanislo. 18th Dynasty,* c. *1350* BC; *granite, from Gebel Barkal, originally from Soleb.* H. *1.17 m.*

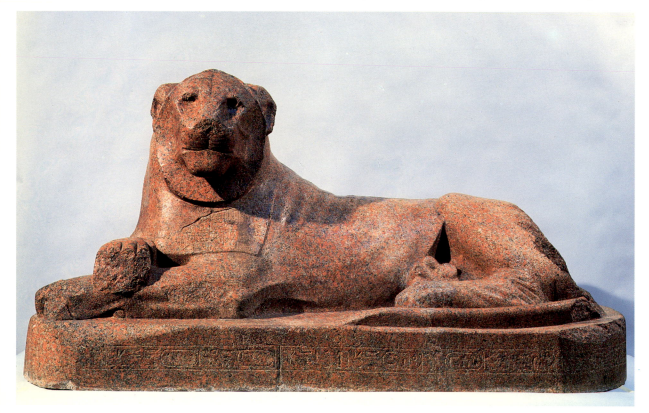

⁵² demonstrate his piety and efficacy by establishing monuments suitable to the gods. In both roles, warrior and builder, the king acts as the fulcrum of creation, passing up to heaven the good of mankind, and passing down to earth the blessing of the creator and the other gods.

In texts of kingship the king alone acts for the good, and is surrounded by an anonymous chorus of courtiers who show their human weakness and praise the successful plans and actions of their king. In the earliest text, the royal entourage both at the palace and in the royal progress through the land surrounds the king under the name of 'followers of Horus'; their role in passing up information to the king and conveying his orders to the world outside the audience-hall receives recognition in official texts as two divine personifications, Hu and Sia. Both stress the role of the king as the creator-god on earth; Hu is the divine word that brings a plan into effect, and Sia is the perception that makes the plan possible in the first place. The traditional three terms for mankind seem to have been built around the king, with *henmemet*, 'solar retinue', perhaps the guards closest to the body of the king, *pat*, the inner circle of people close to the throne, in practical terms the elite, and then *rekhyt*, the outer circle of people farther from the throne, in practical terms the wider populace. At the kernel of humanity stands the king, as a divine rather than human being, placed on earth by the creator to guide mankind. As a god the king receives worship, and temples to the cult of the king were founded in each reign, economy permitting. Although these temples are called mortuary temples by Egyptologists, the cult came into operation during the reign of the particular king, rather than waiting for his death. As soon as the king died and was buried, the new king would start work on his own tomb and cult, and the temple for the cult of the preceding ruler would take second place. After one or two centuries a temple tended to fall into disuse as its estates and personnel were siphoned off for more recent establishments; the cult complex of Menkaura at the third pyramid of Giza was never completed in stone, and fell into disrepair before the end of the Old Kingdom, and the opulent temple for the cult of Amenhotep III was quarried for stone for the temple to Merenptah barely more than a century later. Only in a few instances did successor kings make a special effort to maintain the cult of a particular ancestor, as seems to have happened with the temple of Mentuhotep II at Deir el-Bahri. In the Middle and New Kingdoms the royal cult temple housed the cult of a particular deity other than the king; at Lahun the temple of Senusret II was called the temple of Anubis, and the Theban 'mortuary temples' were dedicated to the god Amun.

If the theory of kingship presupposes an untouchable divinity, practice often differed according to the balance of power between families, individuals and factions within the court, between different regions and between Egypt and her neighbours. The king upon the throne was divine, but he was mortal; he represented Ra, but myth recorded rebellion against Ra too. In the course of Egyptian history we find even within the confines of the

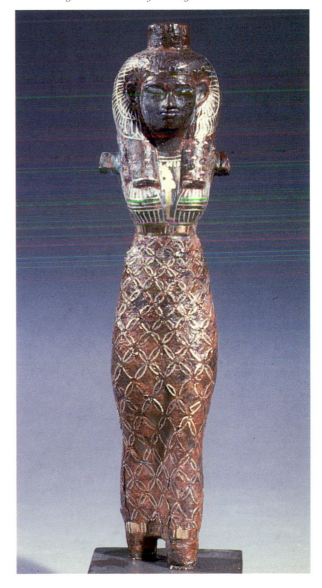

53. *Inlaid metal statuette of a queen or goddess, identified by the vulture headdress and modius (cylindrical headdress). The Egyptian language had no word for 'queen', using instead the phrases 'king's mother' and 'king's wife'; these women and the king's daughters played an important part in court ceremony, as the feminine accompaniment to the sun-god on earth. The role was transferred to the cult of Amun in the person of the 'god's wife' or adoratrice at Karnak from the New Kingdom to the Late Period. Third Intermediate Period, c. 900 BC; bronze with gold and silver inlay.* H. 21.5 cm.

written sources clear instances of treason and usurpation. Judicial records survive from the trials of men and women at court who murdered Ramses III; the religious dangers of such action can be seen both in the use of wax images to assist the conspiracy, and in the reprisals by Ramses IV and the court, including confiscation of not only the titles but also the names of the conspirators, a move designed to condemn them to eternal damnation. Nevertheless, the case remains that a conspiracy was launched and succeeded in the murder of the king, if not the accession of the intended prince; if we know of this conspiracy only because its plotters were prosecuted, how many successful conspiracies were undertaken?

Another attempt on the life of a king, but one that failed, is recorded in the *Instruction of Amenemhat I*, a literary text that purports to contain the words spoken by that king in a dream of his son Senusret I. The king gives a dramatic account of the assault, in the middle of the night while he lay defenceless like a snake of the desert. He went on to place his son on the throne beside him as co-regent for the remainder of the reign, to secure the succession. Under the arrangement the elder king remained in the palace, hidden like the sun in the sun-disk, while the younger partner took the active role moving around the country and prosecuting any wars. The arrangement seems to have been followed by the succeeding kings, a tacit admission of the threat of opposition to the wishes of the old king in the choice of a successor. Even rarer than these indications of disunity among the elite are voices of disrespect raised against the king. Yet we find at the end of the New Kingdom one letter from a general who writes contemptuously of the ruler for whom he is fighting: 'Pharaoh! Whose master is he these days?'. The same king Ramses XI held the crowns, sceptres and fivefold titulary, all the trappings of sovereignty that seem so impregnable in the theory of divine kingship.

Temple Cult and Festival

In addition to the nationwide belief in the themes of deities, such as Ra as creator, Osiris as king of the dead, Thoth as god of knowledge, each town in Egypt was home to a particular deity, resident in a cult image kept within a sanctuary separate from the daily life of the town inhabitants. It is not often possible to suggest reasons for the presence of a specific deity in a specific place. Only with the cult of Sobek the crocodile-god does it seem clear that the sanctuaries of the god are located at dangerous points in the river where the menace of attack from crocodiles was especially strong and required more concentrated efforts at propitiation. The presence of a particular deity might direct local attention

to particular segments of nationwide belief, but the underlying strength of belief in the sun as creator persists, and it would be a misunderstanding of polytheistic religion to imagine that the pantheon of gods and goddesses grew out of once independent beliefs in one deity in each locality. We know little of Egyptian religion before the First Dynasty, but a full pantheon is present from the moment that Egyptian art and writing provide us with evidence. Similarly it would be rash to suppose that unidentified forms in predynastic art or in Pharaonic art and hieroglyphs demonstrate an alleged earlier stage of religion based on fetishes or totemism simply because we cannot account for those forms.

The temples of Egypt were designed not as church-like spaces to establish links between individual human beings and the divine, but as machines to maintain the fabric of the universe in motion. Every detail in the decoration of the temple fitted the intricate programme of bolstering order against its enemies, a plan that finds its extreme form in the great Upper Egyptian sanctuaries of the Graeco-Roman period. From the New Kingdom on the largest temples presented a series of courtyards and halls between the main entrance and the holy-of-holies. Only select initiates were allowed past the main portals, and at each subsequent doorway still fewer priests were qualified to pass within. At each stage the light diminished, the ceiling became lower and the floor higher, in the approach to the central shrine. Temple columns evoke the flowers and plants at the marsh edges of the primeval waters, and the lowest registers of temple walls contain relief scenes of the Nile-god delivering the bounty of the inundated land to the cult. The ceilings of the halls are adorned with stars or scenes with the passage of the sun-god through the skies. The innermost sanctuary stood at the highest point, with the lowest ceiling and no light admitted; texts describe this point as the primeval mound of creation. Here a shrine housed the cult image of a deity identified in its texts or attributes. This statue received not only hymns and prayers, but also physical sustenance in the form of food and drink offerings. The deity was not identified with the cult image itself, but its *ka* or sustaining spirit was thought able to rest in the statue and receive food through it.

According to Egyptian belief only the king could stand on consecrated ground in the company of the gods, as he was considered to be the son and champion of heaven on earth, and in particular of the sun-god; for this reason only the king was represented on temple walls offering to the gods. In practice the king delegated his role in the cult to priests who were able to penetrate the sanctuary and carry out the rites necessary to the survival of creation. From scenes on the walls of New Kingdom and Graeco-Roman temples, and from descriptions in New

124

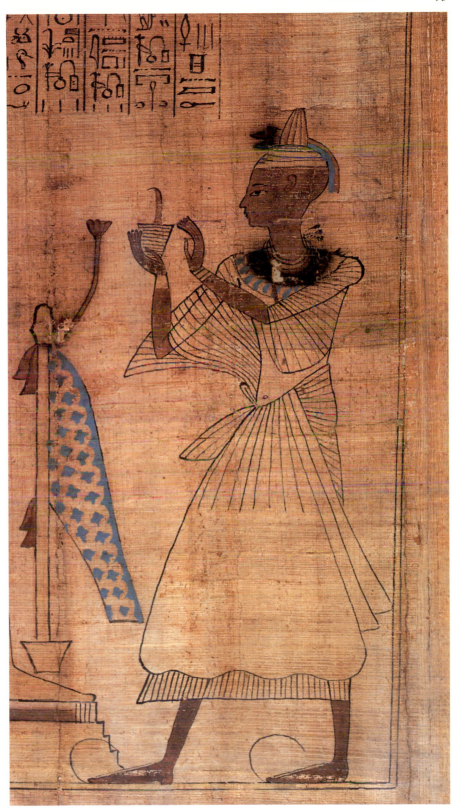

54. *Illustration at the front of the Book of the Dead of Penmaat, the head treasury archivist in the Amun temple. He is shown with his head shaven as a mark of priestly purity and is offering incense; his clothing and elaborate sandals are signs of wealth not priesthood. Third Intermediate Period, c. 950 BC; painted papyrus, from Thebes.* H. *44.1 cm.*

Kingdom and Third Intermediate Period papyri, we know the details of the daily morning service in which the god was glorified and fed in the sanctuary. Upon entering the temple the officiant poured a libation of water from the temple well and offered food prepared in the temple stores. He lit a torch, entered the darkness of the inner sanctuary and cleansed the air with incense. The shrine could then be opened and the veil over the face of the cult image lifted. At this point the priest prostrated himself before the statue and kissed the ground, and hymns were sung in praise of the deity. The image was placed on freshly strewn sand and the shrine wiped clean. Now the statue was unclothed and cleansed with incense and water from sacred *nemset* and *deshret* vases, after which it could be clothed in fresh linen and adorned with its insignia. The anointing with ten oils and two types of eyepaint was followed by the final rites of purification. The priest then put the image back in its shrine, closed its doors and backed out of the sanctuary brushing away his footprints as he went. The sanctuary was then bolted and sealed until the next morning. In certain temples texts of the Graeco-Roman period indicate that other rituals were performed for the cult at specific points of the day, such as midday and evening at Dendera and perhaps an hourly ritual at Edfu. The offering scenes on temple walls maintain magically an eternal cult service in which the king supplies food and drink and performs all necessary rites.

Priests were the men who took the place of the king in practice in the daily ritual. In the Old and Middle Kingdoms and again after the New Kingdom the priesthood was organised in groups known as *sau*, 'watches' (Greek *phylai*); each watch provided temple staff for one month during which it was responsible for festival, daily ritual and the general maintenance and security of temple property. In the Middle Kingdom temple at Lahun four watches each served for three of the twelve months of the year; each watch consisted of a pool of labour in effect, and was divided into four *qahu*, 'corners', from which the various priests, temple doorkeepers and porters were selected for a particular month. In return for their services the temple staff received a fixed share in temple income, making membership of a watch an attractive proposition. Rules for membership of a watch or temple guild are not known before the Late Period, when documents resembling later monastic, guild and trade union guidelines appear among surviving records.

Before the New Kingdom, temples other than the complexes for the royal cult tend to cover little space and contain few externally spectacular features. The small cult image would be of precious material, but there were no large statues of deities. From the Eighteenth Dynasty the temples to the gods come to absorb the bulk of royal building time and expenditure, although each

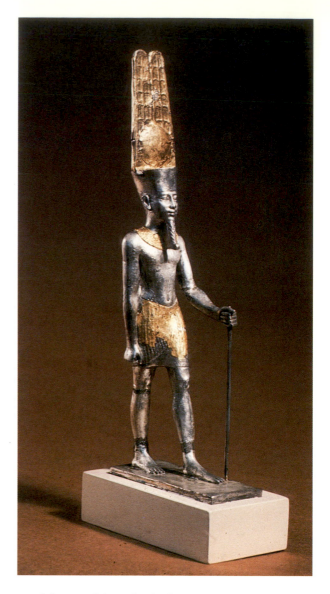

55. *Cult image of Amun, found in his principal temple at Karnak. Silver was rare in the vicinity of Egypt and so cost more, but gold does not corrode and so expresses eternity as well as radiance and preciousness. New Kingdom, c. 1300 BC; silver, partly gold, from Thebes. H. 23 cm.*

king continued to vaunt his building achievements separate to those of all previous rulers. The temples at the national centres of Heliopolis, Memphis and Hermopolis have suffered both from their physical destruction and from the relative neglect of Egyptologists, and their groundplans and external appearance may have differed from the type which we assume to be typical of Egypt. That typical temple survives above all in the New Kingdom complexes at Thebes and then in the Graeco-Roman examples at Edfu, Dendera and Philae. The

approach to the temple is lined at Thebes by ram-headed sphinxes, expressing the power of the god Amun, and the front of the temple presents a triumphal display of massive trapezoidal pylon or gateway, lofty staffs bearing slender tapering banners, and at the primary sanctuary of Amun at Karnak, as at his nearby Luxor sanctuary, paired granite obelisks. The outward orientation of the New Kingdom and later temples mirrors a change in their lifestyle from cult to festival.

The festivals were always central features in the year of the temple, but they receive prominent architectural expression for the first time in the surviving record at Thebes under Hatshepsut. She set up a series of wayside shrines for the sacred bark of the god Amun to allow the procession of the god to rest on the way from Karnak to Luxor. At the same time she legitimised her rule as king, despite being a woman, by appealing to the god himself. The two new features of the cult image, its procession by sacred bark and its oracle, persist from this moment to the Roman Period, and have few parallels in temple cult of the Old and Middle Kingdoms. The Theban Valley Festival existed in the Middle Kingdom (see below) and gods such as Sokar at Saqqara and Osiris at Abydos had sacred barks, but only the rites of the triumph of Horus and Osiris over Seth, outside the temple at Abydos, come close to the New Kingdom practice of festival procession and oracle. The clearest antecedents to New Kingdom festivals seem to lie in palace ritual and the royal progress. From the New Kingdom the deity, like the king, is able to leave his abode and travel by boat; on the move the deity could, again like the king, deliver divine words.

At Thebes the most important festivals of procession were the Valley Festival and the Opet Festival. The Valley Festival originated in the Eleventh Dynasty with the visit of Amun from Karnak on the East Bank to the temple of king Nebhepetra Mentuhotep on the West Bank. For this Middle Kingdom event our only evidence is a group of graffiti left on the hillside by the Mentuhotep priests who were responsible for forewarning the temple of the approach of Amun. The procession became the annual festival for the necropolis on the West Bank, an occasion at which the Karnak Amun statue visited the Amun statue of the royal cult temple on the opposite side of the river. The festival began at the new moon of the second month of summer, and provided an occasion for families of people buried in the western cemeteries to sail across and celebrate with their dead kin. The Opet Festival brought the Karnak Amun statue to visit the Amun statue in the Luxor temple to the south of the city of Thebes. Karnak was known as Ipetsut, 'most favoured of places', while the Luxor temple was called by the Egyptians Ipetreset, 'the southern *ipet*', *ipet* (read *opet* by earlier Egyptologists) being a word for the inner

part of the palace including the bedroom. The Opet Festival seems to have revolved around the fertility of Amun and the identical potency of the king, and may have included some form of sacred marriage or union of the creator and his consort, perhaps for the regeneration of the reigning king. The festival lasted between three and four weeks starting in the second month of the season of flood. The central spectacle came in the solemn procession of the Karnak cult images of Amun, his consort Mut and their child Khons to the riverside at Karnak and then in their ceremonial barks towed along the riverbank south to Luxor, with a musical and military escort and a series of offerings on a massive scale.

Numerous other festivals marked the year, and their importance in the life of the country ensured that each of the twelve months took its name from a festival from the late New Kingdom to the Coptic period. In the Graeco-Roman temples of Hathor at Dendera and Horus at Edfu relief wall-scenes depict an annual voyage of Hathor in her sacred bark to Edfu to wed Horus. Both temples follow the design of Theban temple architecture of the New Kingdom with massive frontal pylons from which flagstaffs were once fastened, creating a suitably dramatic setting for the arrival and departure of deities at the entranceway. In all such movements the cult image remained unseen, hidden within a portable shrine behind the drapery and cabin walls of the boat. Nevertheless, the image came nearer to the outside world than at any other time, and the god was deemed to reside within the image on its journey during the festivals. In addition to the full-scale sacred bark for river journeys the cult image had a small box-like shrine, which could be placed in a further shrine in the form of a miniature bark on a pedestal with carrying-poles by which it could be borne aloft on the shoulders of specially designated priests. The portable bark-shrine allowed the image to be carried shorter distances overland, and here came the moment of closest access between image and populace, providing the opportunity for oracles. In the Egyptian oracle yes-no questions were put to the image while it was in its bark-shrine on the shoulders of the priests; the priests could then move the bark, whether by the weight of faith or by cynical manipulation depending upon the individual instance and personality. Belief in the value of the oracle, at least in its use, extended to all levels of society; rulers such as Hatshepsut, Thutmose III and Alexander the Great used the oracle to legitimate their kingship, and difficult legal and social problems could also be solved by resorting to the final yes or no of the divine bark. Although the opportunity for exploitation may be transparent, the oracle performed a vital social function, as in ancient Greece, of putting an end to disruptive and potentially lethal disputes. By contrast in the Old and Middle Kingdoms the highest court of

56. *Votive bark in stone with a seated female figure protected by the outstretched wings of a vulture behind her. The group produces a three-dimensional sculpted writing of the name Mutemwia, 'Mut in the bark', the queen named in the text along the side; Mutemwia was the mother of Amenhotep III who established a great temple for Mut south of the Amun complex at Karnak. This item was discovered in the floor of the Amun bark sanctuary, and its shape suggests reuse as a long building block. Similar stone barks stood on front of the Ptah temple at Memphis. 18th Dynasty, c. 1350 BC; granite, from Thebes. L. 2.13 m.*

appeal lay in the officials of the national administration and the king.

Another feature not known from earlier periods but common in the Late Period is the burial of sacred animals. Already in the Early Dynastic Period certain deities were considered accessible on earth in visible form through the intermediary of an individual animal. The most important of these divine heralds was the bull of Ptah at Memphis. The bull was called Apis and had special markings on forehead, tongue and flank, and at the death of one a successor was born with the same markings, forming a mystic and unbroken succession through time. The burial of an Apis brought national mourning on a royal scale, and only the most powerful in the land, such as Khaemwaset son of Ramses II,

were involved in work on its cemetery, the Serapeum at Saqqara. Other such individual sacred animals were the Mnevis bull of Ra at Heliopolis and the Buchis bull of the Theban falcon-god Montu at Armant.

Separate from these cults in which a single animal acted as herald of a particular god is the practice of mummifying and burying any animal of a particular species. Vast catacombs of animal and bird mummies grew at numerous points throughout the land from the Late Period to the Roman Period. Apparently any animal species connected with any deity could supply a person with a means of access to the divine, as a concrete prayer. The devotee would pay the priests for a mummy of the required type of animal, for example a cat for Bastet or a dog for Anubis; even crocodile and gazelle cemeteries existed. The required animal was found dead, or a living specimen was killed, and embalmed, and offered to the deity joining the millions of other animals of the same type. By this emphasis on animals as sacred to gods and goddesses, the Egyptians of the Late Period seem to have sought to distinguish themselves from foreigners at a time when the country fell prey again and again to foreign domination, and especially the violent onslaught of the Assyrians against Thebes and the Persians in Lower Egypt.

Amun and Aten

The development of the New Kingdom temple at Thebes created a stark contrast between the secrecy of the cult image hidden within its shrine and the spectacle of bringing the image out of its temple in procession, still hidden in its bark. The creator was worshipped at Karnak under the name of Amun-Ra, fusing in a single focus for worship the god of the city of Thebes, and thus of the dynasties originating there, and the god of the sun and creation. Amun means 'the hidden one' and embodies the notion of the creator as universal and unseen, whereas Ra, 'the sun', identifies the source of life in its most powerful manifestation in visible and locatable nature. A tension between the two halves of the equation, 'the hidden' and 'the sun', is compounded in royal texts of the Eighteenth Dynasty where the creator is both the life-giving Aten, 'solar sphere', and the sovereign 'Amun-Ra king of the gods'. The creator gives not only life to the king and mankind, but also inspiration for royal deeds and the promise of their success. The conquest of cities and the defeat of enemies is given by Amun-Ra to the king, and the king repays his debt by offering his father the god vast wealth in treasure, captives, estates and monuments. The Amun estate became the branch of the royal administration that governed Upper Egypt, and its treasury the national bank in that area for the government.

These vast reserves remained under the Crown, because the king was always the son of the god and his only champion on earth; there was never a division between clergy and state as occurred in Christian Europe. Nevertheless, the Amun temple in its wealthy cult and festival concentrated the tensions between aspects of government and rule as well as between aspects of belief; the king was simultaneously a god and son of the god, and the god was simultaneously distant creator in the skies and, by inspiring the king and through his oracles, himself active ruler. At Thebes most officials held titles connected with the temple of Amun, and yet their chapels and statues include texts of hymns to the sun Ra. In the course of the Eighteenth Dynasty these solar hymns concentrate more and more on the physical presence of the sun in the sky as Aten 'the solar sphere'. The wealth of the age is evident in not only the costly stone monuments of the period but even the luxurious household utensils adorned with motifs taken mainly from plant and animal life. The expansion of ornament and the focus on the physical sun grow in strength to the reign of Amenhotep III from whose reign survive paintings of plants and animals in his palace at Malqata in Western Thebes. Hor and Suty, two Theban architects of the same king and, incidentally, the only documented twins of Pharaonic Egypt, have left for us a stela inscribed with some of the most developed hymns to the sun as physical presence and sole creator, including one passage entitled 'hail to the Aten'.

The tension between the hidden creator Amun and the visible sun Aten as source of life found temporary and violent resolution in the reign of Amenhotep IV / Akhenaten with a new theology and corresponding innovations in art. The reign opens with the construction east of the Amun temple at Karnak of a new sanctuary to the sun-god. The god is depicted in traditional manner as a falcon, with human body so as to hold human attributes such as sceptres. In the third year the style of depiction of both king and god switches abruptly and without warning to a radically new art in which the sun-god is the solar sphere Aten alone, rays extended to give life to the king and his family, and the king becomes a grotesque figure with drawn features, female hips and slight torso but lacking genitalia. The name of the king changed from Amenhotep, 'Amun is content', to Akhenaten, 'of service to the Aten', and the word Amun was hacked out of every inscription in Egypt and Nubia, even at the tips of obelisks. The Aten was given the royal serpent or uraeus and a name written in two cartouches as if for a king, reading 'Ra-Horakhty jubilant in the horizon, in his name as Shu who is in the Aten'.

The mere decision to depict the king naked broke every convention of temple statuary, but the androgynous physiognomy and gaunt face provoke the strongest reaction, even today. It is debated to what extent the features depicted represent the physical condition of the king. Certainly some stylisation must be responsible for the missing genitalia, for Akhenaten produced daughters, but a body of a near relative of Tutankhamun found at Thebes showed a striking mixture of male and female skeletal features, including abnormally wide hips. Since Akhenaten belonged to the same family, nature may have stimulated the revolutionary artistic device of showing the king, like the Nile-god, as male and female, 'mother and father of mankind', as a near contemporary expresses it in a hymn to the sun. Figures of the Nile-god were defaced in the reign, as if to reserve the role of providing fertility for the king and the Aten. Three texts of the reign proclaim the purpose of the royal cult of the Aten: the boundary stelae of Akhetaten, the *Smaller Hymn to the Aten* and, above all, the *Great Hymn to the Aten*. The *Great Hymn* is inscribed in the tombs of officials at Amarna; these record the text as spoken by the king, except in two cases, those of the high priest of the Aten and of the leading courtier Ay. Even in translation the hymn stands among the finest expressions of human awareness of and thanks for the creation, worded in imagery akin to passages in the Hebrew Psalms.

Much of the traditional beliefs in kingship and creation survives in the art and the texts of the reign of Akhenaten, despite the innovations. The king is still the son of the

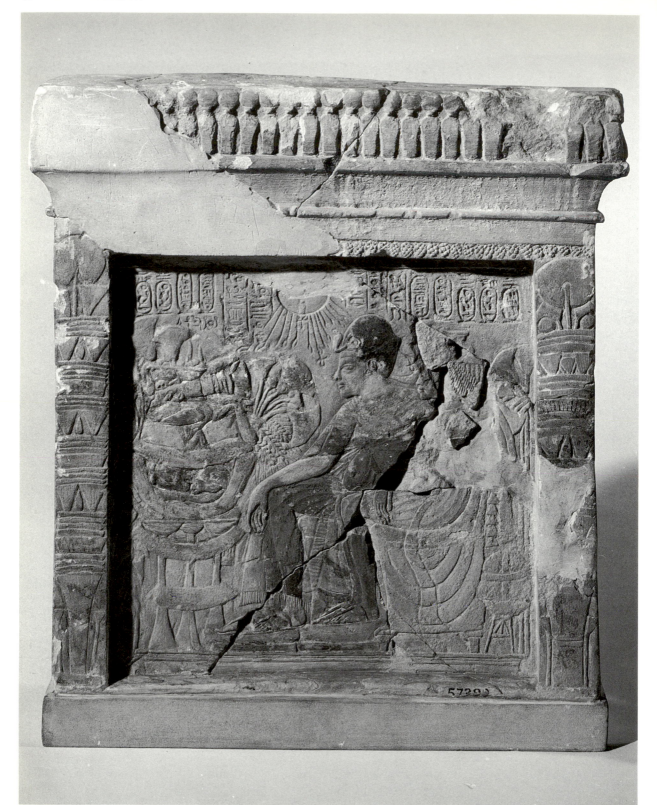

sun-god, of different substance to the rest of mankind, and the creator is still the sun, giving life through the king to mankind. The major difference in belief lies not in what Akhenaten retains but in what he excludes. The sun is the only god worshipped by the king, and the king is the sole means of access from mankind to god; all the deities accompanying the sun-god in the sky, and all the deities of household shrines, disappear to leave the single divinity of the solar sphere and the single channel of the royal family.

In his sixth year the king abandoned the building-projects at Thebes and founded a new city at Amarna on the east bank of the river in Middle Egypt, near Hermopolis the city of Thoth. The new city was called Akhetaten, 'the horizon of Aten', and the eastern edge of the city was marked by an arc of cliffs broken by the entrance to a desert valley at the exact centre of the arc. This dip allowed the sun to become visible at sunrise a fraction earlier at that point in the cliffs, forming the hieroglyph *akhet*, 'horizon', for the Aten 'solar sphere'. At the boundaries of the city territory Akhenaten had inscribed stelae to record his foundation and his promise that he would never pass by its boundaries; since the king did visit other parts of the country, 'pass by' must refer to his day of burial, and indeed the wadi at the centre of the cliffs leads round to the tomb of the royal family deep in the desert. The city lay along the edge of the fields, with the main temple and palace complexes at the halfway point in line with the dip in the cliffs. Palaces with garden pools stood at the northern and southern extremes of the city.

The site has been excavated extensively but is far from exhausted, and the evidence is too broken to assemble a full picture either of the royal family or of the royal court. Some high officials can be traced in records of the preceding reign to the leading families of the time, discrediting the view that all the members of the Akhetaten court came from humbler backgrounds and so depended on the king to an unusual extent. The archive of cuneiform correspondence between Pharaoh and rulers in Western Asia has been interpreted as proof that the king paid no notice to the disintegration of Egyptian overlordship there; this again seems an inadequate assessment of complex political relations in which com-

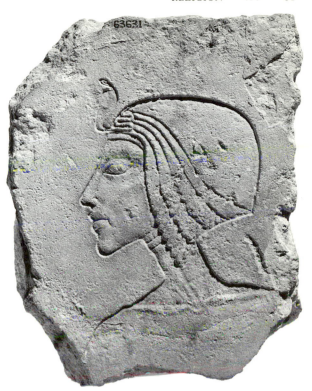

58. *Fragment with the head of a king in relief, wearing a plaited wig and uraeus and represented with the elongated features characteristic of art under Akhenaten. 18th Dynasty, c. 1350 BC; limestone, from Amarna.* H. *17 cm.*

peting rulers claimed to need Egyptian assistance in their own interests. The cuneiform correspondence extends back to the preceding reign of Amenhotep III, and no change in foreign policy is obvious; Pharaoh presumably enjoyed more than one source of information on the turbulent politics of the region, and his response to the growing Hittite threat is not known.

The reign of Akhenaten remains little known beyond his revolution in art and theology; in his twelfth year some great celebration involving his mother Tiy is noted at Akhetaten, but some scholars interpret this as a visit to the city, whereas others regard it as her funeral. Relations at the court and within the royal family are unclear on present evidence, but the dominant figure beside Akhenaten on the monuments is his main queen Nefertiti. One of their daughters, Meretaten, may have married Akhenaten or at least taken part of the role of Nefertiti at the court. A lesser wife Kiya is also recorded, but only the name of Nefertiti was written in a cartouche. The highest date from the reign is year seventeen, and the immediate successor of Akhenaten was a person with the name Neferneferuaten, 'perfect is the perfection of Aten'; again the identity and even the sex of this successor are problematic. Some regard this as a brother of

57. OPPOSITE *Stela from a household shrine showing Amenhotep III with his principal wife Tiy beside a table of offerings under the rays of the Aten or sun-disk. The king wears the so-called Blue Crown with a uraeus. The sun-disk is given the uraeus and cartouches of kingship, and Nebmantra, the throne-name of Amenhotep III, is repeated to avoid reference to Amun, the deity rejected by Akhenaten. The stela demonstrates the inclusion of Amenhotep III's cult with that of the Aten, Akhenaten and the younger generation of the royal family in household shrines at Akhetaten. 18th Dynasty, c. 1350 BC; painted sandstone, from Amarna.* H. *30.5 cm.*

Tutankhamun with a throne-name Smenkhkara, sparsely attested, while others see this as Nefertiti, who was herself regularly called Neferneferuaten on monuments of the king. The mysterious successor disappeared to be followed by the boy Tutankhaten, 'living image of the Aten', who with his queen Ankhesenpaaten, 'she lives for the Aten', ruled for a decade in which, in his name, theology and art were restored to the forms in force before Akhenaten. The names of the king and queen were changed to Tutankhamun and Ankhesenamun, the names and images of the Aten and Akhenaten were everywhere excised, and the city of Akhetaten abandoned to be systematically dismantled for its stone over the ensuing decades. The same fate befell the Karnak Aten temple with its radical royal colossi and, in both places, the reuse of these monuments in later buildings preserved them until they could be rediscovered in the twentieth century and at least partially reassembled.

Tutankhamun and his successor the elderly courtier Ay did not escape the verdict against the Aten episode; as members of the Akhetaten court they fell victim to the same posthumous persecution. Only the tiny scale and the fortune of concealment by rubble from a later tomb preserved the burial of the boy-king from robbers and recycling. Typically of the Aten episode, for all its treasures the tomb leaves the most fundamental problems unsolved; we are not even sure who the parents of the king were.

Despite persecution after death the reign of Akhenaten left its influence in the late New Kingdom, in artistic features such as the femininity of male figures, in the continued strength of sun-worship, and in the growing number of Underworld demons portrayed in the royal tombs as if to refute the vision of a world empty of any divine force other than the physical sun. One change which might pass unnoticed, but which goes to the heart of the self-expression of the state, is the use of the spoken language Late Egyptian instead of Middle Egyptian, the dead classical language of the Middle Kingdom, in royal inscriptions. The first recorded Late Egyptian text appears on the boundary stelae of Akhetaten, and, although Middle Egyptian remained in use for particularly sacred texts, this one conscious reform of Akhenaten survived his removal from the official record.

Prayer and Action in Life-Crises

Egyptian art produces such a persuasive model of harmony that it can easily be forgotten how many dangers the Nile Valley presented to its inhabitants. Disease, lethal animals and death at childbirth would be recognisable problems even today, but in the ages before antibiotics they afflicted everyone regardless of wealth or status. The Egyptians were renowned in ancient Greece for their talents in what we consider the exact sciences such as geometry and medicine, yet these were insufficient in the struggle for survival in this world as much as in the next. In their endeavour to cover the gap between their aspirations and their technical facilities the Egyptians made use of beliefs which, when restricted to words, we condone as 'prayer' but which we condemn prejudicially as 'magic' when the words combine with implements and actions. Egyptian papyri do not separate elements that we might call 'magical' from those we might call 'medical'; instead they divide the texts into three classes: *seshau* or 'treatments' with the diagnoses and prognoses as well as details of treatment; *pekhret*, 'prescriptions', with lists of ingredients and instructions for preparing medicaments and for applying them; and *ru*, 'formulae', the religious texts to be recited during the treatment of the patient. In this holistic approach physician, practitioner of 'magic' and lector-priest (the priest who read the sacred books containing religious texts) perform essentially the same tasks, and it is not clear what distinguishes holders of the different titles.

The Egyptian word translated as 'magic' is *heka*, and it appears as a god in human form beside the sun-god in his bark. According to the *Coffin Texts* Heka appears at creation as the life-giving force of the creator. This force could be harnessed in defence of order by pronouncing a short text, which could itself be called *heka*. The belief in *heka* appears at all levels of society, and is not restricted to any particular social class. At the very peak of the hierarchy one of the names for the uraeus or serpent on the brow of the king was Werethekau, 'the great of *heka*-force'; it defended the king and therefore all order against the forces of evil. Snakes represented one particularly familiar source of danger, and a Late Period list of snakes seems to include every type from Egypt known to modern science, with a description of appearance and harmfulness of each. The risk was confronted by identifying the snake as a manifestation of divinity that could be worshipped and so propitiated, and the lethal character of the animal could then be turned against the enemies of life, as in the example of the uraeus. At Thebes the craftsmen working on the royal tomb worshipped the snake as the goddess Meresger 'she loves silence', protectress of the desert necropolis and its peace. By the doors of their houses in the settlement now called Deir el-Medina these craftsmen placed stones with representations of serpents, to turn the potential enemy of the home into its guard. On a similar basis the scorpion was worshipped as a goddess Serqet, 'she who causes one to breathe', and specialised 'exorcisers of Serqet' were active, for example, in expeditions sent to the desert to procure stone.

The most acute threat of death during life came, as in many societies without modern medical care, at child-

birth. The deities of childbirth included, beside Khnum the moulder of the human form and Renenutet the snake-goddess of fertility, a pair of demonic figures, Taweret, 'the great goddess', represented as a standing pregnant hippopotamus sometimes with a crocodile along her back, and Bes, a dwarf with leonine head depicted, unusually for Egyptian art, face frontal. Again, these figures appear not only on objects from lower levels of society, but also among the products of the royal workshops, and even in motifs of the royal bedroom in surviving palaces. In the late Middle Kingdom markers shaped like boomerangs and adorned with images of protective divinities were used by nurses apparently to draw circles of defence around the infant. The vulnerable mother and child could be protected by appeals to these deities and by reciting texts that act as a complement to the limited medical techniques available. These texts identify the mother and child in peril with the goddess Isis and her infant Horus, and use as models for defence the episodes of myth in which Isis defends Horus from the dangers of life such as disease and harmful animals. The texts survive on papyri of the Middle and New Kingdoms, and on *cippi*, a special type of stelae, of the Late Period. The *cippi* portray Horus as a human child standing on two crocodiles and wielding desert animals such as gazelles, scorpions and snakes, to show that he wields their power and cannot fall victim to them. One of the earliest collections of the *cippi* texts occurs on a statue of Ramses III that was found on a desert road east

59. *Ivory stick shaped from a hippopotamus tusk to form an instrument that could mark out defensive barriers or be wielded by nurses against evil, enlisting the aid of the fearsome powers represented on the surface. This example includes a knife-wielding hippopotamus like the goddesses Ipet or Taweret, and has been broken and then mended in antiquity. Late Middle Kingdom, c. 1800 BC; ivory. L. 30.5 cm.*

of Heliopolis. Evidently the same texts could be applied to any threat to life, whether on individual or national scale, whether at home or on the borders.

The texts for defence against danger and disease consist generally of a title naming the occasion for use, a text in which the cause of the complaint is identified and combatted, generally with reference to a mythical episode, and instructions for use, often involving an implement or ingredients by which the inimical force can be opposed and thwarted in a more concrete way. The bulk of such texts are applied in defence against evil forces. Sometimes, on the principle that attack is the surest means of defence, enemies are identified and destroyed in the form of a particular object, most commonly in the rite of breaking the red jars, performed at temple rituals, in which the red jar embodies the forces dangerous to order, red being the colour of blood and danger. Dangers could also be averted by writing the names of enemies, whether individuals or entire peoples, on figurines of pottery or stone which were then smashed and buried (*Execration Texts*). A large group of these 'curse figurines' was discovered in the desert by a Middle Kingdom fortress at Mirgissa in Nubia, evidence that the state reinforced its military strategy with religious defences, just as an individual might reinforce medical technique with the texts and actions of belief.

Compared with the quantity of sources for defensive religious action little survives of action designed to destroy or to encourage positive responses such as love. Existing love charms seem concerned not so much with seduction as with giving birth, further testimony to the importance of having children. Many simple votive offerings have been found on sites connected with the goddess of love Hathor, and these could be interpreted as pleas for offspring. Religious practices for better crops

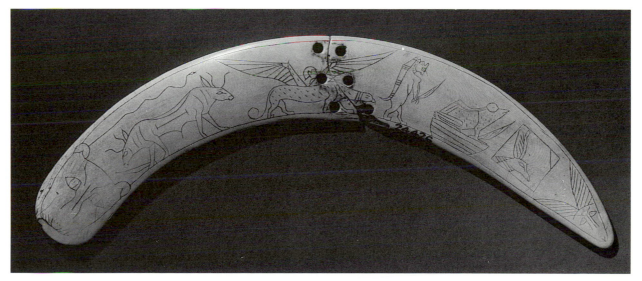

60. Cippus *or 'Horus stela' showing Horus as a child with the power to overcome harmful forces. Like New Kingdom examples this item is of wood, but the prominent Bes head and three-dimensional representation of the child Horus point to the Late Period, when most examples were of stone. Late Period, after 600 BC.; wood, from Memphis (?).* H. *39 cm.*

figures which were used to help overpower the palace guard, but original instructions for such practices have not survived. When appealing for help against evil the Egyptians identified the enemy not as living individuals but as dangerous animals or as hostile supernatural forces such as the dead. From the Old to the New Kingdoms survive letters addressed to recently dead members of the family, to enlist their help against the unseen forces causing any problems, from disease to domestic strife. In the Third Intermediate Period perils could be countered by wearing around the neck a small cylinder containing a papyrus upon which was written the text of a decree passed by a deity at an oracle and guaranteeing the holder protection against every imaginable obstacle to life. In the Late Period the appeals for help against daily difficulties were addressed to local gods.

At the same time it became commoner to sleep on temple ground and then ask a priest to interpret any dreams. Dreams were regarded as 'revelations of truth' from at least the Eighteenth Dynasty when royal texts mention gods appearing to inspire the king in dreams. Two dream texts on papyrus seem from their language to date to the Middle Kingdom, although the surviving copies date to the New Kingdom. The first is the literary text the *Instruction of Amenemhat* I in which the dead king appears 'in a revelation of truth' to advise his son Senusret I. The second is a list of scenes that might be seen in a dream, with an explanation for each.

From the Middle and New Kingdoms survive texts in which each month or each day, or even each third of the day, is marked as good or bad, sometimes with lengthy explanations for the good or bad status based on mythical episodes. Records of work at the settlement of the royal craftsmen at Deir el-Medina refer to special days on which a particular workman could be absent for religious reasons, perhaps partly connected with the calendars of lucky and unlucky days. The small number of surviving calendars do not give the same recommendations for the same days, but it is not known for which reasons the differences arise. The individual person was deemed, at least from the New Kingdom, to enjoy his own personal destiny, sometimes said to be pronounced by seven Hathors at birth, but there remained the possibility of altering this destiny, for example by appealing to a god specifically for an extension to an allotted lifespan. Explorations in astrology by analysing bird or animal movements or entrails, or by looking for meaning in the passage of the stars, seem never to have found an audience in Egypt, in contrast to Mesopotamia, and the zodiacs in Egyptian temples of the Late Period derive from Mesopotamian models. The stars provided the Egyptians with a means of calculating time and with one image of survival beyond death, but not, it seems, with clues to future events.

or richer yields in fishing or hunting are difficult to identify outside the formal temple ceremonies and festivals. The use of belief to destroy, as in the modern concept of 'black magic', is also difficult to detect in private sources, although some texts do refer to people of the evil eye, the eye that falls on an individual and brings misfortune. Legal records from the trial of the conspirators who murdered Ramses III refer to wax

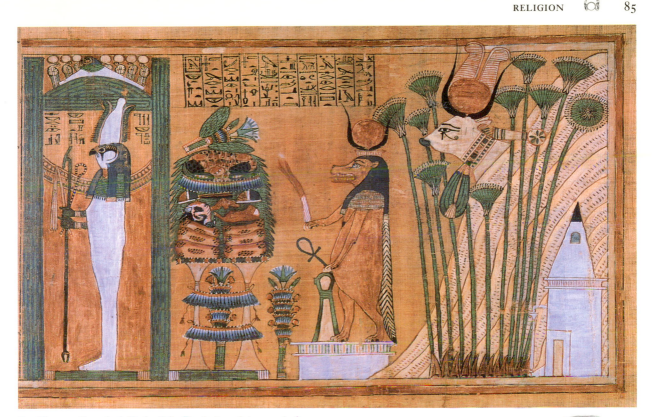

61. *Vignettes from Any's* Book of the Dead. *In a shrine stands the funerary god Sokar-Osiris holding the crook, flail and was-sceptre. Behind the offering table stands the hippopotamus-goddess Ipet, offering life and flame to the deceased. Behind her, Hathor as a cow, wearing a* menat *collar, emerges from the site of Any's pyramid-capped tomb-chapel, into the papyrus clumps fringing the Nile Valley. 19th Dynasty, c. 1250 BC; painted papyrus. H. 38 cm.*

62. *Stone fragment depicting the Western Asiatic goddess Qedeshet, identified by her iconography as a naked woman seen full frontal. In the New Kingdom and later, Western Asiatic deities received worship at all levels of society; beside Qedeshet the king and his subjects accepted Anat and Astarte, Hurun and Baal. 19th Dynasty, c. 1250 BC; limestone. H. 25.5 cm.*

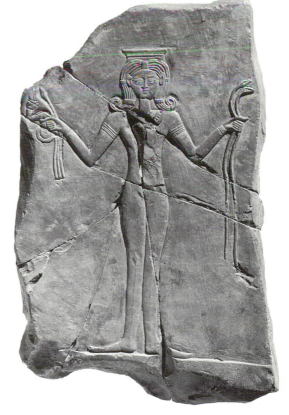

The use of words alone to appeal to a deity provokes a less prejudicial reaction from a modern audience because it is familiar as 'prayer'. Egyptologists use the tautologous term 'personal piety' to label a group of texts, almost all from Deir el-Medina, in which a person acknowledges immediate dependence on a deity. Although the expression is attested most often in that unique settlement of New Kingdom craftsmen, the acknowledgment of dependency is implicit in any belief in a god, and can be seen in personal names of every period such as Samut, 'son of Mut' or Padiamen, 'the gift of Amun'. The Deir el-Medina texts do, however, shed a sharply focussed light on this aspect of belief, and include some of the most poignant details of human life to survive from ancient Egypt.

4

FUNERARY CUSTOMS
AND BELIEFS

Most of the objects preserved from ancient Egypt come from tombs and temples, leading to the misconception that the Egyptians were a particularly religious people, obsessed with death, burial and the Underworld. However, examination of their daily life reveals the Egyptians' apparently overwhelming preoccupation with death springs essentially from their delight in living and in the good things available in Egypt, and a desire to continue to enjoy them in the afterlife. As early as the Predynastic Period, burials contained personal possessions, tools, utensils and pottery filled with food and drink for use in the afterlife, and as the historic period progressed funerary arrangements became ever more elaborate to provide the deceased with every necessity for the expected life after death. It is impossible to give an account of every important element of funerary belief applicable to each class of society at all times; because the richest tombs have the best chance of survival, they provide most of the information about Egyptian funerary customs. Although the resultant account must be one-sided it is quite clear that at every level the Egyptian's hope was for an afterlife consisting of the best available in earthly existence. To participate fully in this afterlife it was necessary that the name should continue to exist, the body remain intact and the spirit forms which survived death be regularly supplied with essential food and drink. During the Dynastic Period these ends were achieved for the wealthy by providing for the incorruptible mummy a coffin and a tomb-chapel covered with texts incorporating the owner's name and with

scenes which would secure for him by magical means food, drink and other desirable objects, even when the services of the appointed tomb-servants had ceased to be performed.

Mummification

The preservation of the body, whose survival in a recognisable form was essential for an afterlife, became the principal aim of Egyptian funerary practices at an early date. During the Predynastic Period, the corpse, curled into a foetal position and sometimes covered with a skin or matting, was usually buried in a shallow grave dug in the desert at the edge of the cultivation. The hot dry sand acted as a powerful desiccating agent removing moisture without which there can be no bacteria or decay. A naturally sand-dried body of the period is preserved in the British Museum; it consists essentially of a skeleton with skin covering. By the beginning of the First Dynasty, however, burials were becoming more elaborate; the corpse was often placed in a burial chamber, completely removed from contact with the preserving sand. As a result natural putrefaction set in; the very measure intended to afford greater protection had the exact opposite effect.

63. OPPOSITE *Painted* shabti *box of the Theban priestess Henutmehyt, which shows her adoring two of the Canopic deities. Her painted* shabtis *are intended to carry out agricultural activities for her in the afterlife. 19th to 20th Dynasties,* C. *1250–1150* BC; *wood.* H. *34.5 cm.*

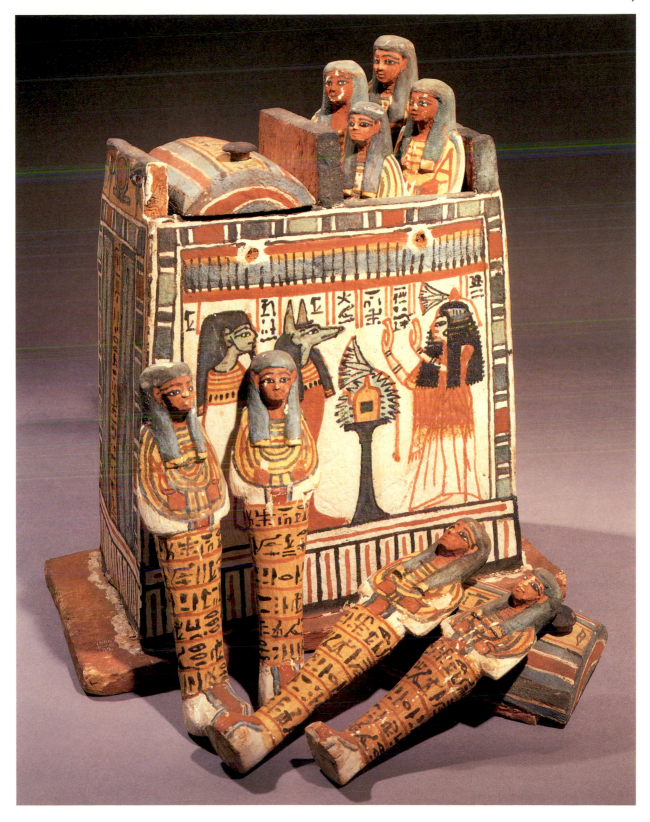

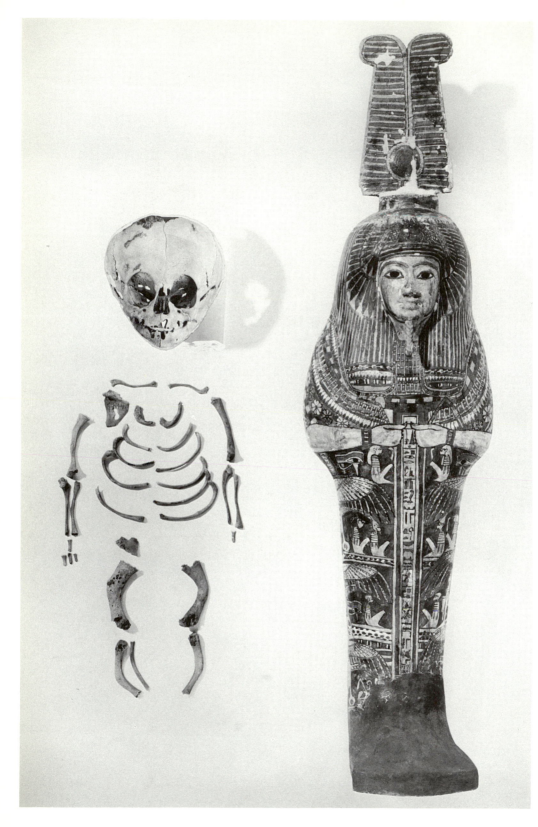

64. *Painted cartonnage mummy-case made for a child, together with the bones of the occupant. The body of the mummy-case is decorated with figures of deities and a series of falcons with outspread wings. The feathered headdress and royal sceptres held in the hands are features very rarely found on coffins, although they are regular attributes of wooden funerary statuettes representing Osiris, dating to the 21st and 22nd Dynasties. The child, whose name has not survived, suffered from osteogenesis imperfecta, a rare condition characterised by brittleness of the bones and consequent deformity of the skull. 22nd Dynasty, c. 945–715 BC; from Beni Hasan. H. of cartonnage 73 cm.*

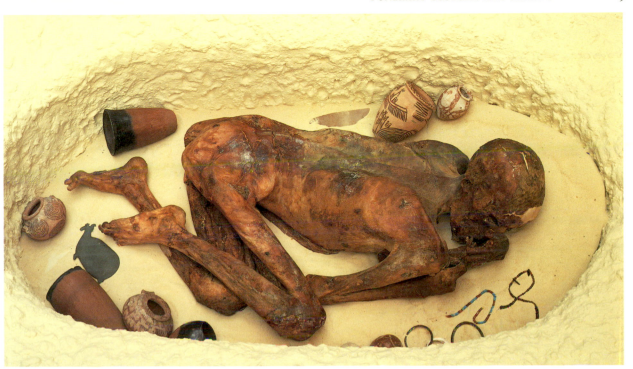

65. 'Ginger', a Predynastic man preserved naturally by the hot, dry sand in which he was buried. The heat of the sand absorbed the body's moisture, without which bacteria could not breed and cause decay. Naqada II Period, c. 3200 BC; L. (unflexed) 1.63 m.

It seems likely the Egyptians soon appreciated the changed fate of the interred corpse and began seeking to secure by artificial means the result formerly achieved naturally by contact with sand. Evidence is scanty before the Old Kingdom but the discovery of bodies with individual limbs tightly wrapped in linen bandages suggests that at first it was thought decomposition could be prevented by keeping the corpse carefully covered. Later the bandages were stiffened with plaster but that only preserved a human-form linen shell. Not until the Fourth Dynasty does clear evidence exist to show it was realised that the removal of the internal organs was an essential step towards preventing decomposition. A partitioned calcite chest containing bandaged packages of viscera, still soaking in a dilute solution of natron, was found in the burial place of Hetepheres, mother of Khufu, the Great Pyramid's builder. However, during the remainder of the Old Kingdom and even during the Middle Kingdom no fixed method of preserving the body is evident: the internal organs and brain were not always removed nor the corpse dehydrated. Not until the New Kingdom were the basic requirements to secure adequate preservation fully understood, namely the removal of the brain and viscera and the dehydration of the empty body shell.

The term 'mummy' comes from an Arabic word of Persian origin which means 'bitumen', a material not used in the embalming process until a very late date. The misunderstanding presumably arose because those mummies most often seen by the Arabs were so blackened and impregnated with resins that they appeared to be made of bitumen, a misapprehension enhanced by their brittleness and burning properties. Egyptian documents of the Late Period and the works of Greek writers, particularly Herodotus, provide most of the written evidence about mummification; it is only relatively recently that mummies have been subjected to scientific research.

The period spent on preparing the body for burial between death and interment was seventy days of which forty were devoted to its drying out. As soon as possible after death the corpse was handed over to the embalmers whose immediate task was to remove the brain and internal organs which would rot most quickly. The brain was usually removed through the nostrils by breaking through the ethmoid bone, the viscera through an incision made in the lower left side. The heart, however, as the seat of understanding, was regularly left in place. Misinterpretation of the relevant passage in Herodotus at first led scholars to believe the principal stage in mummification was a long period of soaking in a solution

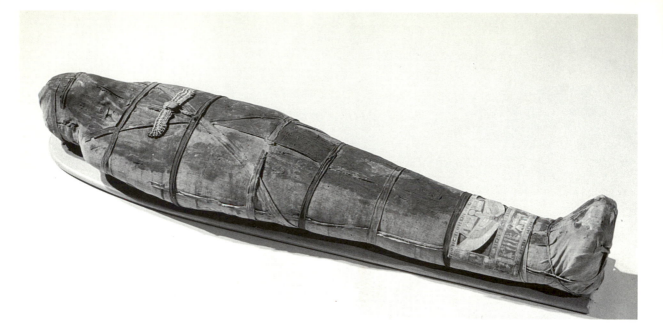

66. *Mummy of an adult female. The presence of subcutaneous packing in the neck and artificial eyes in the eye-sockets has been demonstrated by X-rays. A scarab with wings composed of faience beads lies on the breast, and a cartonnage cover (probably from a mummy of a later date) has been placed over the legs. Third Intermediate Period, c. 1070–664* BC. H. *1.56 m.*

of natron, a naturally-occurring salt compound. It was only fifty years ago that investigations proved that, except during the early experimental phases, dry natron crystals were employed, the effect being to dehydrate the body efficiently, dissolve body fats and leave the skin supple. The internal organs were also treated with natron but separately. All the materials used during this process, including temporary packing which had helped to prevent the corpse's disfigurement during dehydration, were carefully saved for storage in or near the tomb in an 'embalmers' cache', for it was important that the essential juices extracted should not be divorced completely from the body. Finally, the body cavity was repacked with linen, sawdust, even dried lichen, before the lips of the embalming incision were drawn together and covered by a tablet of leather, metal or wax called an embalming plate, bearing a representation of the *wedjat* eye of Horus, a powerful protective amulet.

At first the eye sockets were plugged with linen wads but later a very realistic look was achieved by inserting artificial eyes. Other elaborate measures to obtain a more natural appearance were also undertaken during the Twenty-first Dynasty when the embalmers' skill reached its peak: after dehydration a semblance of living plumpness was restored by packing the limbs with mud or sawdust and the shrunken cheeks with linen pads. Such

elaborate measures, however, were undertaken for only a short time; subsequently the treatment of the corpse became progressively more simple, the embalmer's skill being expended increasingly on the bandaging.

It was after the body had been massaged with lotions, treated with unguents and coated with resin that the wrapping began. Fifteen of the seventy days were allotted to the bandaging of the mummy because the care expended on its tightness would help to maintain the shape and rigidity of the body. Over 324 square metres of linen might be used as the head, fingers and toes and then the limbs were individually bandaged before all were wrapped in with the torso; all the while preshaped rolls and pads of linen were strategically placed to help round out the finished outline. Before the final layers were added a funerary mask was fitted over the head and shoulders to identify the wrapped mummy beneath to the *ka* and *ba* when they returned to the burial chamber. The usual material was cartonnage (linen or papyrus stiffened with plaster) sometimes gilded; for royalty the mask was of precious metal. The outermost shrouds were usually held in place by longitudinal and transverse bandages but in the Roman Period the outer wrappings were frequently arranged in intricate geometrical patterns formed by cross strapping. Characteristic of Late Period mummies is an all-over beadwork netting.

Although the removal of the internal organs was essential for successful mummification the Egyptians considered their careful preservation equally important. From the Old Kingdom until the Ptolemaic Period the embalmed viscera were customarily placed in four containers now called canopic jars. The term was coined by

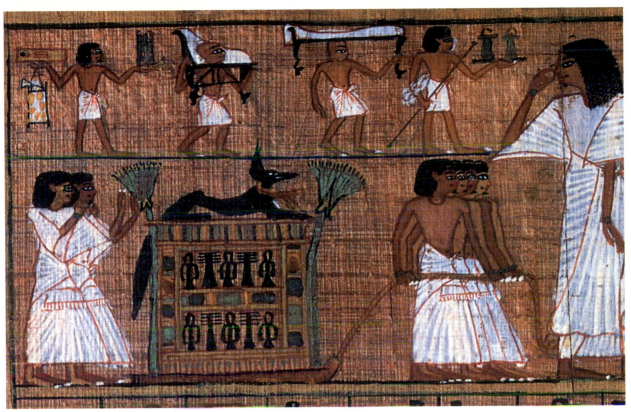

67. *Detail from Any's* Book of the Dead *depicting his own Canopic chest topped by the jackal of Anubis and flanked by bouquets. The figures above it are servants carrying grave goods, including scribal equipment. 19th Dynasty, c. 1250 BC; painted papyrus. H. 10 cm.*

68. *Dummy canopic jars (the embalmed organs were by this time returned to the mummies) for an unnamed person. The stoppers represent the Four Sons of Horus, the canopic deities. 21st Dynasty, c. 1000 BC; wood. H. of human-headed jar 31 cm.*

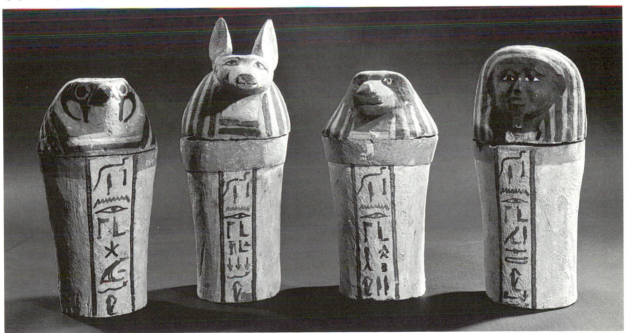

early scholars who linked the jars with human-headed stoppers to a story related by classical authors that Canopus, pilot of Menelaus, had been buried at Canopus in Egypt and was worshipped locally in the form of a human-headed jar. The earliest Canopic jar in the British Museum's collection was made in the late Eleventh Dynasty for a man called Wahka; the earliest complete set, stored in a wooden Canopic chest, belonged to the Twelfth Dynasty Chief Physician Gua.

The Canopic jars' contents were placed under the protection of four minor deities called the Sons of Horus: human-headed Imsety guarded the liver, baboon-headed Hapy the lungs, jackal-headed Duamutef the stomach and falcon-headed Qebhsenuef the intestines. Until the end of the Eighteenth Dynasty the jar stoppers were all human-headed, thereafter they were shaped like the Sons of Horus' heads. The jars themselves were identified with the four protective goddesses Isis, Nephthys, Neith and Serqet respectively. During the Twenty-first Dynasty the embalmed viscera were made up into four packages, each accompanied by a wax figure of the appropriate Son of Horus, and returned to the body cavity. Yet the inclusion of a set of Canopics in the tomb equipment was so established that jars were still supplied simply to fulfil the formal need. During the Ptolemaic Period, when the mummification process was carried out

68

in so perfunctory a manner that the viscera were often left in the body or else were packaged between the legs, solid dummy jars were provided.

The Egyptians' belief that most of their gods could manifest themselves on earth in animal form led to the mummification of sacred animals. At first the practice was reserved for individual venerated animals such as the bulls of Memphis, Heliopolis and Hermonthis, and their cow mothers. The Apis bulls, earthly manifestations of the god Ptah of Memphis, were interred in huge stone sacrophagi in vast underground catacombs in the Saqqara necropolis known as the Serapeum. Only one of these animals existed at any one time and their mummification was performed thoroughly, the full process being employed. The alabaster tables used during the preparation of their bodies can still be seen at the site of Memphis. In contrast, the mass mummification and burial of animals was a phenomenon of the Twenty-sixth Dynasty and later when great cemeteries were laid down in the vicinity of appropriate cult

70

69,
72

69–72. Various aspects of the cults of animals considered to be the representatives of individual deities are illustrated by the photographs shown here. The important Apis-bull of Memphis was provided for under royal direction, and the bronze group of a kneeling king before the sacred bull reflects the status of the animal (Fig. 70). Baboons, sacred to Thoth, were interred in large numbers in underground

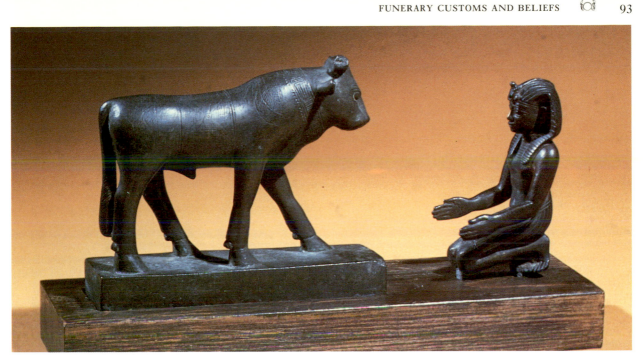

cemeteries, the entrance to one of which at Saqqara is shown (Fig. 69). The bodies of the animals were preserved by mummification (Fig. 71) and votive figures (Fig. 72) were placed in the shrines attached to the animal cemeteries. These examples all date from the Late Dynastic, Ptolemaic or Roman Period, 600 BC to 200 AD, when the animal cults assumed great significance.

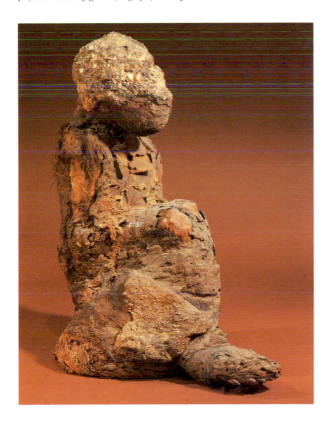

centres. Thus, at Bubastis the graves contained cats, manifestations of the local goddess Bastet; while Hermopolis had ibis catacombs for there the local god was Thoth. The actual mummification of these animals could be very crude, the body often being skeletal before bandaging; however, the wrapping was carried out with great skill, every effort being made to produce a bandaged mummy convincing in appearance.

Amulets and Funerary Equipment

To give further protection amulets of various kinds were placed on the mummy and within the bandages. Most amulets could be worn in life and taken to the tomb but some funerary amulets were made exclusively for the day of burial. Perhaps the most important of these was the heart scarab, made of a prescribed green stone and placed over the breast. Its underside was incised with 'chapter 30B' of the *Book of the Dead*, a short exhortation to the heart not to act as hostile witness against its owner when it was weighed in the balance in the Judgement Hall of Osiris. One of the earliest is of green jasper, set in a gold mount and was made in about 1590 BC for king Sobkemsaf II of the Seventeenth Dynasty. Ordinary funerary scarabs were made of glazed composition, fitted with wings and intended to be stitched to the mummy wrappings. Non-funerary amuletic scarabs which in life served as elements of jewellery were often buried with their owner. Among amulets commonly found on mummies are the *wedjat* eye of Horus, the *djed*-pillar, *tit* or Girdle of Isis, the papyrus sceptre, the heart and the two fingers. Small figures of deities and sacred animals, sometimes made of precious metal, were also regularly used for amuletic purposes. Of particular

interest is a set of glazed composition amulets from a mummy of Twenty-sixth Dynasty date found at Nebesha in the Delta, for their exact placement on the body is known.

Among other amuletic objects found with mummies are wands made of hippopotamus ivory and *hypocephali*. The former, found in Middle Kingdom burials, appear to have been used in life as well as death. They are incised with a frieze of harmful creatures against which they were intended to afford protection but also with the household deities Bes and Taweret. *Hypocephali* are found in a few burials of the Saite Period and later; as their name denotes they were set beneath the heads of mummies. Usually made of cartonnage, although a few examples exist of other materials such as metal, they are decorated with vignettes depicting various universal deities and with extracts from 'chapter 162' of the *Book of the Dead* designed to bring warmth to the deceased.

A form of amuletic protection provided in burials of New Kingdom date was a set of four magical bricks,

74. OPPOSITE Top left *Scarab amulet representing the dung beetle, symbolic of regeneration.* Bottom left *The* tit, *or Girdle of Isis, which afforded protection.* Top right *The* wedjat *eye of Horus, which was protective and warded off evil.* Bottom right *The* djed-*pillar thought to resemble the backbone of Osiris; it offered stability and the possibility of the god's resurrection.* Centre *A composite amulet formed of the* djed, ankh *and* was-*sceptre; it was symbolic of dominion. 25th Dynasty to Late Period, c. 700–500 BC; glazed composition and red jasper, composite amulet from Gebel Barkal. H. of composite amulet 23.1 cm.*

73. BELOW *Human-headed heart scarab set in a mount inscribed with a very early version of 'chapter 30B' of the* Book of the Dead, *the heart scarab formula which names king Sobekemsaf II. 17th Dynasty, c. 1590 BC; green jasper and gold, from Thebes. L. 3.6 cm.*

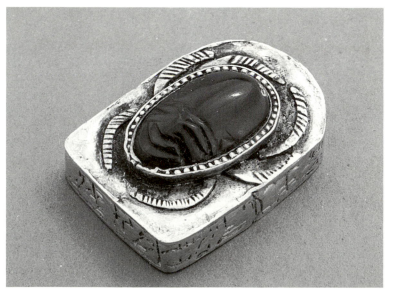

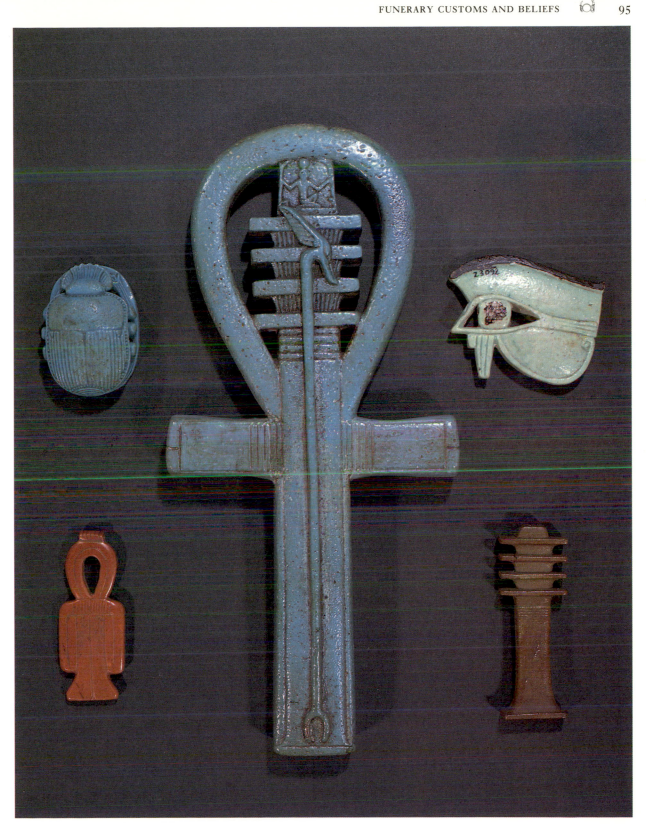

75. Hypocephalus *from the burial of Neshorpakhered, a sistrum player of Amun. The illustration presents four baboons greeting the sun-god, with one ram's head for each of the first four generations of creation (Ra, Shu, Geb and Osiris); beneath and inversely appears Mehytweret, the primeval flood, in the form of a motherly cow. Late or Ptolemaic Period, 4th to 3rd centuries BC; plastered linen with pigment, from Thebes. W. 14 cm.*

their prescribed material unbaked mud, each carrying an amulet, which were placed in niches in the four walls of the burial chamber. The northern bore a wooden mummiform figure, the southern a reed with wick representing a torch, the eastern an unbaked clay jackal and the western a blue glazed composition *djed*-pillar. The purpose of the bricks, which were also inscribed with short individual texts forming 'chapter 151' of the *Book of the Dead* was to prevent the approach of the deceased's enemies from any of the four cardinal points.

From earliest times Egyptian burials were provided with equipment designed to supply the needs of the deceased in the afterlife. At first it consisted almost exclusively of objects from daily life which would allow a continuation of earthly existence: simple graves contained pottery vessels and baskets for food and drink, tools, utensils and personal possessions. From at least the beginning of the Dynastic Period the tombs of royalty and nobles were supplied, in addition, with appropriately

more valuable articles such as furniture and items made of precious materials. Many of the objects in the Egyptian Collection at the British Museum came from burials but they represent objects used in contemporary daily life. The purpose of funerary equipment, however, was closely connected with the fate of the deceased in the afterlife; it was made expressly for the day of burial.

Shabti is the term applied to the funerary figurine which from the New Kingdom onwards became an essential part of burial equipment. The word itself is of uncertain origin, the variant *shawabti* occurring almost as early. In the Late Period the figures were invariably called *ushabtis*, meaning 'answerers', which perfectly describes their function but reveals that by then the Egyptians themselves had forgotten the meaning of the original term.

The Egyptians believed that in the afterlife, as in Egypt itself, there would be a regular need for agricultural labour. Each year when the flood waters of the Nile subsided the rehabilitation of the land involved re-establishment of property boundaries, rebuilding of dykes and cutting canals, tasks accomplished for the most part by conscripted labour. However, it was possible to avoid the corvée by supplying a deputy and the *shabti* came to be regarded as the deceased's deputy for the

same tasks in the afterlife. A very early version of the magical text used to secure the substitution occurs on the lid of the coffin of the Chief Physician Gua. In the New Kingdom it was incorporated into 'chapter 6' of the *Book of the Dead*. Although much variation is possible, the basic form of the spell reads:

X (the deceased) says "O thou *shabti*, if X is counted off to do any of the work wont to be done in the god's land – to make arable the fields, to irrigate the riparian lands, to transport by boat the sand of the East to the West – now indeed obstacles are implanted for him therewith as a man at his duty. If one calls you at any time 'Here I am' you shall say, 'I shall do it'".

It was to perform these tasks on behalf of their dead owners that, from the early New Kingdom, many *shabtis* began to carry hoes, picks or adzes, bags or baskets for the grain, even brick moulds and water pots on yokes. However, when these funerary figurines first appeared during the Middle Kingdom they were invariably mummiform to identify the deceased with Osiris, made of stone (less often wood or wax), frequently carried amuletic emblems and were more likely to be inscribed with a prayer to provide food offerings. Indeed, this concept that originally they represented the deceased rather than his deputy survived into the New Kingdom when some *shabtis* are depicted wearing daily dress and clasping a *ba* to the chest. In the late Seventeenth Dynasty funerary figurines are characteristically little more than crudely human-form wooden pegs. During the New Kingdom, however, some *shabtis* are so finely made as to rank as miniature works of art. Even royalty was now supplied with them, often in considerable numbers, and the range of materials used increased to include glazed composition, pottery, glass and metal.

In the Middle Kingdom the figures were placed individually in burials, sometimes in a small coffin of their own, a practice which continued into the New Kingdom. By the Third Intermediate Period, however, their numbers had grown to such an extent that they had to be accommodated in special *shabti* boxes. Now it was customary to supply a single burial with one *shabti* for each day of the year with thirty-six overseer *shabtis* to control them, the overseers distinguished from the workers by wearing kilts and carrying whips. Almost invariably the material used was glazed composition and the quality of the figures deteriorated progressively. There was a revival with the well-carved stone *shabtis* of the Napatan royal family of the Twenty-fifth Dynasty and their successors and the carefully modelled glazed composition *shabtis* of the Twenty-sixth and Thirtieth Dynasties but the practice of supplying them in burials died out during the Ptolemaic Period.

One of two wooden boards bearing decrees about the *shabtis* of Neskhons is now in the collections at the British

Museum. The text shows that she paid for the figures but whether she bought them as slaves or the payment reimbursed them for their work is unclear.

A funerary object characteristic of burials of the Late Period is the Ptah-Sokar-Osiris figure representing a three-form deity embodying some of the characteristics of Ptah the Memphite creator god, Sokar the god of the Memphite necropolis and Osiris the king of the Underworld. The earliest figures in this category represent Osiris alone, mummiform and on a pedestal, and come from Nineteenth to Twenty-second Dynasty burials. In some cases the figure is hollow, intended to hold a funerary papyrus for its deceased owner. The collection at the British Museum contains not only two such papyri, the *Books of the Dead* made for the scribe Hunefer and the high-ranking priestess Anhay but the two figures from which they came. In the Late Period when the figures have the triple association with Ptah, Sokar and Osiris the bases are often surmounted by a small mummiform falcon representing Sokar and the bases usually contain a small linen-wrapped corn mummy or even a tiny portion of the deceased's body. Presumably in such a case the base represents the coffin and the contents the deceased awaiting resurrection.

Funerary texts

The Early Dynastic and Old Kingdom funerary texts on the walls of private tomb-chapels consist mainly of set phrases designed to ensure the survival of the individual beyond death by preserving the name and, by a magical eternal supply of food and drink, the body and spirit forms. Other central concerns of the texts and images in tomb-chapels are the security of the tomb, the successful life of the owner and his good character. These themes continue to predominate in tomb-chapels of the Middle and New Kingdoms and the Late Period. Texts and images in the burial chamber of a tomb concentrate more on the survival of the person as a divine spirit. The earliest such texts, called by Egyptologists *Pyramid Texts*, occur inscribed on the chamber walls within pyramids of kings from Unas of the Fifth to Ibi of the Eighth Dynasty, and also in queens' pyramids of the Sixth Dynasty; some of these texts seek to ensure the protection of the body from hostile forces such as snakes and scorpions, but most concern the ascent of the king to join the sun or the stars and so achieve resurrection.

Although some *Pyramid Texts* continued to be used as non-royal funerary literature as late as the Ptolemaic Period, the late Sixth Dynasty saw the first recording of a new body of texts, mainly written on non-royal coffins and so called *Coffin Texts* by Egyptologists; these occur most frequently on coffins from the major provincial centres of Upper and Middle Egypt in the early Middle

76. *Map showing the routes to the Underworld; part of the* Book of the Two Ways *painted on the interior of the outer coffin of Gua. 12th Dynasty,* C. *1991–1786* BC*; painted wood, from Bersha.* L. *of coffin 2.6 m.*

Kingdom, sometimes alongside *Pyramid Texts.* A papyrus in the British Museum is one of a small number of rolls with *Coffin Texts,* apparently the original manuscripts from which the formulae were recited at funerals or copied onto coffins in workshops. The *Coffin Texts* differ markedly from the *Pyramid Texts;* hopes for resurrection continued to be pinned on the daily cycle of the sun, but new elements occur such as the inclusion of the family in the next world, the right of appeal to a tribunal there, and the increasing importance of Osiris. The earliest maps appear at this time as guides to the Underworld, known in Egyptology as the *Book of Two Ways;* these appear on the floors of early to mid-Twelfth Dynasty coffins from Middle Egypt. It is not known what texts, if any, accompanied the kings of the Middle Kingdom to their afterlife.

76

In the Seventeenth Dynasty a new set of texts appeared on the shrouds over the bodies of members of the royal family and on their coffins; many of these derive from the *Coffin Texts* but a large number are new compositions. The new body of texts gained the ancient Egyptian title 'formulae for going out by day', and is known in Egyptology as the *Book of the Dead.* In the New Kingdom and Third Intermediate Period about two hundred formulae are known. After their initial appearance on the shrouds and coffins of the Seventeenth Dynasty royal family, the texts were painted along with accompanying vignettes on shrouds of less wealthy burials in the early Eighteenth Dynasty. From the reign of Hatshepsut with Thutmose III texts from the corpus were recorded not only on funerary shrouds but also on rolls of leather or papyrus placed on the body; after the Eighteenth Dynasty leather was no longer used, one of the latest examples being the *Book of the Dead* of the general Nakht which begins on a piece of leather and continues on a roll of papyrus. In the New Kingdom and Third Intermediate Period each *Book of the Dead* contains a selection of spells, and varies in length and in proportion of text to vignette. The vignettes are nearly always in colour, fine examples being the papyri of Hunefer, Any and Anhay; the papyrus of Nebseny has only black outline vignettes, perhaps because its owner was a copyist in the Ptah temple at Memphis, and may have compiled his own selection of texts and drawn the vignettes himself, whereas most vignettes would have been prepared in colour in a different workshop to the hieroglyphic workshop that produced the text. Some papyri were commissioned specially for an individual, while others have the name written in afterwards as in the *Book of the Dead* of Any. Fine vignettes often accompany inaccurate versions of the text, presumably because the text was produced in a different workshop from that producing the vignettes.

The selections from the full corpus of *Book of the Dead* texts vary greatly, and no manuscript contains all

right; 'chapter 110' describes the Fields of Offerings and Rushes where the deceased cultivates grain and flax for his or her eternal benefit; and 'chapter 148' shows the celestial herd and four rudders of heaven by which the deceased secures his share in the abundance enjoyed by the gods.

In the New Kingdom the royal tomb might include texts and images from the *Book of the Dead*, but the principal decoration of the burial chamber depicts various forms of conceiving the next world and specifically the journey of the sun through the night sky to his morning resurrection; in the Eighteenth Dynasty, from at least Thutmose III, the main text was the *Amduat* or 77 'Book of what is in the Underworld', painted in outline figures similar to the sketchy figures on illustrated ritual papyri of the late Middle Kingdom. After the Amarna Period, in response to the idea that the sun might travel alone through an empty sky, additional compositions were included in the decoration of the royal tomb, such as the *Books of Caverns, Portals, Day and Night*. From the time of Tutankhamun, whose small tomb had no room for such texts which had thus to be recorded on the gilt shrines around the sarcophagus of the king, there also occurs a text known now as the *Destruction of Mankind*, in which the sun-god sends his eye as Hathor to destroy rebellious mankind and then relents. Royal burials were populated not only by underworld demons depicted in the *Underworld Books* on the walls of the tomb, but also by monstrous figures, some of which are in the collection, such as the seated human figure with 78 a tortoise for a head; all of these figures were meant to accept the dead king as they accepted the creator, and to repel hostile forces. Some themes of the underworld books are represented in the *Book of the Dead* (the portals of 'chapters 144' to '147') but others such as the *Amduat* were restricted to tombs of the kings.

In Thebes during the Third Intermediate Period two papyri were placed in the burial of each person who could afford it, one with a *Book of the Dead* in hieroglyphs or, for the first time, in hieratic, and the other with a copy of the *Amduat* or the *Litany of Ra*, previously not used in non-royal burials. The first time that the royal texts and vignettes are included in a non-royal papyrus is in the *Book of the Dead* of Anhay which is for this reason dated by some scholars to the Twenty-first rather than the Twentieth Dynasty. Richly coloured vignettes, from the same repertoire as that on Third Intermediate 79 Period coffins, are sometimes combined to form papyri exclusively of vignettes; these are sometimes entitled *Book of the Dead* and sometimes *Amduat*, and include the often cited illustration of the world as the sky-goddess Nut arched over the earth-god Geb separated by the air-god Shu. This vignette also occurs in the long series at the end of the uncoloured *Book of the Dead* of Nes-

texts. Texts in the corpus are numbered 1 to 165 according to their position in the Ptolemaic *Book of the Dead* of Iufankh in Turin, the first to be edited with text-numbers (by Karl Richard Lepsius (1810–84), in 1842); Late Period *Books of the Dead* have a relatively fixed sequence, which makes this sequence convenient for Egyptologists, although strictly it has no relevance to New Kingdom and Third Intermediate Period papyri or to the texts in other positions such as on tomb-chapel walls or on sarcophagi. Texts not in the papyrus of Iufankh have been numbered 166 upwards in the order that they have been edited from New Kingdom and Third Intermediate papyri, by Edouard Naville, a Swiss Egyptologist (1844–1926) and Ernest Wallis Budge once Keeper of Assyrian and Egyptian Antiquities at the British Museum (1857–1934). A conflicting set of numbers exists from 'chapter 166' to '174' edited by Willem Pleyte (1836–1903) from Late Period papyri and some Third Intermediate Period antecedents. The last chapter edited by Budge was 'chapter 190'; since then a few extra chapters in the corpus have been identified but several 'chapters' in manuscripts of various periods remain unedited and unnumbered. Some texts have large vignettes that mark them out as particularly important; 'chapter 15' (hymns to the sun-god) has a vignette numbered by Lepsius as a separate chapter '16', showing the adoration of the rising sun; 'chapter 30' and 'chapter 130 125' refer to the judgement of the dead before Osiris, the most famous illustration from the *Book of the Dead* in which the heart of the deceased is proven pure by being balanced against Maat the goddess of what is

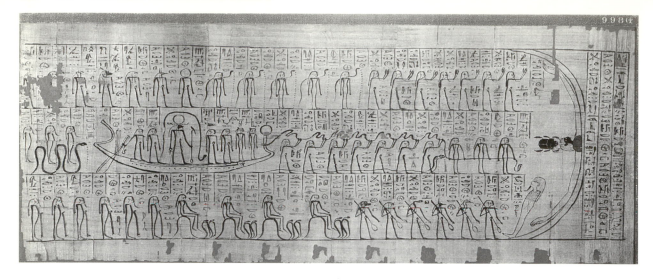

77. *Funerary papyrus of Ankhefenkhons, the scribe of divine offerings of the Amun temple. This portion presents the resurrection of the sun at dawn as the ram-headed sun-god in his bark being towed through the body of the serpent; the scene is the twelfth hour of night in the Amduat.* Third Intermediate Period, *c. 950* BC; *papyrus with pigment, from Thebes.* H. *24 cm.*

tanebetasheru, one of the finest in the collection. The pairing of *Book of the Dead* and *Amduat* continued into the mid Twenty-second Dynasty. In the same period Theban burials often included texts of decrees issued by the oracle of Amun to protect the afterlife of the deceased, such as the decree for the *shabtis* of Neskhons on a wooden board and the more general 'insurance

78. *Figure of the guardian demon of a royal tomb, in human form with a tortoise in place of a head. The demon is sitting on the ground with its upper torso and head twisted to 90° in a dramatic breach of artistic convention.* 18th Dynasty, *c. 1400* BC; *wood with cartonnage, from Thebes.* H. *36.5 cm.*

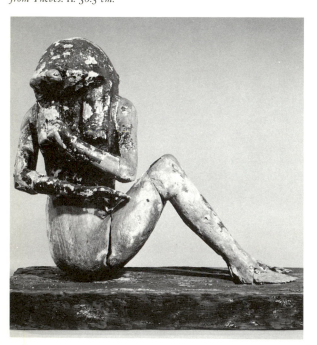

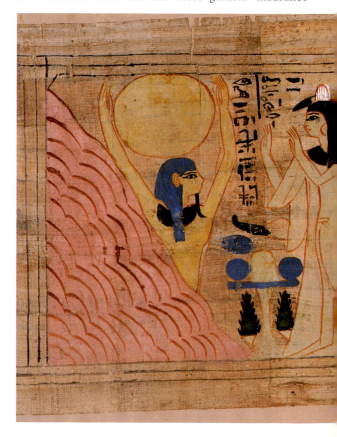

policies' used in life known as oracular amuletic decrees, written on long strips of papyrus and folded into neat packets; single texts could also be written on a sheet of papyrus which was then folded like a letter (these include some of the 'supplementary chapters' edited by Pleyte as part of the *Book of the Dead*). After the ninth century BC there is a gap of two centuries in which burials became plainer and funerary texts were not used.

The tradition of placing funerary texts with the body resumed in the mid-seventh century BC, when the *Book of the Dead* reappears in a new edition, which was studied and numbered by Lepsius in 1842 as chapters 1 to 165 (of which some are numbers for vignettes and others are repeated texts) and arranged in a more or less fixed sequence in contrast to the highly variable order and selection of earlier manuscripts. This new edition is called by Egyptologists the Saite recension of the *Book of the Dead*, after the Twenty-sixth Dynasty nome city of Sais; it is not known where or exactly when the edition was compiled. Both selection and sequence of texts were still not absolutely constant, and short versions continued to be used; both coloured and uncoloured vignettes occur, sometimes on the same papyrus. Very few papyri survive from the Twenty-sixth Dynasty, with most surviving Late Period *Books of the Dead* dating to the fourth

to third centuries BC (Thirtieth Dynasty to early Ptolemaic Period); in the fourth century BC around Memphis and the Fayum the *Book of the Dead* was written on the linen mummy wrappings. In the late fourth century BC some temple liturgies for the glorification of Osiris were taken over for private funerary use to glorify (technically 'make into an *akh*') the deceased; these 'glorifications' derive in part from Middle Kingdom funerary liturgies embedded in the *Coffin Texts*. In the Ptolemaic Period full length *Books of the Dead* were often replaced by abbreviated versions, sometimes a single text such as 'chapter 100' for ferrying Osiris to his cult-centre Busiris and the *benu*-bird of the sun-god to the east. In the late Ptolemaic and early Roman Periods the *Book of the Dead* came to be replaced by a new, shorter composition, conceived as a passport to life after death, with the title 'document for breathing'; one of the finest examples is that of Kerasher, with text interspersed with colour vignettes such as the Judgement of the Dead. Abridged

37

79. Funerary papyrus of Tentosorkon, showing her adoring the sun-disk as it is lifted out of the earth. The figures to the right represent the differently-shaped mounds of the Underworld with their guardians. Third Intermediate Period, c. 900 BC; painted papyrus, from Thebes. H. 24 cm.

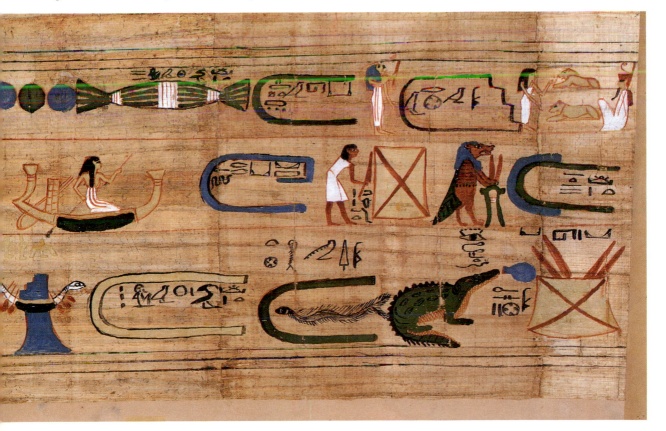

versions of the *Book of Breathing* could be written like letters on a single sheet to be folded and set under the chin or at the feet of the deceased. Similar short funerary texts of the early Roman Period include the *Book of Living Throughout Eternity*, and all these texts together form the last creative output of the Egyptian funerary tradition before it was replaced first by late Greek and then by Christian customs in which funerary texts no longer accompanied the body to the afterlife.

Coffins and Sarcophagi

The coffin was not merely a container for the mummy. It was the most important of the items of tomb equipment which were intended magically to protect the deceased and to ensure him safe passage into the afterlife. These magical associations, which developed and changed over the centuries, were responsible for the form of the coffin, its decoration and even the position it occupied in the tomb.

Coffins were not generally used in the burials of the Predynastic Period. The body was placed in a shallow grave and sometimes covered with skins or matting to protect it from the sand or filling of the grave. In the later Predynastic Period brick-lined graves roofed with logs were made, into which the body was placed wrapped in linen or in a wicker basket. Occasionally primitive

80. *Skeleton of an adult buried in a contracted posture in a basketwork coffin made from bundles of reeds. The burial was found in a subsidiary grave cut into the brickwork of a* mastaba *tomb at Tarkham. 1st Dynasty,* c. *3000* BC; *from Tarkham. L. of coffin 1.17 m.*

coffins of wood, clay or pottery were provided, but it was not until the Early Dynastic Period that a coffin became a regular part of the funerary equipment. No examples made for royal persons or high-ranking officials have survived from this period; people of lower status were buried in containers made of bundles of reeds, or in simple trays or wooden chests. These latter, the earliest true coffins, were designed to hold the body in a contracted position with its knees drawn up close to the face. Some examples reproduced the external form of the great *mastaba* tombs of the period, with vaulted tops and panelled sides. These design features were supposedly adapted from the appearance of the royal palace and may have symbolised the magical function of the coffins as 'houses' for the spirit. The British Museum possesses a wooden coffin of this type from Tarkhan, dating to the First Dynasty.

During the Old Kingdom it became increasingly common for the body to be buried with the limbs fully extended. Consequently a longer type of coffin was developed, though contracted burials in short coffins continued throughout much of the Old Kingdom. Two main types of 'long' coffin were used. The first had panelled decoration and a vaulted lid and was popular at the height of the Old Kingdom. The second, introduced in about the Sixth Dynasty, continued in use throughout the First Intermediate Period and the Middle Kingdom. It had a flat lid and smooth sides, and its religious significance is reflected in the manner of its positioning in the tomb and in its decoration. It was orientated with the head-end pointing north, the body inside being placed on its left side, the head often supported by a

80

81. Sarcophagus with vaulted lid and panelled decoration on the exterior surfaces. On one of the long sides small 'false doors' are represented at either end. There are faint traces of an inscription along the upper edge, deliberately obliterated in antiquity, perhaps with a view to reusing the sarcophagus. Probably 5th Dynasty, c. 2494–2395 BC. Red granite, from Giza. L. 2.25 m.

headrest. The deceased thus faced east, towards the part of the tomb where offerings were presented, and towards the eastern horizon where the sun – symbol of rebirth – rose each dawn. Standard iconographic features of the eastern wall of the coffin were a painted or inlaid pair of eyes, through which the deceased could look, and (on the inside) a false door to enable the spirit to pass in and out. Texts invoking Osiris and Anubis and other deities to provide the deceased with the basic necessities of existence, were inscribed in horizontal bands on the sides and the lid. Coffins of high-ranking officials were made from large straight planks of imported timber such as cedar. Those belonging to individuals of humbler status were generally made from small irregularly-shaped pieces of native wood, dowelled together in a patchwork fashion. A good example of this type is the coffin of Nebhotep, dating to the Sixth Dynasty or slightly later.

Old Kingdom rulers and their courtiers were buried in rectangular sarcophagi made from limestone, calcite (alabaster) and granite. These copied the forms of wooden coffins and could be either panelled or smooth-sided. The sarcophagus served as an outer receptacle into which the wooden coffin was placed at the time of burial. Possession of a stone sarcophagus seems usually to have been a mark of the king's favour in the Old Kingdom, and those who could not aspire to one had to be content with an outer coffin of wood. A fine red granite sarcophagus of the Old Kingdom, from the tomb of an official at Giza, is displayed in Room 25 at the British Museum. Passages from the *Pyramid Texts* and other funerary inscriptions indicate that, already during the Old Kingdom, both sarcophagus and coffin were symbolically equated with the body of the sky-goddess Nut. The deceased inside the coffin thus enjoyed the protection of the goddess, who is addressed in inscriptions as his 'mother'. This symbolic association also emphasised the deceased's identification with Osiris, the son of Nut.

From the end of the Old Kingdom, and during the First Intermediate Period and the Middle Kingdom, significant developments can be observed in the decoration and religious significance of the standard rectangular coffin. Formal developments in the exterior decoration included the appearance and multiplication of vertical inscriptions referring to various deities of the Osirian cycle, and the addition of false door motifs. At first only one false door appeared, painted below the 'eye panel'. From the middle of the Twelfth Dynasty it was often repeated on all the exterior faces, while the shape of the coffin sometimes copied that of a shrine, with a cornice and sloping roof. The interior decoration was gradually enriched with inscriptions and images, whose function was related to that of the decoration on the walls of tomb chambers in the Old Kingdom: notably

82. *Rectangular coffin of the lady Henu. The exterior decoration includes prayers for offerings and a large pair of eyes painted on the eastern side to enable the occupant to see the rising sun. 12th Dynasty, c. 1991–1786 BC; painted wood, from Beni Hasan. L. 1.85 m.*

the depiction of an offering table heaped with foodstuffs; a standardised list of funerary offerings; and the 'frieze of objects', a series of pictures of various commodities including clothing, jewellery, furniture, tools, weapons, amulets and royal insignia. These were to ensure that the deceased was well-equipped for the afterlife and to enable him, by means of the royal attributes, to be resurrected as Osiris, the Ruler of the Underworld.

In addition, the interior surfaces of many coffins were inscribed with religious texts designed to guarantee the deceased's well-being. On some early private coffins from the Memphite area these texts were copied directly from those in the pyramids of Old Kingdom rulers, but after the First Intermediate Period coffins made in all parts of Egypt were inscribed with extracts from the *Coffin Texts*, the heterogeneous collection of spells, deriving in part from the *Pyramid Texts*, with a variety of additions apparently of local origin. The *Coffin Texts* first occur in southern Egypt and are attested in non-royal burials as early as the Sixth Dynasty. Some coffins of high officials, such as those of Gua from Bersha in Middle Egypt include substantial extracts from the *Coffin Texts*. The floors of Gua's outer and inner coffins are inscribed with texts from the *Book of Two Ways*, a composition associated only with Bersha, which includes a map to assist the deceased in finding his way in the Underworld.

These changes in the decoration of coffins reflect developments in their religious significance. On early examples the exterior generally had only images and inscriptions whose main aim was to ensure for the deceased material benefits such as a 'good burial in the West' and funerary offerings. Hence the coffin fulfilled much the same role as the tomb. On the later coffins

the vertical inscriptions on the exterior and the more complex internal decoration were related closely to the rituals performed at the funeral, aimed at bringing about the deceased's resurrection through his association with creator gods, chiefly Osiris and Ra.

Stone sarcophagi continued to be used for royal burials during the Middle Kingdom, and were also provided for high officials. Both the plain and panelled types were used and occasionally, as in the case of those made for the wives of Mentuhotep II buried at Deir el-Bahri, the sides were decorated with scenes of daily life and offering texts. These examples are also of interest in that they were constructed from stone slabs, instead of being hewn from a single block.

During the First Intermediate Period and early Middle Kingdom there were changes in the manner of preparing the body for burial. The head was often covered with a painted cartonnage mask. The faces of these masks were standardised representations of the deceased, and a beard and moustache was often depicted on those of men. On examples of fine workmanship gilding was sometimes applied to the face. The first anthropoid coffins were introduced during the Middle Kingdom. Some of the early examples were made entirely of cartonnage, while others were of wood. In appearance they imitated a mummy wrapped in its linen bandages, wearing a mask and a bead-collar. The religious function of the anthropoid coffin was evidently to act as a substitute body for the spirit, in case the mummy perished (see tomb statues and early *shabtis*), and to reinforce the divine status of the deceased and his identification with Osiris, who was regularly shown as a mummified king.

During the Second Intermediate Period a new type of wooden anthropoid coffin appeared at Thebes. It was usually hollowed out of a tree trunk, and the workmanship was often mediocre. The face was framed by the royal *nemes* headdress (irrespective of the owner's rank) and the lid was painted with a feather design

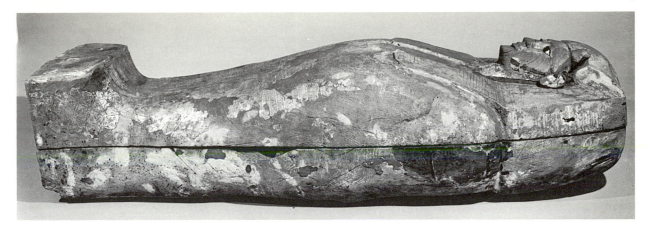

representing two large vulture-wings covering the front of the body. These are usually called *rishi* coffins (from *rishi*, the Arabic word for 'feather'). An exceptionally fine *rishi* coffin in the British Museum was made for a king Intef (perhaps Nubkheperre) of the Seventeenth Dynasty. The decoration of the lid is gilded and the eyes are inlaid.

In the New Kingdom the coffins of royal personages were decorated with a modified version of the *rishi* motif, representing the deceased sheathed in the plumage of a falcon or vulture. Early examples were made of gilded wood or cartonnage, but by the late Eighteenth Dynasty a king's burial equipment included an inner coffin of solid gold, nested within two others of gilded and inlaid wood. The coffins were housed in stone sarcophagi, the design of which changed with almost every new reign. Simple rectangular chests with flat lids were superseded by cartouche-shaped coffers and, after the reign of Akhenaten, by shrine-like chests with cornice-moulding and carved figures of protective goddesses at the corners. In the Nineteenth and Twentieth Dynasties kings were buried in multiple sarcophagi, the inner ones being in mummiform shape and inscribed with texts and representations from the *Underworld Books*. The finest surviving example is the calcite (alabaster) sarcophagus of Sety I, in the Sir John Soane Museum, London.

Non-royal coffins of the New Kingdom were generally made of wood. *Rishi* coffins and simple rectangular chests were still used in the early Eighteenth Dynasty, but during the reign of Thutmose III these were superseded by a new type of mummiform coffin which had been developed about two generations earlier. These were usually made from sycamore planks and were decorated with figures of protective divinities and bands of text. On early examples the background was painted white, but from about the middle of the Eighteenth Dynasty a black ground colour was the norm. The scheme of the external decoration owed much to that of Middle Kingdom rectangular coffins. The texts included ref-

83. Rishi *coffin of king Intef. The massive proportions and large royal headdress are typical of the coffins of the period. A uraeus and false beard (now missing) were originally attached to the head. 17th Dynasty, c. 1600 BC; gilded and painted wood, from Dra Abu'l Naga, Thebes.* H. *1.7 m.*

erences to protective divinities, notably the Sons of Horus and Anubis and Thoth, whose figures were regularly painted on the sides. Beginning in the Eighteenth Dynasty a figure of Nut, often with wings outspread in protection, became a standard design feature of coffin lids.

The black-painted coffins were replaced in the Ramesside Period by a new type, richly painted in bright colours on a yellow background. The representation of the deceased's arms crossed on the breast, which had occurred sporadically on Eighteenth Dynasty coffins, now became a standard feature, and the head was usually framed by an elaborate festal wig. Another innovation of this period was the placing of a cover of painted wood or cartonnage over the wrapped mummy in its inner coffin. Some of these 'mummy-boards' represented the deceased as a living person dressed in the costume of daily life, whereas others were decorated with religious texts and figures of deities in openwork. The richly gilded coffins and mummy-board of the lady Henutmehyt constitute a fine example of a complete burial ensemble of the Ramesside Period.

Stone sarcophagi were also made for some high-ranking officials during the New Kingdom. Both rectangular and anthropoid types were used, the latter becoming increasingly common in the Nineteenth Dynasty. The earliest are the sarcophagi belonging to the Viceroy of Kush Merymose, who served under Amenhotep III. The inner sarcophagus of black granite is finely sculpted, with texts and figures of protective deities, copying those of contemporary wooden coffins. Examples from the Nineteenth Dynasty were often rather roughly carved, as is the lid of the granite sar-

cophagus of Setau, Viceroy of Kush in the reign of Ramses II.

The stylistic traditions of the New Kingdom were maintained in the Twenty-first Dynasty, although economic necessity led the Tanite kings of the Twenty-first and Twenty-second Dynasties to be buried in reused sarcophagi of the Middle and New Kingdoms. Their coffins, however were original works, made to order. The inner mummiform coffin of Pasebakhaenniut I was of silver and retained the *rishi* motif and the crossed hands holding royal sceptres, which had been the norm for kings' coffins at least since the time of Tutankhamun. Non-royal persons were provided with an outer and inner coffin of wood, together with a mummy-board placed directly over the corpse. The exterior surfaces were densely covered with figured scenes, short texts and symbolic motifs. The decoration was normally painted in red, green and blue on a yellow background, and consisted chiefly of symbols of resurrection (the winged scarab-beetle and winged sun-disk occur frequently), depictions of the deceased offering to various deities, and scenes familiar from New Kingdom tomb-paintings: the judgement in the Underworld; the Hathor cow in the necropolis, and the deceased receiving sustenance from the goddess Nut standing within the branches of a tree. Several other vignettes belong to a new repertoire of religious images, which also occur on the funerary papyri at this period, and include scenes such as the creation of the world by means of the separation of Geb and Nut. Some of the images combine allusions to several different mythological concepts simultaneously. These developments seem to have originated at Thebes, at this time the centre of a virtually independent state controlled by the High Priests of Amun. In the course of this period it became customary for the insides of anthropoid coffins to be decorated. A large *djed*-pillar or figure of the Goddess of the West was regularly painted on the floor, and a *Ba* bird often appeared above the head of the deceased. Towards the end of the Twenty-first Dynasty the decoration of coffins of the Theban ruling elite began to include extracts from the *Amduat* and other design features taken from the royal funerary repertoire. These coffins are also distinguished by their very large floral collars and representations of the red leather 'braces' which were placed around the necks of mummies at the same period. The interior surfaces were very finely painted, often with figures of the deified king Amenhotep I and the deceased offering to deities.

At the beginning of the Twenty-second Dynasty coffin styles changed. Wooden mummiform coffins were made on a simpler pattern; the hands were usually not represented on the lid and the decoration was less rich, often consisting only of short inscriptions on the exterior and a figure of the goddess Nut painted full-face inside. The innermost case was usually a mummiform envelope of cartonnage, made in one piece, fitting closely around the mummy and laced together with string at the back. The surfaces of these cases were painted in brilliant colours on a white, yellow or blue background. A common design shows large falcons with outspread wings, embracing the body. The fetish of Osiris, associated with his cult-centre at Abydos, is regularly painted on the front of the cartonnages and another Osirian symbol, the *djed*-Pillar, is sometimes depicted on the back. Cases of this type have been found at many sites in Upper Egypt, and were even provided for the kings buried at Tanis. A remarkable innovation in the design of kings' coffins in the Twenty-second Dynasty was the substitution for the idealised human face mask of a falcon's head, probably representing the ruler as the manifestation of Sokar-Osiris.

Beginning in the late eighth century BC there was a steady change in the design of coffins, and by the beginning of the Twenty-sixth Dynasty many of the standard features of Third Intermediate Period coffins had disappeared. Cartonnages were replaced by anthropoid coffins of wood, representing the deceased as a mummiform figure standing upon a pedestal, with a pillar supporting the back. The paintings on the lid regularly included the figure of the goddess Nut, the deceased's judgement before Osiris or Ra, and a variety of protective deities. The inscriptions often included substantial extracts from the *Book of the Dead* and other funerary literature. One of the most important religious roles of the coffin at this period was to represent symbolically the entire universe, with the mummy of the deceased at its centre taking on the role of creator-gods such as Osiris and Ra, who were the chief agents of resurrection. The celestial associations of the lid were frequently emphasised by the painting of the sky-goddess Nut both inside and outside. The case, in which the mummy lay, symbolised the terrestrial regions in which the kingdom of Osiris was located, and hence was appropriately adorned with a large *djed*-pillar. Outer coffins were often of rectangular form, with a vaulted lid and posts at all four corners. This type is reminiscent of the shrine of a divinity and its iconography reflected the deceased's elevation to divine status through his identification with Osiris. From the Twenty-sixth Dynasty to the Ptolemaic Period stone sarcophagi became increasingly common in the tombs of high-ranking officials, particularly in the north of Egypt. These were frequently anthropoid, copying the general form of the contemporary wooden coffins, though on a more massive scale. The head was often disproportionately large. Rectangular or cartouche-shaped sarcophagi were also made. These had massive vaulted or bevelled lids and the surfaces were often covered with religious scenes and inscriptions. Of special interest are those of the God's Wife of Amun Ankh-

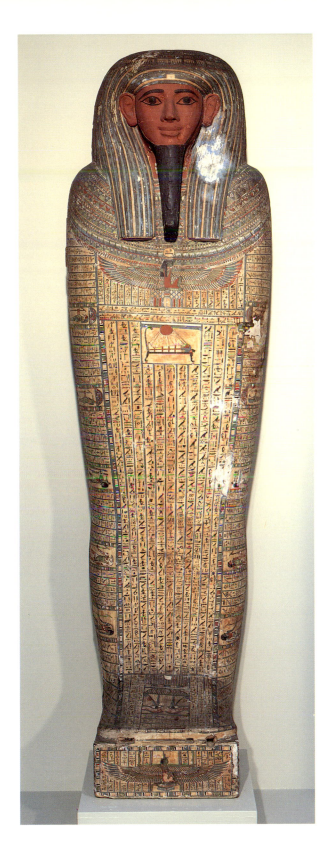

nesneferibre of the Twenty-sixth Dynasty and king Nakhthorheb of the Thirtieth Dynasty. The former is finely inscribed with texts from the *Book of the Dead* and *Pyramid Texts* as well as new compositions, and with low-relief representations of Ankhnesneferibre (on the lid), the goddess Nut (on the interior of the lid) and the goddess Hathor (on the bottom of the case). The sarcophagus of Nakhthorheb is rounded at one end and is inscribed with scenes and texts from the *Amduat*.

After the Twenty-sixth Dynasty the design of wooden coffins was simplified. The proportions of anthropoid coffins were changed, the head, wig and chest being deliberately enlarged, resulting in some very squat and ungainly forms. The pedestal supporting the feet remained a standard feature, appearing on outer as well as inner coffins. On coffins from Thebes and Akhmim the main elements of decoration at this period were a large collar, a winged scarab, sun-disk or figure of Nut, and a scene of the mummy on a lion-headed funerary bier. The coffins of the Theban priest Hornedjitef, who lived under Ptolemy III, illustrate the characteristics of this period. The massive outer coffin, with large face and wig, has decoration in yellow paint on a black background. The painted and gilded inner coffin is decorated inside with a figure of Nut and associated astronomical representations, while Hornedjitef's mummy was enclosed in a gilded cartonnage case and mask. Other coffins dating to approximately the same period, and found chiefly in Middle Egypt, have grotesquely enlarged faces and bodies, and simple painted figures of protective deities. They are often of poor workmanship and the brief inscriptions are filled with errors. A variety of cartonnage coverings was used between the Twenty-sixth Dynasty and the end of the Ptolemaic Period, including complete body-cases and composite groups comprising separate mask, collar, apron and footcase, decorated with short texts and figures of divinities. Bound captives were sometimes painted on the base of the footcases, so that the deceased symbolically trod his enemies underfoot. The rectangular type of coffin with corner posts seems to have survived throughout the Ptolemaic Period and into the time of the Roman domination. Among the latest-known examples of this type are the coffins of Soter, Archon of Thebes, and members of his family, which date to the second century AD.

In other centres, particularly in the region of the Fayum, new customs were adopted in the Roman Period, with the provision of plaster-heads and painted portraits

86

84. *Inner coffin of the priest of Montu Besenmut. Beneath the winged figure of Nut on the breast is the vignette of 'chapter 154' of the* Book of the Dead, *the 'spell for not letting the corpse perish'; the accompanying text appears in the central panel of inscription below. Early 26th Dynasty, c. 650 BC; plastered and painted wood, from Thebes. H. 1.88 m.*

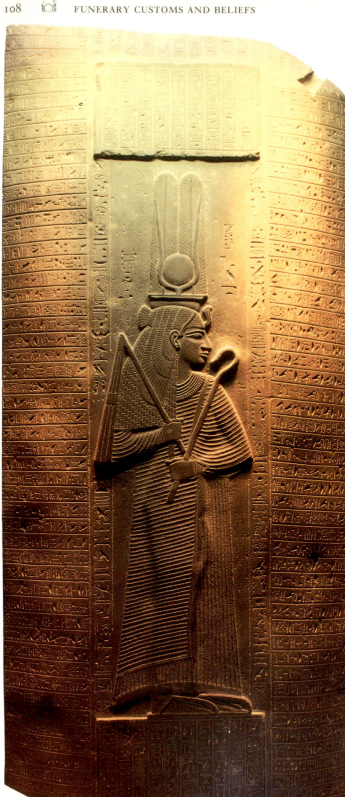

86. OPPOSITE *Portrait-panel from the mummy or coffin of a woman who is shown wearing a gold diadem, earrings and an elaborate necklace of gold and precious stones. Roman Period, 2nd century* AD; *painted wax on wood, from Rubbiyat.* H. *44.2 cm.*

85. *Lid of the sarcophagus of Ankhnesneferibra, last 'god's wife of Amun' before the Persian conquest of 525* BC. *She is wearing a pleated robe and the combined plumed headdress with solar disk and cow horns over a vulture headdress. 26th Dynasty, c. 550* BC; *basalt, from Thebes.* H. *2.6 m.*

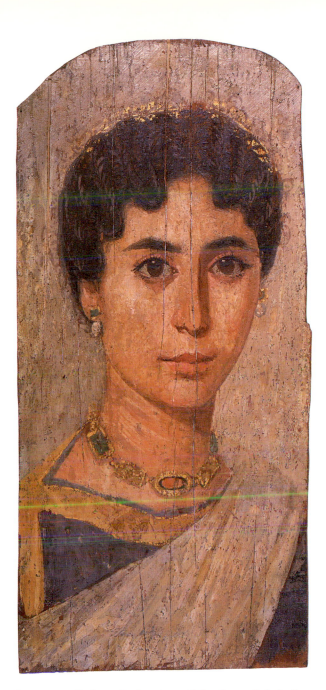

within the second and third centuries, and perhaps about a quarter of the number belong to the fourth century, about which time the practice of mummification was gradually abandoned in favour of simple interment of the dead in their everyday costume.

The early portraits are painted on thin panels of cypress, usually about 43 cm high and 23 cm wide, and no more than 1.6 mm thick, roughly trimmed to a point or arch at the top; they were placed over the face of the mummy and secured in position by the bandages. In later examples thicker panels are more usual, generally rectangular in shape and on average about 30 cm high and 20–23 cm wide. A smaller number of portraits painted on the linen shroud have survived, several of them representing young children.

Some of the portraits, particularly during the fourth century, were executed in tempera. The pigments, most of which were well known in the Dynastic Period, were mixed in water with the addition of an adhesive material, probably egg-white or gum, and applied with a brush, sometimes directly on the canvas, sometimes on a prepared ground of gypsum plaster or whiting (chalk).

Watercolours being easily damaged and the pigment affected by moisture or the action of the air, the medium chosen for the majority of the portraits was beeswax, to which the appropriate pigment was added in a coarsely ground state. It produced a more robust portrait with a luminosity and enrichment of colour reminiscent of modern oil-painting. The technique of painting in wax was already widely practised in the Hellenistic world, but it had not previously been employed in Egypt. The manner of painting is described by Pliny the Elder in his *Natural History*, XXXV. 31, 39, 41, where he uses the term 'encaustic'. So far as the mummy portraits are concerned, there seems to be no question of fusing wax on to the surface of the panel by the application of artificial heat; in the warm climate of Egypt it was possible to apply the wax in more or less liquid form by means of a brush, provided the work was quickly executed. The usual practice followed by the painter seems to have been first to outline the head and the features in black or occasionally red wash upon a prepared white background or directly upon the wood. He then filled in the background in grey, running his brush freely round the outline sketch and covering the remainder of the background with long, full, horizontal or slanting strokes. The drapery and hair were painted in the same way. In some cases the flesh received similar treatment, but usually the wax was applied more thickly. There is still considerable doubt concerning the manner in which this effect was achieved. The coloured wax may have been poured and modelled on the panel from the bowl of a warmed ladle or worked in a creamy state with a hard blunt point, perhaps a brush stiffened by constant use.

in a naturalistic style: in view of the date of their first appearance it is probable that the realistic element, which had always been a prominent feature of Roman sculpture, derives from Roman influence. The greater proportion of the painted portraits has been recovered from Hawara and Rubbiyat in the Fayum, and for that reason they are often referred to as 'Fayumic portraits'. Examples have, however, been found in a number of sites from Saqqara in the north to Aswan. The earliest examples date from the first half of the first century AD, the majority fall

Another possibility is that the wax was simply applied with a brush repeatedly over the same area.

In the earlier examples, the impressionistic handling of the paint and the suggestion of movement in the pose derive from the tradition of classical portrait painting of which the mummy panels are almost our only surviving examples. The subjects are drawn usually with the face turned slightly to the left or right but sometimes frontally. They are never in profile. Head, shoulders and the upper part of the breast are usually shown; examples executed directly on the canvas of the shroud might be full length. Gradations of the individual colour, the use of shading and of highlights, give the portraits a strikingly modern appearance; at close quarters the work looks casual; particularly noticeable are the heavy line of the eyebrows, the white streak down the nose, the thick red smear of the lips separated by a black line and the heavy shading under the chin. But from a distance of one or two metres these prominent features merge and blend with the background.

This tradition was still observed in the third century, but by the fourth there had emerged a different style in which there was a more formal geometrically balanced arrangement of the features and hair. The figures are almost invariably full-faced. The drawing is less assured, particularly around the mouth with its pursed underlip.

Both men and women are shown wearing the ordinary costume of daily life current throughout the Hellenistic world, consisting of a loose sack-like tunic, usually of linen but later also of wool, passing over both shoulders, with an opening for the neck and two projecting sleeves. The normal colour of the costume was white for men, and usually red, but also blue, green, and white, for women. It was decorated with two vertical bands (clavi) which in the eastern Mediterranean had no significance of rank. In the fourth century AD a coloured border appeared around the neckline of the tunic worn by women. One or two of these garments were worn. In portraits of the first and second centuries AD it was customary for men and women to be depicted with a loose garment of the same colour over the tunic, draped over either shoulder or wrapped around both. Women 86 are almost always shown with necklaces and ear-rings derived from models current in the Hellenistic world. The arrangement of the hair and beards of the men and the coiffure of the women follow closely the fashions set by the imperial family at Rome, and provide one of the clearest indications of the date of individual portraits.

Portraits painted on the canvas shroud of a mummy can only have been painted after death, and probably the portraits on thick panels of the later series were for funerary use only. The degree of individual characterisation of the best of the early first-century portraits suggests that they may have been studies from life,

intended in the first instance to be hung in the lifetime of the owner in the living-room of his home. It is, however, noticeable that in nearly every case the subject is portrayed in the prime of youth and beauty, features at rest with a look of calm and serene repose. The probability is that at least from the second century most portraits were painted after death, the painter reducing the wide range of subjects to a small number of well-defined types.

The plaster portrait head-pieces are found from the beginning of the Roman Period until the fourth century. The majority come from Middle Egypt; they were used concurrently with the painted panels. In the earliest type the head-piece was made hollow to fit over the mummy which lay level with the body and it might be secured by cords passed through holes in the base. Gradually the head-piece was raised at an angle to the neck, to give the appearance of a man awakening to the afterlife. The eyes were in the first place painted but from the second century translucent glass was commonly employed.

The emergence of the portrait masks is foreshadowed by the superimposing of naturalistic details on masks more or less in the Egyptian style, particularly in the treatment of the hair. The gold mask attached to the mummy of a young boy from Hawara is fashioned in the conventional way but an alien element is introduced in the realistic arrangement of the curly hair. In the fine mask of a woman, probably from Meir, the hair falls in two ringlets on either side of the neck, possibly representing a more naturalistic treatment of the ancient wig associated with goddesses.

The representations of the head-pieces, like the panel portraits, follow the convention of the fashions set by the imperial family. Generally speaking, however, the modeller of the masks did not succeed in conveying the individual likeness of a person to the same degree as the portrait painter. A notable exception, which must be one of the earliest of the realistic masks, is the head-piece 87 of a man found at Hu (Diospolis Parva) in Upper Egypt.

The graves of the mummies fitted with plaster head-pieces or painted portraits were seldom marked with commemorative stelae recording the names of the deceased. Private funerary stelae, however, continued to be used in the Roman Period; some are carved in a purely Egyptian style with representations of gods, below which there is a short conventional text in the hieroglyphic or demotic script: others, like a stone stela with a Greek epitaph in elegiac verse mourning the untimely death of the child Politta at the age of five, set between two columns supporting a gabled pediment, are in the subject matter of their texts and form of their decoration derived from Greek tradition. From the early Roman Period onwards, the two styles were intermingled; in the stela, of a type found in great numbers at Kom Abu Billo

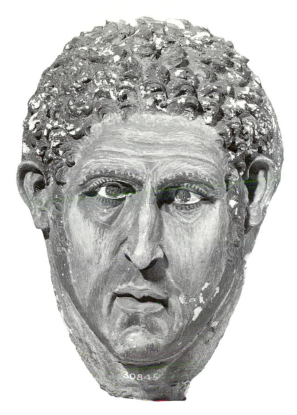

87. *Head piece from the mummy of a man, shown according to the convention of imperial Roman representation. Roman Period, 1st century* AD; *painted plaster, from Hu.* H. *25.4 cm.*

others over 3 m. The body might rest on a wooden board or be placed in direct contact with the sand. Only occasionally was there any form of prepared substructure, or the marking of the grave by memorial stones. Though in some cases there was a perfunctory attempt to embalm by the use of bitumen, generally speaking the preservation of the body was due to natural desiccation owing to the circumstances of the burial.

With the final abandonment of the painted wooden coffins, of the painted burial cloths, of the plaster headpieces, and the mummy portraits, the last lingering traces of the dynastic civilisation disappear. It is difficult not to connect the change in the mode of burial with a fundamental change in belief. There is no indication in the burials of what may have taken the place of the ancient belief in the kingdom of Osiris and the efficacy of mummification, but presumably the change was accelerated by the widespread adoption of Christianity throughout Egypt.

Private Tombs

Egyptian tombs consisted of two elements, the burial place itself and the funerary chapel, in which offerings for the sustenance of the deceased were presented. Normally, the sepulchre and the chapel were situated in close proximity to facilitate the receipt of the offerings by the spirit, or *ka*, of the dead individual. The earliest built offering places so far recorded date from the First Dynasty (*c.* 2900 BC) and were attached to small rectangular tomb superstructures at a site called Tarkhan near the Fayum. These chapels were modest structures comprising a simple room surrounded by thin walls of mud brick, but they were adequate to serve their purpose of providing a focal point where offerings could be left. From these prototypes a line of development can be traced to the very elaborate chapels of later periods. Wealthy tombs of the First Dynasty took the same basic form as their poorer counterparts, with a subterranean burial chamber covered by a rectangular superstructure of mud brick. At first the superstructures were surrounded on all sides with deep recesses in imitation probably of the facades of palaces and other great secular buildings of the period. Later the recesses were reduced in number to two, placed at the north and south ends of the eastern side. These recesses served as false doors, the southern one being made larger and more elaborate to act as an offering chapel. This recess gradually became deeper in later tombs, as part of a process by which it developed into the entrance to a multi-roomed chapel within the superstructure.

(Terenuthis), the deceased is represented clothed in Greek style reclining on a cushioned couch with right arm outstretched, holding in the hand a libation cup. The stela is given a mixed architectural setting with gabled pediment of the kind seen on Greek stelae set on two columns with lotus-form capitals peculiar to Egypt. In the background is the representation of the Anubis-animal. Similar stelae are found with the deceased standing, arms extended at right angles from the body and bent upwards at the elbow in the *orans* position.

In the fourth century AD, to judge from excavations at Akhmim and Antinoopolis, there was a radical change in the burial customs of the country. The dead person was buried in the worn-out garments of daily life consisting of one or two tunics and outer cloak of the type depicted in the mummy portraits and sometimes with cap, socks, leather belt, and sandals. Below the neck there might be a small crescent-shaped pillow of stuffed cut-leather. Hangings were sometimes wrapped around the body as a grave cloth. The depth at which the bodies were buried varied, some being just below the surface,

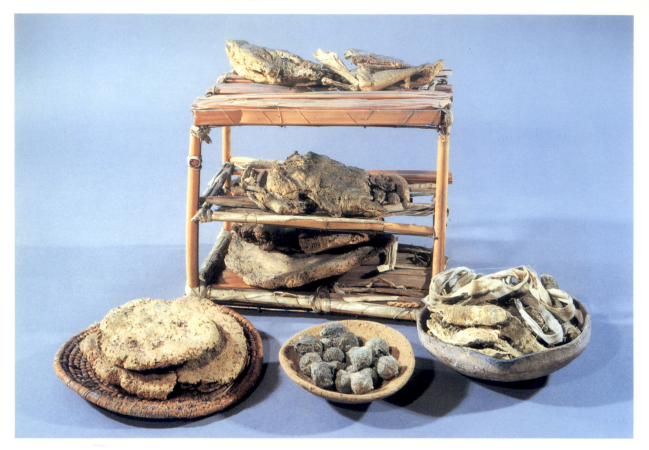

88. *Food offerings for the sustenance of the dead: bread and fowl on an offering-stand of reeds. 18th Dynasty, c. 1450 BC; from Thebes.* H. *of stand 21.8 cm.*

The early offering niches of mud brick tombs were sometimes equipped with a stone panel carved with a relief showing the tomb owner seated before a table piled with food offerings. This element survived as part of the decoration of the so-called false door stelae – slabs of stone cut in the style of doorways through which the spirit of the deceased could pass – which formed the focal point of the complex offering chapels of the late Old Kingdom. An example of an early stone slab from an offering recess is that of Rahotep, and numerous false door stelae are displayed in the galleries of the British Museum. The most elaborate of the latter is the large stela of the Fifth Dynasty from the tomb of Ptahshepses, which has intricate panelling on either side of the central door recess, but the simpler false door of Kainefer is more typical. These large stone false doors came from stone or brick *mastaba* tombs of wealthy individuals of the Fifth and Sixth Dynasties, chiefly from the Mem-

phite necropolis. In the earlier tombs, the false door was set into the east facade near the southern end, in the position formerly occupied by the primitive offering recess of Early Dynastic *mastabas*, but with the added refinement of an exterior chapel of two or three rooms enclosing the area around the stela. Subsequently, the chapel was constructed with many more chambers inside the superstructure and the false door was placed in the room designated for the offering ritual. By this stage, the rooms of the chapels in wealthy tombs were normally built of stone and decorated throughout in relief. This decoration includes scenes of daily life, although its true purpose was to sustain the tomb owner by the magical power of the representations to supply the food required for the afterlife. The whole emphasis of the decoration is consequently focused on food production and its presentation as funerary offerings to the deceased. Lists of offerings with the quantities to be supplied were included in the inscriptions on the walls of the chapel. These representations of food were really only a reserve supply; ideally the relatives of the deceased, or employed mortuary priests, were supposed to bring offerings to the chapel on a regular basis. The provision of offerings was central to the survival of the tomb owner in the next

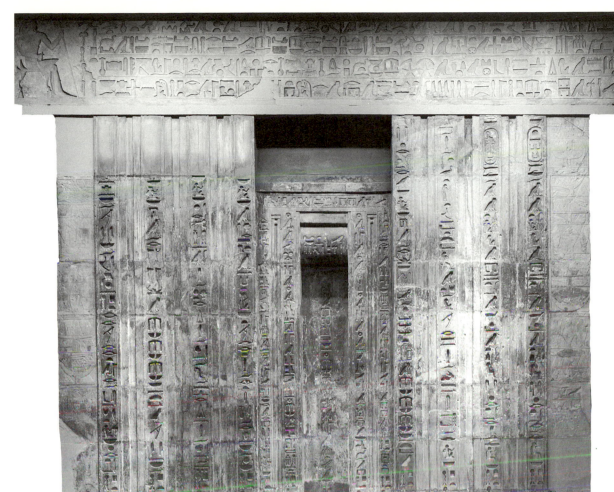

89. *Tomb stela of the 'false door' style, made for the official Kaihap. 5th Dynasty, c. 2400 BC; limestone, from Saqqara.* H. *2.07 m.*

world, and it continued to be a feature of Egyptian funerary practice throughout the history of ancient Egyptian civilisation.

During the late Old Kingdom it became customary for high local officials, the nomarchs, to be buried in their provincial localities and not in the neighbourhood of the royal pyramid. In many places throughout Upper Egypt these cemeteries consisted of rock cut tombs hewn in the cliffs bordering the Nile. In such tombs no superstructure was built, but both the chapel and the actual burial chamber were excavated in the rock, the former being at a higher level and connected to the sepulchre by a vertical pit or sloping shaft. The tombs of important officials were often provided with elaborate facades, approached in certain cases by causeways or ramps from the foot of the cliff. Once established the rock-cut tomb remained in regular use in the south, and fine decorated chapels of the First Intermediate Period and Middle Kingdom were constructed at Beni Hasan, Bersha, Qaw and other localities. The cemeteries in the Memphite region retained the traditional tomb style of the *mastaba* chapel, descended from the Old Kingdom.

Middle Kingdom burials were frequently equipped with wooden funerary models representing items of food or domestic utensils, as an alternative form of provision for the dead. Model substitutes of funerary equipment were used from the First Dynasty, but now much more elaborate models were developed, showing workers

involved in various forms of food production, such as baking, brewing or butchery, and also in other activities including carpentry and brick-making. All these activities had been depicted on the chapel walls of the Old Kingdom; the use of models was simply a different manner of using magic to sustain the deceased with all the requirements of life. More humble burials of Middle Kingdom date were often equipped with pottery model houses with offerings represented in their forecourts, the whole intended to provide a home and sustenance for the *ka* of the deceased.

From the rise of the Middle Kingdom the focal point of the offering chapel was more often a round-topped stela than the older False Door panel, although the latter was never completely discarded. The stelae of the period were usually carved with a relief of the tomb owner receiving offerings, accompanied by the appropriate formulae in which the name and titles of the deceased are listed. In some cases an account of the career of the dead person might be included. The round-topped stela continued in common use for private tombs down to very late times.

Private tombs of the New Kingdom continued the tradition of rock-cut chapels in Upper Egypt, but the wealthy tombs of the Memphite necropolis adopted a different pattern, consisting of a built mortuary chapel on the desert surface not dissimilar in plan from a small temple, with pillared courtyards and roofed halls leading

90. Model house for funerary purposes showing typical features of village houses such as the small window, roof ventilator and stairway to the roof. In the courtyard are shown food offerings for the benefit of the deceased. Middle Kingdom, c. 1900 BC; pottery, H. 17.3 cm.

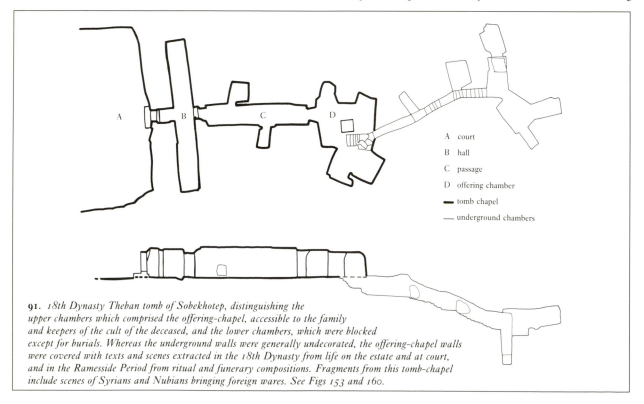

A court
B hall
C passage
D offering chamber
▬ tomb chapel
— underground chambers

91. 18th Dynasty Theban tomb of Sobekhotep, distinguishing the upper chambers which comprised the offering-chapel, accessible to the family and keepers of the cult of the deceased, and the lower chambers, which were blocked except for burials. Whereas the underground walls were generally undecorated, the offering-chapel walls were covered with texts and scenes extracted in the 18th Dynasty from life on the estate and at court, and in the Ramesside Period from ritual and funerary compositions. Fragments from this tomb-chapel include scenes of Syrians and Nubians bringing foreign wares. See Figs 153 and 160.

to a central offering-room. The superstructures beside such chapels could take the form of small pyramids, as were also used at this period above the rock-cut chapels in the great necropolis on the west of Thebes in Upper Egypt. The burial chambers of the Memphite tombs were situated underground at the base of rock-cut shafts. The fine stela of the General Horemheb, with two other reliefs comes from one of the grandest tombs of this kind at Saqqara. The rock-cut chapels of Thebes were designed around a basic plan consisting of a transverse entrance chamber and a short corridor which led to the offering area containing a statue or stela. The burial chamber was reached by a shaft or descending passage from inside or outside the chapel. The special interest of the Theban chapels lies in the painted and relief decoration found on the walls, which contains some of the finest representations of daily activities. Information on the life and career of the deceased was incorporated in the texts which accompanied this decoration, supplemented by the inscriptions on the stela at the back of the chapel.

During the Late Period the wealthiest private burials were made in very elaborate versions of mortuary chapels, good examples of which survive at Thebes in the funerary monuments of the priestly officials Mentuemhat and Padiamenipet. These tombs had vast superstructures of mud-brick standing above decorated underground burial chambers of considerable extent, the texts on the walls being borrowed from the royal funerary inscriptions of earlier periods. At Memphis, tombs of this period probably had substantial chapels above ground, but these have generally not survived and only the burial chambers at the bottom of deep vertical shafts remain, inscribed with extracts from the *Pyramid Texts*.

The Ptolemaic and Roman Periods were an age during which many burials were made in economical fashion by reusing older tombs, although considerable labour was expended on the preparation of stone sarcophagi for certain wealthy individuals. Poorer burials were placed in simple graves, often in the vicinity of older tombs in the desert cemeteries. The ancient tradition of a tomb-chapel as the focus for the bringing of offerings to the dead began to decline, to be extinguished by the spread of Christianity from the third century AD.

Royal Tombs

As early as the late Predynastic Period, certain tombs can be identified as having belonged to individuals of high status, presumably the chiefs of local districts. The clearest example is the so-called 'Painted Tomb' at Hieraconpolis in Upper Egypt, which had elaborate painted decoration over the plastered mud brick lining of the grave pit. In other respects, however, the grave was very similar to many private burial-places of the period, consisting of a rectangular pit subdivided by a short cross-wall. In later times the style of the Egyptian royal tomb was to diverge markedly from that of private sepulchres, reflecting the distance between king and populace.

At the beginning of the history of the unified Egyptian state the tombs of the kings were built at Abydos and consisted of much larger brick-lined pits than had occurred previously. In some cases the space within the pit was subdivided into separate chambers by brick partition walls, or by wooden panelling, and expensive timber was used to form the roof. The superstructures consisted of low, square *mastabas* marked by stone stelae inscribed with the royal name, an example being the granite stela of king Peribsen in the British Museum. Throughout the First and Second Dynasties the tombs grew in size and complexity, and gradually stone elements were introduced into the architecture. At least two of the Second Dynasty kings were buried at Saqqara instead of Abydos, in tombs with long underground substructures cut into the rock.

A dramatic change occurred in royal tomb design in the Third Dynasty with the construction at Saqqara of the Step Pyramid tomb for king Djoser. The pyramid and the whole complex of funerary buildings associated with it were built of stone, the first large stone monument to be constructed anywhere in the world. The pyramid rises in six steps to a height of about 60 m and shows evidence for several phases of enlargement, so that in its final stage it was rectangular in plan, approximately 125 m from east to west and 110 m from north to south. Beneath the pyramid are the burial chamber and a network of passages and small chambers used for funerary equipment and for burials of members of the royal family. At the south end of the great enclosure which surrounds the complex is a great *mastaba* beneath which is a duplicate set of chambers reproducing those immediately connected with the burial chamber beneath the pyramid. The walls of some of these rooms were decorated with blue glazed composition tiles, arranged to represent primitive hangings of reed matting, and fine low reliefs of king Djoser performing various religious ceremonies. On the north side of the pyramid was a mortuary temple – the equivalent of the chapel of a private tomb – for the cult of the dead king and the presentation of food offerings. The whole complex was intended to provide for the dead king a setting in which he could fulfil his function as a monarch after death and it is possible that it contained in its plan elements characteristic of the royal palace at Memphis.

The step pyramid form was used by the later kings of the Third Dynasty, but it was then superseded by the true pyramid, which was used by kings throughout

the Old Kingdom and during the Middle Kingdom. The transition from stepped to true pyramid is demonstrated by the architecture of the pyramid at Meidum, which was enlarged successively from a pyramid with six steps to one with eight steps and finally to a true pyramid. This monument was probably built for king Sneferu at the beginning of the Fourth Dynasty, but two other pyramids built by the same king at Dahshur were designed from the outset as true pyramids. Not long afterwards, the apogee of pyramid construction was attained by Khufu, the son and successor of Sneferu, with the building of the Great Pyramid at Giza. This was constructed from locally quarried limestone with an outer casing of finer stone from Tura on the east bank of the Nile. Its four sides were almost identical in length, having been originally about 230 m long: its height when complete was 146 m. From the illustration, it can be seen that two changes of plan were made in the position of the burial chamber. At first a subterranean chamber was excavated at the end of a long descending corridor. Before it was completed it was abandoned and a second chamber prepared within the masonry of the pyramid; this chamber has erroneously been called the Queen's Chamber. For some reason it was later decided to prepare another room for the burial and the so-called King's Chamber was constructed at a higher level, approached by a gallery of majestic proportions. The King's Chamber is built of granite and its roof is relieved of the weight of the pyramid mass above by five cell-like chambers.

On the east side of the pyramid was a mortuary temple, connected by a long causeway to the Valley Temple on the edge of the cultivated land. The latter building was the reception-point for the body of the dead king. The pattern of a mortuary temple, causeway and Valley Temple on the east of the pyramid remained standard in all later pyramids. Although a very large pyramid was constructed for king Khafra of the Fourth Dynasty, subsequent pyramids were inferior in size and construction. During the Fifth and Sixth Dynasties the royal pyramids were built with a large element of rough internal masonry, although the construction of the associated temples was lavishly executed. From the time of king Unas, last king of the Fifth Dynasty, the internal chambers of the pyramids were inscribed with the magical formulae known as the *Pyramid Texts*.

A dramatic change in the form of the royal tomb came with the construction at Deir el-Bahri on the west bank of the Nile at Thebes of the mortuary complex of Nebhepetra Mentuhotep II, the king of the Eleventh Dynasty who reunited Egypt after the divisions of the First Intermediate Period. In plan this structure was original: the mortuary temple was built on a raised terrace and embodied a podium bearing a small square *mastaba* superstructure, surrounded by colonnades. At the end of a long corridor lay the proper tomb beneath the cliffs; under the *mastaba* was a cenotaph approached by a tunnel from the forecourt. The temple was connected with a valley temple by a long open causeway. This type of

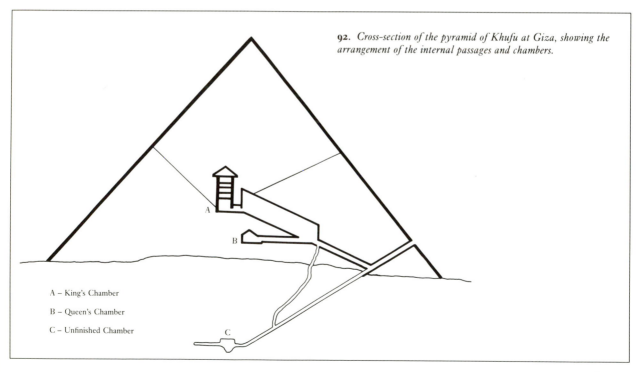

92. *Cross-section of the pyramid of Khufu at Giza, showing the arrangement of the internal passages and chambers.*

A – King's Chamber

B – Queen's Chamber

C – Unfinished Chamber

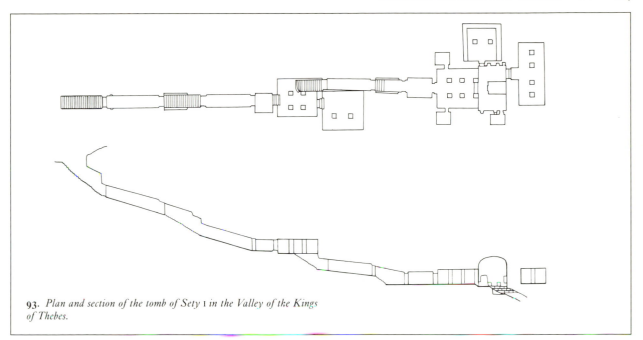

93. *Plan and section of the tomb of Sety* I *in the Valley of the Kings of Thebes.*

tomb was also planned for king Mentuhotep III, but never finished. During the Twelfth Dynasty the kings established their capital in the north and returned to the pyramidal form of tomb characteristic of the Memphite necropolis. The pyramids of the time were, however, inferior in size and construction to those of the Old Kingdom, some examples being built of mud brick within a stone casing. Great care was taken, however, over the construction of the internal chambers in these pyramids, the work being executed with extreme accuracy in the hardest of materials. In certain cases the arrangement of the passages was deliberately complicated, with corridors on different levels, accessible only through concealed entrances. The purpose of these measures was to protect the burial from plunderers, but in no case were they wholly successful.

Royal burials in the Second Intermediate Period continued to be made in pyramids; the few surviving examples in the Memphite region show a continuation of the style of the Twelfth Dynasty. At Thebes there were modest royal pyramids of mud brick, as superstructures above rock-cut burial chambers, but only scant traces have survived. The problems of achieving security for pyramid tombs led to their abandonment at the beginning of the Eighteenth Dynasty. From the reign of Thut-

mose I, throughout the New Kingdom, kings were buried in rock-cut tombs in the Valley of the Kings, lying in the hills on the west bank of the Nile at Thebes. These tombs consisted of a series of corridors and rooms, extending far into the rock, their walls richly decorated with scenes and texts from various funerary compositions describing the journey of the sun-god through the Underworld. The location of these tombs necessitated the separation of the burial places from the mortuary chapels, which were constructed in the style of complete cult-temples some distance away on the edge of the cultivated land.

The Valley of the Kings remained in use as a royal necropolis until the end of the Twentieth Dynasty, but royal tombs known from later periods were built in more economical fashion inside major temple-complexes of the Nile Delta. Certain kings of the Twenty-first and Twenty-second Dynasties were buried in subterranean chambers in the temple of Amun at Tanis, with brick-built mortuary chapels situated directly above them. Similar burials may have once existed in other Delta centres, particularly at Mendes and Sais, but the royal tombs of the Late Period, together with those of the Ptolemies which once existed in Alexandria, have never been found.

5

LANGUAGE AND WRITING

The ancient Egyptian language belongs to a wide family of languages spread across Saharan Africa and Western Asia; this Afro–Asiatic language group includes languages still spoken today in north Africa (Berber, Chadic) and the Near East (Arabic, Hebrew), but Egyptian is today a dead language which finds limited use in church services of the Egyptian Christian community. For a thousand years Egyptians have spoken Arabic in the wake of the Arab conquest of AD 642. Some words in Egyptian are close to north African and Western Asiatic (Semitic) words, as the following selection demonstrates:

EGYPTIAN	NORTH AFRICAN	SEMITIC
mwt 'to die'	*emmet* (Berber)	*mwth* (Hebrew)
ḥsb 'to count'		*hasaba* (Arabic)
ḏbꜥ 'finger'	*giba* (Bedja)	*isba* (Arabic)
nfr 'good'	*nefir* (Bedja)	
šms 'to follow'	*simis* (Bedja)	
gm 'to find'	*egmi* (Tuareg)	

Since words from both African and Asiatic sides of the family occur in Egyptian, it seems likely that the Egyptian language took form before the African and Asiatic sides began to develop to their present separate groupings. In the New Kingdom a number of Semitic words, such as *ym*, 'sea', enter the Egyptian language as loanwords, and are distinguished as foreign by a special system of spelling in the hieroglyphic script known as 'syllabic orthography'. In the Christian period a large number of Greek words were borrowed in translation of Biblical texts from Greek into Egyptian and became a standard part of the language.

Egyptian is known from texts spanning four thousand years, from about 3000 BC to the late first millennium AD when Arabic took over as the spoken language. During this time it went through five distinct stages: Old Egyptian (Old Kingdom), Middle Egyptian (Middle Kingdom), Late Egyptian (New Kingdom and Third Intermediate Period), demotic (Late Period to Roman Period) and Coptic (Christian period). Middle Egyptian was regarded after the Middle Kingdom as the classical language appropriate to royal and religious texts; with Old Egyptian it differs from Late Egyptian, demotic and Coptic much as Saxon differs from modern English or Latin differs from modern Romance languages, i.e. it is a synthetic language with inflected word endings as opposed to an analytic language with articulated elements. For example, Old and Middle Egyptian can express the phrase 'I live' in one word, *ꜥnḫ.ỉ*, where Late Egyptian must break it down into separate elements much as English does to give three words, *ỉw.ỉ ḥr ꜥnḫ* (literally from Middle Egyptian 'I am upon living'). In its treatment of verbs Egyptian concentrates, unlike English, but like Semitic as well as Slavonic and Celtic

94. OPPOSITE *The stela of Hor and Suty, two brothers, who were Overseers of Works of Amun in Thebes under Amenhotep III. The frame is inscribed with invocations for funerary offerings; the central area shows the brothers offering to Osiris and Anubis, above twenty-one lines of a hymn to the sun-god. The names and figures of Hor and Suty have been deliberately defaced. 18th Dynasty; grey granite, from Thebes.* H. *1.45 m.*

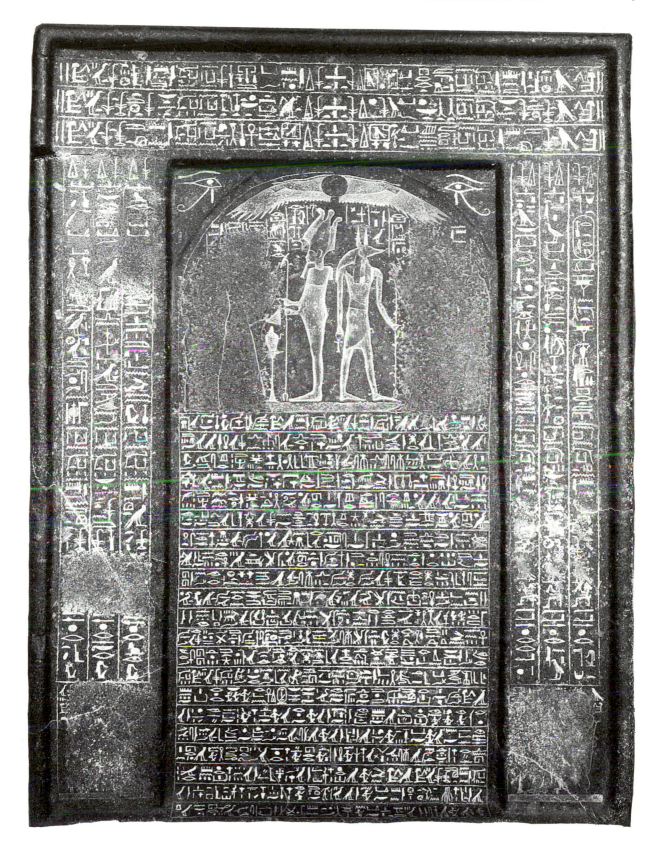

languages, not on tense (past, present and future, i.e. when something happens) but on aspect (imperfective, perfective, i.e. whether something is finished or still going on). A part of its value for linguists lies in its unique position; it is the only language of aspect that has moved within its recorded history from synthetic to analytic phase, giving rise in Late Egyptian and Coptic to the unusual 'second tenses' of verbs that seem to place the emphasis on the words at the end of a sentence.

We know of the history of the language only because it was written and the writing has survived. Writing appears to be one of several features that appear in Sumer shortly before they emerge in Egypt; the other features are artistic, ranging from macehead types to niched brick architecture to a few motifs in scenes. Writing may have arrived in Egypt from Mesopotamia by direct contact with seafaring merchants travelling around the Arabian coast, but as yet the evidence takes Sumerian traders no farther than the Persian Gulf; it is possible that the idea of writing came by land over Syria-Palestine, perhaps indirectly. The two systems of writing, Sumerian cuneiform and Egyptian hieroglyphs, differ in important respects, most notably in that Egyptian hieroglyphs give only consonantal sound value whereas Sumerian cuneiform signs give syllabic value (one consonant plus one vowel for each sound-sign). However, the two scripts share the method of representing a word by combining signs to represent sound with signs to represent meaning; the meaning-signs come at the end of a word, and help to mark each word apart from the next in the absence of punctuation. Like Semitic languages Egyptian has many groups of words formed from a root of (usually three) consonants, and the meaning-signs allow the reader to distinguish between words that share the same consonants but differ in meaning. The script is thus ideally suited to its language, just as Sumerian cuneiform is ideally suited to represent Sumerian (not so well to write languages from other families such as Semitic or Indo-European, neither of which are syllabically constructed; see the table of hieroglyphs).

Hieroglyphs were abandoned in the fourth century AD not because they were less able to represent Egyptian but because they belonged to the non-Christian heritage of Pharaonic Egypt and were considered idolatrous and therefore unusable for writing Christian texts; after the fourth century AD Egyptian was written not in hieroglyphic or its cursive forms, hieratic and demotic, but in Greek capital letters with six additional letters derived from demotic, making a derivative Greek script known as Coptic. In the absence of punctuation and meaning-

𓄿	ꜣ	glottal stop	𓈖	n	𓎡	q	as q in queen	𓋴𓅱 sw	plants	
𓇋	ỉ	ꜣ or i	𓂋	r	𓎡	k		𓌻 mr	copper or bronze	
𓇋𓇋	y		𓉔	h	𓎼	g	as g in good	𓄔 sḏm	sun, time	
𓂝	ꜥ	deep guttural, Semitic ꜥayin	𓎛	ḥ	stronger h	𓏏	t	𓋹 ꜥnḫ	cloth	
𓅱	w		𓐍	ḫ	as ch in loch	𓍿	ṯ	as t in tune	man, occupation, name	book (papyrus roll), abstracts
𓃀	b		𓄡	ẖ	softer ḫ	𓂧	d		people	
𓊪	p		𓋴	s	originally as z	𓆓	ḏ	as d in dune	senses	ꜥnḫ 'to live'
𓆑	f		𓏤	s	originally as ss	𓂋𓅱 rw		motion	sḫrw 'plans, condition'	
𓅓	m		𓈙	š	as sh in ship	𓈍 ḥꜥ		animal (-skin)	ym 'sea'	

signs Coptic is in fact more ambiguous and difficult to read than hieroglyphic texts; the introduction of the alphabet is in Egypt a step backwards rather than a mark of progress in writing and communication, and is entirely due to religious rather than practical considerations.

Hieroglyphs took shape in about 3000 BC and reached canonical form at the start of the Old Kingdom. The word hieroglyph comes from the Greek *hieros*, 'sacred', and *gluptein*, 'to carve in stone'. They share the history and rules of Pharaonic formal art, indicating that they were intended to capture a reality to be preserved for eternity. In contrast to cuneiform and other scripts hieroglyphs never lost pictorial character and their aesthetic connection went beyond the form of the signs to include the groupings of words and the combination of text and images; some nineteenth-century European writers speak of 'hieroglyphic art' which aptly sums up the unity of script and image, with images as, in one sense, large hieroglyphs and hieroglyphs as small images. From the Old Kingdom the hieroglyphs were reserved for sacred texts, particularly carved in stone to last for eternity. Other matters such as accounts and letters were written in a cursive form that allowed swifter writing; this cursive form is known as hieratic, from a Greek word for 'priestly', because it was used like the hieroglyphs only

for religious texts in the Late Period when the Greeks were in Egypt (a rare exception is a hieratic literary text, but that may come from a temple library). Hieratic varied according to the type of text, with careful calligraphy for more self-conscious texts, pre-eminently literary or religious, and very cursive shorthand for rapid writing, particularly for legal records and administrative accounts of a more temporary nature. Private letters exemplify the range of handwriting, often starting neatly and degenerating into a rapid scrawl by the bottom of the page. The main difference between hieroglyphic and hieratic writing is the joining of signs to form abbreviated pairs or groups (ligatures) in the cursive script.

In the Twenty-fifth Dynasty the calligraphic and shorthand branches of cursive writing had diverged so far that they form two separate scripts, known in Egyptology as hieratic and 'abnormal hieratic'; 'abnormal hieratic' is the shorthand used for administrative documents

95

111, 112

95. *A sheet of the Great Harris Papyrus. The long roll provides a list of temple endowments throughout Egypt under Ramses* III, *drawn up by his son Ramses* IV *after his father's assassination. The text concludes with a historical section in which the dead king addresses the commanders and regiments of Egypt: 'Listen and I shall inform you of the excellent things I did while I was king of the people'. 29th Dynasty; papyrus, from Thebes.* H. *42.5 cm.*

96. *Demotic 'double document' recording a loan of wheat and barley with a précis of the text under seal to prevent alteration of the amounts. Ptolemaic Period, 194 BC; (dated to the reign of the native rebel Pharaoh Ankhwennefer); papyrus, from Thebes. H. (sealed) 23 cm.*

96, 110 at Thebes, and it was replaced in the Twenty-sixth Dynasty by a new standardised shorthand called demotic that had probably developed separately in Lower Egypt at the same time as 'abnormal hieratic' in Thebes. In the Late Period, hieroglyphs were known as 'words of god', reflecting their consistently religious role, while the cursive demotic was called 'script for documents'. It is not known if the same distinction was drawn earlier between hieroglyphs and the earlier cursive hieratic used for documents, but it seems likely that no difference was made because finely written hieratic could be used from at least the Middle Kingdom for religious texts.

Only a tiny minority could read and write in Egypt, and scribal work was seen in Egyptian literary texts as the opposite of manual labour, a social division found in every culture with literacy. In Egypt writing meant state service and brought with it state income. The *Instruction of Khety* points to the hardship of all manual professions and exhorts the scribal apprentice to learn to write because 'Renenutet [the goddess of abundance] is engraved on his [the scribe's] shoulder from the day he is born'. However, most scribes did not learn to read hieroglyphs, a sacred script confined to works of art in offering-chapels and temples; instead they began with

109

the cursive hieratic (and later demotic) to be used in routine tasks of calculating accounts, recording legal procedures and writing letters.

The equipment of the scribe forms the hieroglyph for 'writing' and connected words; it consists of a rectangular case or palette for cakes of pigment and reeds, a pot of water for wetting the pigment, and the reeds themselves (of the plant *Juncus maritimus*). Most palettes were rectangular pieces of wood, about 20–43 cm long by 5–8 cm wide and 1.5 cm deep; shallow circular cavities held the pigment at one end and many examples have a long central slot for the reeds, which are usually 15–25 cm long. The scribe cut and bruised one end of the reed to maximise absorption of pigment; to write he moistened the cut end with water and brushed it over the cake of pigment, much as a watercolour artist works with paints. Reeds with split ends like the nib of the modern pen are not found in Egypt before the third century BC. The plant used for reeds with split nib was the *phragmites aegyptiaca* and it produced a finer line that gave hieroglyphs and hieratic an awkward crabbed appearance that is the hallmark of Roman Period writings in those two scripts. The most common pigment was carbon black with highlighted sections such as headings and dates sometimes in red made from ochre. Ink with lead was not used until the Ptolemaic Period and even then it seems to have been used only by scribes writing Greek, with the demotic part even of the same document being written in the traditional carbon. The act of writing was itself like painting, with hand raised above the writing surface as in Chinese and Japanese calligraphy; the word for writing, *sš* (or *sḫ*), also denoted painting and drawing outlines for artistic compositions. The scribe wrote either standing or sitting on a mat with legs folded and reeds tucked behind the ear ready for use. The text was written from right to left, until the Twelfth Dynasty in vertical columns, afterwards mainly in horizontal lines; hieroglyphic texts can be read left to right only where this provides symmetry with another text so that both read toward the central axis of the hieroglyphic monument, and this never occurs with hieratic or demotic texts.

Various materials could be used for writing letters and documents. Where available, as on the West Bank at Thebes, small flakes of limestone provide a fine white

97. A scribe's palette. It is inscribed with a titulary of the reigning king: 'The perfect god, Lord of the Two Lands, Nebpehtyra ...' (Ahmose 1). The palette has a slot for several reed pens, and depressions for two cakes of ink, usually red and black. 18th Dynasty; wood. H. 28 cm.

surface on which both black and red stand out clearly, and pieces of broken pottery could also be used for recording short texts, although they do not show up red well. These limestone and pottery fragments are called ostraca by Egyptologists, and were used for any temporary recording, from informal letters to legal records to excerpts from literary texts; they could be used in the first stage of drafting longer accounts, but were not themselves suitable archival material for longer term storage, because they are irregular in shape and therefore difficult to store in a manner that allows access for consulting the contents. Also temporary in nature, although occasionally used as final version of a text taken to the next world among the gravegoods of a person, are the wooden boards covered in a thin slip of white plaster. These writing boards could be wiped clean and reused, and provided a scribe with a convenient surface for replaceable accounts and calculations as well as literary texts to be practised for good handwriting, spelling and moral instruction. Linen sometimes occurs as a writing surface, but only in a funerary context, and tends to suffer distortion of the text when the fibres of the textile stretch or become displaced over time; the most common occurrence of writing on linen is the use of the funerary shroud in the early Eighteenth Dynasty and the mummy-bandages in the Thirtieth Dynasty as a surface upon which to record chapters from the *Book of the Dead*. The two most common surfaces for writing in hieratic were leather and papyrus. Dressed leather and vellum were used particularly in the Second Intermediate Period and Eighteenth Dynasty, sometimes for administrative records (for example a legal record now in Berlin) but predominantly for library texts. Although several texts refer to leather rolls kept in temple libraries these rarely survive, but the British Museum houses one literary text, two *Books of the Dead* in hieroglyphs, and most curiously one mastercopy of the *Book of the Dead* that was taken over by a man called Nebimes for his own burial.

14, 98

106

Papyrus was at all periods the typical writing surface. The Greek word papyrus presumably comes from an Egyptian term (possibly *pa-per-aa*, 'material of Pharaoh') and is the origin of our word paper. Egyptian papyrus was from the stem of the flowering marsh plant *Cyperus papyrus* which died out in Egypt after the Roman Period. The hard outer fibres were peeled away from the stem and used for basketry, matting, sandals and rope, while the pithy inner fibres were cut into strips never more than 50 cm high (the *Book of the Dead* of Nestanebetasheru in the British Museum is made of sheets of 49.5 cm). Strips were laid out side by side, and then a second layer was placed over them at right angles. The two layers were beaten together, and the natural juices in the plant provided enough adhesive material to bind the fibres together; the resulting sheet gave a smooth light-coloured writing surface.

Individual sheets, about 48 cm by 43 cm at full size, could be joined together to create long rolls; the oldest roll is one found in the tomb of the First Dynasty minister Hemaka at Saqqara (now in the Egyptian Museum, Cairo). The Hemaka roll shows that papyrus could, at the beginning of Pharaonic history, be made to the same standard as in later periods. The roll remained the natural form of 'book' until the Roman Period when the continuous roll was superseded by the codex, a set of individual sheets bound in the manner of the modern book. The roll tied by string was the hieroglyphic sign for anything connected with writing, including any abstract ideas that could be described but not portrayed, such as *shr*, 'plan' or *snb* 'health'. Although the longest roll, the Great Harris Papyrus in the British Museum extends to 41 m, the different 'pages' rarely have identifying numbers; the great medical text Papyrus Ebers in the University Library, Leipzig is one exception, and another is the *Book of the Dead* of Tui (part in the Museo Civico Archeologico, Bologna, another part in the British Museum), both of Eighteenth Dynasty date. Full-height documents are rare and confined to products of the royal chancellery such as the Great Harris Papyrus. More commonly the sheets were cut into two, to give half-height, or four, giving quarter-height. Letters and short funerary texts or charms could be made from single quarter-size sheets or smaller pieces. Papyri could be kept in leather bags or, for greater protection, in wooden caskets or pottery vessels. Unfortunately, papyrus is vulnerable to all the vicissitudes of time against organic materials: it can be devoured by insects or fire, spoiled by damp, and can become brittle and disintegrate over the centuries. For this reason the great archives of state, temple and families survive only if they lie in waterless town levels or if they were taken from the damp reach of the valley to the dryness of the desert. Most papyri have come down to us because they were placed in the

42, 44, 95

cemetery areas at the edge of the desert in Upper Egypt, above all at Memphis and Thebes.

The Rediscovery of Egypt and Decipherment

When the temples, underwritten by Roman emperors, ceased to commission monuments in the Egyptian style, and when the land converted to the new faith of Christianity in the third century AD, Egypt lost both use and knowledge of hieroglyphic and derivative cursive scripts. Diocletian (emperor AD 284–305) attempted to wipe out Christianity, and to his reign dates the latest hieroglyphic inscription in the British Museum, from AD 296. In the course of the following century, as the state embraced Christianity, the base for hieroglyphic workshops disappeared entirely, and the year AD 394 saw the carving of the last known hieroglyphic text, on the island of Philae at the margins of Egypt. For the new faith the pagan scripts were banned, and the Greek alphabet was

98. *Sherd bearing eighteen lines of psalms written in the Coptic script. Biblical literature, church sermons and tales of martyrdom form the bulk of written output in this final stage of the ancient Egyptian language. Early Islamic period, 7th or 8th century AD; pottery with pigment, from Thebes (?), H. 13.2 cm.*

98 adapted to the Egyptian language, forming a new script known as Coptic to bring the scriptures to the population. For fourteen hundred years the Pharaonic world stood severed from human consciousness, represented only in the Bible and in Greek and Latin accounts of pre-Christian Egypt, often with negative judgements on the Egyptian way of life and beliefs. The break with the past was completed when Egypt converted to Islam and the Egyptian language, then at its Coptic stage, fell into disuse.

In the Middle Ages and European Renaissance travellers rarely ventured out of Christian Europe into what was considered the perilous world of Arab, then Ottoman, Egypt. Egyptian motifs appear in western European art only sporadically, as when Pinturicchio responded in 1493–5 to the commission to celebrate the Apis bull on the coat of arms of Pope Alexander VI, borrowing from the Roman author Diodorus Siculus the legend that Osiris became king of Italy. Ignorance of the Pharaonic past began to recede in the late sixteenth and seventeenth centuries when obelisks were re-erected in Rome amid great acclaim, and Egyptian antiquities first became accessible to inquisitive collectors, such as two Ptolemaic sarcophagi brought to France by a Marseilles merchant in 1632 and cited in verse by La Fontaine. In 1638–9, an English astronomer called John Greaves visited Giza and Saqqara, and in 1646 published an account of the pyramids including measurements and references to earlier works, not omitting Arabic authors.

The new generation of travellers and, most importantly, their published accounts, prompted the interest and support of states; the French regent commissioned from Father Claude Sicard work on Egyptian antiquities *in situ*, leading to his identification of Thebes in 1718, and the Dane Frederik Norden was sent by his king to explore the Nile Valley in 1737–8, resulting in publication of his travels on a lavish scale from 1751. In France Montfaucon in 1719–22 and the Comte de Caylus in 1752–67 published antiquities, including many from Egypt, already at that date in European collections. When the British Museum itself was founded in 1753 by posthumous state purchase of the Hans Sloane collection, it too contained a small proportion of Egyptian antiquities such as the stela of the priest Nekau from Sais. Scholarly endeavours were matched on the literary and theatrical level by the bestselling novel on the life of an Egyptian priest *Séthos* by Jean Terrasson in 1731 and by such works as the opera *The Birth of Osiris* by Jean Philippe Rameau produced in 1751. On the artistic front Johann Dinglinger created for the king of Saxony an exuberant Apis altar in 1731, and Giovanni Battista Piranesi decorated one of the main Roman rendezvous for travellers, the *Caffè Inglese*, with Egyptianising motifs in 1760.

The later eighteenth century saw James Bruce in 1771–2 reach Ethiopia and on his way home the site of Meroe, former capital of the Meroitic realm; in 1797 the Scandinavian Jörgen Zoëga published the first authoritative treatise on obelisks and hieroglyphs in Rome; and Wolfgang Amadeus Mozart in 1791 wrote the *Magic Flute* with its masonic celebration of Osiris and Isis. These deeper acknowledgments of Egypt anticipated a vast new enterprise of European involvement, the scientific and military expedition launched by Napoleon Bonaparte in 1797 to conquer Egypt. The expedition met with military disaster when the British joined Ottoman Turkey to drive out the French army in 1801 with the sieges of Cairo and then Alexandria. The academic side of the expedition brought more productive results, among which may be counted the science of Egyptology; as First Consul of revolutionary France Bonaparte included in his forces a large team of scholars who were to draw up accurate maps and record the fauna and flora of the land as well as its Islamic and ancient monuments. Despite the capitulation of the military, the scholars were able to keep their papers and could thus produce an astonishing series of text and plate volumes still used by Egyptologists, the *Description de l'Egypte*. Publication of those volumes in 1809–30 and of the popular account by the expeditionary Vivant Denon, *Travels in Upper Egypt*, in 1802 brought Egypt with unprecedented accuracy into the heart of Europe. Equally vital for the new study of Egypt, the French weakened the feudal rule of Egypt by the Mamelukes, enabling the Ottoman governor Mohammed Ali to destroy their power and open Egypt to European technology as soon as the Napoleonic wars were over in 1815. Once the floodgates were open, the 1810s and 1820s witnessed extensive recording and collecting of antiquities of all types and sizes at the major burial grounds of Thebes, Memphis and Abydos. The more accurate reporting and copying of monuments coupled with the steady stream of major collections arriving on European shores created the conditions in which Egypt could be studied and her ancient scripts and life rediscovered.

99, 100

The story of decipherment runs parallel to the growth of interest in Egypt. In the fifteenth and sixteenth centuries a number of Greek and Latin works were rediscovered and published bringing to the Renaissance world some ancient commentaries on the hieroglyphic script or particular Egyptian words. Of these the most influential was the *Hieroglyphica* of Horapollon, a treatise on hieroglyphs written by the Egyptian priest Hor Apollo (the two names are the same, Apollo being considered the Greek equivalent of the Egyptian deity Horus). An imperfect edition of the *Hieroglyphica* by an uncomprehending ancient Greek was bought on the Greek island of Andros in 1419 by a Florentine traveller Chri-

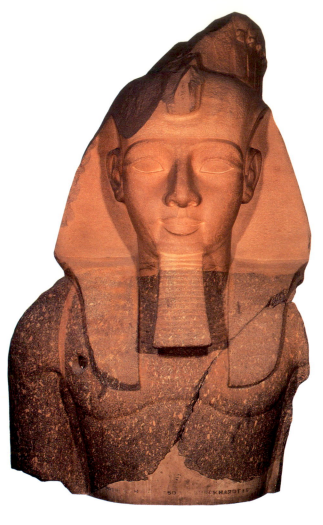

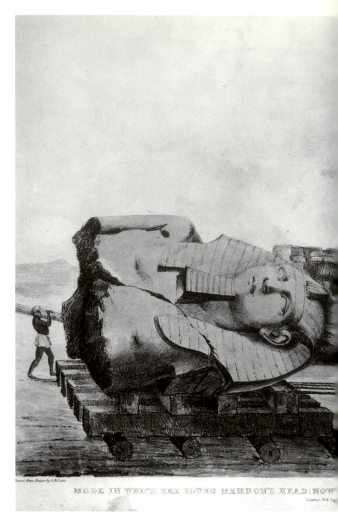

99. *Upper part of a colossal statue of Ramses II, exploiting the lighter vein of stone to highlight the head. The piece was acclaimed in the early 19th century and designated the 'Younger Memnon'. 19th Dynasty, c. 1250 BC; granite, from the Ramesseum, Thebes.* H. *2.67 m.*

100. *A contemporary depiction of the removal of the 'Younger Memnon' by Giovanni-Battista Belzoni for transportation to London where it arrived in 1818. The presence of such outstanding sculpture in their midst transformed the debate among the scholarly and wider public on the merits of Egyptian as opposed to Greek art.*

stofero Buondelmonti, and published in Greek in 1505 and in Latin, more widely read, in 1515. This was followed by publications of works by Herodotus, Diodorus Siculus and Ammian Marcellinus, the latter with translation of a text on an obelisk in Rome. Unfortunately none of the ancient Greek and Roman visitors to Egypt learnt either the Egyptian language or the hieroglyphic script, and their writings tend to regard hieroglyphs as deeply obscure and symbolic, understood only by initiates and without any direct phonetic content; the symbolist view of hieroglyphs blocked the path to decipherment for centuries.

The first step to decoding the ancient hieroglyphic

and cursive Egyptian texts came in the mid-seventeenth century, when Father Athanasius Kircher proposed that the Coptic lanuage used in church services in Egypt should be the same language as that spoken and written by the ancient Egyptians. Although his works such as the four volume *Egyptian Oedipus* (1652) insisted on the obscure symbolism of hieroglyphs, the recognition of Coptic as the latest stage of the Egyptian language formed the first breakthrough, one that proved decisive in the final episode of decipherment. Despite forming his own collection, Kircher had access to insufficient Egyptian material, and indeed one of the most often debated monuments at the time was not Egyptian but a Roman

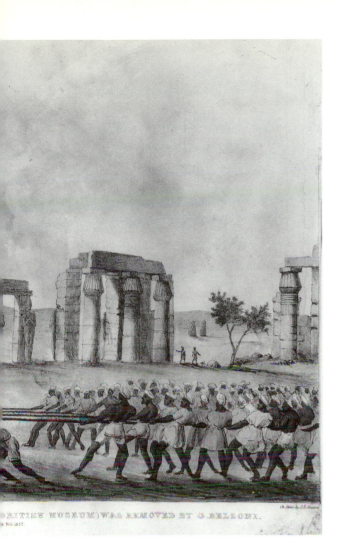

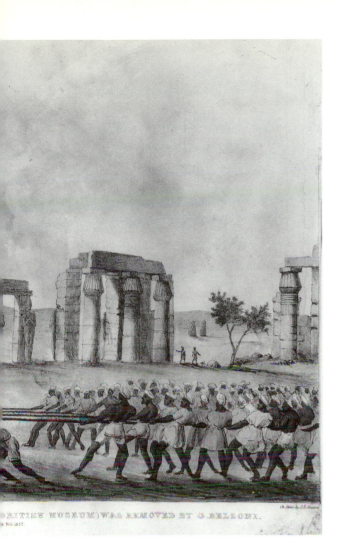

Egyptianising altar, the *Mensa Isiaca*, first documented in the collection of Cardinal Bembo in the early sixteenth century. As the eighteenth century brought increasing numbers of Egyptian objects to light, occasional achievements in decipherment can be observed, if with the benefit of hindsight. Abbé Barthélemy, decipherer of Palmyrian and Phoenician, endorsed the hypothesis of Kircher that Coptic and ancient Egyptian were the same language; he also published in 1762 the correct deduction that the only prominent punctuating mark in Egyptian texts, the oval sometimes used to enclose signs, was a device to highlight names of kings or divinities.

The field of debate was transformed in July 1799 when an officer in the French expedition, Lieutenant Pierre Bouchard, received orders to restore the medieval fortress at Rashid (known to Europeans as Rosetta) as part of the defences against the British and Turkish reconquest of Egypt. Bouchard or his men came across a granitic slab inscribed in three scripts, the hieroglyphic,

its cursive derivative the demotic, and the Greek script. Since the expedition included a scientific wing with the mission to collect antiquities, Bouchard sent this stone to his superior, General Menou, who in turn informed scholars at the new French Institute of Egypt installed in Cairo. Originally the stone presented the accomplishments of the boy-king Ptolemy V and the decree to establish his cult as god in all Egyptian temples as passed by the Egyptian priests when they met at Memphis in 196 BC for a coronation in Egyptian style. It would have been a round-topped stela, but has been squared off to form a rectangular slab more convenient for reuse as a building block, probably when moved to the medieval fortress at Rashid in the Islamic period. Only the Greek text could be read, but its last line revealed what might have been expected, that the same text was recorded on the stela 'in sacred, native and Greek letters'. This raised hopes that the lost hieroglyphic and demotic scripts could be deciphered by comparing those renderings of the text with the known Greek version on the monument, which was moved to the French Institute in Cairo and soon became known as the Rosetta Stone. When the French withdrew from Cairo after siege in June 1801, they brought the Stone with their other papers to Alexandria, but there Menou received no reinforcements. On 8 September 1801 he was forced to capitulate, signing away by Article XIV of the Treaty of Alexandria over a dozen major antiquities including the Rosetta Stone. King George III of England presented the finds in 1802 to the British Museum and since that year the Stone has been displayed in the Egyptian galleries of the collection. 1802 also saw the first published attempts at decipherment from the Stone, possible because both the French and British custodians of the monument had keenly copied the inscription and copies had been sent to all the major scholarly institutions of Europe, in an exemplary display of international cooperation amid the national rivalries and hatred of the Napoleonic wars.

A. I. Silvestre de Sacy, a French orientalist, laid down guidelines for a method to decipher demotic from the Greek by locating the names in the text, deducing the sound values of individual demotic signs in the names; the signs deciphered from the names could then be used to discover the sound value of other words isolated by comparison with the parallel Greek text. In 1802 both de Sacy and the Swedish diplomat J. D. Åkerblad presented many readings of signs, among which some were correct but most still false. They confined their efforts to demotic, partly because the demotic part of the Rosetta Stone is preserved intact whereas the hieroglyphic text is severely damaged, lacking much of the first half of the text; perhaps more seriously the hieroglyphs were considered to be arcane symbols, whereas the demotic was regarded as a less obscure script for daily work, and

so more susceptible to decoding. The next two decades saw firmer progress in deciphering demotic by the English physicist Thomas Young; Young wrote an account of hieroglyphic and demotic scripts for the *Encyclopaedia Britannica* in 1819, in which he made use of the Rosetta Stone and new material coming out of Egypt in the aftermath of the French expedition, in particular demotic papyri. Among his principal achievements Young confirmed that demotic was a cursive script derived from hieroglyphs, established correct phonetic values for several hieroglyphic signs from comparing the Greek writing of Ptolemy, and, crucially, recognised that demotic and the Macedonian names Ptolemy, Berenice and Cleopatra isolated in hieroglyphs in cartouches used not one but two principles of writing, phonetic and 'symbolic', sound-signs and sense-signs. For example, in Berenice, Young recognised the hieroglyph *n* and the egg-hieroglyph as a sign denoting femininity. However, Young did not believe that hieroglyphs in general could include sound-signs; he continued to insist that Egyptian hieroglyphs were in general sense-signs, symbols, without alphabetic or phonetic value, and that they were used to represent sounds only when they had to convey foreign Macedonian names such as Ptolemy and Cleopatra, much as signs in the Chinese script can represent single sounds only when writing European names. Even when in 1822 he had deciphered the hieroglyphic writing of Cleopatra from an obelisk now in Kingston Lacey, Dorset, Young could not read a single word of Egyptian in hieroglyphic texts.

The breakthrough in deciphering hieroglyphs came not when the names Cleopatra and Ptolemy could be read, but when Egyptian Pharaonic names and Egyptian words could be read. This occurred for the first time in 1822 when the French scholar Jean-François Champollion read to the Paris Academy his famous *Lettre à M. Dacier*, a lecture in which he extended the reading of hieroglyphs beyond foreign names to all hieroglyphs and beyond the Graeco-Roman Period into the earlier ages of Pharaonic history. Champollion had wrestled with hieroglyphic decipherment since his childhood, and tended to turn impetuously from one method to another and from one point of view to another, at one time embracing the view that hieroglyphs could be alphabetic, then returning to the view that they were sacred symbols. Despite these constant changes, he had two decisive assets, a speaking knowledge of Coptic and an assiduous study of every Egyptian text that he could find, from the

collections in his native Provence to the papers published by members of the French expedition to the texts on objects copied or brought out of Egypt in ever increasing numbers. In 1822 he saw copies of texts from Egyptian temples in Nubia with the cartouches or royal name rings of Thutmose III and Ramses II. Aware of the possible meaning of the names from Coptic and of the fame of Thutmose and Ramses in ancient Greek authors, Champollion became the first man in fourteen centuries to recognise the dual principle behind the Egyptian hieroglyphic script, in the specific writing of those two royal names. The name Ramses illustrates most clearly the dual principle: Ra means 'sun' in Coptic, and in the cartouche Champollion recognised the sun-disk, clearly representing the sense or idea 'sun', with the sound-value *ra* in Egyptian. The sign at the end of the cartouche was used to write the letter *s* in the name Ptolemy (Greek form in full *Ptolemaios*) on the Rosetta Stone, and so Champollion could read *ra-?-s-s*; he was then able to guess that the middle sign should read *m*, and he had the name Ramses, which he could explain from his knowledge of Coptic as 'Ra-mise' or 'Ra is the one who gives birth to him'. In the case of Thutmose he was able to read similarly the ibis at the start of the cartouche as the god Thoth and the ending -mes in the same way as for Ramses. In other words some signs represented ideas (ibis for ibis-god Thoth, sun for sun-god Ra) while others within the same name represented sounds (the values discovered by Young for individual signs in the writing of foreign names, notably *p, n, s*).

Champollion already had charts equating hieroglyphic, hieratic and demotic signs, and he could quickly build up a substantial dictionary of ancient Egyptian; in all his writing, what most impresses the modern reader is not so much how much he read correctly, which certainly far outstrips any predecessor or contemporary, as how little he read incorrectly, which cannot be said of any of his predecessors or contemporaries. In 1824 Champollion published his *Précis du système hieroglyphique* in which he laid out not only the script but also, using Coptic, the grammar of ancient Egyptian. Much remained to be done, and after his death in 1832 his work was continued by the German scholar Karl Richard Lepsius, who removed one error in 1837 when he showed that some phonetic hieroglyphs represent not one but two or three sounds; thus the sign in Ramses and Thutmose that Champollion read *m* should in fact read *ms*, followed by an *s* to confirm the value *ms* ('phonetic complement'). Despite such important refinements, the system of Champollion had already opened the door to reading hieroglyphic and hieratic texts. When Champollion achieved his lifetime ambition and visited Egypt in 1828–30, the sights and monuments seen and copied by so many travellers over the previous

101. OPPOSITE *The Rosetta Stone, a name coined in the early 19th century for a slab inscribed in three scripts with the text of a decree by priests gathered at Memphis for the coronation of the boy-king Ptolemy* V. *Ptolemaic Period, 196* BC; *granitic stone, from Rashid (Rosetta), originally perhaps from Sais.* H. *1.14 m.*

two decades opened to him like the pages of a book, the texts could be read, and the vast jumble of Egyptian antiquity could finally be ordered in proper sequence in time.

Literature

Egyptian literature can be defined as the self-conscious use of language, in other words as all statements that go beyond the immediate and practical conveying of information. This definition includes mathematical texts and the like as well as more poetic compositions, but may be taken to exclude accountancy texts, juridical documents and private and official letters. It is difficult to assess the role of the lost oral literature, and what follows concerns primarily the surviving written texts. Despite the almost miraculously fresh appearance of some manuscripts, the texts are not generally well-preserved Some compositions are known from many copies, but these are usually limited to excerpts written by apprentice scribes on ostraca and often abound in errors; others have come down to us solely through the chance survival of a single manuscript. Very few texts are known to us complete, and it is not possible to know what we have lost from the body of literature; the impression remains that the total corpus was comparatively small, and that samples of most types of text have survived. Conditions for preservation are best in the cemeteries and occasional towns at the dry desert edge; much of what survives accordingly has a funerary character (see the section on Funerary Texts in chapter 4). Two exceptional finds should be noted, because they provide rare examples of a private library in Pharaonic times: the 'Ramesseum library' (now in Berlin and in the British Museum) containing hieroglyphic as well as hieratic papyri, and thus indicating unusually advanced competence in literacy, found in 1898 in the tomb of a learned Thirteenth Dynasty Theban on the ground later occupied by the Ramesseum, cult temple to Ramses II; and the 'Deir el-Medina library' (now in the French Institute, Cairo, the Chester Beatty Library, Dublin and the British Museum) belonging to a Twentieth Dynasty family of royal craftsmen, discovered in 1928 and including the Chester Beatty papyri. These two private collections of books correspond to the two principal ages from which hieratic literary texts are known, the late Middle Kingdom and the post-Amarna or Ramesside Period, perhaps to be identified as the two great ages of literary production in Pharaonic Egypt. Both groups include medical prescriptions and incantations, ritual liturgies, hymns, and literary tales and instructions. The unity of this range of texts under the bracket of 'literature' appears to be confirmed by the fragmentary papyri

from the library of the Sobek temple at Tebtunis in the Fayum, dating to the Roman period, covering a similar range of texts of knowledge, religious texts and literary texts.

The audience receptive to written literature would have been restricted to the elite, as in Europe until recent times, since perhaps as little as one per cent of the population could read. The identity of an author seems to have played virtually no part in the institution of literature, and this anonymity makes it difficult to determine the precise date of composition for texts. From the Old Kingdom only business documents, accounts and letters have survived on papyrus; inscriptions on stone in tomb-chapels expand from the First Dynasty, when they are confined to name, titles and offering-list in the Early Dynastic Period, to the Sixth Dynasty, by which time they elaborate both the stock virtues of the tomb-owner and the highlights of his career, as in the narratives of the high officials Weni, on his pyramidion from an Abydos offering-chapel, and Harkhuf, on the outer wall of his tomb-chapel on the West Bank at Aswan. The late Old Kingdom also saw the first use of funerary literature to secure a non-earthly afterlife, inscribed initially only on the chamber walls of the pyramid of the king (*Pyramid Texts*). The First Intermediate Period and early Middle Kingdom saw a proliferation in such self-justification on stone stelae from offering-chapels, but manuscripts with literary tales and instructions are not known before the late Twelfth Dynasty. The new genres presumably reflect earlier oral literature, but the compositions are not merely transcripts of spoken texts; they are conceived and composed in written form. An example of the lost world of oral literature is the genre of animal fables; these are not known in written form before the Graeco-Roman Period, but their existence is implied by the numerous ostraca and rarer papyri bearing illustrations of animals in human roles. The late New Kingdom sees an expansion of genres with longer texts and greater variation in form; at this period Middle Egyptian, the classic language of the Middle Kingdom, had been superseded by Late Egyptian, the vernacular of the Ramesside Period, and from the reign of Akhenaten both were used in official texts and literature, although Middle Egyptian was retained for the most select texts, particularly those of religious character. The Third Intermediate Period is poorly represented in the surviving record, but two manuscripts of the period hint at creative developments of existing genres, if they are not copies of late Ramesside works; the *Report of Wenamun* and the *Literary Letter of Woe* are preserved each on a single papyrus, both found in a pot together with an onomasticon at Hiba in Middle Egypt, and now in the Pushkin Museum, Moscow. In the Graeco-Roman Period, series of tales were developed around historical figures of the past, and a genre grew

102

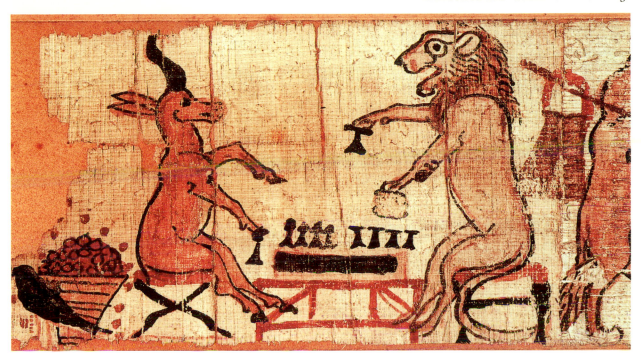

102. *A scene from the Satirical Papyrus, in which animals imitate figures from funerary scenes. An antelope plays a board game with a lion, whose expression suggests that he expects to win. Late New Kingdom; painted papyrus, from Thebes (?).* H. 9 cm.

up of prophecies of foreign rule to be followed by a glorious native dynasty; in these literary texts the fruitful contact with foreign literature and the resentment at foreign rule find full expression.

The analysis of Egyptian literary form has proven problematic. It has been argued that most texts were composed in metre, with two or three accented syllables per line. Metre would have been distinct from stylistic devices such as 'parallelism of members' which would have complemented it in the patterning of compositions. In the late Middle Kingdom rarely and in the Ramesside Period much more frequently, red points were used to indicate the ends of groups of words, apparently metrical verses, perhaps as an aid to the copyist. Very occasionally verses were written stichically as in European poetry, with each verse on a separate line. Red ink also marked the openings of individual stanzas.

If we can analyse the creation of literature as an institution in Pharaonic Egypt, our attempts at interpretation are hampered by the fact that it has no direct posterity in European literature; the most substantial link is European translation and imitation of Biblical narratives and instructions. The form, style and conventions through which modern literary meaning is created have evolved independently of Egyptian tradition. Nevertheless, enough features are common to both the ancient and the modern audience to allow us to attempt a reading of these ancient texts.

Texts of knowledge

Texts of knowledge were as much part of Egyptian literature as they were of early European *belles-lettres*. The quintessential text was the onomasticon, which presents under the encyclopaedic title of 'an instruction for the inquisitive, a correction of ignorance, to know all that exists' a bare list of place-names and words for various categories of object and creature. It reveals a belief in the omnipotence of words not only to label but also to embody the categories of existence; in the same spirit the Egyptians called the hieroglyphic script 'words of god', signs that embodied the existing order of things as established in the creation and experienced by humanity. The list is the archetypal device for recording information, and retained a profound stylistic influence. More elaborate texts are attested from the Middle Kingdom onwards, though the knowledge they contain would have been known to the architects of Old Kingdom monuments. They are not the analytical treatises that we expect of scientific writings; instead they consist of compendia of problems with their solutions. The Rhind Mathematical Papyrus in the British Museum (*c.* 1550 BC) opens with the grandiloquent title 'standard for entering into matters of knowing all that exists and [all] obscure things'; it is a collection of arithmetical problems on calculating areas, measuring the angle of slopes, etc.

103

103. *Part of the Rhind Mathematical Papyrus, written in the Hyksos Period, but claiming to be a copy of a 12th Dynasty work. This section contains a series of problems about calculating the volume of rectangles, triangles and pyramids. The examples are arranged between ruled lines, with diagrams of the objects. 15th Dynasty, c. 1550 BC; papyrus, from Thebes. H. 32 cm*

as in the following example: 'Fat [worth] ten gallons [of grain] is issued for one year: what is its share per day?' The papyrus would have equipped a scribe in the state administration to cope with all daily accountancy problems and more complicated architectural problems than most scribes would have had to confront during their careers.

Medical texts follow the same principle of compilation. Examples from the 'Ramesseum library' include collections of prescriptions and incantations to help pregnant women and their children, and for stiffness of limbs while others from the 'Deir el-Medina library' include incantations against headaches, called 'half-head' exactly as in the Greek word *hemikrania*, the origin of our word migraine. Many manuscripts group together texts of similar purpose, as in the treatment texts concerning

surgery in Papyrus Edwin Smith, in the Brooklyn Museum, New York, or the prescriptions for medicaments in Papyrus Ebers, in the University Library, Leipzig. Like treatments and prescriptions the incantations to be spoken in treatment are generally grouped separately, as in the London Medical Papyrus in the British Museum; unlike the instructions for diagnosis and treatment, and the prescriptions for medicaments, incantations to be spoken are tightly patterned in metre. Egyptologists usually call such incantations magical texts, but the ancient Egyptians themselves did not distinguish between 'magical' and medical practice; the back of Papyrus Ebers bears incantations to be spoken by the same healing practitioners who were intended to use the 'medical' prescriptions on the other side of the papyrus. One of the latest manuscripts in this tradition is a third century AD demotic manuscript with Greek glosses, in two rolls, now in the British Museum and the Rijksmuseum in Leiden.

Written incantations were not only reference works for practitioners, but were also themselves potent; small sheets of papyrus with a single incantation could be worn

in life or placed on the neck of the deceased as amulets. The extent to which the supernatural pervaded daily life is demonstrated by calendars in which each day was marked as lucky or unlucky, for example, because a good or bad event was supposed to have taken place on that day in the contest between the gods Horus and Seth. The earliest surviving calendar of lucky and unlucky days dates to the late Middle Kingdom, and more expansive calendars marking each of three parts of the day as lucky or unlucky according to specific mythical episodes survive from the new New Kingdom. The interpretation of dreams probably also goes back at least to the Middle Kingdom, although the principal Pharaonic dreambook comes from the Ramesside 'Deir el-Medina library'; the Deir el-Medina dreambook lists dreams in tabular form, one column identifying the content of the dream and another giving the interpretation, for example '[if a man sees himself in a dream]: with an erection: good: this means that his possessions will multiply'. Astronomical texts existed, although they survive before the Graeco-Roman Period only as star-charts on coffin-lids and burial chamber ceilings, where they would enable the deceased to know the time of night or date in the calendar. Demotic astronomical and astrological papyri survive, and copies of the Mesopotamian zodiac are famous from Graeco-Roman temple ceilings.

Of the texts which enshrined religious knowledge, hymns were among the most important. They formed a central part of religious practice, were recorded on papyri and also figured in tomb and temple wall-decoration. The 'Ramesseum library' contained a papyrus with a series of hymns to the crocodile-god Sobek, in hieroglyphs and therefore probably a ritual roll used by a lector-priest in temple cult or festival. One hymn begins:

> Hail to you, who arose from the primeval waters,
> lord of the lowlands, ruler of the desert edge,
> who [.], who crosses backwaters;
> mighty god, whose seizing cannot be seen,
> who lives on plunder,
> who goes upstream by his [own] perfection,
> who goes downstream, after hunting a multitude,
> a [great] number.

These eulogies consist of titles and epithets that build up a poetic definition of the deity. They were also esteemed for their literary value, and might on occasion be composed as literary texts rather than for practical use in a cult; a possible example of the literary, non-liturgical hymn is the *Hymn to the Nile Flood*, known from several Ramesside copies but thought to date to an earlier period, perhaps the Middle Kingdom. Narrative myths seem not to have played a role in religious practice, where single episodes of encounters between gods sufficed for purposes of cult and festival; where longer

narratives connecting several episodes about the gods are found, they seem to belong more to the literary than to the religious sphere. Therefore, hymns provided the main channel for presenting religious information, as in New Kingdom hymns to the sun; one of the most striking of the latter is the set of hymns inscribed on the funerary stela of the twin architects Hor and Suty, from the reign of Amenhotep III and now in the British Museum:

94

> Hail to you Ra, perfection of each day
> All eyes see by you;
> they lack when your Person sets.
> You stir to rise at dawn,
> and your brightness opens the eyes of the flock;
> you set in the western mountain,
> and then they sleep as if in death.

This portrays the sun as a universal deity, and in the *Great Hymn to the Aten* from the reign of Akhenaten the universality of the sun comes to exclude all other divinities, with motifs strikingly similar to Psalm 104. Similar hymns were also recited in royal ceremonies, with eulogies of the king and of his victories.

Although such hymns were for the state cult, and were highly esoteric – much religious experience was conceived as possessing knowledge – they were adapted for private use in tomb-chapels and in daily life. From them evolved texts expressing a personal dependence on the gods with unusually explicit emphasis on the individual relationship between the person and a deity; a man named Nebamun from Deir el-Medina recorded on a stela now in the British Museum 'an account of the power of Ptah' whom he had offended and who had punished him:

> I am a man who swore falsely by Ptah lord of Truth,
> and he caused me to see darkness by day;
> I will tell of his power to him who knows it not and him who does to little and great.
> May you beware of Ptah lord of Truth;
> see, he does not overlook the deed of any man!

Papyri also preserve rituals, for example the earliest illustrated roll, from the 'Ramesseum library', which presents a kingship ritual with instructions for speakers and interpretation of their texts; the 'Chester Beatty library' contained a hieratic copy of the ritual conducted for Amun at Karnak as established by Amenhotep I and elaborated under Ramses II. In these ceremonies the incantations, hymns and performative rites were enacted by the priest or priests, theoretically in place of the king, in various divine roles. In the fourth century BC and Ptolemaic Period, temple rituals were included in a small number of burials and have thus survived, two well-known examples in the British Museum being the rituals on Papyrus Bremner Rhind (such as the *Felling of the*

Serpent Apep, *Lamentations of Isis and Nephthys*), and a ritual for the end of the mummification procedure in which prescriptions are given for setting up a pavilion known as the House of Life; the House of Life is attested in other texts, from which it seems clear that it was the kernel of the hieroglyphic culture, staffed by scholars trained in all texts of knowledge from astronomical to religious and funerary compositions. Rituals present the nearest Egyptian analogy to drama, although there was no audience-oriented performance in the European sense of drama in theatres.

For details of funerary literature see the section on Funerary Texts in chapter 4. Songs of harpists featured in funerary celebrations to extol the blessedness of the tomb, although some express horror at death and its dangers more forcefully even than incantations and rituals designed to secure a physical and an otherworldly afterlife. One of the most radical songs was copied on a Ramesside papyrus now in the British Museum, but may be dated to the Middle Kingdom from comparison with literary texts of that date, especially the *Dispute of a Man with his Ba*:

Make holiday! Do not weary of it!
See, no-one can take his goods with him.
See, no-one who had departed returns again.

Despite the absence of analytical texts, sometimes expository elements were combined to form compositions more reminiscent of treatises. A famous example is the Shabako Stone in the British Museum, which purports to be a copy of a 'work of the ancestors which was worm-eaten' and so inscribed for eternal preservation on a slab of basalt at the orders of king Shabako of the Twenty-fifth Dynasty. The text fuses traditional elements of narrative and discourse into a discussion of the role of the god of earthly creation Ptah and of his city Memphis.

These texts, both technical and religious, demonstrate the extent to which writing enabled a codification of knowledge, but was not in itself an analytical tool.

Commemorative texts

Commemorative texts evolved out of the labelling function of writing which accompanies representations on tomb and temple walls. Tombs often included captions to scenes of daily life, words of funerary rituals and the like. The most important inscription was the name and title of the tomb-owner; out of the list of titles and epithets grew the narrative account of the career of the tomb-owner in the service of the king. Early Old Kingdom tomb-chapels also contained texts threatening would-be damagers of the monument; these threats were backed by assertions that the tomb had been built justly, for example that the craftsmen had been paid or that

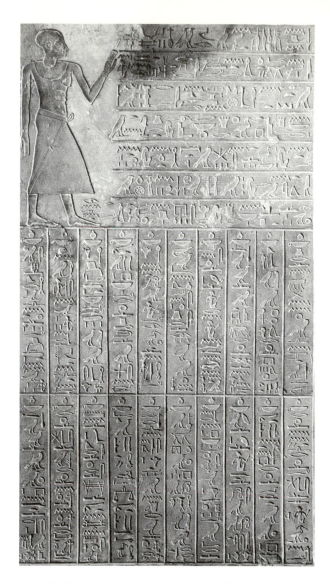

104. *The funerary stela of the chamberlain Intef, from his chapel at Abydos. Intef is shown with a description of the chapel's dedication in the top register. The rest is occupied by his autobiography; the stanzas are arranged in separate columns. Early 12th Dynasty; limestone, from Abydos. H. 66 cm.*

the tomb was built on fresh ground without damaging existing monuments. Such justifications of the tomb evolved into justifications of the tomb-owner, and these had become a formulaic list of stock virtues by the late Old Kingdom. The self-justifications make no mention of the king and rest their claim for an afterlife on good conduct in life. Both career narratives and lists of stock virtues continued to be used and developed throughout Pharaonic history and into Graeco-Roman times; they were usually inscribed on stone elements of the tomb-

chapel or offering-chapel, either the stone walls or one or more stone stelae. A formulaic example of the self-justification is the following excerpt from a Middle Kingdom stela in the British Museum:

104

> I was good within the offices,
> patient and free from piggishness.
> I was good, not short-tempered,
> not one who seizes a man for a remark.

A related genre of text is the expeditionary inscription carved at desert sites from which the Egyptians extracted certain more highly esteemed stones. Three sites are particularly rich in inscriptions: the turquoise mines of Sinai; the amethyst mine at Wadi el-Hudi; and the greywacke quarries in the Wadi Hammamat. The inscriptions vary from mathematically precise lists of staff on expeditions to poetic narratives such as the wonders recorded by the expedition of the vizier Amenemhat to the Wadi Hammamat for king Mentuhotep IV.

By the Middle Kingdom there existed texts celebrating the reigning king for his accomplishment of deeds in accordance with the repertoire of kingship, principally the defeat of foreign or domestic enemies and the establishment of temple buildings or offerings. In this tradition Thutmose III had the daybook record of his campaigns embellished and inscribed on the walls of Karnak temple; the principal focus of these annals was the prelude to the siege of Megiddo, not so much for its tactical importance as for the way in which it revealed the king as decisive actor and champion of order, fulfilling his role as the deputy of the sun-god on earth. Under Ramses II this genre was dramatically transformed to celebrate a similar event in which the king narrowly escaped annihilation at the battle of Qadesh; two compositions were created, one in the sober style of annals and the other in more exuberant poetic style:

> I arose against them, the likeness of Montu;
> I was equipped in the panoply of victory;
> I entered the ranks, fighting like a falcon's
> seizing,
> the serpent on my brow felling my enemies for me.
> She gave her flame of fire into the faces of
> my foes.
> I was like Ra when he rises at dawn!

As well as being known from papyri, the text was inscribed on temple walls where the record was further embellished with vast pictorial compositions of unprecedented ambition. The monumental tradition was continued into the Late Period, when inscriptions such as the great triumph stela of Piy were still composed in the formal language of the Middle Kingdom. One of the last products of this tradition was the bilingual Greek and Egyptian stela of the Graeco-Roman Period, in which the king or, against Pharaonic practice, the priests issued decrees; one example of priestly decree is the Rosetta Stone, one in a series of stelae set up to record achievements of the boy-king Ptolemy V in the reconquest of Egypt and simultaneously, as part of the reconquest, to promulgate the new royal cult in all the temples of Egypt.

There was little historiography beyond these inscriptions of kingship; for reference on the kinglists of the Old and New Kingdoms see the section on Chronology in chapter 2.

Instructions, discourses and narrative tales
Within the totality of literature there stands a core group of genres which formed a distinct and coherent corpus equivalent to the modern narrow idea of literature. All were fictional and the settings were either timeless or in the past, often construed as a golden age. The compositions are stylistically extremely self-conscious, and they display a capacity for exploring the darker side of life which was generally lacking in other writings. Although they articulate the values of the elite they were not propagandistic but rather highly challenging in their treatment of their themes. Nevertheless, all have happy endings in the sense that some resolution is offered even if it fails to quell all doubts. Humour, high seriousness and the tragic element were freely intermingled, as were the various styles and genres – the exclusive purity of genre was foreign to the Egyptians, and the discourse and narrative genres in particular were often densely interwoven. The narrative style tends to simple presentation, while the discourse was more elaborate and metaphorical. Two absences should be noted: there was no drama, whether tragedy or comedy, and no epic genre. Neither absence need surprise us; there were strong performative or recitative elements in many genres, and some characteristics of epic, such as a sense of grandeur or cultural enactment, pervade several types of text, most clearly the royal commemorative inscriptions. The two most important types of literary compositions were always texts and tales. The wisdom tradition, already encountered in the ethical epithets and self-justifications of tomb- and stela-owners, found didactic expression in the sapiential texts called instructions. These were attributed to sages of the past such as a vizier Ptahhotep of the Fifth Dynasty, but first appear in Twelfth Dynasty manuscripts. The *Instruction of Ptahhotep* presents a series of maxims introduced by a narrative prologue and concluded with a reflective epilogue:

> Do not be proud of being wise.
> Consult with the ignorant as with the wise.
> The limits of art have not been attained;
> there is no artist fully equipped with his
> excellence.

Perfect speech is concealed, more than turquoise;
yet it is found among the maids at millstones.

Although apparently full of pragmatic advice for
worldly success, the maxims are concerned with the
nature of the ideal life; the universality of the genre is
implied in the title of one such Instruction on a badly
decayed Eighteenth Dynasty leather roll now in the
British Museum: the 'instruction made by a man for his
son'. Perhaps the most brilliant adaptation of the genre
is the short *Instruction of king Amenemhat* I, preserved
only in New Kingdom copies; it is delivered in a dream,
in Egyptian a 'revelation of truth', by the dead king to
his son and successor Senusret I, and has the king recount
bitterly how his good deeds were repaid with a court
conspiracy to assassinate him before he could place his
son on the throne as co-regent. Since historically Senus-
ret I did reign as co-regent with his father for ten years,
it seems likely that the king escaped the assassination
attempt; whatever the exact historical background to the
text, it gives voice to the dilemma of divine kingship,
the contrast between the divinity of the king and his
mortality, and in so doing it addresses a more universal
dichotomy between the ideal and the actual. Similar
problems are raised in the *Instruction to king Merykara*,
also known only from New Kingdom copies; Merykara
ruled in the First Intermediate Period when Egypt was
divided between a northern and a southern kingdom,
and this allows the author to explore royal failings in
unusually outspoken ways. A prayer in the 'Deir el-
Medina library' names the author of the *Instruction of*

king Amenemhat I as Khety and dates him to the reign of
Senusret I; it is often suggested that this is the same
Khety from whom we have an Instruction that lauds the
profession of scribe by describing the most extreme
possible hardships associated with the professions of
manual labour (hence its modern title, the *Satire of
Trades*). All surviving copies of the *Instruction of Khety*
date to the New Kingdom, when the composition
spawned numerous shorter depictions of manual hard-
ships, extended now to two new professions that had not
existed so concretely in the Middle Kingdom, the soldier
and, interestingly, the priest. The most famous Late
Egyptian wisdom text is the *Instruction of Amenemipet
son of Kanakht*, partly because of its similarity to the
Biblical Proverbs; the similarity may be due to a common
context of Near Eastern Wisdom at the end of the Bronze
Age, but there are some concrete indications that the
compilers of the Proverbs were influenced by the *Instruc-
tion of Amenemipet*. The most complete manuscript is
now in the British Museum, and it contains all thirty
sections laid out stichically on the papyrus. The New
Kingdom witnessed changes in the concept of the good
man, and the equation of wisdom and piety becomes
markedly more pronounced:

105. *The* Instruction of Ankhsheshonqy, *demotic moral precepts
written in captivity: 'Don't open your heart to your wife, what you've
said goes to the streets'; 'who has been bitten by a snake is afraid of a
coiled rope'. Ptolemaic Period,* c. *100* BC; *papyrus.* H. *21.5 cm.*

Do not go to bed fearing tomorrow;
day dawns and how will tomorrow be?
Man knows not how tomorrow will be.
God shall ever be in his perfection,
and man in his shortcomings.

Other notable instructions are those attributed to Any and the scribe Amennakht. Demotic wisdom texts survive from the Graeco-Roman Period, the two characteristic examples being the *Instruction of Ankhsheshonqy*, best preserved on a manuscript in the British Museum, and the instruction known from Papyrus Insinger in the Rijksmuseum, Leiden. The *Instruction of Ankhsheshonqy* is introduced by a narrative prologue, and its maxims are stylistically distinct from the earlier texts of the genre, being short aphorisms such as 'he who gathers wood in summer shall not be warm in winter'; the same style can be seen in Papyrus Insinger, though there the maxims are grouped more thematically and expound more thoroughly the idea that the pious man is wise, the impious man a fool.

The genre of discourses present a more reflective tradition of wisdom, and so form a subset of the general genre of instructions. The *Discourse of Sasobek*, known from a single Thirteenth Dynasty manuscript now in the British Museum, is spoken by a scribe who has been imprisoned, like the later Ankhsheshonqy, and consists of sayings and meditations on the problems of life. A

106. *A wooden board, prepared with gesso to provide a reusable writing surface. A hole (on the right) provided a means of suspending it from a peg with a cord. The board is the only known copy of the* Words of Khakheperraseneb, *a literary discourse concerning social and personal chaos. The copy is not complete, and each paragraph seems to be an excerpt from the* Words, *which had been composed over two centuries earlier and was regarded as a classic in the New Kingdom. The text is punctuated with red verse points. Early 18th Dynasty; painted wood, provenance unknown.* H. *30 cm.*

Discourse of Neferty from the Middle Kingdom is preserved in New Kingdom copies and describes how king Sneferu of the Fourth Dynasty asked the priest Neferty to entertain him with a vision of the future; in reply the priest foretells a future state of chaos and woe in Egypt, to be righted by the arrival of a saviour king called Ameny, meaning the 'hidden' but also an abbreviation of the name Amenemhat held by various kings of the Twelfth and Thirteenth Dynasties. The *Discourse of Khakheperraseneb*, dated to the late Middle Kingdom by the name, survives on an Eighteenth Dynasty writing board in the British Museum, is introduced by an elaborate wish to be able to compose new sayings, and contains further laments on the imperfections of the world:

The land falls apart, has become as a wasteland
 to me,
made as the [desert].

Truth has been cast outside,
and evil placed within the council;
the gods' plans are disturbed and their
 ordinances neglected.
The land is in distress!

This type of discourse lent itself to dialogues. Two Middle Kingdom examples are especially famous: that between Ipuwer and the Lord-of-all (a title of the creator), known from a single Nineteenth Dynasty copy now in the Rijksmuseum, Leiden, in which Ipuwer admonishes the creator for allowing injustice to prevail amongst humanity, and the *Dispute of a Man with his Ba* known from a single Middle Kingdom papyrus now in Berlin, in which a world-weary man debates how death should be regarded. Such reflective texts are characteristic of the Middle Kingdom, although some new examples of discourses are known from later periods, such as the New Kingdom *Dialogue of the Head and the Belly*, now in the Egyptian Museum, Turin. In the Graeco-Roman Period several texts present prophecies reminiscent of Neferty and the other Middle Kingdom 'pessimistic literature'; in the late texts as Egypt under the yoke of foreign rule is promised a golden future under a new native dynasty. The *Demotic Chronicle*, known from a papyrus in the Bibliothèque Nationale, Paris, relates how king Nakhthorheb searched for secret books of knowledge and instead found ancient prophecies that foretold the good and evil fortunes of his predecessors and himself; as in the Late Egyptian and demotic instructions, piety brings success and impiety leads to catastrophe, applied here to the fourth-century BC kings in reverse (successful kings must have been pious, unsuccessful kings wicked). The prophecies go on to 'foretell' the rule of Alexander and the Ptolemies, to be followed by a saviour dynasty of native kings. Curiously an equally virulently anti-Greek text of prophecy is known from a translation into Greek, the *Oracle of the Potter*; here an anonymous potter (possibly a manifestation of the potter god of Elephantine, Khnum) foretells to a king Amenophis (presumably an Amenhotep of the Eighteenth Dynasty) the destruction of Alexandria and the coming of a king sent by the sun-god. Khnum was represented in Egyptian art as a ram, and may therefore also be the deity behind a third prophecy text, that of the *Lamb of Bakenrenef* (Greek Bocchoris), a demotic composition in which a lamb is said to have foretold with human voice in the sixth year of king Bakenrenef the misery of Egypt to last for centuries before final deliverance; unlike the other two texts the *Lamb of Bakenrenef* seems to be directed against the Persians rather than the Greeks, but it shares with the other demotic and Greek texts of the genre a specific hatred of foreigners that distinguishes the late prophecy

texts from the hieratic pessimistic literature of the Middle Kingdom.

The fictional tales are the most accessible genre for the modern reader. An early example, the *Tale of Sanehet* (often read Sinuhe, from Coptic), is modelled explicitly on the late Old Kingdom genre of the narrative description of career in the tomb-chapel. This early masterpiece may be analysed as a composition in five segments or 'chapters', further reducible to forty stanzas. In the first segment, Sanehet panics on hearing of the death of Amenemhat I and flees Egypt; in the second he becomes established as ruler of an Asiatic dominion. The central segment represents the turning-point, as he overcomes an Asiatic rival but realises the futility of his life outside Egyptian culture: 'Whatever god ordained this exile – be gracious, bring me home! Surely you will let me see the place where my heart still stays!' His desperate cry is miraculously answered in the next segment with a letter from the new king Senusret I summoning him home to the Residence. The final segment ends with his reception at court and the tale ends with his death and sumptuous burial. It is a dazzling display of fine writing and a profound vision of the world as seen in the Twelfth Dynasty, as the life of one fallible man is smitten with chaos and grace; it survives in several Middle Kingdom papyri and numerous New Kingdom ostraca. Another similarly complex work is preserved only in Middle Kingdom papyri and relates the *Tale of the Eloquent Oasis-man*, in which a poor dweller of the Wadi Natrun is robbed and appeals to the high steward with speeches so perfect that the official informs the king; he in turn orders the man to be kept unaware that his family is being supported by the state while distress drives him to ever more moving and perfectly formed petitions. Only when, after nine petitions, he is on the verge of suicidal despair is he publicly vindicated and given back his goods. The whole is a deeply unsettling probe of justice, human and divine, although the narrative sections are written in a deceptively simple style. The same point on style is true of the *Tale of the Shipwrecked Sailor*, presented as an adventure story about a sailor who meets a giant divine serpent on a phantom island; the tale of the sailor in fact extols the virtue of fortitude and explores themes of court rather than folklore.

Later tales seem less carefully constructed and more attuned to oral and perhaps folk traditions. The *Tales of Wonder* set in the court of king Khufu of the Fourth Dynasty present the king being entertained by his sons recounting tales of wonders worked by wise men in past reigns; he is then told by his son Hordedef of a living wise man Djedi, who is brought to the court to perform feats of joining a severed head to its body, though he refuses when the king suggests he experiment on a criminal awaiting sentence. When the king then attempts to

107

107. *Part of the* Tale of the Eloquent Oasis-man, *one of the literary masterpieces of the Middle Kingdom. The manuscript is written in vertical columns, except for where the tale includes a list of the man's goods, which is arranged in horizontal lines like a set of accounts (on the right). Late 12th Dynasty; papyrus, from Thebes(?).* H. *14 cm.*

prise some esoteric knowledge out of Djedi, the sage reveals instead that the family of Khufu will lose the throne after two generations to three children already in the womb of a woman impregnated by Ra. The tale is vastly entertaining, as in the wonder in which a lake is parted to find the fish-pendant of one of a crew of girl rowers dressed only in fishnets, but it is also a comment on what makes a good king; it survives on a single manuscript of the Second Intermediate Period, now in Berlin. Late Egyptian tales of the Ramesside Period are longer and more episodic, and their thematic presentation is more allegorical. *The Tale of the Two Brothers*, known from a single British Museum papyrus, incorporated mythical elements reminiscent of the Osiris cycle, as well as folklore motifs such as the seductive wife tempting the young brother, and the ability to speak to animals. The same mixture is met in the *Tale of the Predestined Prince*, on another British Museum papyrus; its plot is representative of the group. It begins 'it is said, there once was a king to whom no child had been born'. After prayer is made to the local gods, a prince is born, and his fate is fixed by the Seven Hathors, who pronounce that 'he will die through the crocodile, or the snake, or the dog'. Despite the concern of his parents, the prince leaves home with a pet dog and wins as his bride the princess of Naharin by scaling the tower in which her father had placed her as a test for suitors. The princess, one of the few positive portrayals of women in Egyptian literature, averts the fate of death through the snake, but the manuscript breaks off as the prince confronts the crocodile and his own dog. The *Tale of Truth and Falsehood* presents the conflict between right and wrong as a family vendetta, and the *Tale of Horus and Seth* consists of a series of satirical episodes in which the two gods contend for the throne of Egypt; both tales are known only from the Deir el-Medina library. The *Tale of the Capture of Joppa* and the *Tale of Seqenenra and Apepi* draw on historical conflicts and are also known only from single manuscripts, both in the British Museum. From the end of the New Kingdom or slightly later come two tales of woe known from single manuscripts of the Third Intermediate Period, now in the Pushkin Museum, Moscow; the *Report of Wenamun* recounts the misfortunes abroad of an Egyptian sent to procure cedarwood for a new bark of Amun, at a time when Egypt no longer held sway over Asiatic suppliers, and the *Literary Letter of Woe* presents in the guise of a letter the misfortunes of an Egyptian within Egypt and the oases. Both accounts are in the first person, and the *Report of Wenamun* uses the setting of a powerless Egyptian in both friendly and hostile foreign lands to brilliant comic and ironic effect.

Demotic narrative fiction survives on manuscripts of the Graeco-Roman Period, generally extremely fragmentary; two groups of stories stand out, the Setne tales and the 'cycle of Inaros' (also known in Egyptology as the 'cycle of Petubastis'). The Inaros stories do not form a clearly connected cycle of narrative but all concern a hero Inaros and various people identified as sons of Inaros; one long but damaged papyrus in the Austrian National Library, Vienna, describes a contest between Pamu of Heliopolis (a 'son of Inaros') and Werdiamenniut of Mendes for the armour of the dead Inaros, at the time of a king Padibast (Greek Petubastis). Two tales use the character of Setne, based on the historical high priest of Memphis and *setem*-priest Khaemwaset, son of Ramses II and known to Egyptologists from his inscriptions recording the restoration of monuments such as the pyramid of Unas at Saqqara. The first Setne tale, on a papyrus in the Egyptian Museum, Cairo, recounts how Setne wrongfully gains possession of a secret book of Thoth from the tomb of one Naneferkaptah who had himself forfeited his own life and those of his wife and children in his obsession to possess the book; Thoth causes Setne to be seduced and shamed by a phantom woman Tabubu, and so forced to return the book to the tomb of Naneferkaptah. In the second Setne tale, on a papyrus in the British Museum, Setne is taken by his son Sawesir into the underworld, where he sees a bad rich man punished and a good poor man rewarded, as well as the torture of the damned. Certain motifs in demotic fiction are known from classical Greek literature, such as the visit to the underworld, specific tortures there, and the contest for the armour of a dead hero; the motifs may have reached the demotic authors through a variety of channels such as oral accounts of Greek works, or from written versions of Homer and other classics, or from more widely circulating editions of Hellenistic, particularly Alexandrian, novels and poetry. The connection between Greek and demotic literature is more concrete in the transmission of the Graeco-Roman story of Thoth and Tefnut (here in the role of the eye of the sun-god), in which Thoth is sent to coax the goddess back to Egypt from self-imposed exile in Nubia; beside the demotic version, best preserved on a papyrus in the Rijksmuseum, Leiden, a Greek adaptation of the same story is known from a third-century AD manuscript now in the British Library. Part of the coaxing of Tefnut involves Thoth relating animal fables; the genre is attested in Egyptian texts first in demotic but it is known from other ancient literatures such as Greek, most famously the fables of Aesop, and Indian, and it is implicit in New Kingdom representations of animals in human roles. The example of animal fables demonstrates how difficult it is to determine connections between different literatures with similar motifs; for a

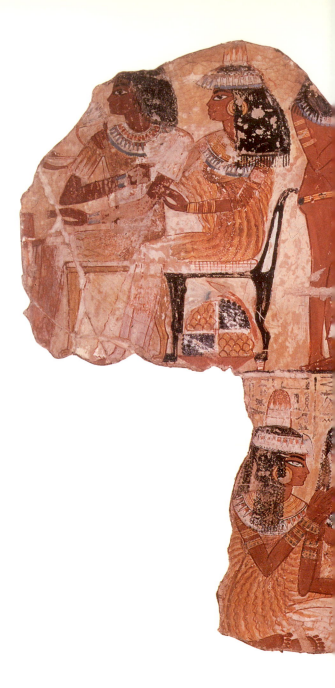

sound assessment it would be necessary first to estimate the date at which the particular motif or genre appeared in each literature.

Teaching texts played an important role in broadening the rules for written literature; from the Ramesside period survive collections of short texts used or composed for educational purposes, manuscripts that Egyptologists call *Late Egyptian Miscellanies*. The short discursive pieces in these papyri are often lyrical in tone, and include official letters, eulogies of the king and

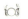

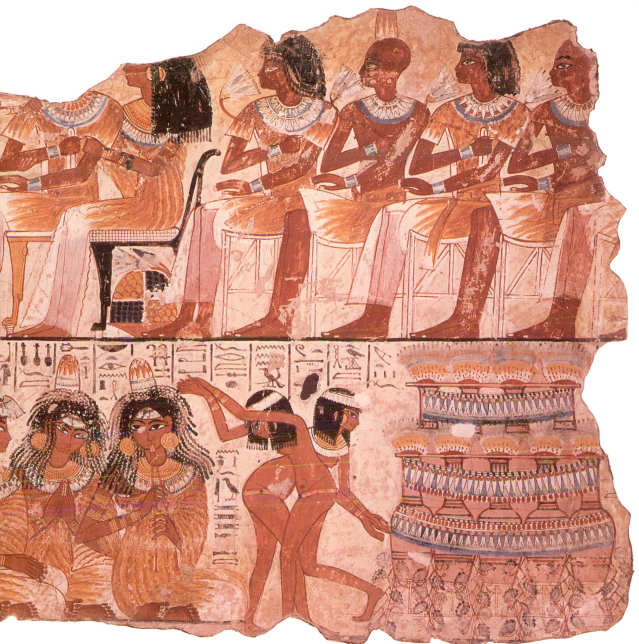

his Residence, hymns and prayers, and the negative portrayal of manual professions modelled on the *Instruction of Khety*. A work similar in purpose but unitary in its composition is the satirical *Letter of Hori*, in which the scribe Hori taunts a scribe Amenemipet in an extensive letter, challenging him on all the information that a scribe in the administration needed, from knowledge of placenames to mathematical calculations. These scholastic texts added to the body of literature in the New Kingdom, although in some respects they find ancestors

108. *Wall-painting of part of a banquet scene from the tomb-chapel of Nebamun. In the upper register men and women sit together. Below, beside some wine-jars, are dancing girls and musicians with their song written above them; the representation of the full front of the face is rare. 18th Dynasty; painted plaster, from Thebes.* H. *61 cm.*

in other genres among Middle Egyptian texts such as the *Tale of the Sporting King*, known from an Eighteenth Dynasty copy in the Pushkin Museum, Moscow. Another prototype is the narrative literary letter of the Middle Kingdom known as *kemyt*, 'the Compendium', used as a text to teach apprentice scribes presumably already then, though we have no copies earlier than the Ramesside Period.

The New Kingdom also saw the inclusion of lyrics into the corpus of hieratic literary texts, previously attested only as short labelling texts to scenes of life on tomb-chapel walls. An Eighteenth Dynasty example is that written above the muscians on one of the paintings in the British Museum from the Theban tomb-chapel of Nebamun:

> [...] of scent,
> which Ptah [bestows (?)] and Geb has made to
> grow, and its beauty is in every body.
> Ptah has made this with his hands so that his
> heart be carefree.
> The pools are full of water anew,
> and the earth is flooded with his love.

The same bucolic atmosphere pervades the love songs first written on hieratic manuscripts in the Ramesside Period. These are short dramatic monologues spoken by one or a pair of lovers. Three cycles of love lyrics are preserved on a Nineteenth Dynasty papyrus in the British Museum, including these verses in which the woman sings in a garden:

> I am your best beloved. I am yours like this
> field
> which I have planted with flowers, ...
> a lovely place for strolling,
> with your hand in mine.
> My body is satisfied, my heart in joy
> at our going out together.
> Hearing your voice is pomegranate wine;
> I live for hearing it!

Literature enshrined the Egyptian culture, and has a unique historical value for this reason; however, it also communicates these values with a vividness and an immediacy of feeling. Its genres embrace a wide range of styles, moods and degrees of characterisation; more importantly, it can still reveal layers of meaning and relevance for its modern readers, despite our lack of familiarity with its conventions. The fascination of a work such as Sanehet – which was in circulation for at least eight hundred years – can still be felt. In one Ramesside eulogy of the scribal profession, perhaps a part of the *Instruction of Amennakht*, on a papyrus from the Deir el-Medina library, a claim is made for the

ancient writers, which our experience now validates once again:

> Departing life has made their names forgotten,
> it is writings which makes them remembered.

Accounts, legal documents and letters

One of the most prominent uses of writing, and probably a crucial factor in its original development, was the accurate recording of information for accountancy. Papyrus rolls allowed the Egyptians to keep accounts records in tabular form, as can be seen already in the Old Kingdom accounts papyri from Abusir. The Abusir papyri include detailed work rostas and temple equipment inventories, recording every person in service for

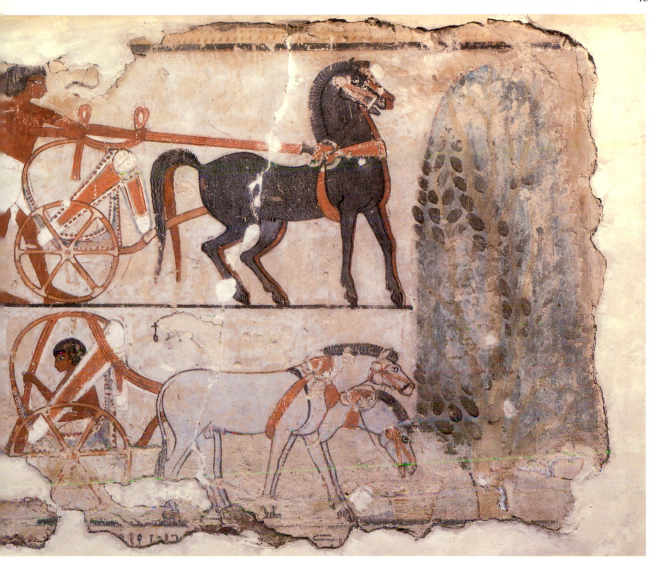

each part of the day, and noting in minute detail the wear and tear suffered by objects used in temple work and ritual. Equally important are the Eighteenth Dynasty accounts from the royal dockyards at Memphis where the Crown Prince Amenhotep (the future Amenhotep II) was responsible for organising the task of building and equipping ships for the campaigns of his father Thutmose III. The reign of Sety I is notable for the extraordinarily fine handwriting of even routine accounts compiled in the royal chancellery, such as an account of army bread rations, one of the finest examples of writing in the British Museum collection.

Several great accounts papyri survive from the Ramesside Period, and lesser transactions were often recorded on ostraca among the literate community on the West Bank at Thebes; the value of objects was assessed in

109. *Fragment of a wall-painting from the tomb-chapel of Nebamun showing the checking of a field boundary-stone before harvest. To the left the farmer swears an oath that the stone has not been moved; to the right the chariots and drivers of the scribal team rest in the shade of a tree. Comparison with problems in the Rhind Mathematical Papyrus indicates the training of accountants somewhat beyond the tasks of measuring and planning required of them in managing or serving a great estate. 18th Dynasty, c. 1400 BC; painted plaster, from Thebes. H. 43 cm.*

terms of quantities of grain, and a large or more valuable object could be 'bought' by giving in exchange enough smaller or less valuable items to make up the agreed 'price', a system mixing the more concrete elements of barter with the abstraction more typical of currency. Thanks to the large number of such transactions recorded on ostraca by the community of royal craftsmen at the

site now called Deir el-Medina, we can today assess the prices of goods across the course of the Twentieth Dynasty in greater detail than is possible for many ancient and even medieval societies. Ostraca from Deir el-Medina also give detailed work registers, as in one example which records reasons for absence from work on the tomb of king Ramses II in the Valley of the Kings; the reasons range from personal feastdays to ill health and even caring for a sick workmate.

Some of the most famous papyri from Ramesside Thebes are the records of legal procedures. One document lists a series of allegations by a man called Amennakht against Paneb, a foreman of the royal craftsmen at Deir el-Medina; Paneb stands accused of every crime in the book, from abuse of privilege to theft of objects from the tomb of king Sety II to a string of cases of adultery in the community of craftsmen. The case, and this papyrus, was to go before the Vizier or First Minister of the king as chief judicial authority of the royal craftsmen; its outcome is unknown. The Twentieth Dynasty saw two unusually dramatic legal cases, from which a number of papyri survive. The first concerns a court plot to assassinate Ramses III; he survived long enough to see the conspirators prosecuted and made to take their own lives. The second case revolves around the theft from gold-filled tombs at Thebes at the end of the Twentieth Dynasty. In the aftermath of the premature death of Ramses III, his son Ramses IV had a great document drawn up to record all the pious deeds of the great king, and principally his endowment of temples in his favour for all the gods of Egypt. The papyrus is written in a fine chancellery hand and, at 41 m, is the longest surviving roll. Contrary to repeated statements by modern interpreters the papyrus does not record the gift of most of Egypt to the temples, particularly the Amun temple at Karnak; the specific grants of land are for the royal cult and probably follow a normal practice in which the reigning king established his cult through temples and temple estates throughout the land, in the case of Ramses III principally for his great cult temple at Medinet Habu on the West Bank at Thebes. Since the land for royal cult was still royal land, it is likely that it was rediverted by the next king for his own cult. The Abusir papyri reveal the intricate diversion of offerings (i.e. goods in kind from numerous estates) to and from various royal cult foundations such as the pyramid complexes already in the Fifth and Sixth Dynasties.

From the second great legal case, twelve 'tomb robbery papyri' survive, of which seven are in the British Museum. The twelve documents record the evidence given by the accused after beatings, list objects found in the possession of some, and refer to the acquittal of others. One of the documents records a royal commission sent to inspect tombs vulnerable to robbery; none of these lay in the Valley of the Kings, being the tombs of Eleventh, Seventeenth and early Eighteenth Dynasty kings, on the West Theban hill-slope facing Karnak. Only one of the tombs had been robbed, that of king Sobekemsaf II and his queen Nubkhas; this may have been the incident that persuaded the authorities that the ancient tombs with their hordes of treasure could no longer be kept safe during the breakdown in law and order at the end of the Twentieth Dynasty in Thebes. Several of the burials mentioned by the royal commission were found by local villagers in the 1820s, perhaps in a joint tomb or cache, and one of these, the coffin of a king Intef, came to the British Museum in 1835 from the residue of the Salt Collection (Henry Salt 1780–1827, British Consul in Egypt). The bodies in the great tombs in the Valley of the Kings were transferred in a number of separate moves during the Twenty-First and early Twenty-Second Dynasties to ever safer hiding-places until they came to rest in two great caches, one in a remote corner of Deir el-Bahri and one in the tomb of Amenhotep II in an out-of-the-way sector of the Valley of the Kings itself, where they remained until their rediscovery in the late nineteenth century and removal to the Egyptian Museum, Cairo.

Although it is often said that the tomb robbery papyri refer to the robbing of the Valley of the Kings, it seems more likely that the tomb of Sobekemsaf II was one of the only royal tombs to be robbed at the end of the Twentieth Dynasty, and that its desecration prompted the authorities to start moving all the royal bodies inside as well as outside the Valley of the Kings to safety. The treasure with the Eighteenth and Nineteenth Dynasty kings may have been recycled by the Theban state into its own economy, and indeed some items of New Kingdom jewellery did become part of new royal burials at the Twenty-first Dynasty capital Tanis in the Delta. The only tomb to escape recycling at the end of the New Kingdom, whether by petty thieves or state authorities, was that of Tutankhamun, a small set of four chambers hidden beneath the rubble caused by the building earlier in the Twentieth Dynasty of the tomb of Ramses VI. This tomb was rediscovered intact, except for some small-scale robbery of the late Eighteenth Dynasty, in 1922 by Howard Carter (1874–1939), and the contents are now in the Egyptian Museum in Cairo with a small group of objects in the Luxor Museum and the body of the king resting in its original burial place, alone of the former inhabitants of the Valley of the Kings.

In comparison to hieratic documents, demotic business papyri survive in considerable numbers, particularly from the last three centuries BC. One of the longest known demotic papyri contains the cession of her considerable property and various rights at Thebes by the woman Neskhons to her eldest son Panas. The text is

really a will masquerading as a cession and so does not have an accompanying bill of sale; the date is December 265 to January 264 BC. Neskhons confers the use of half of her two houses in Thebes and half of a third house in Djeme on the West Bank plus half of her rights from serving as a funerary priest at a great number of Theban tombs. In return she is to receive for her lifetime a subsistance consisting of two cooked cakes daily, a woven shawl and one garment yearly and a *hin*-measure of oil monthly plus half of the rations Panas will receive from his duties as funerary priest and a promise that he will pay for her mummification. There are four witness copies of the text, a relatively rare occurrence although there are two other papyri in the collection with this feature, whereby four of the witnesses of the transaction out of the sixteen who usually signed their names and filiation on the verso were required to copy out the whole document in their own hand on the recto. As is usual in most legal documents of the Ptolemaic Period the text proper begins with the regnal date and names of the eponymous priests and priestesses, continues with the names of the contracting parties followed by the legal clauses and ends with the scribe's signature.

110. *Demotic contract of the cession of Neskhons' property between her sons in return for subsistence until her death. Four of the sixteen witnesses have copied the whole text in their own hands. Ptolemaic Period, 265–264 BC; papyrus. H. 39.7 cm.*

Another rare demotic document records a loan of grain with a resumé of the main text still under a clay seal in a rolled up section at the top of the papyrus. This was a ruse to prevent any tampering with the figures in the main text – the true figures could always be ascertained by unrolling the précis. Of further interest is the dating of this text to year 7 of one of the two rebel native Pharaohs who controlled Upper Egypt during much of the reign of Ptolemy V.

Letters were written on papyrus or, being relatively short texts, on ostraca where available for less formal communication or for drafting a text. One early letter from Egypt dates to the Sixth Dynasty and contains the complaint of an official responsible for workgangs at the Tura limestone quarry; the letter is now in the Egyptian Museum, Cairo. The oldest Egyptian letter in the British

Museum is another complaint, this time from an Eleventh Dynasty general called Nehesy who appears to accuse his family of holding back food he had sent for a female member of the household called Senet. About two hundred years later, the master of another household sent a letter requesting that the house be prepared for his arrival and asking in particular after the nurse Timat. Both letters present the curt phrasing typical of superiors addressing dependants or subordinates.

Official correspondence is represented in the earliest postal service, a system of despatches sent from one fortress to the next in the annexed territory of Nubia; a letter sent from the southernmost fortress (in the Middle Kingdom this was at the Second Cataract) would go to the next fortress in the chain, where it would be joined by any additional despatches due to go to Egypt, and so forth until the bundle arrived in the relevant government office in Thebes, where a scribe copied all the texts onto a single roll of papyrus. The despatches report every movement of population in Nubia and record the measures of military commanders in controlling nomads and traders. The roll of despatches survives because the other side was used a century later, presumably after that part of the office archive had been dissolved, to write incantations of defence against ill health, and these were placed with other defensive and literary texts in a burial.

From the Eighteenth Dynasty the British Museum collection holds letters of Ahmose of Peniaty, an administrator in the works department; in one the mayor Mentuhotep asks Ahmes to carry out some small-scale building work, but it is not clear if this is for official or private purposes. A Nineteenth Dynasty letter in the collection contains, alongside the customary courteous formulae, some highly literary phrases; the letter is from a man called Meh, but it incorporates a message from a woman called Isetnefret who says 'how, how I long to see you; my eyes are as big as Memphis so hungry am I to see you!' The largest group of letters in the collection comes from an extraordinary mass of correspondence mainly between Thutmose, scribe of the royal craftsmen in West Thebes, and his son Butehamun. These late Ramesside letters, now dispersed among many museums, virtually document the death of the New Kingdom amidst the decline of royal power, breakdown of law and order in Thebes, and outright war between the general Payankh and the rebel viceroy of Nubia Panehesy; Djehutymes accompanied Payankh on his Nubian campaign, and much of the correspondence with his son is resonant with fears for safety and the desperate wish to return safely home to Thebes.

In contrast to the florid phrasing and lengthy formulae of Middle and New Kingdom letters, demotic letters appear more concise and matter-of-fact; a group of four demotic letters in the British Museum's collection comes

111. ABOVE *A Middle Kingdom letter from the town of Lahun, written in vertical lines of hieratic. In it, the writer announces his intended return to his household. The damage on the sheet shows where the letter was folded for delivery. In the following generation, the use of vertical columns was superseded in literary manuscripts and letters by horizontal lines. Late 12th Dynasty; papyrus. H. 33 cm.*

112. RIGHT *A late Ramesside letter from the scribe of the necropolis Thutmose, known as Tjaroy, to a colleague. The swiftly written horizontal lines are recognisably from Tjaroy's hand. 20th Dynasty; papyrus, from Thebes. H. 17.5 cm.*

from official correspondence of the police station at the Serapeum in the Memphite necropolis in the year 159 BC. Coptic letters return to the extensive courteous formulae of earlier letters, and include pastoral letters from bishops in literary style.

A special category of correspondence is formed by the letters to the dead, pleas for help written to recently deceased relatives. Less than twenty such letters have survived, but they cover the period from the Old to the New Kingdoms and have been found in various parts of the country; this suggests that there was a widespread belief that the dead could remove invisible obstacles in daily life such as ill health or domestic strife. Letters to the dead could be written on papyrus and delivered, like any letter, to the dwelling-place of the recipient (i.e. his or her tomb), or they could be written on the pottery vessels in which offerings were placed, as if to guarantee that the dead person would read and act on them. In the Late Period people wrote their pleas for divine aid not to their dead relatives but to a deity; an example from the first century BC contains the complaint of Pasherdjehuty and his sister Naneferher to the Ibis, Hawk and Baboon, three gods of the Memphite necropolis, that their father threw them out when taking a new wife after the death of their mother. Such direct appeals to deities illustrate both the change from the earlier appeals to the dead, and the remarkable continuity of Egyptian civilisation.

6

ART AND ARCHITECTURE

Art in the Predynastic Period

The earliest depictions in Egypt are drawings incised on rocks in the desert; these are difficult to date unless there is connected archaeological material. An example at Sayala in Nubia is dated to the period before the arrival of the A-Group culture, and animals depicted on rock-drawings suggest the wetter climate of the Predynastic Period or earlier. However, similar drawings occur on the walls of the Trajan kiosk at Philae, and thus can only date to the second century AD or later; this makes dating by style alone impossible at present.

The first farming communities in the Nile Valley produced a range of decorated objects, surviving mainly from fourth-millennium BC burials in which the most characteristic item is painted pottery. The red ware of Naqada I sites bears geometric patterns in white paint with occasional depictions of animals and people, while Naqada II buff ware has brown or purple painted figures principally of ships and people. Sculpture seems confined in the earlier period to roughly shaped pottery figures of naked women and men; a few sculpted stone figures, of stylised standing men, for example, appear to date to the Naqada II period. Stone palettes of the early fourth millennium BC often have the rough outline form of animals or fish, and in the later fourth millennium BC are decorated with scenes sculpted in relief, while knife-handles and maceheads also become surfaces for relief carving. The reliefs depict sometimes single signs, sometimes groups of images; the groups can be masses of animals and people without dominant focus or ordering,

or neatly arranged lines of animals. In these late Predynastic compositions elements of the future Pharaonic art appear, as too on the single surviving painted tomb-chamber of the period, at Hieraconpolis. Figures of a man holding two lions and of entwined long-necked animals echo Mesopotamian art of the same period, but the bulk of decoration appears to develop without external influences; fragments of painted linen bear the same motifs of ships and men found on the pottery and in the tomb painting, and suggest a single dominant range of subjects. Predynastic art is often studied only as the precursor to Pharaonic art or as a supposed historical document, and the exact development and rules of depiction for the period have yet to be reconstructed.

Pharaonic art

The monuments from First Dynasty royal and noble tombs obey in general the same rules of depiction that continued in force throughout the three millennia of Pharaonic history. The emergence of these rules coincides with the birth of both hieroglyphic writing and the Egyptian state. The feature that distinguishes Pharaonic from Predynastic art is the baseline upon which the composition is constructed; this is implicit in the neat rows of animals of the Predynastic knife-handle but absent from relief on slate palettes and painting on pottery and tomb walls. Upon the baseline the artist built up a timeless image; the object was depicted not as it appeared to one person from one standpoint, but in the

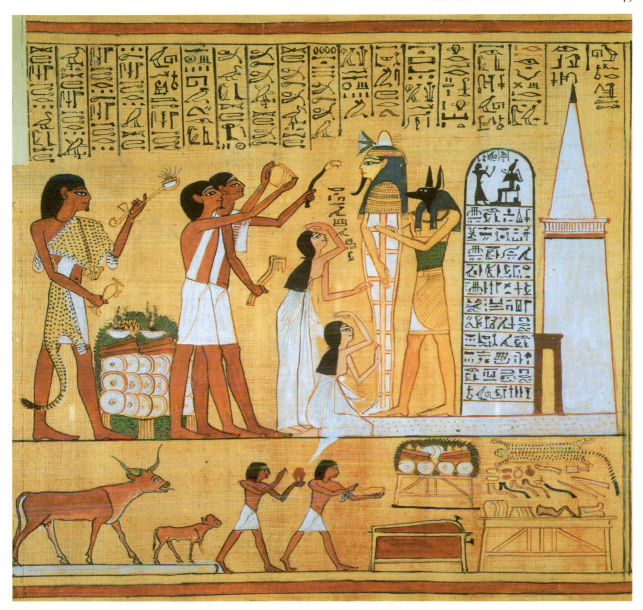

form that the object could most readily be recognised as itself, animal, plant, human, part of the body or whatever. Already in the First Dynasty writing and single or group images share the same rules for communicating form to a reader or viewer, and this unity of hieroglyphic script with images holds firm to the end of Pharaonic culture. By the Fourth Dynasty a canon, or fixed set of harmonious proportions, had been developed to govern the way in which objects were depicted, rather as in Greek architecture the evolution of harmonious forms for the Doric column stops in the fifth century BC, presumably because that final form continued to satisfy the aesthetic demands of artists and patrons to the end of that culture,

113. *Vignette from Hunefer's* Book of the Dead, *illustrating the rites 'opening the mouth' as performed on his mummy. The same life-giving ritual enabled all images to receive energy through offerings. 19th Dynasty, c. 1300 BC; painted papyrus, from Thebes. Full H. of papyrus 39 cm.*

and in others. It should go without saying, although modern minds often forget, that Egyptian art does not cease to develop and explore its own potential after the Third Dynasty, any more than Greek art ceases to innovate once the golden rules of classical fifth-century BC Greek art had been evolved. Pharaonic art is the formal depiction of objects according to certain pro-

portions in use from the Fourth Dynasty to the Roman Period; this artistic canon took shape from the First to Third Dynasties but, like Predynastic art, Early Dynastic art tends to be studied as the forerunner of Pharaonic art or for any non-artistic content, and therefore its precise rules and development have yet to be understood.

Pharaonic art has specific rules in part because it serves a specific purpose: not merely to represent or record an image but to bring that image to life. The scenes and statues in temples and tomb-chapels were intended to create and maintain a perfect world in which the good life available in Egypt could continue to flourish without opposition from the bad side of life that was equally present in the land. Therefore, Pharaonic art excludes almost universally images of decay, old age, disease, death and imperfection; people and objects are depicted in ideal condition, because they are intended to become the living people and tangible objects of an ideal cosmos and afterlife. The last and most crucial act in creating an image was the 'opening of the mouth', in which special ritual tools touched the mouth of the main person depicted to enable him or her to receive sustenance through that mouth. It follows that the classical European tradition of art, in which the world is seen in perspective as in direct photographic reproduction, betrays the purpose of Egyptian art by showing people or objects from only one side and in only one transient condition. The Egyptian would rather depict an object in formal contexts not as it appeared concretely in one time and place but as that object was known to the society from all sides; the object was created in two dimensions by drawing it from the aspect considered most characteristic. Complex objects could be built up out of the elements considered distinct; a box with raised top could be created in two dimensions by drawing it in profile, and a flat-topped box by drawing it from side and top, juxtaposed to communicate and create the full rounded identity from all points of view.

The human body presents one of the most complex sets of elements to be depicted by the Egyptian artist; the face, arms and legs are most instantly recognised in profile, and are depicted in that way, while the eyes and shoulders are depicted full-frontal, and the waist almost profile but turned to reveal the navel. The strict rules for proportions of part to whole ensure that, when the complete image has been built up, the harmony of the whole has not been lost, and this canon of proportions provides both clarity and the means by which the method of depiction survived across the millennia. The modern success of Egyptian art rests not least on the instant recognition that the artist has achieved for compositions both as a whole and in their constituent parts. Proportions could be guaranteed for an apprentice or for difficult images, such as very long rows of figures or combinations of figures at different scales, by drawing guidelines at strategic points, such as the knee of the human figure, or even by setting out a complete grid of squares. It is often mistakenly thought that the strict canon of proportions, and especially the grid of squares used to apply the canon in those few special cases, make Egyptian art lifeless, as if it was painting by numbers; the modern eye should remember that the grid was rarely used, that guidelines occur no more frequently than in the finest European art, and that the canon of proportions is not a straightjacket but a method of depiction that enables an artist to construct compositions in accordance with the purpose and aesthetics of Pharaonic art.

The wall-painting fragments from the Eighteenth Dynasty tomb-chapel of Nebamun at Thebes allow the modern observer to appreciate both the efficiency of the rules of depiction and the details through which the greatest artists produced innovations. Such paintings comply with the rules for formal art, because they were meant to help the tomb-owner and his family achieve new and perfect life after death; thus the principal human figures are shown in traditional manner, face in profile,

eyes and shoulders frontally and so forth. In colour men are shown dark brown, on the grounds that men work in the sun, while women are shown fair skinned, from spending more time indoors. In the hunting scene the tomb-owner appears larger than his wife, to indicate status. The formal rules are broken to dramatic effect where this does not endanger the purpose of constructing the perfect world for life after death; to capture the beat and movement of dance and music the artist presents the bodies of the dancing girls not in traditional composition form but in pure profile, and the musicians are shown partly at three-quarters or full-frontal.

The Nebamun paintings are typical of Egyptian formal art in presenting a highly edited view of life that can be read both literally and symbolically. Literally the paintings construct a luxurious standard of living with banqueting, music and dance as well as aristocratic pursuits of fishing and hunting wild birds. Even at the literal level certain features are clearly combined for artistic effect rather than to capture the photographic image of reality; human figures in the same scene can be shown at different scales, bird nests perch on the tips of flowers,

115. A drawing board with a prepared gesso surface and artist's sketches. The left half is laid out with a grid in red ink, within which is a drawing of Thutmose III. On the right side are hieroglyphs of an arm (upside down) and a quail chick. New Kingdom; pigment and plaster on wood, from Thebes. H. 35.4 cm.

and the cat with the impressive catch of birds has jumped up from a reed boat still burdened by tomb owner with wife and daughter and an untouched bird. These instances of artistic licence should alert the modern observer to the underlying meaning and purpose of tomb scenes and equipment; everything in the tomb should assist in the task of obtaining for the tomb owner a perfect afterlife. Every detail in the scenes relates symbolically to the purpose of tomb-chapels as places where the dead received food and drink and, crucially, the guarantee of perpetual regeneration. Thus, the hunting scene echoes the hunting of the god of disorder Seth by the god of order Horus in the triumph of order over chaos; the mass of birds forms the same dramatic counterfoil to the tomb owner as the throng of state enemies does to the victorious king in royal scenes. Motifs of music and dance evoke the world of sexual activity that held the

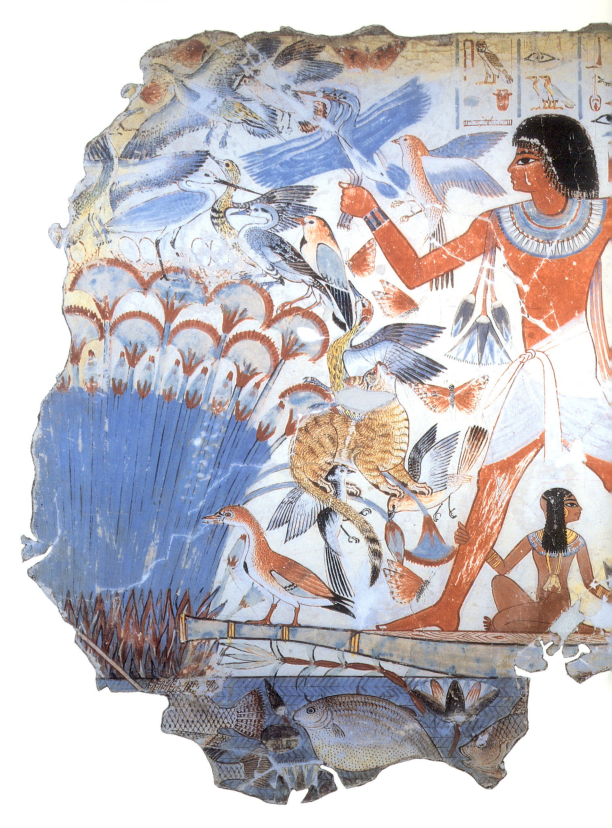

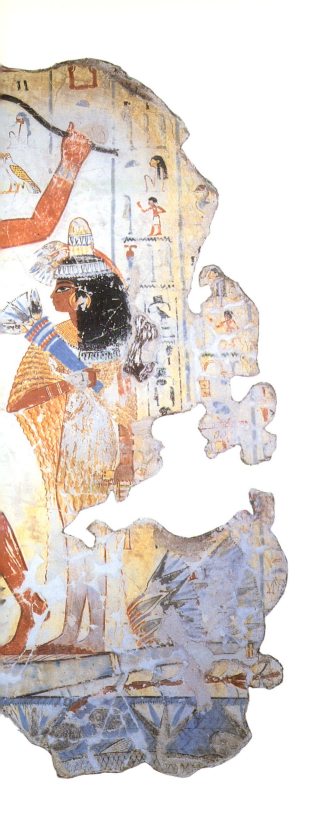

promise of eternal rebirth with the sun-god. Whereas Old, Middle, early New Kingdom and Late Period tomb-chapels include many such 'scenes of daily life' with their underlying message of regeneration and rebirth, in the late New Kingdom the range of tomb-chapel decoration becomes more overtly religious, with more texts from the *Book of the Dead* and fewer 'scenes of daily life'. The purpose of all these scenes and texts remains constant, to procure eternal life for the owner.

Given the constancy of purpose of formal art in Egyptian tombs, for their owners, and in temples, where scenes underwrite the bond between the offerings from earth and the blessings from heaven, it is not surprising that many modern eyes find that art repetitive. One sign of vitality that is often overlooked is in the variety of composition; another is the subtle variation of details such as the image of a lotus in the hand of a standing woman. It should also be remembered that formal art was one of two major spheres of expression in Pharaonic Egypt; alongside the images in temples and tombs there existed a range of less formal expressions for different purposes. Paintings in royal palaces show birds, plants, animals and geometric designs in less rigid style than much temple relief, and the few recorded paintings in town houses suggest loose compositions. Domestic utensils of the Eighteenth Dynasty display a similar looseness of subject-matter and treatment within the approximate rules for depiction, such as presenting each element from its most characteristic angle. In contrast the non-formal art of prayer often stands entirely outside the formal

116. LEFT *Wall-painting from the tomb-chapel of Nebamun showing him hunting birds in the marshes with his wife and daughter. This elegant pastoral scene, teeming with fish and fowl, shows him brandishing a throw stick from the boat while his cat attacks several birds. 18th Dynasty; painted plaster, from Thebes.* H. *81 cm.*

117. BELOW *Women holding a lotus, as shown on funerary stelae from three different periods. The Old Kingdom example (left) shows a naturalistic bending flower; the Middle Kingdom bloom (centre) is more severe and geometrically stylised; the New Kingdom example (right) is flamboyantly curved. The same tendencies can be observed in the treatment of the figures. 5th, 12th and 18th Dynasties respectively.*

 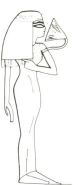

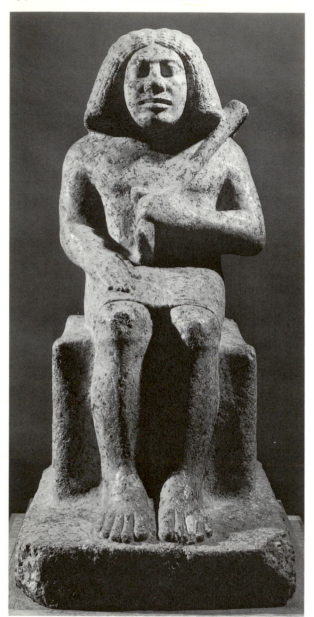

118. *Seated statue of the shipbuilder Ankhwa shown holding a carpenter's adze. This figure is an early example of sculpture in hard materials. Late 3rd Dynasty,* C. *2650* BC; *granite.* H. *64 cm.*

conventions governing portrayal of the human figure are just as apparent in sculpture as in two-dimensional representations. The design was first marked out in red ochre on a block of stone of roughly the size required, then the basic shape of the figure was blocked out without distinguishing face, arms or legs. This process and the modelling of the features were carried out with the use of guide lines in subsequent stages. The working of soft stone was comparatively easy with the available copper (and later bronze) chisels. In the case of hard stone the modelling was done by pounding with a ball of dolerite, and by rubbing with stones of various sizes in conjunction with an abrasive, probably quartz sand. Sawing and drilling with copper tools was also done with an abrasive. The final stages of the work consisted of modelling the features by light bruising and burnishing, followed by the addition of inscriptions and paint.

As with other features of Pharaonic culture, statuary can be divided into royal (properly 'of kings', to be distinguished from monuments of other members of the royal family) and 'private' (all monuments of persons other than the reigning king). The sculpture of the first three Pharaonic dynasties is confined to images of the single seated man or woman; at this point the set of proportions and characteristic angle of view differed from later work, and these differences can be seen in the stocky posture and sloping shoulders of the statue of Ankhwa. 118 From the Fourth Dynasty the poise becomes more angular and the proportions more elongated; new types of sculpture survive such as standing statues and pair 24, statues of man and woman. A specialised type of seated statue is the man with legs folded seated on a mat, with a papyrus scroll unrolled across his lap, ready to write, forever ready to take up the dictate of his divine king. The only composite image of the Old Kingdom is the sphinx, attested in the exceptional colossal stone figure sculpted from the Giza plateau to depict king Khafra of the Fourth Dynasty as a lion with human head; the body conveys the attribute, here superhuman strength, and the head conveys the identity, an idealised portrait. The role of the head as the identifier reaches extreme limits in the separate sculpted heads, called 'reserve heads' by Egyptologists; they were placed in the tomb apparently to ensure the tie between the burial-place, its intended owner and his or her soul.

At this stage private statues were placed in tomb-chapels and burial chambers, and statues of kings were placed in the pyramid temples for the royal cult. In the

canon of proportions; images of naked women to procure fertility for the offerer are found at shrines to Hathor, the goddess of love, and bear little immediate relation to formal Pharaonic art.

Stone sculpture shows clearly the development of types within the framework of the formal rules for depiction. The method of fashioning statues ensured that the

119. OPPOSITE *Seated pair-statue of Katep and Hetepheres, a typical style of tomb sculpture, the effectiveness of which was increased by the careful application of paint. 4th Dynasty,* C. *2500* BC; *limestone.* H. *47.5 cm.*

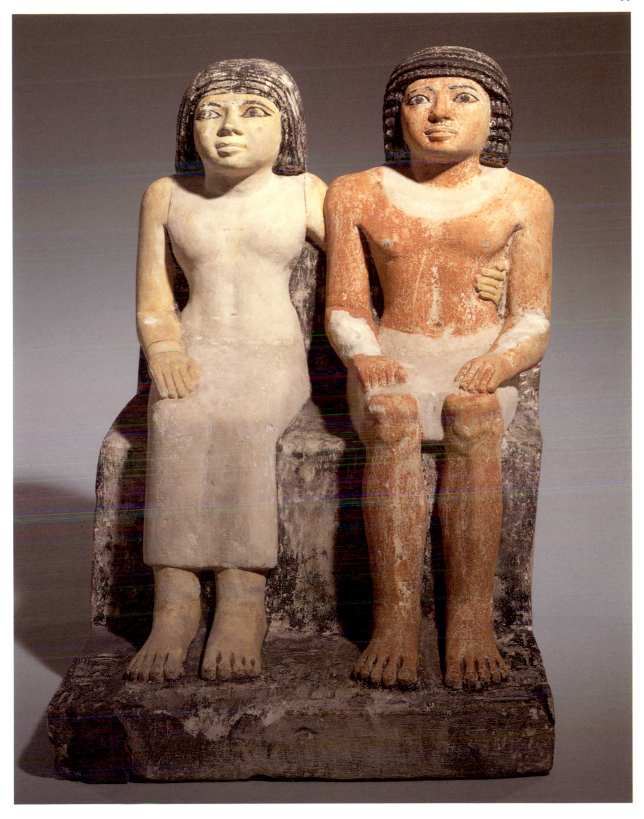

Middle Kingdom statuary moves into the temple instead of being confined to the place where offerings were made to the dead individual, royal or private; from the late Old Kingdom onward one of the most popular sites for setting up monuments had been Abydos, cult-centre of Osiris, god of the dead. The Old Kingdom portrayal of the head as jutting slightly forward from the body is replaced by the figure with head held straight in line with the back; another new posture in private sculpture is that of the block statue, in which a man (never a woman) is shown squatting on the ground with knees held to the chin, to form a virtual cube. In some instances, the block statue reveals the limbs of the human form, and in others the shape is reduced almost to a geometric cube with head placed on top; according to New Kingdom texts the block statue presented the man in the posture of a temple guardian, squatting at temple doorways. Monumental stone sculpture of kings also seems to be an innovation of the Middle Kingdom, although an example in metal survives from the Sixth Dynasty (now in the Egyptian Museum, Cairo) and the Great Sphinx at Giza provides a second exception. Life-size statues of Khafra were also found in the valley temple of his pyramid complex at Giza. Perhaps the most striking change in Middle Kingdom statues of kings, mirrored in non-royal sculpture, is the presentation of the face of the king as frowning and furrowed, in place of the even smile and youthful countenance of traditional style; the change occurs in sculpture of Senusret III and continued to have effect until royal sculpture apparently ceased to be produced in the Seventeenth Dynasty.

When the royal workshops resumed production at the start of the New Kingdom, they drew upon the varied traditions of Old and Middle Kingdoms to produce a distinctive new style with an expanded repertoire of types. The Deir el-Bahri statue of Amenhotep I owes its mixed style to earlier Middle Kingdom statues on the same site, the temple of Mentuhotep II, founder of the Middle Kingdom. The main new type of statue in the Eighteenth Dynasty was the stelophorous or stela-bearing statue placed in tomb-chapels and representing a man holding up a stelae inscribed with a hymn to the sun-god. The form developed out of the image of a man with hands held aloft in prayer, with the space between the hands filled by a supporting band of text in praise of the sun-god. The type appears in the joint reign of Hatshepsut and Thutmose III, a period of concentrated

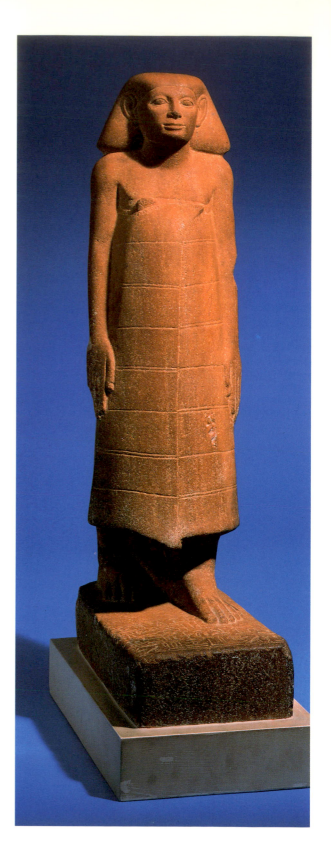

120. *Statue of Senebtyfy, also named Ptahemsaf, in the dress of an high official. Late Middle Kingdom, c. 1700 BC; quartzite.* H. *51.5 cm.*

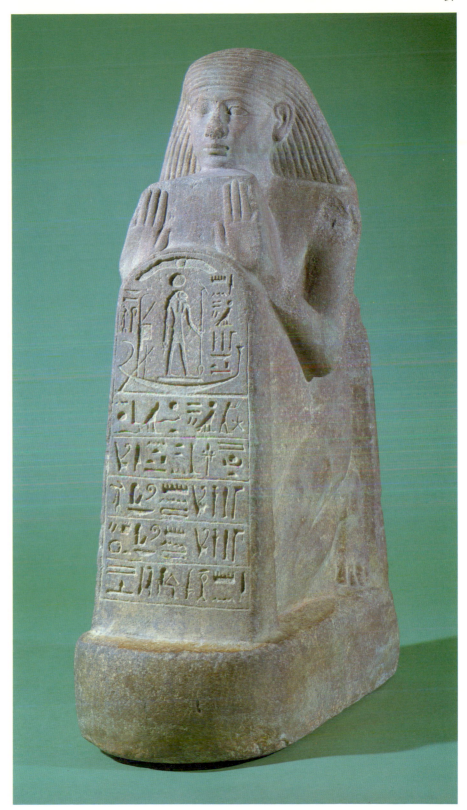

121. *An example of the stelophorous (stela-bearing) type of statue, representing Amenwahsu, shown in an attitude of worship. The usual text of the stela consists of a prayer to the sun-god. 18th Dynasty, c. 1450 BC; quartzite. H. 56 cm.*

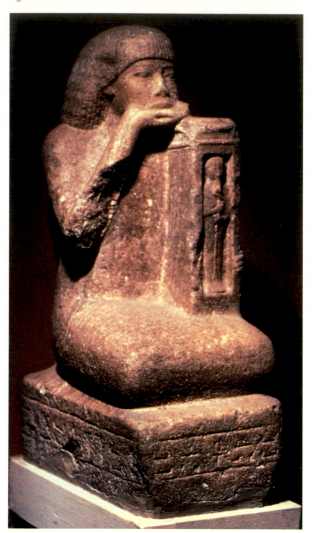

122. *Statue of Peraha, shown holding a shrine containing a figure of Ptah, and with one hand cupped before his face to indicate his wish to receive offerings from the god. 19th Dynasty, c. 1270 BC; quartzite. H. 33 cm.*

of the king as the one responsible for maintaining offerings to the gods. Royal sculpture also shows the king making eternal offerings with other vessels, such as the broader libation-bowls or the small spherical *nu*-pots; similar types appear in private sculpture, as does a type with a man proffering the name of the reigning king. Another innovation of New Kingdom sculpture was the standard-bearer that first appears in royal sculpture in a relief of king Thutmose IV of the Eighteenth Dynasty, and is adopted in private sculpture after the Amarna Period; the carrying of the standard seems to connect the man with the cult of the god whose image is born on the standard, and in private sculpture with the cult of the reigning king.

After the New Kingdom few original stone sculptures are found, although metalwork of the Third Intermediate Period included small statuary of a quality rarely equalled. Stone sculpture production resumed in the Twenty-Fifth Dynasty with a narrower range of types, now, drawing exclusively on the inspiration of the past. The stelophorous statues and standard-bearers no longer occur, but naophorous statues found a wide vogue covering standing and kneeling men. As in the New Kingdom these statue types were restricted to men, perhaps because they were intended for temple forecourts and hypostyle halls inaccessible to women other than temple musicians. At the end of the Late Period Greek and Roman influence appears in the tendency to sculpt faces furrowed with lines and removed from the idealised youth of traditional images, echoing the late Middle Kingdom and Amarna Period royal sculpture. From the Egyptian side the Pharaonic canon of proportions provided archaic Greek art of the sixth century BC with the framework from which the proportions and rules of perspective were developed to depict the human body. Pharaonic art depended upon the existence of workshops within which to maintain the canon and develop its potential; the task of these workshops, called the Hutnub, or 'foundation of gold', was sacred, and it required lector-priests who could read the necessary ritual prescriptions to make an image active, i.e. able to perform its duties and to absorb the energy of offerings. The last rulers of Egypt to maintain such workshops were the Greek-speaking Ptolemies and the Roman emperors. When the Roman Empire became Christian the workshops ceased to function and Pharaonic art was then replaced in the fourth century AD by late Roman art in city-centres and its provincial offshoot, Coptic art.

The bulk of Coptic stonework comes from the monasteries of the fifth to the ninth centuries AD. It consists of tombstones and decorated architectural fragments, few of which have been found still standing in position. Much of the material has no known provenance and there are many problems in connexion with its dating.

creativity; from this period some seated and block statues include the figure of a child wrapped in the folds of the cloak of the statue-owner, most famously in the sculpture of Senenmut, minister of Hatshepsut. The same minister owned the earliest surviving examples of two other types of statue that became more popular in the Nineteenth Dynasty, figures holding a naos (inner cell of a temple) or shrine, and figures holding a sistrum, the musical instrument associated with temple cult. Royal sculpture from the New Kingdom includes sphinxes with arms holding jars; these were placed at temple entrances, and combine the power of the lion to protect with the role

The work is executed in limestone and sandstone, the tradition of work in hard stone having died during the third century. With the exception of a form of cross, derived from the *ankh*, the hieroglyphic sign for 'life', there is almost no trace of the art of the Pharaonic Period. The style and subject matter of its decorative work can be traced back to the sculptured fragments found at Oxyrhynchus and Ahnas (Ehnasiya), which date from the beginning of the fourth century. The term Coptic is by general consent applied to this work, though for the most part it does not seem to have come from Christian buildings and may be considered as the last manifestation of Graeco-Roman work.

The carved relief of the architectural fragments of this early Coptic sculpture is drawn from familiar Hellenistic decoration, consisting for the most part of plant ornamentation and geometric designs seen at its best in friezes with acanthus and vine-leaf scrolls inhabited by birds and animals.

Particularly common at Ahnas are the friezes, niches and other architectural elements with figure subjects in high relief, cut so deeply that at times they are almost detached from the plain background. In contrast with the general Hellenistic style, the proportions of the figures show the clumsiness commonly associated with Coptic art, particularly in the small heads, conventional treatment of the hair, and the large eyes: the movements are angular and the forms sharply outlined. The subjects of the representations are drawn from the familiar repertoire of late pagan and classical mythology: Aphrodite, Herakles, Leda, Erotes, Nereids often riding on dolphins, Nymphs and other semi-divine powers, and personifications of the Earth, of the Nile, of Plenty (Euhemera), and of Good Fortune (Tyche). The style is illustrated by a female head of unknown provenance which formed the top of a niche. When the Christian communities built monasteries and churches, they used the current decorative style incorporating the repertoire of motifs with which they were familiar. They were influenced in the course of time by the art of other Christian communities of the eastern Mediterranean. In general there was a tendency for the ornamentation to become more abstract, less naturalistic and less deeply cut. The decorative pattern of the friezes was simplified and monotonously repeated. The deep-cut relief characteristic of the Ahnas style disappeared, and figure subjects became uncommon except on tombstones. Free-standing sculpture is unknown.

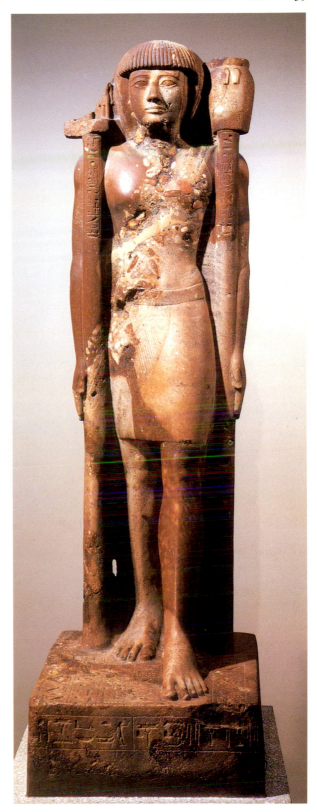

123. *Standing statue of prince Khaemwaset, a son of Ramses II, shown with the attributes of a priest. This figure exemplifies the great skill of the craftsmen in overcoming problems caused by the presence of inclusions in the stone. 19th Dynasty, c. 1240 BC; sandstone conglomerate. H. 1.46 m.*

Large numbers of Coptic tombstones, most of them dating from the seventh and eighth centuries, have been recovered. In inscription and relief they clearly evolve from the style of the mixed Romano-Egyptian stelae of the third and fourth centuries. The inscriptions carved upon them usually give the name and status of the deceased introduced by one of the common Christian funerary formulae, sometimes invoking the intercession of local saints. Only a few, and these of late date, contain more poetic compositions with reflections on death. If the date of the death is recorded, it is usually only by the year of an indiction, the cycle of fifteen years which was introduced at the time of Diocletian for administrative reasons. Some stelae contain no more than the text; others are carved in flat relief, the common themes being the representation of the deceased standing with his hands raised in the *orans* position, foliate borders, crosses with and without an encircling wreath, and the facade of a building rendered in an increasingly less naturalistic style. In the later period the memorial stones are usually small with rounded tops or large slabs, rectangular in form or carved at the top with a gabled pediment. In the earlier period, up to the sixth century, there was more diversity to type: the upper part of a stela from Badari, carved in the form of an *ankh*-cross, the loop filled with a chubby-faced mask and surrounded with a gaily painted decoration of vine stems and grapes, is of a type which seems to have been confined to Middle Egypt. The niche with a carved figure of a young boy, which comes from a late Roman necropolis at Oxyrhynchus, belongs to a type which was originally pagan, then adapted for Christian burials; also from Oxyrhynchus comes a standing figure which presumably once stood in a similar niche. Some of the original impact of the Coptic sculpture is lost by the disappearance in most cases of all traces of its original colour which would have concealed the general lack of modelling and the absence of fine detail in the carving.

Architecture

Egyptian architecture possessed distinct characteristics, derived in large part from primitive plant forms which had been the basis of the earliest buildings, and which persisted for centuries with relatively little alteration. The tradition is particularly evident in monumental architecture, in which the preservation and constant repetition of familiar patterns and motifs was not simply conservatism, but part of an active desire to sustain the original model and maintain things as they had always been. This was important in temple architecture because the traditional design of religious structures was inextricably linked with their function. Although it is the stone monuments which have received the majority of

attention from scholars, it should not be forgotten that the vast majority of Egyptian building was formed of sun-dried brick, used in all areas of architecture but especially for domestic, administrative and military projects. The Egyptians were prodigious builders and their great monuments were constructed by essentially very simple methods, by means of which they were able to move blocks of stone of great weight and, on occasion, work with extreme accuracy.

Temples

The earliest temples were constructed of mud brick and were of fairly simple design, consisting of a small number of anterooms before a sanctuary. Very few early temples have survived and consequently our view of the standard Egyptian cult-temple is coloured by monuments of the New Kingdom and later. In these buildings it is possible to discern a regular pattern in the layout of the temple, although almost every temple possesses its own variant elements or adaptations to the basic model. The standard design, often illustrated by reference to the temple of Khons at Karnak or the small temple of Ramses III at the same site, consists of a monumental pylon (gateway) entrance leading to an open court, surrounded by colonnades. Beyond this lay the hypostyle, a roofed hall with many columns, followed by one or two smaller rooms before the sanctuary, in which the image of the local divinity rested, was reached. Around the sanctuary were smaller side-rooms for the storage of temple equipment. The different parts of the temple were arranged on an axial plan, to suit the processional nature of many ceremonies, although in the earlier temples this axial layout had not been so apparent and the temple had been closer to the design of a house. The concept of the temple as the 'House of the God' always remained, and the phrase was used as a regular term for the monument. Large temples, sometimes constructed by gradual development over a long period of time, had adapted versions of the standard plan in which additional courts and pillared halls, separated by pylon gates, were added along the axis of the building. Great entrances were normally marked by monolithic paired obelisks, flanking the pathway. The finest example of this process occurred in the Great Temple of Amun-Ra at Karnak in Thebes. No temple was complete, however, until the stone building was enclosed by a mud-brick perimeter wall which ran around the whole of the sacred precincts, within which the subsidiary buildings – stores, priests' houses, temple libraries and usually a Sacred Lake – were constructed.

The stone temples exhibit well their origin from the plant forms mentioned above. Columns were generally cut in the style of reeds, most often the papyrus, with various forms of foliate capitals. These became most

36

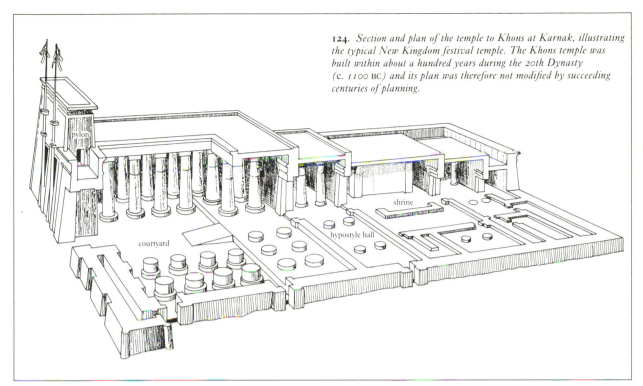

124. *Section and plan of the temple to Khons at Karnak, illustrating the typical New Kingdom festival temple. The Khons temple was built within about a hundred years during the 20th Dynasty (c. 1100 BC) and its plan was therefore not modified by succeeding centuries of planning.*

pylon

courtyard

hypostyle hall

shrine

elaborate on the temples of the Ptolemaic Period, when columns of different plant-based styles were given composite capitals in which elements of various plants were mixed. The whole building was considered to be a replica of the prototype temple of reeds; not only the columns, but also the walls show evidence of this tradition. The overhanging cornice and rounded torus moulding on the walls was imitative of reeds falling free at the top of a screen-wall, or bound together along the corners; the indication of the lashing, carved in relief on these features, is proof of the origin of the motif. Such details, and all the reliefs and representations in the temple, were originally painted in bright colours.

Certain temples had special functions which influenced their design, leading to a different arrangement from that of the standard cult-temple. Mortuary temples were one class; these are nothing more than the offering-chapels of royalty, enlarged and developed to an extent which brought them to the scale of substantial monuments. In the Old Kingdom, the royal mortuary temples were attached to the pyramidal tombs of the kings but their New Kingdom counterparts became freestanding stone-built temples, very similar to cult-temples in many cases. One of the best preserved examples is the temple of Ramses III at Medinet Habu, which had a full complement of subsidiary buildings inside its brick enclosure wall. Atypical examples are found in certain mortuary temples of the Eleventh Dynasty at Thebes, copied by

Queen Hatshepsut of the Eighteenth Dynasty. The temple and adjacent tomb of King Mentuhotep II at Deir el-Bahari was designed as a terraced building around a central superstructure, surrounded by colonnades of polygonal columns. This terraced pattern was adopted by Hatshepsut in her mortuary temple at the same site. Another distinct class of temple was designed for solar worship, exemplified by the Fifth Dynasty sun temples at Abu Gurab near Abusir and the later temples of the Aten at Amarna. A characteristic feature of these sun temples was the presence of large, unroofed courtyards, so that the sunlight should not be excluded as in the standard temple.

The construction of the temples varied considerably in quality; the mortuary temples of the Old Kingdom were lavish structures built from a variety of materials, including much granite, basalt, quartzite and other hard stones. Later cult-temples were more generally constructed of limestone or, in the New Kingdom, of sandstone, with more exotic stones used for certain elements such as doorsills and jambs, shrines and sometimes also for columns. The foundations of Pharaonic temples were generally formed of trenches along the lines of the walls, with the lowest courses of stone blocks laid on a layer of sand in the bottom of the trench. Frequently, the depth of the foundations was inadequate for the structure built above, and regular use was made of parts of older buildings as foundation masonry. The blocks of the walls,

pylons and columns, if the latter were not monolithic, were only roughly shaped before being built into place; the final dressing flat of the surfaces, including the shaping of the cornices and corner mouldings, was done after construction. This practice was characteristic of Egyptian stoneworking and was also used in the construction of the pyramids. Another link between pyramid building and temple construction was the use of brick and earth ramps to raise the blocks to the required height to place them in the higher courses. Remains of such ramps survive around the first pylon of the temple of Karnak, together with large areas of undressed masonry, showing clearly the process of construction. The roofing of the great temples consisted of stone architraves supporting stone slabs, often with clerestory lighting provided for the larger halls. The entire temple complex was normally surrounded by a mud-brick enclosure wall of large perimeter, within which the administrative buildings attached to the temple were built.

Mud-brick building

The use of mud brick in Egypt was far more widespread than the use of stone, vast quantities of bricks having been produced for all kinds of domestic, administrative, military and official buildings. Brickmaking required less skilled craftsmen that the quarrying of stone: the bricks were easier to transport and handle in bulk than stone and the raw material lay plentifully at hand. Brick provided houses of sufficient durability, which could easily be adapted and expanded, and, once the walls had been coated with a layer of plaster, could form comfortable dwellings. The first use of mud brick dates to the late Predynastic Period and thereafter it was used on a vast scale down to modern times; only now is this traditional building material being replaced in Egyptian villages by fired brick and concrete. Arches and vaults were developed in the Early Dynastic Period and by the New Kingdom they were used over spans in excess of seven metres. Vaulted roofing in domestic architecture became

common in the Late Period, as an alternative to the flat wooden roofs of earlier structures. Huge quantities of mud bricks were assembled for the construction of massive fortresses in Nubia and for the great enclosure walls of temple complexes, which could be anything up to as much as 20 m in thickness and could extend over a vast perimeter.

The method of brickmaking is illustrated by a wooden tomb model of Middle Kingdom date from Beni Hasan. The mud used was the alluvial deposit of the Nile after the inundation. When a deposit of the right consistency had been selected the mud would be carried to the brickyard, where it would be mixed with water. It was the usual practice to knead in at the same time some chopped straw and a certain amount of sand to improve the durability of the brick. The mud was then ready for shaping into bricks: the brickmaker formed each brick in a rectangular wooden mould on a suitable level area of ground. After sprinkling the bottom and sides with a little chopped straw, he filled the mould with handfuls of mud, pressing it down firmly. When the mould was full, it was removed, leaving behind the moist brick; another would be struck by its side until the whole area was covered with a regular series of bricks. Here they would be left to dry for two or three days, although some bricks were stamped with a royal or private name whilst the mud was still soft. Bricks with royal names were destined to be used in official projects, such as the enclosures of mortuary temples; those with the names of private individuals were employed as a decorative device in private tombs of the New Kingdom at Thebes.

Although the technique of preparing baked bricks was known from early times, the Egyptians used such bricks only in places where they had a particular advantage, such as floors, steps or structures exposed to damp. The earliest known use of fired bricks in this manner dates from about 1900 BC in the Middle Kingdom and further instances occur in later periods. Fired brick was much more commonly employed during the Roman Period. The actual size of bricks varied according to their use and their date. The bricks of the Early Dynastic Period are small; then comes an increase in size until the Middle Kingdom, followed by a fluctuation until the Twenty-sixth dynasty, after which there was a decrease to modern times. From the Old Kingdom to the Ptolemaic Period, two distinct groups of bricks were in use: a small type suitable for house building or for private tombs, commonly measuring 30 x 15 x 8 cm, and a large size for official buildings such as temples and palaces, measuring from 35 to 45 cm in length.

125. OPPOSITE *Massive wall of mud-brick, part of a Late Dynastic temple enclosure at Saqqara, built over the remains of a stone tomb of the Old Kingdom. The Egyptians were adept at building on a large scale in brick and strengthened great walls with timber ties, the positions of which are shown by regular rows of holes in the brick face. The curved lines of the brick courses was motivated by religious and mythological considerations.*

7

TECHNOLOGY

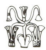

Stone-quarrying

The main building stones used by the Egyptians were limestone, sandstone and granite. The first of these materials was plentifully available from the cliffs bordering the Nile Valley from the Memphite region down to just south of Thebes, whilst further south the valley was bordered by sandstone desert. Granite, of pink and grey varieties, occurred in outcrops at Aswan. Core masonry for the Old Kingdom pyramids at Giza and Saqqara was of local surface rock taken from open quarries in the vicinity of the building site. For the outer casing, great quantities of a good quality limestone were transported across the Nile from vast rock-hewn quarries in the desert cliffs south of Cairo, in the region of Tura and Masara. The stone was soft, easily quarried with flint and copper tools, and was an excellent medium for fine masonry or relief carving. It was removed from the quarry economically, a block being isolated on four sides by means of narrow trenches cut into the rock and detached from its bed by the application of pressure from wooden levers after partial undercutting of the block. The best strata of rock were followed by tunnelling, a hollow space being driven along the whole length of the layer to be worked between the roof of the tunnel and the top of the first blocks to be detached, to enable the workmen to cut vertically down behind and around the block, and so gradually lower the floor of the quarry. The quarrymen used heavy stone mauls and stone or metal chisels, and wooden mallets. Fine limestone from Tura was used for quality masonry throughout the Dyn-

astic Period and the quarrying was carried out on an extremely large scale.

In Upper Egypt, the local limestone was generally of poor quality, but it was used as the chief building stone until the early part of the Eighteenth Dynasty when it began to be replaced by sandstone as the main material for the great temples of the region. Good quality sandstone was available on both sides of the Nile, very close to the river, at Gebel el-Silsila, from where it could easily be transported to Thebes to supply the ambitious building programme of the New Kingdom. The method of quarrying was similar to that used for limestone, the blocks being extracted by open and underground quarrying. Sandstone allowed for a greater span of architrave to be achieved, although the surface of the stone rarely permitted such a fine finish as that on Tura limestone.

Granite, both pink and grey, was regularly used throughout the Dynastic Period for impressive architectural features, such as columns, door frames and temple shrines. It came from the region of the First Cataract at Aswan, and much of the quarrying consisted of the trimming and removal of large boulders of the stone, which lay exposed in the desert. For particularly

126. OPPOSITE *Squatting figure of a baboon, one of the sacred animal representatives of the god Thoth. The statue is inscribed with the name of Amenhotep* III, *who was also responsible for the creation of several baboon-statues of colossal size at Ashmunein in Middle Egypt. 18th Dynasty,* C. *1390* BC; *quartzite.* H. *67 cm.*

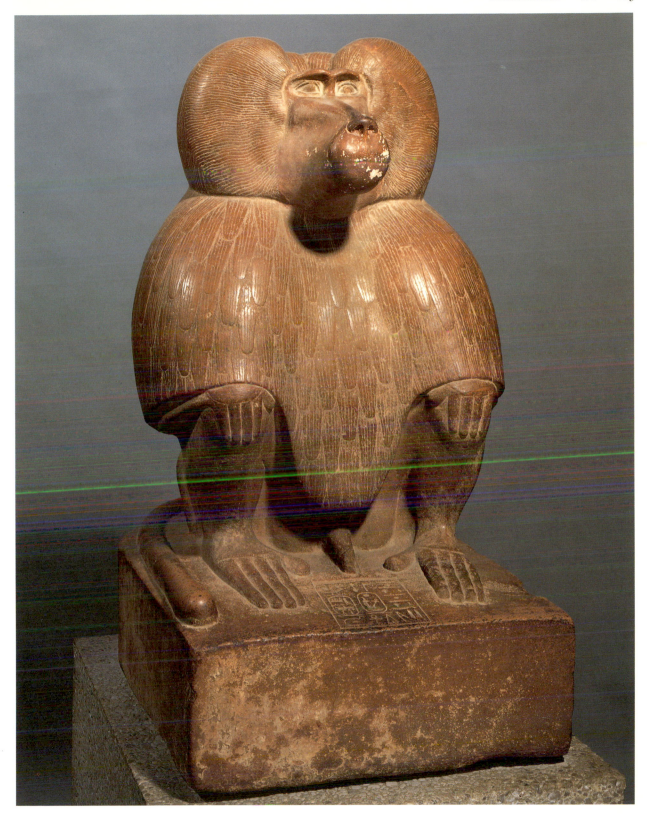

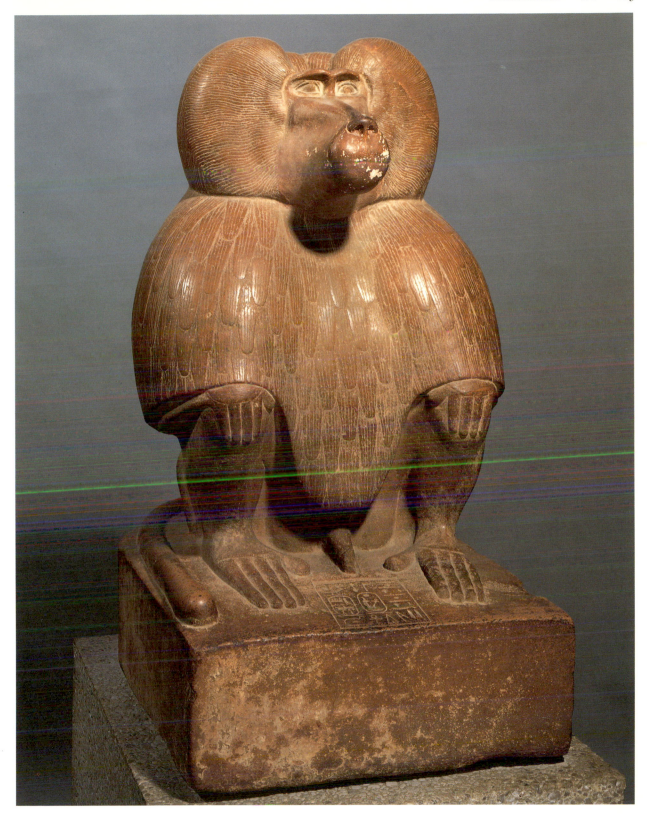

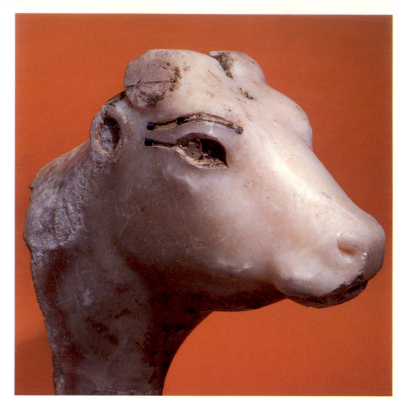

127. *Head from a statue of the goddess Hathor represented as a cow, from her shrine at Deir el-Bahri. Traces of the rock crystal and lapis lazuli inlay remain in the eyes. 18th Dynasty, c. 1450 BC; calcite with rock crystal and lapis lazuli, from Thebes. H. 35.5 cm.*

massive architectural elements, such as monolithic columns and obelisks, the granite had to be cut from the bedrock, a feat achieved by pounding out a trench all round the piece to be extracted, before undercutting the mass and splitting it from its bed. The majority of the work was carried out with stone tools, particularly hammers of dolerite; bronze chisels were too soft to cut granite, although the material could be sawn or drilled with copper implements provided quartz sand abrasive was used in the cut.

Other stones used to a limited extent in building were alabaster, quartzite and basalt, usually for important elements of temples. Alabaster was quarried in Middle Egypt at Hatnub, although technically this stone is calcite rather than true alabaster. It was used for temple floors, altars and occasionally for entire shrines. Quartzite, an extremely hard stone, was extracted near Aswan and at Gebel Ahmar, close to modern Cairo. Basalt was used in the pavements of the Old Kingdom pyramid temples and in temples and sarcophagi of Late Dynastic date.

Blocks of stone removed from quarries of all kinds were dragged on wooden sledges to the riverbank for transport by barge. More difficult was the transport of material from quarries distant from the Nile, such as those situated in the eastern desert and accessible only through the Wadi Hammamat from Qena. It was from this region that the Egyptians obtained a variety of silt-stone known as greywacke which they regarded as an exotic material for architecture or sculpture.

Extraction of Metals

Iron and lead, gold, silver and copper are all found as deposits in the rocks of the eastern desert and all, except iron, were known to the Egyptians from Predynastic times. However, not only are there few iron objects from Dynastic Egypt, but analysis has shown that the earliest examples are meteoric in origin. In this connection it should be noted that a piece of iron found during excavations at the Great Pyramid in 1837 is certainly intrusive. The scarcity of this metal even for royalty may be judged from the paucity and size of the iron objects found in Tutankhamun's tomb. Although there is an increase in its use in Egypt from the Twenty-second Dynasty onwards it is not until the Ptolemaic Period that iron tools are at·all usual. In the Roman Period iron household implements such as knives and flesh hooks become common.

MEDITERRANEAN SEA

128. *Distribution of stones, minerals and metals from the neighbouring deserts, used by the Egyptians.*

Wadi Natrun Φ

LIMESTONE

Memphis Tura
BASALT

Fayum

Beni Suef

Serabit el-Khadim

COPPER

Wadi Maghara

SINAI

EASTERN DESERT

Bahriya Oasis

Minya

Gebel el-Zeit

GALENA

Hatnub

IMPERIAL PORPHYRY Hurghada

Asyut
CALCITE (ALABASTER)

Farafra Oasis

Nile

ε

WESTERN DESERT

Qena

δ

Quseir

GREYWACKE

RED SEA

GOLD

Dakhla Oasis

θ

Esna
Elkab
GOLD

Kharga Oasis

Silsila

SANDSTONE

Aswan

Berenice

α GOLD

Quban

Abu Seyal
COPPER

DIORITE – GNEISS
Toshka

GOLD

Wadi Halfa

GOLD

NUBIAN DESERT

GOLD

GOLD

GOLD

GOLD

GOLD

Timna
COPPER

+ Rock Crystal

Φ Natron

θ Alum

α Amethyst

ε Garnets

I Turquoise

◇ Felspar

▽ Jasper

▼ Red Jasper

¤ Agate

δ Chalcedony

✳ Serpentine

⌗ Beryl

⋈ Malachite

0 — 300 mls
0 — 500 kms

Atbara

Meroe

There is almost nothing in Egyptian records of mining activities for lead although the ores are reported from a number of areas, mostly near the Red Sea coast, and the process of extracting it by roasting them was a simple one and mastered early. The chief ore found in Egypt is galena, sulphide of lead, which from Predynastic times was used in the manufacture of kohl, the ancient eye-paint. The raw material was finely ground on stone palettes which were among the most common items of grave equipment in Predynastic burials. Palettes of the Badarian Period (late fifth millennium BC) are flat and rectangular with a notch in the side; during the subsequent Naqada cultures they are frequently of green schist, shaped in the likeness of birds, animals and fish. The height of their development was reached with the series of large ceremonial palettes finely carved on both faces with scenes commemorating political and religious events. In later times, galena was mined extensively at Gebel el-Zeit in the eastern desert.

In the main lead was used for small objects of daily use such as sinkers for fishing nets or for ornaments such as rings but a siphon, strainer and small cup found together at Amarna are of lead. Like all metal in Egypt it could also be used as a medium of exchange and valuation: a problem put to the student in the Rhind Mathematical Papyrus (c. 1650 BC) reveals that at that time it had half the value of silver and a quarter that of gold.

The galena deposits of Egypt, unlike those at Laurion worked by the Greeks, are not rich in silver content; consequently, from at least the time of the Middle Kingdom, silver had to be imported from Asiatic sources by way of both trade and tribute. Analyses have shown that so-called silver objects predating the Middle Kingdom are actually manufactured from naturally silver-rich gold which has a white colour. For the ancient Egyptians silver always remained more highly prized than gold yet an indication of the scale of its importation during the New Kingdom at least can be seen in the constant ratio of 1:2 between the two metals in spite of the quantities of gold then coming to Egypt from Nubia.

Electrum is both a naturally-occurring and an artificially-produced compound of which the main constituents are gold and silver. Modern authorities have termed electrum any gold-silver alloy containing between twenty and fifty per cent silver, thus ranging in colour from deep yellow to pale-yellowish-white. However, since most ancient Egyptian gold is impure, containing by nature up to twenty per cent silver, the distinction to be drawn between low-grade gold and electrum is often arbitrary. Since it is rather harder-wearing than gold alone, electrum was in use from the earliest dynasties especially for jewellery elements.

The gold-bearing region of the eastern desert extends broadly speaking from a short distance to the north of the modern road connecting Qena with Quseir southwards into the modern Sudan. The main areas of exploitation are to be found in three concentrations which have their natural outlet on to the Nile Valley at Qena and Qift (ancient Coptos), at Elkab and Edfu and at the mouth of the Wadi el-Allaqi in ancient Nubia where, in the Middle Kingdom, the Egyptians built the forts of Quban and Ikkur.

Gold occurs both in the alluvium of the *wadi*-beds and in the veins or dikes of white quartz which are present in the igneous rocks of the great central range of hills between the Nile and the Red Sea, running parallel to the river. Recovery of the gold from the alluvium was a simple matter, given water to run down a sloping surface over the gold-bearing gravel and a body of unskilled labour; the lighter material was carried off and the heavier gold was left behind as fine particles or occasionally as small nuggets. In the case of the quartz veins, exploitation necessitated considerable organisation, involving the use of skilled miners or quarrymen to extract the rock and a large body of labour to crush the matrix with heavy stone mortars (rotary grinders were not known in ancient Egypt). The gold reached Egypt either as dust tied in linen bags or small fragments of metal fused into nuggets, even as moulded hide-shaped ingots or heavy rings, as can be seen in scenes of tribute brought from Nubia depicted in private Theban tombs of New Kingdom date.

The thoroughness with which the ancients prospected for gold, removing the alluvial gravel and following the gold-bearing quartz veins, has often been remarked upon. There are no centres of modern exploitation which do not have some indication of ancient working: deep galleries, open cuts, numerous stone ore-crushers, troughs, washing tables and stone huts. It is, however, rarely possible to say whether these workings are of Pharaonic, Ptolemaic, Roman or Islamic date.

The Egyptians themselves left few written records which bear directly upon the nature of their expeditions or upon the organisation of the mines. There is nothing at the ancient sites in the nature of the official commemorative stelae and rock tablets which are found at the quarries of ornamental stone. The absence of official inscriptions may in part be explained by the nature of the rock – usually granite – in which the quartz veins occur; it does not lend itself to carving. The passage of workmen to and fro from the site is attested by occasional graffiti in the sandstone area. Certainly at some periods there seem to have been permanent settlements in the desert, banishment to which was one of the punishments inflicted upon criminals by the courts, as is recorded by accounts of investigations into the activities of the tomb robbers in the Twentieth Dynasty.

Copper does not occur in its metallic state in Egypt; but was extracted from ores as early as the Badarian Period, being manufactured into beads and small implements like needles and borers. A number of areas show traces of ancient mining and smelting both in the eastern desert and also in Sinai, at the Wadi Maghara and Serabit el-Khadim. The ore was smelted close to the site at which it was mined or else was dragged on sledges to the nearest point at which sufficient supplies of fuel could be obtained. The crushed ore was mixed with charcoal on the ground or in a hollow pit; practical experience no doubt taught the value of siting the fire in the best position to take full advantage of air currents. Representations of metal-working in tomb scenes show the metal being placed in an open clay crucible on a charcoal fire the temperature of which was raised by using blow-pipes. Some time early in the New Kingdom a form of bellows was introduced: a pair of inflated skins was worked by foot and a current of air directed on the embers by means of clay nozzles. Primitive though the method was, it was sufficient to obtain the required temperatures for casting metal, but the amount of ore normally worked upon at any one time must have been small and the metal produced contained considerable impurities, heating and reheating being the only method of refining.

Metal-working

The addition of a small proportion of tin to copper produces bronze, and results in a lower melting-point, an increased hardness and a greater ease in casting. Bronze is attested in Egypt from the early Dynastic Period on but its use was on a limited scale until the Middle Kingdom. Tin does not occur in Egypt and it is not known whether the bronze used was originally all imported in a manufactured state or whether the alloying was done in Egyptian workshops. Before the introduction of tin, Egyptian copper was hardened by the addition of arsenic. It is not yet known how or whence the arsenic was obtained, though a foreign source seems likely. Arsenical copper was employed from the Early Dynastic Period right up to and including the Middle Kingdom, after which it was largely supplanted by bronze.

Metal-working scenes regularly include a representation of the crude metal being weighed in a balance before issue to the metal-worker. The Egyptian balance in its simplest form consisted of a wooden beam suspended from its centre point by a cord held in the hand and drilled at the ends to take a single cord and hook for pans, in one of which the weights were placed and in the other the metal. From at least the Fifth Dynasty the beam was supported by an upright standard. A plummet line was hung parallel to the upright so that the weigher could check the accuracy of the balance by comparing the plummet with a rectangular board attached at right angles to the balance arm. In the course of time improvements in design were made ensuring greater precision, though the basic principle of weighing remained unaltered throughout the Dynastic Period. From the Middle Kingdom the pans were suspended by four cords. By the New Kingdom two further refinements increased the accuracy of the balance. The rectangular board was replaced by a pointed metal tongue. Tubular beams, terminated with flanges in lotus or papyrus form, were introduced so that the strings of the pans came out together from inside the beam and diverged from the lowest point of the edge of the flange. This is the design of the elaborate standard balances illustrated in vignettes in *Book of the Dead* papyri of the New Kingdom. Representations of the Roman Period suggest that the balance

129. *Pair of vessels from the tomb of Khasekhemwy at Abydos, a spouted ewer and an open basin, used traditionally for hand-washing after a meal. Both vessels consist of bronze, and are the earliest confirmed examples of its use in Egypt. 2nd Dynasty, c. 2700 BC; H. 11.4 cm, 12 cm.*

had disappeared from daily use and that the draughtsman was reproducing an object of which he had no direct knowledge.

Large numbers of weights have survived from Egypt. They are, for the most part, made from the harder stones and are simple in shape, the duck, lentoid and animal forms familiar in Western Asia being rare. The great majority of weights are unmarked; actual weighing shows that there were a number of different standards in use. Weights marked with the unit and standard to which they belonged (or with their equivalent value in another standard) are uncommon. In the British Museum, a felspar weight of 1,021 grammes from Gebelein, inscribed with the figure 5 and the name of Amenophis I, belongs to the ancient gold standard, the most commonly named of all the standards, indicated by the writing of the hieroglyphic ideogram for 'gold', *nub*. In texts of the New Kingdom the weight of metal is usually expressed in a number of *deben* approximately 140 grains or 91 grammes each consisting of 10 *kite*.

The dynamic development of the material culture of Egypt, which coincided with the unification of the country, must be largely attributed to the more plentiful supply of copper and to its use in making tools. Flat objects like chisels, knives, axe-heads and adzes were cast in open pottery moulds. Since, in the earlier periods, the Egyptians did not possess tongs for holding hot metal the final shaping of the tool and the hardening of its cutting edge was done by cold hammering. Metal tools or models of tools are not uncommon from funerary equipment or foundation deposits.

Because of the value of all metal, care was taken to weigh tools before they were issued to workmen and again when they were returned to the store to ensure that there had been no pilfering of the metal. The theft of metal tools figures prominantly in the surviving records of trials. Of particular interest, both for their comparative rarity and for their firm dates, are the tools marked with royal names: an axe-head tied with its original leather thongs to a wooden handle inscribed with the name of Thutmose III, and an axe-head of Amenophis II, and another inscribed 'King of Upper and Lower Egypt, Usermare-setepenre, beloved of Horus Lord of Tanis', probably Sheshonq III.

The personal weapons of the Egyptian soldiers comprised daggers, swords, spears and axes. Daggers were short with rounded cheek pieces of bone or ivory. The sword was little more than a long dagger for thrusting and slashing in close combat; the short, straight, two-edged blade had grooves, which might take the form of lotus stems and birds. A curved scimitar-like sword with handle fashioned in one piece (called in Egyptian texts *khepesh*) was introduced on the pattern of Western Asiatic models during the Second Intermediate Period. The

spear had a pointed metal blade and metal butt riveted to a wooden shaft. The battle-axe was the main weapon of the Egyptian infantryman. In the Old and Middle Kingdoms rounded and semicircular forms, designed for slashing and cutting, predominated, the most popular of these being the type with three rear tangs forming open scallops in the blade.

A particularly fine scalloped axe in the British Museum's Collection consists of a bronze blade riveted to a hollow silver tube which was originally fitted on a wooden haft. An identical battle-axe hafted in precisely this manner is shown in the hand of one of the body-guards of a Twelfth Dynasty nomarch, represented on a limestone relief from Bersha. In the Second Intermediate Period, a new form of battle-axe was evolved, suited for piercing rather than slashing, with a narrow, elongated blade and concave sides. The elaborate axe-heads with open fretted designs which appear from the beginning of the Middle Kingdom were more often ceremonial rather than functional. The designs most favoured were details of the hunt, or fighting animals, such as two bulls with their horns engaged. One axe from the early

131
131

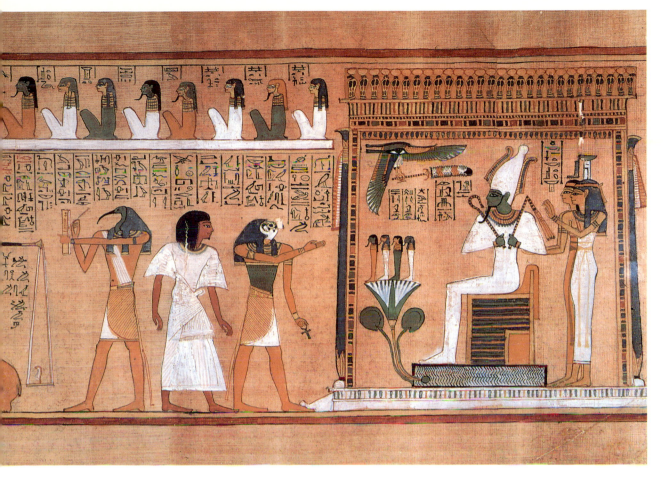

130. ABOVE *Vignette from Hunefer's* Book of the Dead *depicting his heart weighed against Maat's feather to ascertain his worthiness to enter heaven. Anubis checks the balance, Amemet waits to eat sinful hearts, Thoth records the result and Horus introduces Hunefer vindicated to Osiris. 19th Dynasty,* C. *1285* BC; *painted papyrus.* H. *39.5 cm.*

131. BELOW *Part of a wall relief from the tomb-chapel of the governor Djehutyhotep, showing his retinue, some of whom carry weapons. 12th Dynasty,* C. *1850* BC; *painted limestone, from Bersha.* H. *36 cm.*

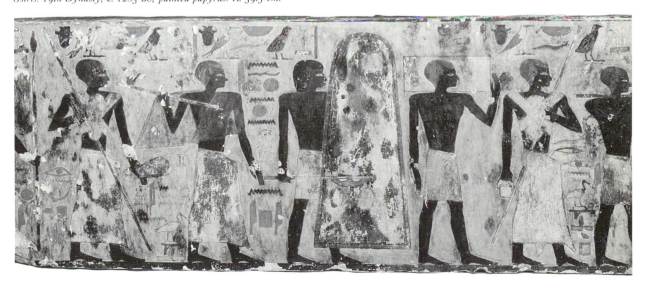

Eighteenth Dynasty shows an early representation of a man riding bareback on a horse. These axe-heads were fitted to wooden hafts and secured by leather thongs. Until the New Kingdom, the Egyptian soldier seems to have had no defensive armour except for his shield of tough leather stretched over a wooden brace to which it was attached without an additional frame. Defensive mail coats made by riveting small bronze plates to leather jerkins were also adopted during this period; helmets first appear on battle scenes with representations of foreign mercenary elements in the Ramesside Period.

Copper, and later bronze, provided material for a wide range of domestic utensils in addition to tools and weapons. Household vessels, cauldrons, ewers, basins, and ladles of metal formed, with textiles, part of a house-holder's negotiable property which could be used for barter. Among articles of the toilet, circular flat disks were used for mirrors from the beginning of the Dynastic Period, the polished metal giving a good reflecting surface. They were usually undecorated before the Twenty-first Dynasty, then scenes of ritual significance were sometimes incised upon them. The mirrors were fitted by a tang to handles of metal, wood, glazed composition or ivory, usually shaped like a papyrus column, a washerman's club or a Hathor-head but also sometimes in the form of a nude woman; protecting falcons or snakes might appear on the cross-pieces. Glass mirrors did not occur before the Roman Period.

Pins, tweezers (for the extraction of thorns as well as the removal of hair) and razors are also common. The last in the New Kingdom consisted of a small flat piece of metal, shaped not unlike a minature axe with sharp edge, which was fixed in a curved wooden handle and rotated by the fingers. These objects of daily use are for the most part simple in design; among the more unusual examples is the handle of a toilet implement in the form of a man on horseback.

The use of metal for figure subjects is comparatively rare before the late Dynastic Period. The Palermo Stone records the making of a copper statue of Khasekhemwy of the Second Dynasty; a remarkable copper statue in Cairo of Pepy I of the Sixth Dynasty is, however, the earliest surviving example of metal sculpture. The precious nature of all metal in Egypt no doubt accounts for the rarity of early pieces, since much of the metal would eventually have been melted down and reused. On the other hand, the wealth of Egypt from the New Kingdom onwards, when the empire was at its height, may explain the apparent increase in the number of metal statues of kings and gods from the Eighteenth Dynasty. The kneeling figure of a king making an offering, inscribed on the girdle with the prenomen of Thutmose IV without cartouche, is the earliest in the series of the inscribed statues of kings. The outline of the eyes and eyebrows

132

132. *Statuette of Thutmose* IV, *identified by the cartouche on the belt. The king wears the* nemes-*headcloth and is kneeling and offering two pots, a posture attested in royal sculpture in stone from the reign of Hatshepsut. 18th Dynasty, c. 1400* BC; *bronze.* H. *14.5 cm.*

is inlaid with silver; small pieces of alabaster painted black to indicate the iris and eyeball are inserted in the eye sockets.

Of statues of private individuals, the 34–cm high standing figure of Khonsirdais, a priestly official under Psamtek I is exceptionally fine in its detail. He is shown standing with his left foot forward, clad in a long pleated garment over which is the priestly panther skin passing over the left and under the right shoulder. Originally he held in his hands a figure of a god which was cast

separately and secured to the group by a metal tenon. On the right shoulder is incised a figure of Osiris; the front of the skirt has an incised scene of the dead man before Osiris.

The majority of bronzes represent gods, sacred animals and emblems and date, for the most part, from the Saite and Ptolemaic Periods. Casting was by the lost-wax technique, *cire-perdue*. A model of the object was first fashioned in beeswax and coated with clay pierced by holes so that when it was heated the wax melted and ran out leaving a hardened clay mould into which the molten metal was introduced through the holes. After the metal had cooled the mould was broken away. Small objects were normally solid cast but in the interests of economy larger statues were shaped in quartz sand which was then thinly coated with beeswax. A clay mould was made in the same manner as if the object were to be solid cast. On heating the core hardened and the metal was introduced to replace the thin coating of beeswax, now melted which had lain between the mould and the inner core of sand. It is still uncertain how this inner core was held rigid during the process; perhaps pins passing through the outer casing of the mould were used. When the metal had cooled the clay was broken away and the object was given the final touches with a chisel.

Jewellery

Even before the beginning of the First Dynasty gold and silver were being formed into beads of sheet metal or foil over a core. Before long they were also being cast to make small statues in the same way as copper and bronze. The ability to work large masses of the material is shown by the solid gold innermost coffin of Tutankhamun which weighs just under 113 kg. However, precious metal was the first objective of the ancient and modern tomb robbers and so vessels, small sculptures and solid funerary masks in these materials are uncommon in museum collections. Consequently, most surviving examples of the goldsmith's craft are items of jewellery which in Egypt was worn by both men and women, even sacred animals, on just about every part of their anatomy. Diadems and circlets, hair ornaments, earrings, ear plugs and studs, torques and chokers, collars, bead strings and necklaces, pectorals and girdles, bracelets and bangles, armlets, anklets and finger-rings have all been identified.

Most basic types of jewellery were in general established in form by the end of the Old Kingdom; only earrings made a relatively late appearance at the end of the Second Intermediate Period, apparently influenced by Nubian fashions. Of jewellery which has survived some had been worn in life as a sign of rank of office, as military or civil award, to be amuletic and protective or purely decorative and then taken to the tomb for use in the afterlife. A gold foil amulet of the goddess Maat on a loop-in-loop gold chain was the insignia of a judge during the Late Period. At the beginning of the New Kingdom gold flies, large but light sheet gold *awaw* bangles and a *shebyu* collar with tightly strung rows of solid gold disc beads were all part of an honorific award for valour. A string of pendant gold figures of the hippopotamus goddess Taweret might have aided women in childbirth; metal oyster shells were intended to endow them with health. A fish pendant with central green stone inlay was worn at the end of a child's or maiden's plait to avert the danger of drowning. A string of metal cowrie shells formed a girdle to ward off the evil eye from its female wearer. Two gold spacer bars, each topped by three reclining cats, came from a bead bracelet belonging to queen Sobekemsaf, wife of a Seventeenth Dynasty Theban ruler.

Other pieces are prescribed funerary jewellery made specifically to be set on the mummy and give amuletic protection during the fraught passage to the Underworld. Of this category among the most important was the stone heart scarab, often set in gold, like that of king Sobekemsaf II of the Seventeenth Dynasty made of green jasper with a human head. Other funerary scarabs of glazed composition with separate wings were to be stitched onto the mummy wrappings over the chest.

Even before the beginning of the First Dynasty a diadem for a non-royal female exhibits the Egyptian jewellery maker's skill at combining highly-coloured semiprecious stones and precious metal. The most commonly used stones were cornelian, turquoise, lapis lazuli (always imported from Afghanistan), feldspar, green and red jasper, amethyst (especially popular during the Middle Kingdom), quartz and, to a lesser extent, agate, garnet and steatite. Most of them could be and often were imitated by coloured glass and glazed composition. Perforating stone beads by means of multiple bow-drills and polishing the finished items are depicted in a fragmentary wall-painting from a Theban private tomb of New Kingdom date.

When gold was not cast solid it was beaten into a sheet on a flat surface by a stone held in the craftsman's hand. Any design on it was executed with a hand punch on the back (repoussé work) and with a chasing tool on the front. Most simply, wire was made by cutting strips off the edge of a sheet or, for a more continuous thread, by cutting the sheet in a spiral. Since the Egyptians had no shears or fine saws separation was by punching out with a sharp chisel, a technique called *ajouré* which was used in particular to produce the base plates of openwork inlaid pectorals. An *ajouré* gold plaque in the collection depicts king Amenemhat IV offering unguent to the god Atum. For pectorals details of the design would be

133. LEFT *Gold scarab finger-rings with swivelling bezels. 12th (c. 1820 BC), 18th (c. 1470–1425 BC), 22nd (c. 945–924 BC) Dynasties and New Kingdom (c. 1250 BC); blue glass, green glazed steatite, green glazed composition, green jasper, amethyst, obsidian, lapis lazuli.*

134. BELOW *Amuletic strings on which hang: solid cast flies with beads; date-shaped pendants alternating with lizards which symbolise regeneration; hollow beads and amulets of Taweret, the goddess of childbirth. 18th Dynasty, c. 1470–1350 BC; gold, garnet, cornelian, lapis lazuli.* L. *of outermost string 41.8 cm.*

135. OPPOSITE ABOVE *Diadem of beads and chips of stone and sections of tiny metal rings. It was found on a woman's head, still holding a piece of cloth like a veil over the face. Naqada II Period, c. 3200 BC; turquoise, garnet, malachite, gold, from Abydos.* L. *31.2 cm.*

136. OPPOSITE BELOW *Gold pectoral of a flying falcon. Its back is a mass of cloisons which were once filled with polychrome inlays, now much decayed. Saite Period or later, after 600 BC; gold with red, blue and green glass.* W. *14.8 cm.*

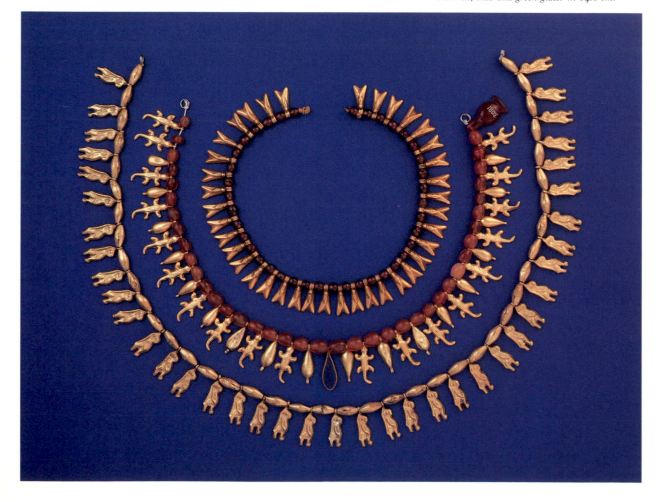

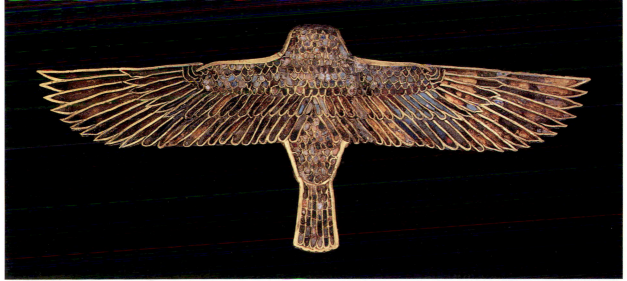

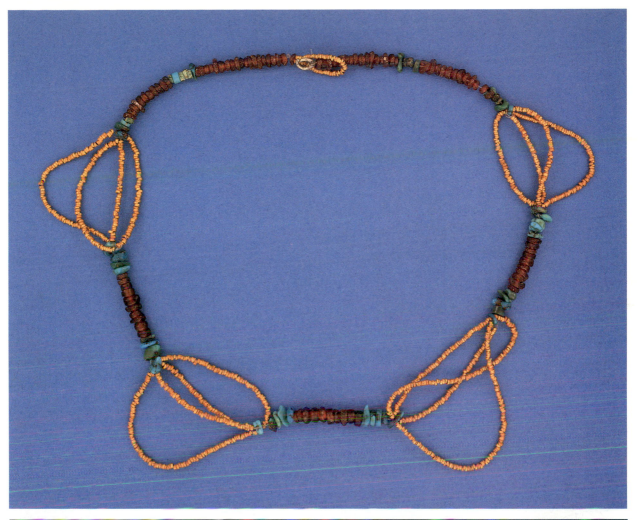

executed on the base frame in chased repoussé work and on the front by a series of metal cells (cloisons) fitted with semiprecious stone or polychrome glass inlays usually held in position by cement but in the best work only by the walls of the cells. In the case of glass inlays heat was not used to produce true enamelled work before the Meroitic Period. Some of the finest stone-inlaid cloisonné work was produced during the Middle Kingdom, as illustrated by a tiny winged scarab and elements spelling out the throne name of king Senusret II. The tradition was maintained a thousand years later in a pair of stone and glass inlaid gold bracelets made for a son of Sheshonq I and later still in a flying gold falcon in the round, its back a mass of glass-inlaid cloisonné feathering. Other metal decorating techniques mastered by the jewellery-makers of the Middle Kingdom were granulation, the art of attaching gold granules to a sheet gold surface, best seen in a hollow gold amulet case.

Gold in sheet form was used to decorate wooden furniture. Thick sheets were hammered directly onto the wood and fixed by small gold rivets. Thinner sheets, i.e. foil, were attached by an adhesive to a prepared plaster base. The finest and thinnest gold leaf was freely used to gild statues, mummy masks, coffins and other items of funerary equipment. It too was applied over a layer of plaster but the adhesive used is still uncertain.

Stone Vessels

The wide range of fine stones available in the desert quarries of Egypt was exploited effectively in the large-scale production of vessels of various styles and sizes. For certain special purposes, such as royal funerary equipment or temple ritual vessels, care would be taken to select particularly rare or attractive varieties of stone, enhanced by mottled or banded colour differences in the material. Mastery of the art of hollowing stone vases was developed early in the Predynastic Period, when tall vases of basalt were manufactured in addition to vases made in softer stones. Certainly by the time of the Naqada I Period stone vessels were made in great quantity, the usual forms being slightly curved in a barrel- or heart-shape with two perforated lug-handles for suspension. With the increasing wealth of the population towards the end of the Predynastic Period, stone vases were made in a wider range of styles and in larger sizes, a trend which continued into the First Dynasty.

137. *Group of early stone vessels of various forms, examples of the Egyptians' mastery in working hard stones. Such vessels were normally used for funerary equipment. These vases range in date from the Predynastic Period to the 2nd Dynasty, 3500 to 2750* BC.

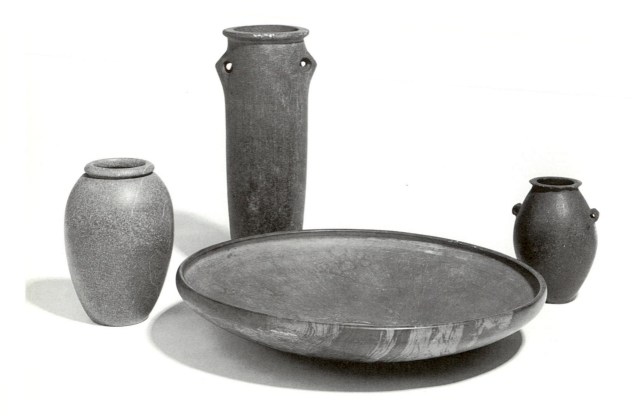

Great numbers of stone vessels have been recovered from royal and private tombs of the Early Dynastic Period and of the Third and Fourth Dynasties. The hoard of vessels from the subterranean galleries of the Step Pyramid of Djoser is numbered, for instance, in thousands. However, the bulk of these vessels consisted of calcite, and the greatest number of different forms of stone vessel, in the widest range of materials, is found in the First Dynasty. Particularly fine vases were found in the royal tombs at Abydos, some examples being of great size and weight. Exotic forms have been found amongst the funerary equipment of these royal burials, manufactured in particularly colourful stones with the addition of gold plate over the rim and handles. The majority of stone vessels were made for funerary purposes, with pottery being the main material for everyday use. Those stone vessels which do occur in domestic contexts are generally very rough troughs or basins of limestone, or querns and mortars of quartzite and granite.

Representations in tomb scenes of the vessels being made as well as examination of finished and unfinished vases show that the hollowing was done, once the outside had been roughly shaped, by drilling the stone. For the creation of vessels in soft stones the drill was tipped with crescent-shaped bits of flint, whilst harder materials were ground away by the use of hard stone drill-bits used together with quartz sand as an abrasive. Sometimes vases were made in sections to simplify the task of interior hollowing. In later periods, more regular use was made of tubular drills of metal, which left a cylindrical core.

Stone vessels continued to be made throughout the Dynastic Period: during the Old Kingdom they were a regular part of funerary equipment, although hard stone examples were steadily replaced by calcite and model vessels were regularly substituted for full-size versions. Some inscribed vessels bearing the names and epithets of kings are known, usually small cylindrical jars of calcite with a broad, flat rim. By the Middle Kingdom the majority of vessels were small and were used for containing cosmetics, particularly characteristic examples of the period being made in a pale blue anhydrite. With the New Kingdom new shapes were introduced, some inspired by forms previously made in pottery, with loop handles in a variety of styles. Elaborate vases of calcite were still manufactured for funerary purposes, often shaped into the form of animals or birds. In addition to the ubiquitous calcite, brown serpentine became popular at this period for the production of tall, single-handled jugs, frequently made in two or more sections.

Late Dynastic and Ptolemaic Period stone vessels were produced in a number of new styles, influenced by foreign imported pottery. A common form from about 600 BC was the so-called 'alabastron', a tall, narrow vase

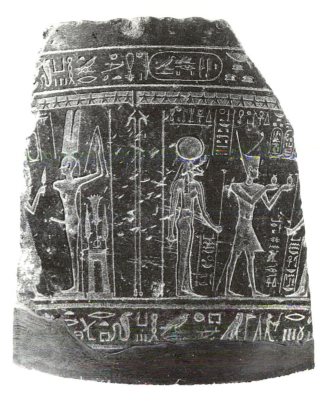

138. *Outer surface of a fragment from a water-clock inscribed with texts and scenes of offering in which the figure of Pharaoh is identified as the Macedonian king Philip Arrhidaeus, a successor of Alexander the Great. Macedonian Period, c. 320 BC; basalt. H. 35 cm.*

with vestigial handles, narrow neck and broad, flat rim. In settlement sites of the period many examples have been found of heavy dishes and mortars in hard stones, produced for everyday uses. Fragments of water-clocks, or clepsydrae, a device invented in the Eighteenth Dynasty, inscribed for Alexander the Great and Philip Arrhidaeus are preserved in the British Museum's collection. On the interior of these devices the twelve hours of the night were marked by vertical lines of small holes, so that the passage of time could be recorded as the water inside the vessel gradually drained away thorough a small aperture in the base. A less elaborate calibrated vessel in the collection is the late New Kingdom jar with lid, which is marked with a measure of its capacity at $8\frac{1}{6}$ *hin*, equivalant to 4.83 l.

Pottery Vessels

The Egyptians made extensive use of Nile river clay for the production of a range of domestic items, the most common among which were household pots. The earliest pottery containers date back to the Fayum and Badarian

Predynastic cultures, of which those from Badarian sites are by far the better made. The walls of the pots are thin; the regularity and evenness of the shape are noteworthy, the more so since they were built up by hand without the use of a wheel. Before firing the pots were polished with a pebble to give a characteristic burnished red appearance, but some vessels were given a black surface treatment, either completely or simply in a band around the rim. Also characteristic of the period is a fine decoration of rippled lines produced by running a comb-like instrument over the wet clay.

The pottery of the succeeding Predynastic cultures shows considerable development in the range of shapes produced. External roll-rims appear and vessels with perforated lug-handles were made. The range of decorated pottery was increased, with examples of modelled, incised and painted motifs on the polished red exterior surfaces of the vessels. The blackening of pots around the rim, noted from the Badarian Period, was still common.

The earliest painted designs consist of geometric patterns on a red surface, although occasionally the abstract patterns are replaced by animal figures. This class of pottery seems to have been fairly rare compared with the simpler black-topped vases. Characteristic of the Naqada II phase of Predynastic culture is a class of pottery manufactured in a pink marl clay, decorated in dark red paint with scenes of boats and figures of people and animals. Other vases of the period were painted with spiral or mottled designs in imitation of the appearance of vessels of hard stones.

With the end of the Predynastic Period, decorated pottery virtually disappears, to be replaced by utilitarian ceramics which, with few exceptions, were characteristic of Dynastic Egypt. Decorated pottery remained in use in Nubia and imports of this material appear at certain times at Egyptian sites, particularly during the Second Intermediate Period. Pottery of Minoan, Cypriot and Syrian origin has also been found in Egypt at sites of this period. The native pottery was formed of Nile silt or marl clays in a variety of shapes which altered over time. By the New Kingdom a range of tall drop-shaped vases had become popular and painted pottery reappears briefly, the finest decorated vessels belonging to the Amarna Period. A characteristic blue paint was used at this time, with details picked out in red and black, usually to create floral designs.

After the New Kingdom Egyptian pottery reverts to its traditional utilitarian style, but a feature of Third

139. *Vase for ointment in the shape of a woman playing the lute. During the 18th Dynasty, the range of figured vessel types expanded in all materials (compare the fish in Fig. 142 and Fig. 146). At the same time, the practice of placing such luxury items in the tomb ensured their survival in a domestic context. 18th Dynasty, c. 1350 BC; painted terracotta, from Thebes. H. 23 cm.*

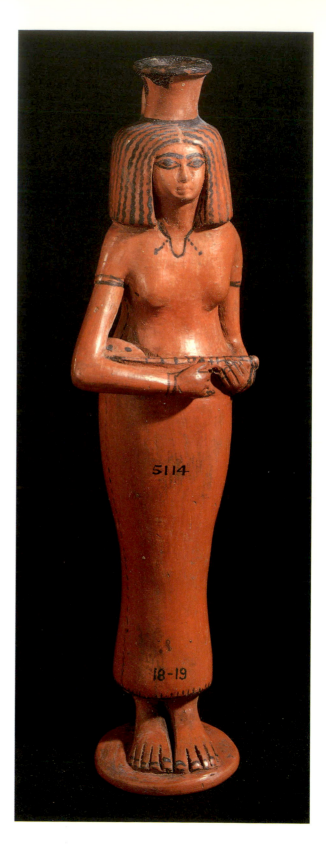

Intermediate Period ceramics is the adoption of a fine pink marl clay with a pale greenish surface to make vessels of good quality. Rougher, siltware pots were made at the same period for heavy domestic use. Improvements in ceramic technology in Late Period and Ptolemaic times led to an increase in the range of shapes produced, supplemented by greater numbers of imported vessels.

Terracotta

Nile silt clay was regularly used for the production of human and animal figures, the earliest of which occur in the Predynastic Period. Part of a well-modelled female figure of Badarian age is preserved in the British Museum and numerous examples of steatopygous female figurines are known from the middle Predynastic Period. The latter figures are stylised representations with beak-like faces and the arms raised above the head. From a grave at Amra comes a pottery model of a group of four oxen. The extent of the use of terracotta during the Dynastic Period has been underestimated, partly due to the relative lack of attention paid to settlement archaeology by early excavators. Recent work has shown that pottery animal figures, in particular, occur regularly in domestic contexts. More elaborate terracottas are the female fertility figurines of the Middle Kingdom and figures of bound captives of similar date. Both of these styles had magical significance.

The use of terracotta was extended in the Late Period and it became widespread during Ptolemaic and Roman Periods, as a result of the increasing influence of the Greek and later Hellenistic world on Egypt. Large numbers of terracotta heads have been recovered from late settlements at Memphis, whilst figures of deities and animals are common in sites of Roman date.

From the Roman Period also dates the widespread use of clay lamps. Some, like a lamp with two wickholders on a stand in the form of the god Bes from the Fayum, have some pretence to individuality, but the majority belong to the familiar type current throughout the Mediterranean world. The usual shape of the lamp is lentoid, made in two pieces from moulds and frequently stamped on the base with the potter's mark, a letter, or simple geometric design. They are provided with a central opening for filling with oil and a nozzle with a hole for the wick of twisted flax or papyrus. A common type has modelled on its upper surface a representation of a frog. They belong for the most part to the third and fourth centuries AD. More uncommon are lamps in the form of a human face with oil-hole at the top of the forehead and burner at the base of the neck, or a lamp with loop handle decorated with a frog and mythological animals. The use of clay lamps continued late into the Coptic Period.

Faience and glazed stones

Glazed composition, less correctly faience, is more typical for plastic art in dynastic Egypt than terracotta, appearing as early as the Predynastic Badarian Period. Beads are the commonest glazed objects from this early time, not just of composition but also with a solid quartz or steatite core. Indeed, massive girdles with multiple strings of steatite cylinder beads glazed green in imitation of a like-coloured semiprecious stone are particularly characteristic of the Badarian culture. Glazed solid quartz remained in use until the end of the Middle Kingdom, mostly for beads, small amulets and pendants, only a few larger objects being known. Presumably its hardness and the difficulty of shaping it prevented its greater employment. Steatite, however, being a soft stone was particularly suitable for carving into small objects like amulets and figurines of gods and proved an ideal base for glazing since it does not disintegrate under heat. Glazed steatite objects are found throughout the Dynastic Period and it is by far the most common material for scarabs.

Glazed composition consists of a core made ideally but rarely of pure quartz sand grains or quartz or rock crystal pebbles ground into a fine powder. Although in this dry state the body material was light and friable it had no coherence; it is most likely that the small addition of a weak solution of natron or salt provided the binding agent. When heated it would have combined chemically with the quartz to produce a mass which could be worked with the fingers. For small objects the material was shaped in open-backed pottery moulds, large numbers of which have survived from the New Kingdom and later. The popularity of this composition material for small objects of personal adornment (such as beads and necklace elements, pendants, finger-rings and ear-plugs) was unrivalled. For funerary equipment light blue is a feature of glazed composition objects of Thirtieth Dynasty date such as *shabtis* and small items of daily use like a lidded dish in the shape of a lotus capital with three compartments for unguents. Black, white and purple (based on a manganese compound) were used sporadically from the Old Kingdom onwards; yellow and red were added during the mid-Eighteenth Dynasty when polychrome glazed composition reached its highest stage of development, being especially well illustrated by objects from Amarna. Openwork broad collars made up entirely of floral elements are particularly characteristic examples of the variety of colours in use at this period. In one collar the lotus-headed terminals are inlaid with glazes of different colours and the component elements are yellow mandrake fruits, green palm leaves and white lotus petals with purple tips. Finger-rings with polychrome bezels, signet rings in many different colours imitating the shape of

140

140. *Openwork broad collar of beads and pendants with a floral motif: mandrake fruits, date-palm leaves and zoned petals. The inlaid terminals are lotus-shaped. 18th Dynasty, c. 1430 BC; polychrome glazed composition, from Amarna. L. 52 cm.*

metal examples and ear-plugs with highly decorated domed tops are also common. Among attractive combinations of colours which occur in other objects is purple on a white ground found on some *shabti*-figures and on a tubular eye-paint container inscribed with the cartouches of Tutankhamun and his queen Ankhesenamun.

From houses and palaces at Amarna and from Ramesside royal residences with their decorated walls or architectural elements come numerous polychrome tiles and inlays with floral patterning; the commonest are small plaques bearing a white flower head with a yellow centre. Their prototypes date back to the Third Dynasty when large numbers of rectangular tiles measuring about 6 cm by 4 cm glazed in plain green or blue panelled the underground passages of the Step Pyramid at Saqqara in imitation of reed mat hangings. Particularly remarkable for the skill with which the different coloured glazes were fused to the composition core are tiles from the Ramesside palaces at Qantir and Tell el-Yahudiya in the Delta and at Medinet Habu at Thebes which bear representations of foreigners with details of their gaily patterned costumes carefully executed. The larger tiles seem to have been modelled by hand, the composition being made into a coarse paste, moulded and dried before the glazes were applied.

A number of small objects of daily use in glazed composition demonstrate more clearly than any other class of antiquities from Egypt the taste and artistic genius of its ancient inhabitants. Inspired largely in their choice of decoration by the natural flora and fauna of the Nile Valley and brilliantly coloured in monochrome or polychrome, they immediately appeal to the modern eye. Such a piece, unusual for its design, execution and colouring, which shows the art of the New Kingdom at its best, is a small two-handled vessel of Eighteenth Dynasty date with pointed base for scented oil. The body colour is white with applied decoration of lotus flowers, petals and buds in blue and black. It was found at Sesebi in Upper Nubia. An open polychrome lotus head is the main decoration of a bowl naming Ramses II which shows that fine work in glazed composition continued in the Ramesside Period.

From the Eighteenth Dynasty onwards drinking cups in glazed composition are usually modelled in low relief in imitation of chased metal work. Most often the bowl of the cup takes the form of a lotus flower on a thin trumpet-shaped stem or of a pomegranate fruit. From the Third Intermediate Period comes a series of vessels elaborately modelled in low relief with friezes of animals,

141. OPPOSITE *Decorative tile from a Ramesside palace audience hall depicting a captive Libyan enemy of Egypt wearing the characteristic sidelock and penis sheath, and decorated with tattoos. 20th Dynasty, c. 1170 BC; polychrome glazed composition, from Tell el-Yahudiya. H. 30.5 cm.*

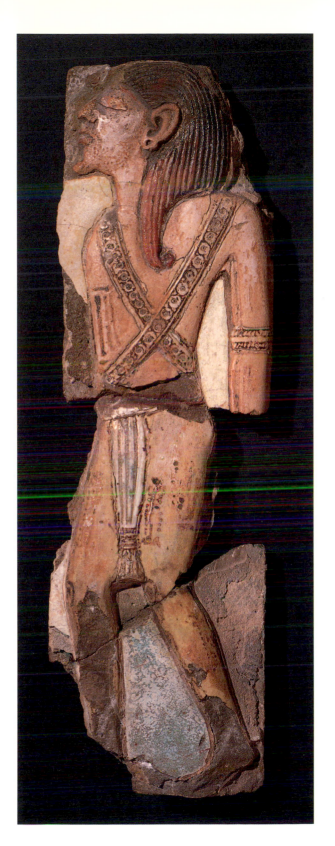

birds and fish. The tradition continued into the Roman Period although the fine thin walls of Dynastic work and thin evenly applied glaze are replaced by a coarser ware and glassier glaze. One example with figures of birds, animals, baskets of fruit and petals, probably carved, demonstrates Roman work at its best. Other techniques of decoration popular in the Roman Period are incising patterns on the core material before glazing or the application of lighter coloured strips of the body material to suggest patterning such as laurel leaves.

Glass

Glass and glaze as manufactured by the ancient Egyptians are basically the same material; the difference lies in their employment. If the raw product was to form glass it was used independently, if glaze it was provided with a core of a different material. Although some individual beads and scarabs predating the New Kingdom are known (probably manufacturing aberrations of glazed composition), glass was not produced in any quantity until the reign of Amenhotep III. Undoubtedly some new stimulus led to the first manufacturing of glass vessels in Egypt in the reign of Thutmose III, probably the contact made with Asiatic glass-makers during his military campaigns in Syria.

Ancient glass was formed by strongly heating quartz sand and natron in clay crucibles with a small admixture of colouring material, normally a copper compound, to produce both green and blue glass, though analysis also shows the use of cobalt which would have been imported. Heating continued until the ingredients fused into a molten mass. Experience would have dictated the moment to stop but tongs may also have been used to remove small quantities for testing. As the mass cooled it might be poured into moulds, rolled out into thin rods or canes about 3mm in diameter or left to be used as required after the crucible had been broken away. The British Museum's collection contains many examples of raw glass recovered from glass factories.

In the manufacture of a glass vessel the first stage was to fashion at the end of a metal rod a core of sandy clay roughly in the intended shape. The core was then enveloped in molten glass either by dipping into a crucible or, more probably, by winding threads around the surface as it was rotated. Marvering, the process of rolling against a flat stone slab, would have removed any surface irregularities. Decoration could be provided while the mass was still hot and semi-viscous by winding thin rods of manufactured glass of different colours around the object. The cold rods softened on contact with the hot mass of the base and fused into the surface in horizontal bands of colour. By combing a sharp metal instrument up and down the surface the glass-worker was able to

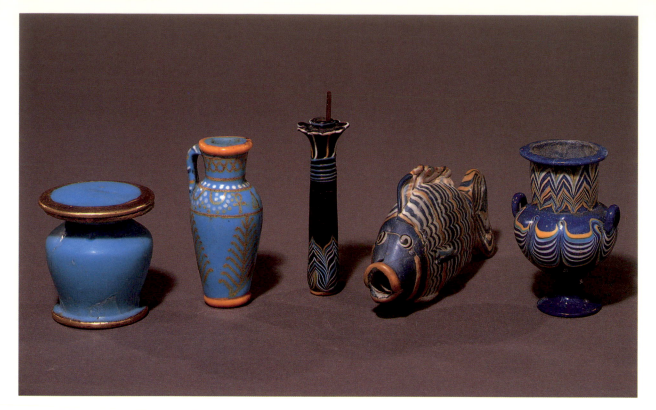

142. *Containers for unguents, oils and eye-paint (with the applicator), all core-formed except for the gold-rimmed solid cast example. The jug, which names Thutmose III, is among the earliest datable Egyptian pieces in this medium. 18th Dynasty, c. 1450–1336 BC; polychrome glass, from Amarna. L. of fish 14.5 cm.*

tease the bands into a characteristic flamed festoon of chevron patterns. It was at this point, while the basic fabric was still malleable, that the rim might be pinched into a lip, a ready-formed handle attached or a mass of molten glass added with a pair of tongs and shaped into a foot. When the vessel had cooled the outer surface was usually polished. Finally the core was removed by patient chipping and scraping.

One of the earliest dated Egyptian glass vessels is a jug of turquoise blue, perhaps imitating the semiprecious stone, with elaborate yellow and white enamel patterning – the first appearance of this technique in Egypt – incorporating the name of Thutmose III. The yellow and white colouring perhaps imitated gold and silver. Before long, dark blue glass, presumably in imitation of lapis lazuli, became very common for body material. Red, black, green, blue of every shade and violet coloured glass also occur. The British Museum holds the earliest example of transparent glass in two beads inscribed with the name of queen Hatshepsut's minister Senenmut. One of only two known complete examples of a com-

posite mosaic dish was mould-formed from different coloured glass segments randomly fused together. The many highly coloured glass fragments which have survived from royal burials in the Valley of the Kings and, in particular, from the glass factories at Malqata and Amarna can still serve to give a glimpse of spectacular pieces which would otherwise be totally lost.

However, the limitations of the techniques used, a certain intractability in the material and the brittleness of the finished product prevented the same general range of employment of glass as of glazed composition. Nevertheless, the remarkable skill which could be applied to this medium is illustrated by such pieces as a vessel from Amarna for scented oil made in the shape of a fish from reassembled polychrome glass. Two other unusual shapes for the medium are an eye-paint container rimmed with gold shaped like a squat jar with a lid and a wafer-thin cosmetic dish in the shape of a mussel shell.

For the most part objects made of glass are seldom more than 10 or 15 cm in height and must always have been considered luxury items. The material was chiefly used for the manufacture of small toilet vessels such as eye-paint containers in the shape of palm columns, handled bottles for scented oils and wide-necked jars for unguents. It was also often used for inlays, whether human parts in profile in figured scenes, hieroglyphs from accompanying texts or the insets in metal jewellery.

It was the material of beads, pendants and ear ornaments. During the New Kingdom, however, glass amulets are surprisingly uncommon. Small sculptures in glass were always rare but a superb, though badly damaged head of a sphinx, perhaps with the features of Amenhotep II is a miniature masterpiece.

For reasons perhaps not merely connected with taste, glass does not seem to have been made in Egypt between the end of the New Kingdom and the Saite Period; none, for instance, was found in the royal tombs of the Twenty-first and Twenty-second Dynasties at Tanis. It was the renaissance in all branches of the arts during the Twenty-sixth Dynasty which apparently led to a revival of the Egyptian glass industry. A walking ram in the round is a superb example of the Saite glass-maker's skill. The art of inlaying other materials with glass inserts, now also mosaic as well as monochrome, reappears at this time rather than during the late Dynastic Period as used to be believed. An interesting early example is the wooden panel with an inlaid offering scene in which the Pharaoh is named as the Persian king Darius. Most characteristic of this late flourishing are colourful fused and drawn mosaic slices and tiles with floral decoration intended for inlaying, all dating to the Ptolemaic Period.

Towards the end of this period, sometime in the first century BC, the technique of glass-blowing was developed and during the Roman Period Egypt with Syria was one of the main centres of glass-working. By the end of the third century AD, to judge from the number of fragments of vessels found at town sites, glass was generally used to provide rich and poor alike with tableware and cosmetic containers. Although opaque glass was still common in the Roman Period the medium for the majority of vessels was clear, the shapes for the most part following pottery models. In the course of time most ancient clear glass has acquired an attractive iridescence due to its breaking up into layers which refract the light like a prism.

Woodworking

Wooden objects are found from the Predynastic Period but fine woodwork was not possible before the Early Dynastic Period when copper tools became available. Examples of the carpenter's tools, mostly found together in a woven basket in a Theban tomb of New Kingdom date, are exhibited in the British Museum. For the preliminary shaping of a length of wood or log, use was made of axes, to trim and split the timber, and of saws, which occur from the Early Dynastic Period. The saw used by the Egyptians was of the pull variety, that is to say the cutting edge of the teeth was set towards the handle and the saw-cut made on the pull of the saw, and not on the push. The most efficient method of using this type of saw was to cut vertically down from the top with the tip of the saw pointing upwards. Small pieces of wood, easy to work, were held upright by hand, but heavier timber was tied to a pole fixed firmly to the ground. The lashing was kept tight by a stick weighted with a heavy stone acting as a tourniquet. The saw could then be operated with two hands from a standing position. A small wedge was inserted in the saw-cut to prevent binding; as the carpenter cut down the piece it was necessary for him from time to time to relash it higher up the vertical post. For shaping, planing, and smoothing the wood, adzes of different sizes were used. Joints were cut by chisels, with different sizes and shapes to the cutting edge. They were struck by wooden mallets. Hammers of modern form, with metal heads, were not used. Holes were bored by bradawls of metal with wooden handles or drilled by means of a bow-drill. The metal bit of the drill was held upright, its top turning in half a dom-palm nut held in the hollow of the hand. Rapid sawing with the bow rotated the bit. An important item in the equipment was an oil flask and honing-stone. The plane was unknown in ancient Egypt, the work of smoothing being done by adzes and by rubbing the object with sandstone rubbers. There is no firm evidence for the use of the lathe for turning before the Roman Period. The rounded terminals and legs of furniture, for instance, were fashioned by hand and eye: square, level and plumb-rule could be used to check.

With the help of these tools, the woodworker was capable of extremely fine joinery which made possible the construction of strong wooden boxes, coffins and furniture. Wood was carefully cut into lengths and firmly joined by dovetailing and cramps; corners were fitted by different kinds of mitre joints and separate pieces by mortice and tenon joints and sometimes lashed together with leather thongs. Dowels of wood were used in the construction of coffins; small wood or ivory dowels or pins of copper or gold fixed inlay work of faience and ivory. Glue was probably used to secure inlay as early as the Early Dynastic Period but it was not widely used otherwise before the New Kingdom. A piece of six-ply wood from a coffin discovered in the Step Pyramid of Djoser, the separate layers of different woods secured by pins, shows the rapid development of the craft of woodworking. Veneer is found in furniture of the Eighteenth Dynasty.

The general nature of the Egyptian box or chest did not greatly vary over the centuries. Typical examples from the New Kingdom are an ebony box inlaid with tinted and untinted ivory and plaques of faience, a shallow painted wooden casket from Akhmim and a chest of sycamore wood which belonged to the ship's captain Denger. The designs on boxes are usually drawn from hieroglyphic signs of amuletic significance or from con-

143

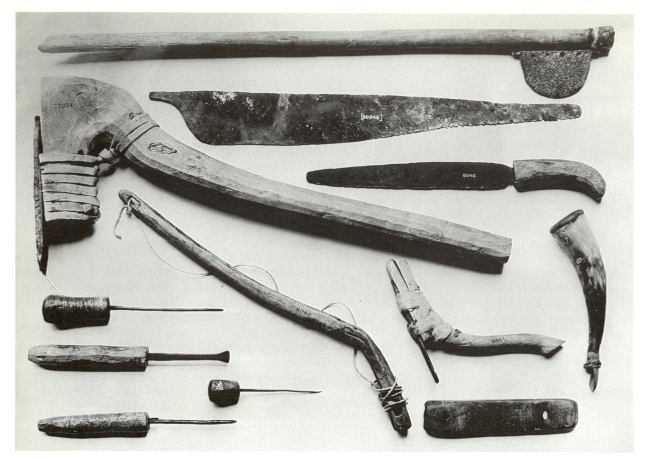

143. *Tools used in carpentry, principally of the New Kingdom. Several of these items were found together in a basket, a common means of storage. New Kingdom,* c. *1300* BC; *from Thebes.* L. *of axe at top 76 cm.*

ventional floral motifs and block patterns. The covers of these examples are detachable. Hinged lids also occur in the Eighteenth Dynasty. Metal locks and keys were unknown before the Roman Period. Examples are found of coffin lids being permanently sealed by an elaborate device of tumblers. Boxes were sometimes constructed to enable the cover to be secured, thus preventing the contents from spilling out if they were knocked or dropped, but the only means of safeguard against pilfering was to secure the lid to the box by lashing around the projecting knobs on the lid and the side of the box which could then be sealed with a lump of mud bearing a seal impression.

144 Though wooden furniture is represented in tomb scenes from the Old Kingdom, actual surviving examples before the New Kingdom are not very common. Egyptian houses were probably always sparsely furnished, use being made of low divans of mudbrick covered by

cushions. The normal items of furniture were chairs, stools, tables and jar-stands. Some of the light open wicker-work examples of stools and of jar stands clearly derive in design from reed and rush constructions of the Predynastic Period. Other stools are three-legged (a type used by craftsmen at their work) or four-legged. Particularly popular in the New Kingdom was a type of folding stool consisting of two pairs of crossed uprights pivoted about half-way down, with carved duck-head terminals inlaid with ivory and ebony. The seat was of leather, stretched across two curved wooden cross-pieces. Chairs are usually low, with seats of plaited cord mesh, generally no more than 20–25 cm from the ground. The legs are carved usually in the form of a lion's paw or, less commonly after the New Kingdom, a bull's hoof; backs are high and straight, often decorated with open-work designs of amuletic signs and figures of Bes; one example in the British Museum has a back panel with small insets of ivory in the design of four lotus stems and flowers. Another is a higher chair, with straight, uncarved legs and a sloping back. A further example is a low table supported on three splayed legs; on the flat surface is painted a representation of the goddess Renenutet in

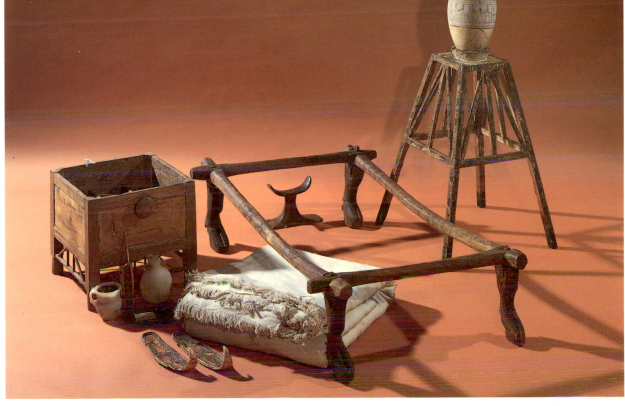

snake form before an offering table; an inscription contains the conventional formula of the funerary offering for a certain Paperpa, from whose tomb the table doubtlessly comes.

An Egyptian would also possess a wooden bed-frame provided with a footboard. The finely carved fragments from a bed overlaid with decoration in silver and gold come perhaps from a royal tomb at Thebes. In place of pillows, which would have been too uncomfortable for the hot nights of Egypt, the bed would be provided with a head-rest, the greater number of which are of wood. The rest consisted of a carefully carved, fitted, crescent-shaped piece for the back of the head, supported on a wooden pedestal; more elaborate forms are also found, like that shaped in the likeness of a crouching hare. Head-rests may be carved with the name and title of the owner, perhaps also with a prayer for a good night's rest, and in examples made for funerary rather than everyday use, with chapters from the *Book of the Dead* on the base of the pedestal.

The technical skill of the Egyptian woodworker is best seen in boat-building and chariot-making; in both cases the ability of these objects, built up of small pieces, to

147

144. Various household objects: a box of cosmetic items, linen, a bed, a headrest, a jar and jarstand. The chest is said to have been found in the burial of the scribe Any, and so is often thought to belong to his wife Tutu; it could as easily have belonged to Any himself, since men and women applied in general the same cosmetics. New Kingdom, c. 1300 BC; from Thebes. H. of chest 61 cm.

withstand the stresses and strains in their use depended upon knowledge of the natural quality of different woods, and the strength and accuracy of the joinery which gave them their durability and rigidity. The earliest boats were made of papyrus or reed, and the characteristic high prow of the typical Egyptian boat is a legacy of this early material. Already by the Early Dynastic Period local wood was used for constructing river craft. The greater size of planks obtainable from imported timber allowed the boat builders to produce large craft, a magnificent example of which is the funerary boat of Khufu, found close to his pyramid at Giza. Sea-going vessels were constructed along the same lines as river craft, with the exception that greater rigidity and strength was given to the frame by trussing the boat at the prow and the stem and running between them a hogging truss which passed over wooden crutches.

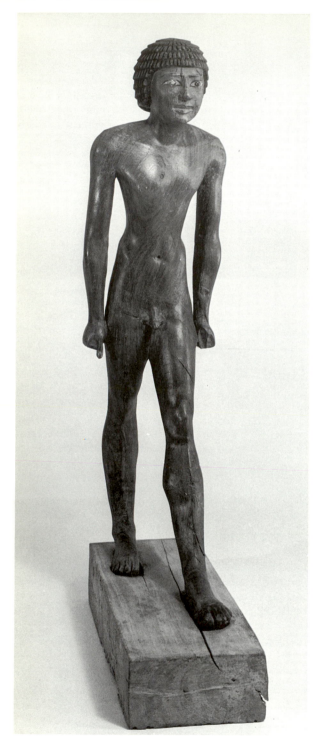

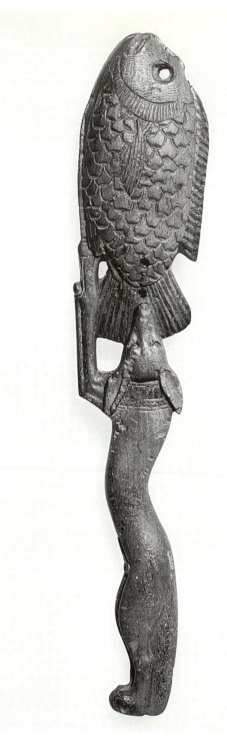

145. *Statue of Meryrahashtef, shown naked and striding with left foot forward. In the late Old Kingdom a wealthy tomb might contain a group of wooden statues of the owner in different poses and appearance. 6th Dynasty, c. 2200 BC; wood, from Sedment.* H. *51 cm.*

146. *Container for cosmetics in the shape of a jackal leaping with a fish in his jaws; the top of the fish forms a moveable lid with the pivot at its eye. 18th Dynasty, c. 1350 BC; wood with blue paint, from Memphis.* L. *26 cm.*

The chariot is believed to have been introduced by the Hyksos invaders; it was used in the struggle between them and the Theban kings of the Seventeenth Dynasty. It was employed in the New Kingdom in warfare, hunting, inspections of estates and for official appearances. It consisted of a light wooden frame with an open back, set forward of a short axle fitted to two wheels of four or six spokes. A pole projected from the centre of the axle beneath the carriage, terminating in a yoke to which a pair of small-framed horses were harnessed by leather accoutrements. Particularly remarkable is the skill with which the wheels were joined together from separate segments and bound with leather tyres. To bend the wood, a piece was tied to a forked post stuck in the ground, welted and bent with the help of a lever.

The carving of solid woods into statues, models and household equipment was also practised with high skill throughout the ancient period. It is clear that in many cases the provision of statues of offering bearers and of models in the period from the end of the Old Kingdom to the Middle Kingdom was a substitute for carved stone relief and stone statues. If such figures charm, it is rather in the state of their preservation, particularly of their colour and the interest of the subject-matter rather than in their skill of carving. The statues of the tomb-owner were, however, also often of wood – such indeed form a large proportion of surviving wooden statues – and the choice of material was not necessarily dictated by reasons of economy. Wood statues were provided, for instance, for royalty from the First Dynasty and persisted to the New Kingdom. Three of these large over-lifesize figures, all of New Kingdom date, from the royal tombs of the Valley of the Kings at Thebes are in the British Museum.

The statues of private persons, broadly speaking, follow in their pose and style the conventions of stone sculpture. They are usually carved in one piece, except for the arms which are fitted on by mortice and tenon joints. Some of the best examples of this class of work are the statue of Meryrehashtef as a young man, one of a group of statues from his tomb at Sedment of Sixth-Dynasty date, in which the arms are carved in one piece with the body; the small but attractive standing figure of Netjernakht from his tomb at Beni Hasan, Twelfth Dynasty; and the standing figure of an official elaborately draped from the time immediately following the Amarna Period. 145

In these statue-figures the woodworker was limited by the religious conventions of the patron; greater freedom of style is to be found in the small objects of wood. Particularly attractive is the series of cosmetic jars and containers from the New Kingdom carved in various forms, a running jackal with a fish in his mouth, a negro girl carrying a small chest on her head, a swimming girl, a cucumber, or a bouquet of lotus flowers and buds, some of the latter in tinted ivory. 146

Ivory-work

Ivory from the tusks of both the hippopotamus and the elephant was used, like wood, for a variety of small objects as well as for inlay, either in its natural state or stained pink. The use of ivory had a certain magical significance; it was employed, for instance, for the making of flat curved wands (often referred to as knives)

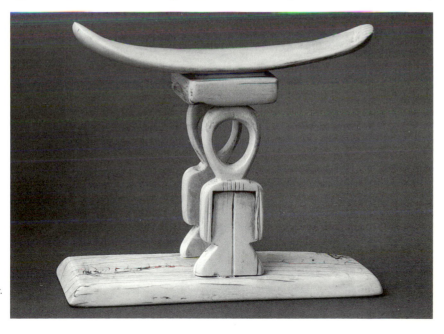

147. *Headrest said to be from the burial of Gua, Chief Physician of the governor of Djehutyhotep at Khmun (Ashmunein). The supports take the form of the tit amulet and thus afford the sleeper protection from danger. 12th Dynasty, c. 1850 BC; ivory, from Bersha (?).* H. *15.3 cm.*

on which were incised with a fine line the figures of
various demons and deities. Finely carved objects include
handles for knives and wands, toilet spoons, button seals
and gaming pieces. The ivory pieces are mostly small,
but larger objects were also built up, for instance the
147 Twelfth-Dynasty head-rest of Gua with the support in
the form of the girdle of Isis.

Fine carving goes back to the Badarian Period; a
particularly skilful example from that time is an unguent
pot from Mostagedda in the form of a hippopotamus.

Figurines in ivory date back to the Predynastic Period;
they are mostly in the form of naked women. An excep-
tionally fine early ivory is that of a standing figure of a
50 king, probably of the First Dynasty, found in a temple
at Abydos and clothed in a garment usually associated
with the *sed*-festival, the detail of the quilted pattern of
the cloak being carefully done.

Textiles

Weaving was one of the earliest crafts to be developed;
fragments of woven cloth date back to the earliest Neo-
lithic cultures and already show advanced skill. A small
fragment of linen cloth from the Fayum is of two-ply
thread (Z-spin S-ply, see below), with ten by twelve
threads per cm and dates to the fourth millennium BC.
The woven cloth of Egypt was almost invariably of linen;
the scarcity of wool before the Roman Period suggests
that there may have been a religious taboo against its
use, as Herodotus wrote. A few pieces of wool cloth have
been found at Amarna and may date to the fourteenth
century BC; this would make them among the earliest
surviving wool textiles, though they are not necessarily
of Egyptian manufacture. Cotton fragments from
Nubian sites have been found dating to the Roman
Period; in Egypt itself woven cotton does not commonly
occur before the Islamic Period, and modern Egyptian
cotton is made from the American strain introduced into
Egypt in the nineteenth century. Silk is first found in
Egypt in the late Roman Period, although Lucan, writing
in the mid-first century AD, describes Cleopatra as
wearing silk garments.

Flax, the source of linen thread, is frequently shown
in agricultural scenes in tomb-chapel reliefs and paint-
ings. It was pulled up by the roots and the seeds after-
wards removed; for the best quality fibre, the flax was
harvested before the linseeds had ripened. Next the stalks
must have been soaked in water (retted) until most of
the pectin binding the fibres together had been washed
out. The woody centre of the stalks was then removed
by beating and finally the fibres were combed. The
process of spinning differed from modern methods; it
began with the preparation of a rove, made by splicing
small groups of fibres together end to end. The residual

pectin helped to strengthen the splicing to be more
secure; it probably also accounts for the yellowing of
ancient linen. When sufficiently long the roves were
wound into balls, perhaps around pottery sherds, and
these balls could be placed in pots to prevent them rolling
away during spinning. Spinning itself was carried out
with a spindle which was set in motion by rolling it down
the right thigh, producing an S-spin yarn. The spindle
was made of a shaft and a whorl, the whorl toward the
upper end of the shaft; the typical Middle Kingdom
whorl was flat and cylindrical, that of the New Kingdom
domed. The shaft had a spiral groove at the top around
which the thread was hitched. Two or more threads
could be twisted together (plying), as is often shown in
representations but rarely attested in the surviving cloths.

The earliest type of loom in Egypt was the horizontal
ground loom, on which the lengthways threads (the
warp) were stretched around two wooden beams attached
to four short pegs driven into the ground; the same type
is still used by Bedouin weavers. The warp might be
threaded directly around the beams or wound over three
pegs set in a wall and afterwards transferred to the loom.
The threads of the warp were divided into two sets; the
odd-number threads were joined by loops of string to a
wooden rod (heddle-rod). When the rod was raised, a
space (shed) was created through which the transverse
threads (the weft) were passed by means of a stick. The
space for the return weft was made by bringing forward
another rod (shed-rod) and enlarging it with a flat
wooden instrument (weaving-sword). A thick-looped
fringe was created during weaving down the left selvedge
of the cloth. In the New Kingdom, perhaps as one of the
technical innovations of the Hyksos Period, the hori-
zontal loom was replaced by an upright loom on which
the warp was stretched between two beams fastened to
an upright wooden frame; this type of loom was operated
by weavers sitting or squatting at the base of the frame.
In other respects textile technology changed little before
the Roman Period.

Most ancient Egyptian cloth has survived as shrouds
and bandages on mummies. It seems that this was not
the first use of the cloth, since many shrouds show signs
of wear and repair and the bandages were full-width
cloth that had been torn into strips. Folded sheets of
cloth (perhaps including garments to be worn draped)
were also included in burial equipment, and cloth was
one of the items in the standard funerary prayer for
offerings as early as the Second Dynasty. Early Middle
Kingdom examples of funerary linen have notes in hier-
atic to record such details as the name of owner, the date
(perhaps of burial) and the quality; a set of textiles of
the early Eighteenth Dynasty is inscribed 'given in the
favour of the god's wife, king's wife and king's mother
Ahmose Nefertari may she live, to Satdjehuty', pre-

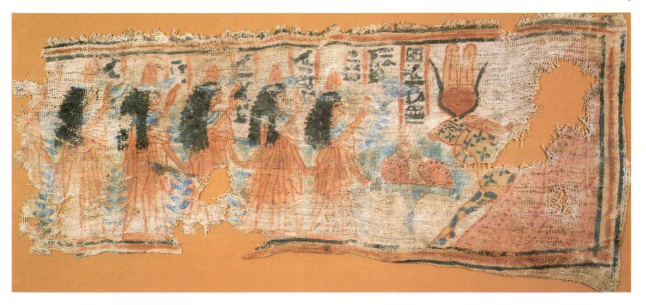

148. *Painted and inscribed cloths are valuable for the history of textiles because they can be closely dated by the style of representation and writing. This cloth is painted with figures of the donor women worshipping Hathor, here shown as a cow. It has one plain and one fringed longitudinal selvage. One short side has a starting border; the lost opposite end presumably had a warp fringe. 18th Dynasty; painted linen, from Deir el-Bahri.* L. *46 cm.*

sumably from the burial of the woman Satdjehuty. This group includes one very large cloth about 4.5 m by 1.85 m, as well as one of the rare examples of a made-up garment, a sleeveless tunic that had already been extensively darned. This tunic, in a fine open weave, has about thirty-one warp threads and about sixteen weft threads per cm. In general the quality of the cloth improved gradually over the centuries; one of the finest pieces in the British Museum, a patch of fragments bearing texts from the *Book of the Dead* of the fourth century BC, has about one hundred and sixty threads in the warp and about thirty-three in the weft. After the Ptolemaic Period, Graeco-Roman styles and techniques, based on wool weaving, extinguished the native Egyptian tradition and such fine linen is no longer found.

Egyptian clothing was characteristically plain; in representation and texts the whiteness of the linen is stressed. By contrast the clothing of Semitic and Nubian peoples is shown in Egyptian art as brightly coloured; Asiatic influence probably accounts for the appearance of coloured and figurative clothing in Egypt, confined in the surviving record to the Eighteenth Dynasty. At other periods colour in dress was provided by elements external to the cloth, such as metal accoutrements and most typically by beaded nets and belts.

In contrast to the plain linen so common in the Dynastic Period, colour was an essential element of the Coptic textiles which have survived in quantity from the fourth century AD onwards, particularly in the cemeteries of Akhmim and Antinoopolis. The appearance of the coloured textiles at that time was due to the change in burial customs described in chapter 4. Christian 'Coptic' textiles remained a distinctive type up until about the twelfth century AD when they finally merged with the Islamic textile tradition.

Coptic textiles are mainly of linen with the characteristic coloured wool usually restricted to contrasting bands or panels. By the fourth century textiles made entirely of wool were also being produced, linen and silk and cloths entirely of silk occasionally occur, and from the sixth or seventh century cotton is increasingly common. The two-beam upright loom, which had been in use in Egypt since the beginning of the New Kingdom, remained the most important piece of equipment. The weaving techniques owed more to Graeco-Roman traditions; this is particularly true of tapestry weave, much the most common method of decoration. Other techniques included various types of pile weave – simple loops as on the decorative hanging depicting cupids or Erotes, long loops with asymmetrical knots making a warm lining to a wool cloak fragment, and cut pile with symmetrical or Turkish knots on two fragmentary carpets from the Nubian sites of Buhen and Qasr Ibrim. Furnishing textiles were also decorated with brocading; coloured threads were used alongside a main weft of linen, and some large-scale designs were carried out in a resist technique where a wax resist was painted on and the cloth afterwards dyed in indigotin. Embroidery was sometimes applied but many details which look like embroidery are in fact woven, for instance, the white outlining on the late Roman geometric designs. Sprang,

a type of plaiting, occurs particularly in the form of women's hairnets, and knotless- or needle-netting, a technique resembling knitting but actually unrelated, was used for socks.

The earliest colour scheme for clothing was a dark purple with cream or white. The white was undyed fibre, either linen or wool, and the purple was wool; this was rarely dyed with the very expensive real purple made from Mediterranean whelks, but usually with a combination of two vegetable dyes, red from the madder family and blue from woad or indigo. Furnishing textiles, particularly of the fourth and fifth centuries, used wool in a wide range of colours, red and blue on their own, yellow from weld, and again combinations of these for greens and oranges and purples, with naturally-pigmented wool used for browns. Over the centuries, while decoration became increasingly stylised, clothing began to be more brightly coloured (red backgrounds were particularly common in the eighth and ninth centuries) and furnishings lost their fine nuances.

Broadly speaking, the style of textile decoration follows the same progression as Coptic sculpture. The earliest of the larger tapestries show characteristics of late Hellenistic work in their choice of subject, treatment of figures and naturalistic shades of colour. They are well illustrated in the two fragments of a large linen textile with a design in coloured wool loops from Akhmim with a representation of two Erotes in a boat surrounded by a border at the corners of which are well-modelled masks within small roundels.

The evolution of the more specifically Coptic style is shown by the large tapestry in coloured wools and undyed thread on linen aproximately 1.5 m wide and 1.8 m high with two lateral and one broad medial vertical bands, the intervening space being occupied by two large standing figures set against an open background studded with decorative rosettes. The treatment of the figures, with the stressed whites of the eye, heavy eyebrows,

149

149. *Tapestry with divine or mythological figures associated with hunting. 5th century* AD; *undyed linen and coloured wool.* H. *1.8 m.*

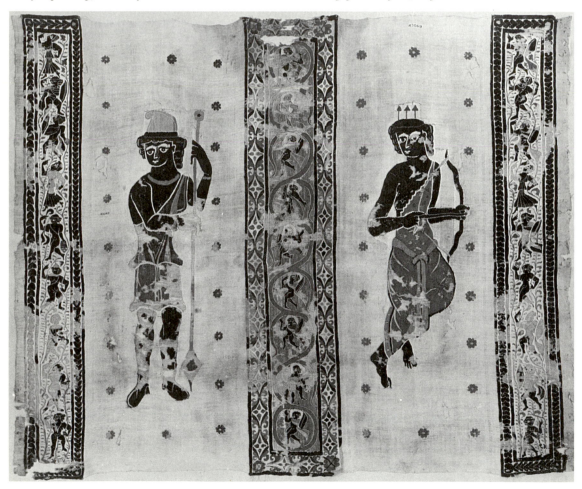

stylised treatment of the hair and even rendering of the colour, marks the transition to the Coptic Period.

The bulk of the surviving textiles of the fourth to the sixth century consists of clothing ornaments. Surviving examples show that there were different methods of arranging the ornamentation on the tunic, which in its essential form differed little from the costume depicted on the mummy portraits of the first four centuries AD. In its simplest form the tunic contained only two vertical bands running over the shoulders down to the hem and one or two bands ornamented in similar style around the cuffs. A continuous broad horizontal band might run around the neck opening. In more elaborate decorated costumes woven panels or roundels were added, usually on the shoulders or near the bottom corners at the front and back. In later tunics the bands are regularly shortened to about waist-level and terminated in a roundel or pendant ornament. Roundels are far more common than the square panels. Large oblong cloths, mantles, were used as an outer garment loosely draped over the shoulders as in the mummy portraits.

The earliest of the clothing ornaments are of intricate geometric patterns woven in purple wool and undyed linen thread. They are characteristic of the fourth century. Purple was the standard colour used in the monochrome work. The designs for both monochrome and polychrome work were drawn from the repertoire of late Hellenistic art: fish, animals of the chase, particularly the desert hare and lions, baskets of petals and fruits, trees, the most common of which was the vine-stem growing out of a vase or basket. Figure subjects are common, sometimes apparently drawn from popular stories of the classical heroes, identification of which is uncertain in the absence of detail; the figure of a nude man and woman set apparently in a meadow or garden may perhaps represent Herakles and one of the classical heroines with whom he was associated. The mythical creatures of classical invention also appear, like the half-human half-horse centaur or half-horse half-fish hippocampus. The scenes are often animated, leaping boy warriors with flying cloaks, dancing figures with their heads tossed back and mounted hunters. Several elements, not necessarily harmonious, were combined in one piece, the central design enclosed by a surrounding border of intertwining stems, forming scrolls for further subjects. Vertical bands were given a continuous decoration of figure or animal subjects within a border, depicting in particular male or female dancers and hunted animals.

Christian subjects are rare before the seventh century and not common until the eighth. The figures are commonly woven on a red background, in a highly stylised but decorative form, which gave the impression of having been built up from rectangular segments. The most common themes are haloed figures of saints, either standing or on horseback. Scenes drawn from biblical stories, their subject not always readily apparent, also occur.

The sequence of textiles from Christian cemeteries continues until about the twelfth century; thereafter the Christians were a minority and their traditions in weaving as in other crafts became submerged in Islamic culture.

Basketry

Mat-making and basketry, crafts closely allied to textile weaving, were also fully developed in the Predynastic Period. The fragment of woven reed matting in the British Museum comes from Badari; boat-shaped baskets of grass stems, possibly for sowing grain are characteristic of the Predynastic Fayum.

Mats were woven on horizontal looms of rush, reed, and the coarse grasses of Egypt. The patterns of the mat weaves are reproduced in early architecture and remain one of the dominant artistic motifs of the Dynastic Period.

Baskets were made by coiling a fibrous core spirally into the shape required; the principal material employed was palm leaf with the split rib of the branches for foundation. Baskets were the most common form of household container after clay pots and might serve a number of purposes analogous to wooden boxes. Of the examples in the British Museum one, of palm leaf, originally contained a linen tunic, another a set of carpenter's tools, and a third, model bronze tools with the name of Thutmose III. Receptacles were also made of cane and papyrus (but not plaited); one such contained a wig. An unusual example of cane and reed construction is the Eighteenth Dynasty model table with offerings.

Reed, flax, and halfa-grass were also employed for ropes from Predynastic times. In the Dynastic Period palm fibre was generally employed, but the large thick cables required in the hauling of stone were of papyrus. The process of making these papyrus ropes is illustrated in the copy (lower register, right) of a painted scene from the tomb of Khaemweset at Thebes of New Kingdom date. Three men are at work; two stand twisting together two separate strands. The third is seated holding a spike between the strands. There are four finished ropes coiled above the figures, a bundle of papyrus stems, and a group of six tools: two spikes, two twisting tools, a mallet, and a knife.

The survival of basketry, as of all organic material from Egypt, is a miracle we owe to the climate of the country and burial customs of its inhabitants across five thousand years of settled life in the Nile Valley.

8

EGYPT AND HER NEIGHBOURS

Egypt and the north

In the Pharaonic view of the world Egypt was bounded on the north by watery wastes expressed in the phrases *wadj wer*, 'the great verdant [area]', and *hau-nebu* (of unknown meaning). Such terms might apply both to the northern Delta marshes and to seas and lands beyond; in earlier texts *wadj wer* and *hau-nebu* are often linked with marsh fauna and flora, but *hau-nebu* could be used in Ptolemaic times to refer directly to Greece, as on the Rosetta Stone where the Greek word *hellenikos*, 'Greek', is rendered in hieroglyphs by the Egyptian phrase 'of the *hau-nebu*'. Until Alexander the Great founded Alexandria in 332 BC, no city existed on the Mediterranean shore, and the marshes along the northern reaches of the Delta provided a defence and a barrier against northern contacts. Mediterranean sea travel seems to have been left largely to other peoples; Egyptian words for seagoing ships either are borrowed from other languages, such as *menesh*, or refer to foreign places, such as *kepeny* (usually translated as 'Byblos-ship') and *keftiu*-ships. The marshes between the river civilisation of the Nile and the Mediterranean may explain the virtual absence of evidence for contact between Egypt and the north-east Mediterranean world in the Early Bronze Age. Egyptian Old Kingdom material has been found on the north side of the Mediterranean, but it is not known when it left Egypt; stronger evidence of contact has been seen in motifs such as spirals that appear in Egyptian art in the First Intermediate Period and Middle Kingdom, but the allegedly Aegean inspiration of such features has not

been established beyond doubt. For the Middle Bronze Age some Minoan pottery has been found in excavations of Egyptian Middle Kingdom sites such as Lahun, and a statue and about twenty scarabs of the Middle Kingdom have been found in Crete; however, it is uncertain what contact the pottery implies, and it is again not known when the Egyptian objects left Egypt.

One of the most remarkable recent discoveries is the 1990 find of Minoan wall-paintings at Tell el-Daba in the north-eastern Delta. The paintings survive as fragments on plastered bricks from a destroyed building dating to the end of the Second Intermediate Period, when that part of Egypt was Semitic and ruled by foreign kings, the Hyksos of later tradition. The find indicates firmer links between the Hyksos and Minoan Crete, and it is now easier to believe that the Cnossos ointment-jar lid with the name of the Hyksos Khyan reached Crete in his reign.

In the New Kingdom the evidence increases, although it does not become easier to interpret. Under Hatshepsut and Thutmose III some Theban tomb-chapel paintings include depictions of people labelled as Keftiu and identified by modern scholars from their clothing and from the goods they carry as Minoans. Some depictions include

150. OPPOSITE *Gold openwork plaque with chased details showing Amenemhat* IV *offering unguent to Atum, god of the setting sun. Such cutting out from sheet metal provided base-plate for openwork pectorals with cloisonné details. 12th Dynasty,* C. *1795* BC; *gold.* H. *2.8 cm.*

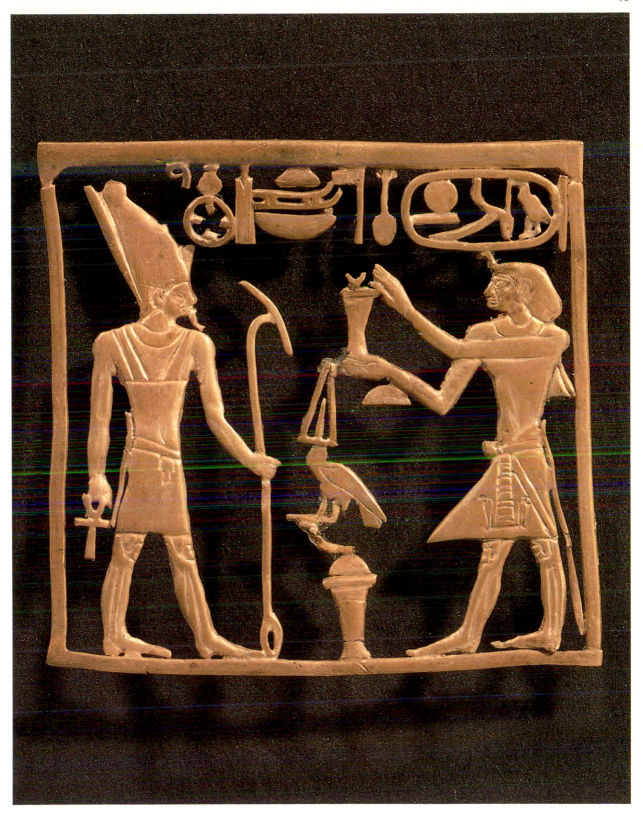

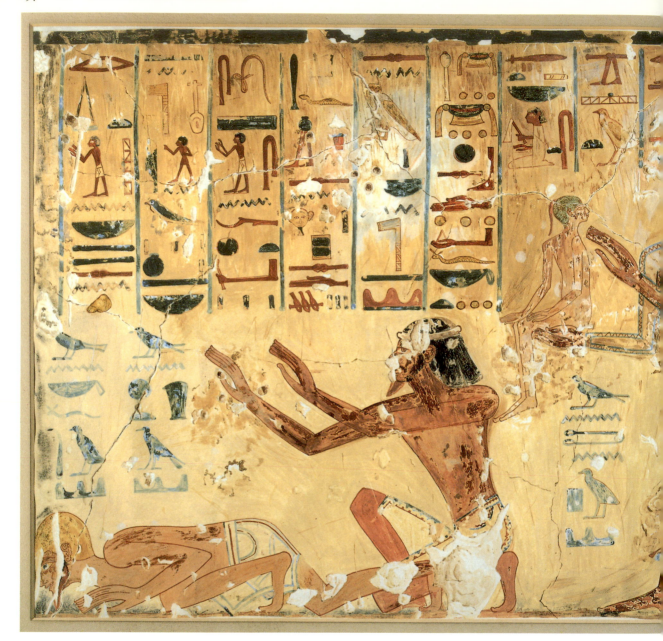

151. *Copy of an 18th Dynasty (c. 1450 BC) wall-painting from the tomb-chapel of Menkheperraseneb at Thebes showing foreign rulers in obeisance at the court of Pharaoh. The text identifies the three rulers here as the princes of Keftiu, Kheta and Tjenepu, generally identified as Cretans, Hittites of Anatolia, and the Tunip in Syria. The third proffers on his arms a child, a pictorial echo of textual evidence for the practice of rearing children of foreign rulers inside Egypt. The fourth figure bears a metal object in the shape of a bull's head and wears clothing of Aegean style.*

Mycenaean elements, and late Eighteenth and Nineteenth Dynasty paintings appear to mingle and develop motifs as if the craftsman was working from copybooks rather than from eyewitness accounts. These paintings do not reveal where or when the Egyptians encountered Aegeans; the earliest depictions may not date to the earliest direct contact, because only a few Theban tomb-chapel paintings earlier than Hatshepsut have survived. References in Egyptian texts are as rare as paintings; the early Eighteenth Dynasty Papyrus Ebers includes in its prescriptions the ingredient 'Keftiu-beans', and an

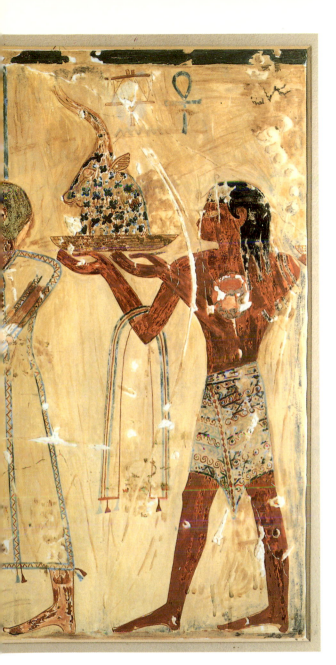

the palace site of his father Amenhotep III at Malqata in Western Thebes; some of this foreign pottery appears to be tableware, but much would have been imported not for its own sake but for the contents, foodstuffs or oils. Our knowledge of international trade in the late Bronze Age has been greatly advanced by the discovery of a shipwreck off the Anatolian coast at Ulu Burun; the cargo included a gold ring with the name of Nefertiti, wife of Akhenaten, and a range of materials recalling those carried by northerners on Theban tomb-paintings. Egyptian material found in Cyprus and the Aegean includes objects inscribed with the cartouches of Amenhotep II and III, and late Eighteenth and Nineteenth Dynasty faience vessels (examples found at the major late Bronze Age town Enkomi on Cyprus are in the Greek and Roman galleries in the British Museum). In sum the Aegean material found in Egypt and the Egyptian material found in Cyprus and the Aegean provides general evidence of the network of tradelinks, but these cannot yet be reconstructed in detail.

Whatever the precise network of communications in the Eastern Mediterranean, the area witnessed violent disruption at the end of the Bronze Age. Nineteenth and Twentieth Dynasty texts refer to a variety of northern foreign peoples who are grouped together in the term 'peoples of the sea'. Some occur already in the cuneiform diplomatic correspondence found at Amarna (the Rekek/Lekek as pirates, and the Sherden as soldiers serving the prince of Kepen). At the battle of Qadesh the Hittite army that fought Ramses II included Sherden, enough of whom were brought to Egypt to be settled in villages of their own in the Nile Valley. In his fifth year Merenptah fought a western ruler Meryawy who had assembled a coalition including the Rekek/Lekek, Sherden, Teresh, Shekelesh and Iqewesh. A generation later Ramses III in his fifth and eighth years fought on land and water against coalitions of new enemies, including the Denen, Peleshet, Tjeker and Weshesh. In the second wave of attack the earlier peoples appear either on the Egyptian side (Sherden) or in less prominent position among the invaders (Shekelesh) or not at all; the record of victory at the Theban temple to Ramses III at Medinet Habu presents not only texts but also vast pictorial compositions where the invaders are differentiated in facial features, headgear, clothing and weaponry. Despite the richness of this evidence the exact origin and final destination of these northerners remain sketchy; the Aegean and Anatolia are usually identified as their homeland, and it is possible that placenames such as Palestine/Philistine, Sardinia and Sicily lie over the Egyptian renderings of foreign words (Peleshet, Sherden, Shekelesh), but the Egyptian script records only consonants and has no *l*. In general terms the Egyptian texts about 'peoples of the sea' can be related

incantation for good health in a British Museum papyrus is said to be 'in the speech of Keftiu' (unfortunately the language has not been identified), while texts of the reign of Thutmose III include the only two known references to Keftiu-ships and the list of Keftiu names on a writing-board. Aegean material in Egypt gives an uneven picture. An early Eighteenth Dynasty tomb at Saqqara contained pottery ranging from Kerma ware to a Cypriot handled jug. Mycenaean pottery has been found on late Eighteenth and Nineteenth Dynasty sites and in large amounts at Amarna, city of Akhenaten, but is entirely absent from

to the destruction of late Bronze Age cities throughout the Aegean and the Levant, and to the subsequent appearance of new cultures in the early Iron Age, such as the Philistines in Palestine whose culture points to an origin in the Aegean.

During the early Iron Age there is little evidence for northern contacts; the literary *Report of Wenamun* relates among other episodes the landing of its Egyptian hero Wenamun in the harbour of Ires/Iles where the female ruler saves him from threatening locals. This land of Ires/Iles occurs in New Kingdom documents, once to translate the cuneiform placename Alashiya in the Amarna diplomatic correspondence; in part because it is connected in the texts with copper, it is often identified as Cyprus, known as an ancient source of copper. After the *Report of Wenamun* direct contact with the north can be traced again in the surviving record with the rise of the Twenty-sixth Dynasty in the seventh century BC. The kings of that and later periods sought in the Aegean and Anatolia partners in commerce and, more critically, troops to fight foes at home and abroad. The new strength of relations is reflected in the appearance of Egyptian and Egyptianising objects at places associated with Greek and Phoenician maritime expansion, including into the Western Mediterranean. According to the Greek historian Herodotus, writing in the fifth century BC, Psamtek I secured the rule of the Twenty-sixth Dynasty over all Egypt with the help of men from Caria in south-eastern Anatolia; Psamtek II invaded Nubia with an army comprising a division of Egyptians under the general Ahmose and a division of Greeks, Carians and Phoenicians under the Greek general Potasimto (perhaps an Egyptian name, implying that this Greek general had already become Egyptianised). Many Carians settled in Memphis where they formed a separate community known as the Caromemphites, with their own script and mixture of Egyptian and Carian lifestyle. From the reign of Ahmose II Greek traders were concentrated in the western Delta at a city called Naucratis, an Hellenic colony within the kingdom of Egypt; the colony served Pharaonic interests by attracting Mediterranean trade to the country, and the city flourished into the Roman Period. In the other direction Ahmose II cemented his Aegean alliances with votive gifts to sanctuaries such as Delphi and Lixdos; these gifts included Egyptian sculpture and this as much as Greek visits to Egypt may have encouraged the adoption of Egyptian proportions and postures in archaic Greek statuary.

Hellenic and Anatolian soldiers continued to play a dominant role in the struggle for power both at court and between Egypt and her neighbours down to the arrival of Alexander the Great in 332 BC. The Macedonian rulers brought the Greek script and language for the administration and court life of Egypt; with their control of Cyprus and Aegean territories, and above all with the new city of Alexandria on the Mediterranean, Alexander and his successors the Ptolemies gave Egypt an entirely new orientation. Cross-fertilisation can be seen in literature of the period, with a Greek version of the Egyptian tale of the *Eye of the Sun*, and on the other side Egyptian heroic cycles in Homeric vein. Although Alexander and the Ptolemies spoke no Egyptian, they adopted much of the powerful imagery of Pharaonic kingship, and this new Hellenistic model of monarchy, drawing on Egyptian and Near Eastern patterns of kingship, left perhaps the deepest mark on European history. The kingship of Alexander was emulated by the Roman emperors, and following them consciously by European monarchs, less consciously by modern heads of state including presidents. The incorporation of Egypt into the Roman Empire in 30 BC led to the exclusion of Egyptians from the administration of the land, but the emperors continued to have temple walls sculpted in Egyptian style and to make donations to the traditional deities. The cult of Isis had spread to Greece and Italy in Ptolemaic times, and by the first century AD Rome housed one of the largest temples of Isis outside Egypt, the Iseum Campense, adorned with Egyptian monuments. The emperors brought obelisks out of Egypt to mark great works in the imperial capital, such as the massive sundial set up by Augustus and the Circus Maximus, and a few new obelisks were commissioned. Shrines to Isis, along with those of the Persian deity Mithras, became among the most common places of worship in Roman cities such as Ostia and Pompeii, and the Roman army brought the cult of Isis and Serapis to outposts as remote as London and York.

The demise of Pharaonic tradition was completed in the Byzantine Period, when Egypt can no longer be separated from the wider Eastern Mediterranean horizon of Byzantine culture. However, even at this stage, Christianity acquired from Egypt at least one distinctive feature, monasticism; this developed in the third and fourth centuries AD during persecution of Christians, out of the practice, attested already in the Middle Kingdom, of individuals fleeing to the desert to escape state control. The transfer of monasticism from Egypt to its next home in Ireland, beyond the farthest reach of the Roman Empire, serves to remind us of the extent of ancient networks of communications, so often invisible in the surviving record.

Egypt and Asia

The eastern desert and the Sinai Desert formed a protective barrier for the Nile Valley on its eastern flank, but this barrier was far from impenetrable. The pastoralist nomads who roamed the deserts viewed the Nile Valley

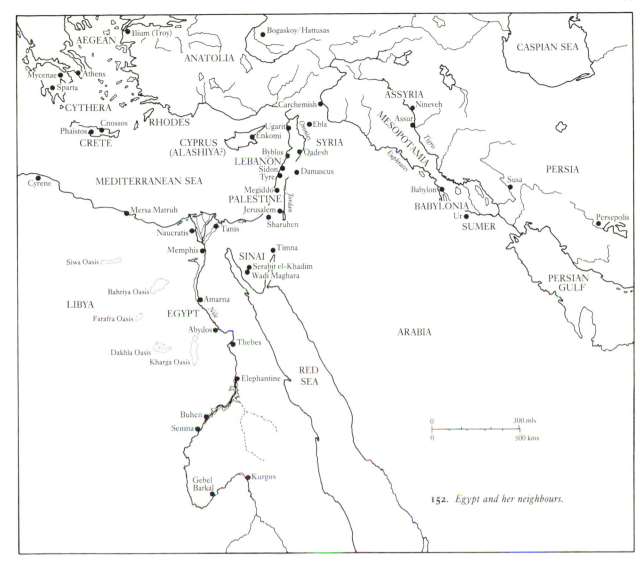

152. *Egypt and her neighbours.*

as a source of sustenance to themselves and their flocks, not always with the consent of their prospective hosts. However, these same tribesmen could also serve as intermediaries in the trade routes, which were formed very early in Egypt's history. Apart from the probable overland route through the North Sinai or a sea-route to Syria, there is some evidence of trade links by sea and land directly from southern Sinai to Upper Egypt. This route may also have served for the import of goods and ideas from further afield. The discovery of lapis lazuli from Afghanistan in Predynastic graves is evidence of a trade network possibly via Mesopotamia and Arabia. At the end of the Predynastic Period Mesopotamian influences may be detected in certain similarities of style in artistic motifs, in brick niche architecture and the use of cylinder seals and possibly in the impetus to writing.

The establishment of a strong united state in the Nile Valley enabled the new rulers to exert some control over the eastern border and undertake expeditions to the Sinai to exploit its mineral resources. There are vague references to clashes with Asiatics in the First Dynasty, while reliefs of rulers from the Third to Sixth Dynasties are carved at Wadi Maghara in the Sinai. Trade relations by sea with the Syrian coast in the Early Dynastic Period are evidenced by the importation of wood for the royal tombs at Abydos and the discovery of a vase of Khasekhemwy at the major Mediterranean port of Byblos. Trade with Byblos continued to flourish throughout the Old Kingdom. The arrival of a number of sea-going ships laden with timber is recorded in Sneferu's reign and reliefs from the temples of Sahura and Unas in the Fifth Dynasty probably depict these trading journeys.

Rulers from the Fifth and Sixth Dynasties are attested from inscribed material at Byblos and vases with the names of Khafra and Pepy I have been unearthed at the site of Ebla, possibly a staging-post in the lapis lazuli trade, although these need not indicate direct Egyptian contact. A major punitive expedition into Southern Palestine in the reign of Pepy I does not imply any firm Egyptian control of the area but rather Egyptian worry over the stability of its borders. The Egyptian ruler claimed to be the natural overlord of all foreigners who are depicted in subservient positions in Egyptian reliefs and sculptures as part of royal propaganda, but these claims would not reflect reality nor hinder mutually beneficial trade. It is generally believed that this trade contributed to the growth of urbanisation in Southern Palestine, and that the collapse of the Old Kingdom and the severing of this trade connection hastened the decline of settled life in that area.

The instability and civil war in Egypt during the First Intermediate Period allowed the Asiatic nomads on the border to infiltrate into the eastern Delta. The situation was reversed towards the end of the Tenth Dynasty when Egyptian control of this area was re-asserted and the sea-route to Syria was re-opened for trade as is demonstrated by the use of Lebanese cedar wood for the large painted coffins which are so characteristic of the Heracleopolitan culture. The reunion of Egypt under Mentuhotep II probably led to a renewal of Egyptian expeditions to the Sinai now to the turquoise mines of Serabit el-Khadim although firm evidence for the Egyptian presence there appears only in the Twelfth Dynasty. To keep out from the Delta the continuous waves of infiltrating Asiatics from the east, Amenemhat I, founder of the Twelfth Dynasty, constructed a fortification known as the Walls of the Ruler. However, as a famous painting from Beni Hasan demonstrates, Asiatic traders were still allowed into Egypt and an Asiatic settlement has been identified in the eastern Delta at Tell el-Daba. Trade was actually conducted through Byblos and Ugarit whose rulers came under strong Egyptian cultural influence. Two of the most interesting objects of the period in the British Musuem were acquired in Beirut and probably came from Byblos: first is the diorite sphinx of Amenemhat IV (1798–1790 BC) whose face was reworked in later times; the second is the gold plaque of the same king. Egyptian messengers and fugitives such as Sanehet passed freely into Palestine, and Egyptian records refer to various petty principalities in that area. The most detailed lists of towns and rulers occur on figures of bound enemies that were inscribed with the names of all potential enemies of the king and then ritually destroyed (the *Execration Texts*). Very little is known of actual warfare in Western Asia during the dynasty apart from a foray by the General Nesmont in the joint reign of Amenemhat

I and Senusret I and punitive expeditions under Amenemhat II and Senusret III. It appears that the occasional Egyptian raid was thought sufficient to maintain stability in the eastern border and confirm Egyptian prestige as the dominant power of the area.

This state of affairs continued for a time under the Thirteenth Dynasty, but the unstable position of the kings of the period, the precise reasons for which cannot now be determined, eventually led to a weakening in government, while the Asiatic settlement in the eastern Delta at Tell el-Daba grew in power and influence. Eventually the eastern Delta Asiatics produced a rival line of kings, the Hyksos (Greek form of the Egyptian *heqa-khasut*, 'rulers of hill-lands'), an account of whom more properly belongs in the history of Egypt proper. Scarabs bearing their names have been found at Kerma in the Sudan and in Palestine, and a jar-lid in Crete may also testify to the widespread nature of their contacts. A granite lion in the British Museum bears the name of the Hyksos Khyan. It was found in Baghdad where it was brought in later times. The Rhind Mathematical Papyrus was written under the other great Hyksos, Apepi, showing the extent of the Egyptianisation of these foreign rulers. Nevertheless, war with the indigenous Theban dynasty broke out under Seqenenra Taa who was apparently defeated and killed. However, the Theban forces under Kamose invested the Hyksos capital at Avaris and finally destroyed it in the reign of his successor Ahmose, expelling the Hyksos from Egypt.

The rule of the Asiatic kings in Egypt had severely affronted the Egyptian psyche, and now in the ascendant the Egyptians sought to forestall any future problems by extending their rule over the Asiatics in the north. Ahmose began the process by besieging and reducing, after a three years' siege, the Hyksos stronghold of Sharuhen in Southern Palestine. This new positive policy of aggression in Asia was followed by his immediate successors, especially Thutmose I, who penetrated as far as the Euphrates defeating the strong kingdom of Mitanni and setting up a stela on the eastern bank of the river. Thutmose III crushed the resistance of the local princes at Megiddo, and in a series of well-planned campaigns he followed up his initial success by extending the limits of Egyptian control far to the east across the Euphrates and to the north to the borders of the Hittite Empire. His successors maintained Egyptian prestige in Asia and strengthened the Egyptian position by reaching an accommodation with Mitanni sealed by marriage alliances. Control over the conquered territories was exercised by local princes who could be trusted, their fidelity in most cases being stimulated by the presence of Egyptian envoys with some armed forces. Members of the ruling families were taken to Egypt to be educated and to be held as potential hostages. The establishment

150

103

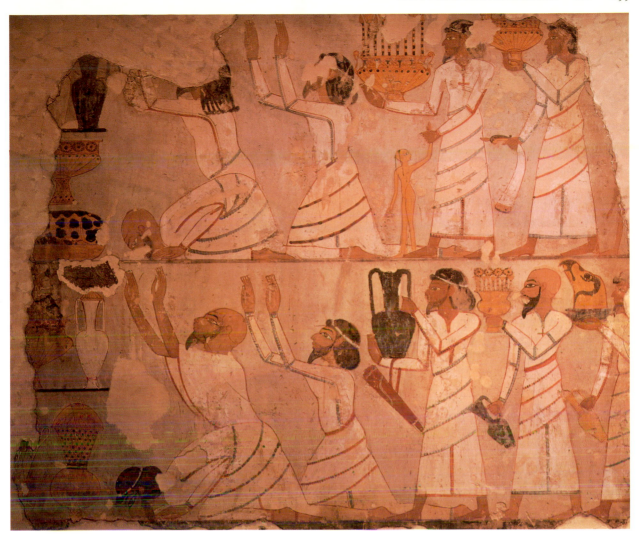

of Egyptian control in Palestine and Syria led to an increase in trade and cultural contacts. Trade was also established with Crete and the Aegean area.

The situation in Western Asia changed dramatically at the end of the Eighteenth Dynasty, with the rise of the Hittite Empire which effectively destroyed the Mitannian state and sought to subvert Egypt's northern vassals, notably the rulers of Amurru and Qadesh who changed sides. The rulers of the Nineteenth Dynasty sought to reassert Egypt's control of Palestine and regain lost ground. Sety I, after inflicting a defeat on the Hittite forces, eventually withdrew south of Qadesh. Ramses II launched a new offensive in his fourth year followed in the subsequent year by a great attack which culminated in a battle at Qadesh on the Orontes River. The Hittite and Egyptian records give divergent accounts of the outcome of this struggle, and it is probable that neither side could properly claim a victory, although the Egyp-

153. Fragment of wall-painting from the tomb-chapel of Sobekhotep (see Fig. 91) showing Western Asiatic envoys bringing exotic vessels and paying homage to Pharaoh. The envoys are distinguished from Egyptians by their clothing, hairstyle and skin colour. 18th Dynasty, c. 1400 BC; painted plaster, from Thebes. H. 1.14 m.

tians withdrew. Ramses, however made out that a great triumph had been achieved through his own valour, and the battle was celebrated on the walls of a number of temples in Egypt and Nubia. Parts of two copies on papyrus are preserved in the British Museum. In the years following the battle constant vigilance and frequent punitive expeditions were needed to preserve the security of the Asiatic Empire. Ultimately in his twenty-first year Ramses II concluded a treaty with the king of the Hittites recognising the loss of the northern provinces but guaranteeing peace between the two powers. This alliance was subsequently cemented by a marriage

between Ramses and the daughter of the Hittite king. This understanding was to endure until the end of the Hittite Empire at the beginning of the Twentieth Dynasty.

Secure in possession of Palestine and part of Syria free from outside interference, the administration of these territories was reorganised about this time with key Egyptian strongholds and permanent garrisons. Further unrest was put down by Ramses II's successor Merenptah. Cultural interchange between Egypt and its Asiatic possessions flourished. Asiatics sought employment in Egypt and appear under their own and adopted Egyptian names on Egyptian monuments, even holding positions at court. Asiatic gods and goddesses were introduced into the Egyptian pantheon. Ramses II gave his eldest daughter the Semitic name Bint-Anath, while one of his sons married the daughter of a Syrian ship's captain. The Egyptian language exhibits a number of Semitic loan-words at this period. This cosmopolitan era came to an abrupt end with civil war in Egypt and the invasion of the Sea Peoples who destroyed the Hittite Empire, and overran part of Syria and Palestine but were thrown back from Egypt by Ramses III. The Egyptians managed to hold on to certain strongholds in Palestine for a while longer but by the reign of Ramses VI Egypt had lost the remnants of her Asiatic Empire.

The withdrawal of Egypt from Palestine was followed by the growth in power of the Philistine city-states and the kingdom of Israel. Egypt maintained tenuous commercial relations with the region, but apparently only became actively involved in the area at the end of the Twenty-first Dynasty. Sheshonq I, founder of the Twenty-second Dynasty launched a major offensive in Palestine more as a raid for booty than an attempt to reassert permanent Egyptian hegemony. The fragmentation of Egypt into petty principalities weakened her influence in the Levant. When Egypt was reunited under the Nubian kings of the Twenty-fifth Dynasty, they attempted to stem the growing power of Assyria in vain. The struggle came to a head in 671 BC when Esarhaddon the Assyrian king succeeded in penetrating into Egypt as far as Memphis, winning over many of the petty Delta rulers. Shortly afterwards the Nubian ruler Taharqo succeeded in regaining Memphis, deposing the administration set up by Esarhaddon; but in 667 BC the Assyrians returned, this time under their new ruler Ashurbanipal whose forces occupied Memphis and advanced as far as Thebes. Nekau of Sais was installed as Assyria's vassal ruler but in 664 BC he was killed by the Nubian ruler Tanutamani. In a second campaign Ashurbanipal again occupied Memphis and his forces sacked Thebes. The Nubians were expelled and Psamtek I, son of Necho, was appointed new ruler of Egypt. During his long reign he eventually felt strong enough

to discontinue tribute to Assyria and thus Assyrian control over Egypt lapsed. His successor sought to prevent the rise of the Babylonian Empire, as a successor to Assyria. Some success under Necho II in 609 BC when Josiah King of Judah was slain at Megiddo was followed by a crushing defeat at Carchemish in 605 BC. The Egyptians withdrew to their border, but in 525 BC the Persians, who had annexed Babylon, invaded Egypt under Cambyses. The Persian rule was resented and constant revolts eventually succeeded in driving them out about 405 BC. However, in 343 BC the Persians returned and the last Egyptian ruler Nakhthorheb II fled to Nubia. Thereafter Egypt fell to Alexander the Great who was welcomed as a deliverer. The Greek Ptolemaic Dynasty was in turn conquered by Rome in 30 BC and Egypt became an adjunct of a greater empire.

Egypt and her western neighbours

Whereas the name Libya refers today to the nation-state west of modern Egypt, in classical Greek and Roman texts it was used to denote the area west of the Nile Valley, starting at the very edge of the desert. This area was home to nomadic tribes and both area and tribe were named Tjehenu and Tjemehu in the Old and Middle Kingdoms; evidence for relations with Egypt is sparse, but Fifth Dynasty reliefs depict the defeat of Tjehenu chieftains and the *Tale of Sanehet* opens with the defeat of Tjehenu by Senusret I. In the *Execration Texts* of the Middle Kingdom, western nomads occupy little space by comparison with domestic, Asiatic and Nubian enemies of the king, and in general the scarcity of evidence may reflect a lack of interest on the part of the Egyptians in the resourceless Sahara. In the late New Kingdom and Third Intermediate Period new tribe names appear in Egyptian texts, among which the most common were Libu and Meshwesh. These new tribes formed part of the array of foreign enemies of Ramses II and Merenptah, and were defeated again by Ramses III at the end of the New Kingdom. The threat to settled life in the Delta and valley can be seen both in fortresses set up by Ramses II at the western Delta edge and in Twentieth Dynasty texts at Thebes referring to danger and disruption from desert nomads.

Despite the proclamations of victory on Ramesside royal monuments, the Libu and Meshwesh successfully infiltrated the Delta and Middle Egypt to the extent that they ranked among the leading families in several towns by the Third Intermediate Period. One family of Meshwesh in the Delta city of Bubastis produced the general who became first king of the Twenty-second Dynasty, inaugurating the so-called Libyan Period of Egyptian history (the latter part of the Third Intermediate Period). When this dynasty failed to maintain

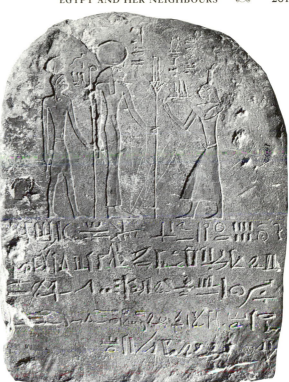

154. Vessel hollowed from a single piece of basalt expanding in diameter to the base. This unusual shape belongs to a class of vases thought to be of Libyan origin, some examples having been excavated near Marsa Matruh in graves of the early 3rd millennium BC. H. 27.5 cm.

155. Stela showing a Libu chief offering the hieroglyph for 'countryside' to Sekhmet and Heka, a donation dated in the hieratic text below to year 7 of Sheshonq V and specified as ten arouras (about seven acres). 22nd Dynasty, c. 760 BC; limestone, H. 30.5 cm.

centralised control of all Egypt, it shared power with other Meshwesh dynasts in the eastern and central Delta, while a rival family of Libu origin arose in the western Delta city of Sais. The Saite Libu achieved control over much of Lower and Middle Egypt under the rule of Tefnakht and Bakenrenef, who entered the history of Manetho as the Twenty-fourth Dynasty. Their efforts to reunify Egypt were thwarted only by the intervention of the Napatan king Piy and his successors, but the same or another Libu family can probably be identified in the Twenty-sixth Dynasty from Sais; the new Saite dynasty was installed to govern Egypt for the Assyrians when they invaded Egypt and overthrew Napatan rule. Gradually as the Assyrians became embroiled in ever more serious conflicts on their home front, their Saite governor Psamtek managed to assert his own sovereignty over the country as Psamtek I. The new rulers of Egypt continued to develop the renaissance begun by the Napatan kings in Egypt, and like the Twenty-second Dynasty kings only their names betray Libyan origin. After the defeat of the last Twenty-sixth Dynasty king Psamtek III at the hands of the Persians the western desert nomads seem not to have played a part in Egyptian life. In Ptolemaic

times the Libyan coast formed a part of the Ptolemaic dominion, but more to incorporate the Greek colony of Cyrene than as a continuation of Pharaonic ambitions.

The Land of Punt

References to Punt form one of the most alluring and enigmatic problems presented by Egyptian texts. The word Punt is used to denote a foreign land from which the Egyptians procured exotic produce, in particular aromatic trees, incense and myrrh. The texts span the Old Kingdom to Graeco-Roman Periods, and the most elaborate description comes in the pictorial record on the walls of the temple of Hatshepsut at Deir el-Bahri; the scenes present an expedition sent by Hatshepsut to bring back exotic trees for the production of incense or other material used in temple ritual; in the approach to the temple archaeologists found the remains of perhaps the same trees. In the scenes the journey includes a voyage by ship along the Red Sea, identified by the fish and other sealife represented; this concurs with Middle Kingdom evidence for a Red Sea harbour at the end of the Wadi Hammamat, including texts referring to Punt. At all

periods the evidence is too slight to allow an identification of Punt, although the Hatshepsut reliefs give a glimpse of the society witnessed by her expeditionaries to Punt, including tree houses and a startling portrayal of the wife of the ruler of Punt as an obese woman, perhaps suffering from a disease. The Deir el-Bahri record also records tropical fauna and flora such as palms and giraffes from which most scholars have concluded that Punt should be located on the African shores of the southern Red Sea, along the coasts of what are now the republics of the Sudan, Ethiopia and Djibouti, or slightly further in Somalia. However the Hatshepsut expedition is preserved in an extended description, and it is not possible from this alone to be sure that Punt denoted the same place at all times; even in the Eighteenth Dynasty the term Punt may have covered a wider area than the one specific destination of the Hatshepsut expedition. Until archaeological work uncovers the early history of the Red Sea litoral, Punt will remain a vague designation of the south-eastern commerce of Pharaonic Egypt.

Egypt and Nubia

South of the First Cataract lay Nubia, a vast land now divided between the Arab Republic of Egypt and the Sudan. In antiquity the region was the home of some of the most advanced early cultures of tropical Africa. It was also an area of great economic importance, a factor which was instrumental in bringing about a long-term relationship with the Egyptians. On account of the harsh environment of Nubia, the land never supported as large a population as Egypt. As the Nile flows northwards between Khartoum and Aswan, it passes alternately through barren desert and relatively fertile floodplain suitable for agriculture. The cultivable strip in ancient times was nonetheless very narrow and intermittent, while the climate was marked by extreme heat and aridity. The dark-skinned people of Nubia, while speaking a different language to the Egyptians, shared with their northern neighbours a common ethnic background and many points of similarity between the material cultures of the two regions can be observed.

The economic importance of Nubia stemmed in a large degree from the valuable mineral resources which were to be found within convenient reach of the Nile. The most sought-after of these were gold, copper, semi-precious stones such as amethyst and hard stones such as diorite. Moreover, Nubia occupied a strategic position on the principal route by which the luxury products of sub-Saharan Africa passed north to the Mediterranean. A painted cast from a wall relief in the temple of Ramses II at Beit el-Wali gives an informative picture of the wealth of exotic products which the Egyptians obtained from Africa: the Pharaoh is shown receiving leopard-

skins, giraffe tails, giraffes, monkeys, leopards, cattle, antelopes, gazelles, lions, ostrich feathers and eggs, ebony, ivory, fans, bows, shields made of hides, and gold. The trade in these goods, conducted chiefly by land, passed to Egypt either via Aswan, where it was subject to careful control, or by way of the desert oases running from Kharga south-west.

The relationship between Nubia and Egypt changed repeatedly over the centuries. As cultural and political advances in Egypt outstripped those in Nubia from about 3000 BC the pattern was set which was to dominate the relationship between the two lands for millennia. Egyptian rulers aimed to gain control of the southlands so as to exploit the natural resources directly and to control the lucrative trade networks. This resulted in the annexation of large areas of Nubia which were ruled by Egypt as imperial possessions in the Middle and New Kingdoms. At other times the Nubians remained independent, tending to be at their strongest when Egypt was weak. At such times they achieved prosperity from their control of the desired trade goods, acting the role of commercial middlemen. The Nubians' frequent contacts with foreign peoples made their homeland an important focal point for the diffusion of cultural traits between the Mediterranean world and sub-Saharan Africa.

In the Palaeolithic Period Nubia, like Egypt, was inhabited by nomadic peoples who relied on hunting, gathering and fishing for their survival. The first settled societies began to appear in the Mesolithic and Neolithic periods. An indication of a move towards sedentary life at this period is the appearance of the earliest Nubian pottery: handmade globular vessels with wavy line designs impressed into the exterior surface with a fishbone or stamp. This type of pottery, known mainly from the central Sudan, particularly the area around Khartoum, appears to belong to a far-flung ceramic tradition which has manifestations in other parts of north-east Africa.

The people of the Khartoum Neolithic culture were keeping domesticated cattle and cultivating cereal crops as early as about 4000 BC. In spite of these advances, settlement in the central Sudan seems to have been interrupted shortly after 3000 BC. The first uniform indigenous culture to spread over a wide area (known as the A-Group or A-Horizon) is associated principally with Lower Nubia, though related material is known from sites further south, which remain comparatively little-known. Though it seems to have developed from earlier indigenous cultures based in the Second Cataract region, the material remains of the A-Group show that the people had much in common with the Naqada cultures of Predynastic Egypt. The A-Group Nubians still lived a semi-nomadic life but agriculture was becoming more widely adopted. Quartzite and sandstone grinders

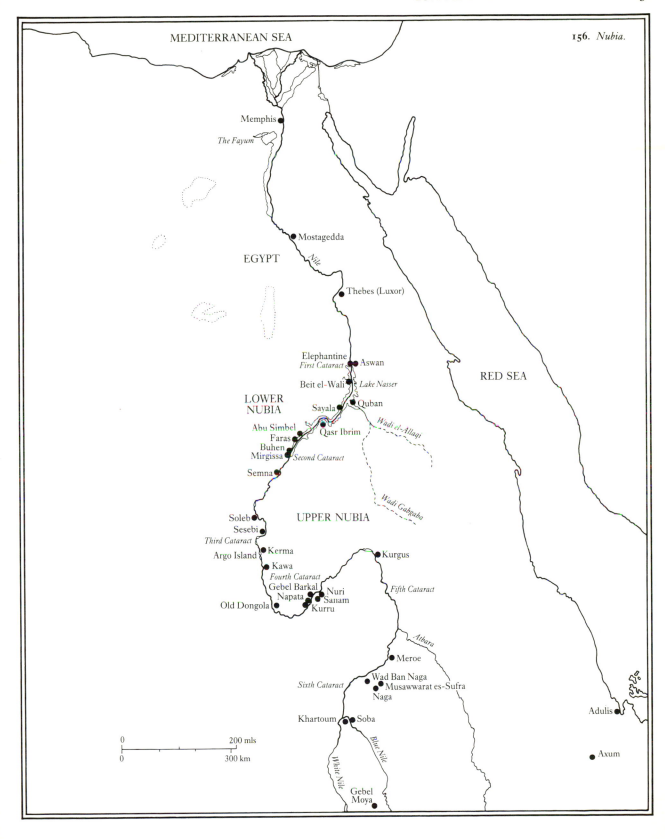

156. *Nubia.*

MEDITERRANEAN SEA

Memphis

The Fayum

EGYPT

Nile

Mostagedda

Thebes (Luxor)

Elephantine
First Cataract
Aswan

Beit el-Wali *Lake Nasser*

LOWER
NUBIA
Sayala
Quban

Abu Simbel
Qasr Ibrim
Faras
Buhen
Mirgissa *Second Cataract*

Semna

RED SEA

Wādi el-'Allāqi

Wādi Gabgaba

Soleb
Sesebi
Third Cataract
Kerma
Argo Island
Kawa

UPPER NUBIA

Kurgus

Fourth Cataract
Gebel Barkal
Napata
Nuri
Sanam
Old Dongola
Kurru

Fifth Cataract

Atbara

Meroe

Sixth Cataract
Wad Ban Naga
Musawwarat es-Sufra
Naga

Adulis

Khartoum Soba

Blue Nile

White Nile

Axum

Gebel
Moya

0 200 mls
0 300 km

found in graves testify to the preparation of cereals for making bread, and sheep, goats and cattle were probably kept. Grave goods show that trading with Egypt was already in operation; Egyptian pottery jars which probably held wine or beer have been found, as have copper tools and weapons and occasionally more elaborate objects; stone palettes and vessels, and gold-handled maces decorated with animals in a recognisably Egyptian style have been found in a grave at Sayala, perhaps the burial place of a chief. Such goods were probably received in return for ebony and ivory, which were already being used by the Egyptians to make figurines, ornamental containers and furniture fittings.

The lifestyle of the A-Group Nubians, as attested by their settlements and grave goods, was a relatively simple one. Communities were probably based on small family groups living in reed or grass huts or rock-shelters, though towards the end of the fourth millennium stone houses became more common. Body ornaments of shell, ivory, bone, faience and stone were popular, and rhomboidal quartzite palettes were used to grind malachite for eye-paint. The finest A-Group pottery is distinguished by its thin walls and external decoration in red ochre, sometimes copying the patterns of woven baskets.

Following the emergence of Egypt as a hierarchical society with a centralised government and written language, around 3000 BC, the rulers turned increasingly to aggression to obtain the products of the south which had hitherto been acquired through trade. Beginning in the First Dynasty predatory raids into Nubia seem to have increased in frequency and scale. This change of attitude, perhaps combined with a deterioration in the climate, seems to have been influential in forcing the A-Group Nubians to move away from the Nile Valley and to retreat to the desert fringes. Their material culture practically vanishes from the archaeological record of Lower Nubia during the First Dynasty. The virtual elimination of local opposition gave the Egyptians the opportunity to exploit the region more fully. A feature of their new expansionist policy was the establishing of permanent settlements in Lower Nubia to work the region's mineral resources. By the Fourth Dynasty, copper was being smelted at an Egyptian town at Buhen, while ceramic evidence indicates that another Old Kingdom settlement existed at Quban. Diorite extracted from the quarries west of Toshka near Abu Simbel was used to carve royal statues destined for the mortuary temples of Khufu, Khafra and other kings.

After a hiatus of about five to six hundred years, Lower Nubia was resettled by people who perhaps moved into the valley from the western desert. Known as the C-Group or C-Horizon, the material culture of these newcomers appears to stem from the same tradition as that of the A-Group (the existence of an intermediary 'B-Group' is now generally discounted). Once established, this culture persisted in the region until the Eighteenth Dynasty, gradually evolving towards more settled living patterns. Cattle herding played an increasingly important role in the economy, and temporary shelters were gradually replaced by permanent houses with walls of stone and wattle. Graves were pits with stone superstructures. One of the main differences in material culture between the A- and C-Groups is to be found in the pottery. The most characteristic of the C-Group types is a black ware used for bowls and drinking cups. The exterior is decorated with geometric patterns incised into the clay, filled with a white pigment and highly polished.

Quarrying operations near Toshka appear to have ceased after the Fifth Dynasty and the Egyptian settlement at Buhen was evidently abandoned. Nonetheless, contacts with the African luxury trade were maintained, chiefly through the activities of the provincial governors of Aswan, who led trading expeditions into Nubia. Records of this activity survive in rock graffiti and in the biographical inscriptions in the tombs of these officials at Qubbet el-Hawa. The most informative account is that in the tomb of Harkhuf (Sixth Dynasty). Harkhuf's narrative mentions distinct regions of Lower Nubia, the most important of which were named Wawat, Irtjet and Satju. The Egyptians endeavoured to maintain good relations with the chiefs of these localities, who traded cattle with them, and provided mercenaries for Egyptian armies. But the goal of most Egyptian trading expeditions during the Sixth Dynasty was a region known as the Land of Yam, which probably lay in the Dongola Reach, south of the Third Cataract. Harkhuf's accounts of his journeys there mention the goods brought back, which included ebony, incense, oil, leopard-skins and elephant tusks. The ruler of Yam was clearly a powerful figure who controlled the traffic in African goods entering his territory from south, east and west. It is believed that Yam is to be identified with the site of Kerma, centre of an advanced indigenous culture as early as the twenty-fifth century BC (see below).

The disturbances of the First Intermediate Period appear to have been accompanied by a break in Egyptian commercial contacts with Upper Nubia. With the recovery of strength in the Middle Kingdom, Egypt's rulers pursued an ambitious policy, aimed at the domination of Lower Nubia. A series of military campaigns in the reigns of Senusret I and Senusret III broke the resistance of the C-Group population in Lower Nubia, and all the territory as far south as Semna was permanently annexed to Egypt. To guard the new frontier and to administer and exploit the region a chain of massive mud-brick fortresses was constructed along the Nile, concentrated in the regions of the First and Second Cataracts. These installations possessed elaborate defensive systems inco-

157

157. *Small cup of black polished incised ware, decorated with geometric motifs. Late C-Group, c. 1700–1500 BC; from Faras, cemetery 2, grave 8. H. 8.1 cm.*

porating ramparts, ditches, bastions and huge fortified gates with drawbridges. The forts were garrisoned by Egyptian soldiers, who were regularly relieved and kept supplied with rations and other essentials by river. Careful surveillance was maintained over the movements of the local inhabitants and the nomadic Medjay Nubians of the eastern desert. The main threat to the security of the frontier, however, undoubtedly came from the growing power in the Kerma Basin, referred to in Egyptian records as Kush.

During the Twelfth Dynasty the gold mines in the Wadi el-Allaqi and the Wadi Gabgaba, in the eastern desert, began to be worked. Copper was mined at Abu Seyal and the diorite quarries west of Toshka were reopened. The fortresses served as bases for these activities; gold was smelted and stored at the fortress of Quban, at the mouth of the Wadi el-Allaqi and scales and weights for weighing gold have been found at other installations in the Second Cataract region.

The local C-Group population seems to have coexisted fairly amicably with the occupying Egyptians. Although small-scale trade was carried on, there was no significant cultural interaction and the indigenous Nubians probably continued to follow their traditional lifestyle, practising agriculture and cattle herding. Their society was still a

tribal one, with little outward indication of social stratification, but gradual developments in material culture can be traced. Grave types became more elaborate, the range of ceramics broadened and the individual vessel-types developed. Settlements grew into small villages of houses of partly dry-stone construction, either circular one-roomed huts or larger dwellings of several rooms built up in an agglomeration. The peace imposed on the region by the Egyptian presence, while perhaps facilitating the evolution of local culture, may have stultified political development through preventing contact between the C-Group and the more advanced Kerma Culture to the south. This may have been a deliberate policy on the part of the Egyptians, to prevent the emergence of a threat to their authority in Lower Nubia.

The origins of the Kerma Culture are still imperfectly understood, but there is no doubt that the A- and C-Group cultures and those of the eastern desert, the Sahara and the Upper Nile region were all among the formative influences. The strategic location of Kerma in one of the most fertile stretches of the Nubian Nile Valley was doubtless an important factor in the kingdom's steady growth. While agriculture and animal husbandry formed the backbone of the economy, the prosperity of the state seems to have depended largely on the ruler's ability to control the influx of luxury commodities from the south and from the east and from the west. Ivory, ebony and other African products were reaching Egypt again in quantity via Kush during the Middle Kingdom, despite occasional hostilities between

158. *Handmade 'Kerma ware' beaker. The black mouth and interior, red-washed base and undulating purple-grey band are typical of the colouring of these pots. Classic Kerma phase, c. 1750–1550 BC; from Kerma, Tumulus* K. IV. H. *11.6 cm.*

the lands. The abundance of Egyptian objects found at Kerma indicates that trade was reciprocal.

The ancient town of Kerma, which was occupied continuously between about 2500 and 1500 BC, was one of the earliest urbanised communities in tropical Africa. The most prominent landmark on the site is a massive mud-brick structure known as the Western 'Deffufa'. It appears to have been the main religious structure of Kerma, and underwent numerous rebuildings and changes of design over the centuries. Around the Deffufa were grouped workshops, public buildings and the dwellings of the inhabitants, which varied in complexity from simple huts to houses with two or three rooms and a walled courtyard containing animal pens and granaries.

The Kushite craftsmen were skilled in the production of tools, weapons and toilet articles of bronze, and bowls, vases, figurines and inlays of bright blue faience – the

manufacturing techniques of which were probably learned from the Egyptians. The most distinctive artistic products of Kerma, however, are the ceramics. Without the aid of a potter's wheel the craftsmen were able to fashion bowls, jars and beakers of astonishing fineness and with a characteristic colour-scheme of black top and rich red-brown base, separated by an irregular band of purple-grey. Enormous quantities of these vessels have been found in graves, sometimes stacked one inside the other.

Although the Kushites had no written language, some idea of their beliefs in an afterlife can be gleaned from their graves. The standard grave type was an earth tumulus erected over a burial pit. The body, dressed in leather garments, sandals and jewellery, was often placed on a wooden bed with animal legs. Weapons were frequently placed in the grave and offerings of food and drink provided. Sheep were regularly sacrificed and buried with the dead. In the later phases of the kingdom's history the sheep sacrifices were gradually replaced by those of humans, perhaps servants of the deceased who were killed to accompany their master into the next life. The richest graves of all were those of the last rulers of

158

Kush, dating to the late seventeenth and early sixteenth centuries BC, consisting of massive tumuli with associated brick funerary chapels. The principal burial lay on a bed in a small chamber beneath the mound. In addition to subsidiary burials, the largest mounds contained a broad central corridor in which were discovered the skeletons of hundreds of men, women and children, all apparently buried simultaneously as sacrificial victims.

A conspicuous element in the populations of Egypt and Nubia in the Second Intermediate Period were nomadic groups, of which the Medjay are the best documented. At various times during the third and second millennia BC bands of these people descended from their homeland in the eastern desert into the Nile Valley, where they regularly found employment as soldiers in the Egyptian armies. On account of the simple tribal nature of their society, however, the allegiance of individual groups was narrow, and they posed a constant threat to Egyptian miners and other prospectors in Lower Nubia. The character of the defences at the Second Cataract fortresses indicates that attacks from the desert fringes, as well as from the south, were a real possibility.

Whereas the Medjay are known chiefly through Egyptian written records, there is widespread archaeological evidence for another nomadic Nubian group, known as the 'Pan-Grave' people. These settlers entered southern Egypt and northern Nubia in considerable numbers during the late Middle Kingdom and Second Intermediate Period and retained their distinctive culture for several generations before becoming integrated into local societies. The Pan-Grave Nubians take their name from the distinctive shallow circular pits in which they were buried. Their pottery includes incised ware and black-topped red ware vessels, and shows links not only with the ceramics of the C-Group and the Kerma culture, but also with that of groups from the Eastern Desert and the Gash Delta near the Red Sea coast. Typical finds in pan-graves include jewellery made from Red Sea shells, faience, ostrich egg shell and mother of pearl, weapons of Egyptian type and skulls and horns of oxen, sheep and gazelles, sometimes painted with patterns.

With the renewal of Egyptian prosperity following the expulsion of the Hyksos in about 1550 BC Nubia once more became a target for colonial expansion. The Kerma rulers had annexed all the Lower Nubian territory as far north as Aswan, and military incursions into this region in the reigns of Kamose and Ahmose were undertaken, probably as a preliminary measure to safeguard the southern frontier before the Egyptians turned their attention to attacking the Hyksos in the north. Campaigns against Nubia continued after the reunification of Egypt, culminating in the destruction of Kushite military power and the probable sacking of Kerma in the reign of Thut-mose I. Resistance to the imposition of Egyptian authority continued for several generations, until the reign of Thutmose III, when full control over the region was achieved. The region of the Fourth Cataract was chosen as the new imperial frontier, and all territory north to Aswan was permanently annexed, though looser control was probably exerted over the area between the Fourth and Fifth Cataracts. A new frontier settlement called Napata arose close to Gebel Barkal, a flat-topped mountain which was visible from many miles away and probably served as a landmark on ancient trade routes. An Egyptian colonial administration, based on that operating in Egypt, was imposed on Nubia. The head of the administrative system was the viceroy, who bore the titles 'Overseer of the Southern Lands' and 'King's Son of Kush'. His main duties were the running of the administration, and the exploitation and collection of the valuable resources obtained from Nubia itself and from the south. He also organised building works on the king's behalf and was responsible for military operations in the region. The conquered territory was divided into a northern and a southern province, respectively named Wawat and Kush, each governed by deputies responsible to the viceroy. Smaller territorial divisions were ruled by native chiefs.

The Nubian gold mines were worked intensively during the New Kingdom. The richest deposits came from the Wadi el-Allaqi mines. In the course of the New Kingdom attempts were made to extend mining operations to other areas, as gold became an increasingly important bargaining counter in Egypt's diplomatic relations with the powerful states of the Levant. The Karnak 'annals' of Thutmose III record the regular reception of large quantities of gold from Nubia, and wall-paintings in the tomb chapels of Theban officials include scenes of Nubians presenting gold, along with other products of the southlands, to the Pharaoh. The trade routes to the African interior were now controlled directly by the Egyptians for the first time and wall-paintings, reliefs and inscriptions in tombs and temples emphasise the rich variety of luxury goods which they obtained.

In addition to the mineral and animal resources, living captives were brought to Egypt, often to act as labourers on religious or civil establishments, as servants and as soldiers, while others served as a police force. The Egyptians displayed little respect for the indigenous traditions of the Nubians, and adopted a deliberate policy of acculturation towards them. The sons of the native chiefs who ruled the smaller districts were taken to Egypt as hostages and educated at the court, where they were taught the Egyptian language, given Egyptian names, and persuaded to adopt Egyptian dress and customs. They were then sent back to be rulers of their local chiefdoms and

159

160

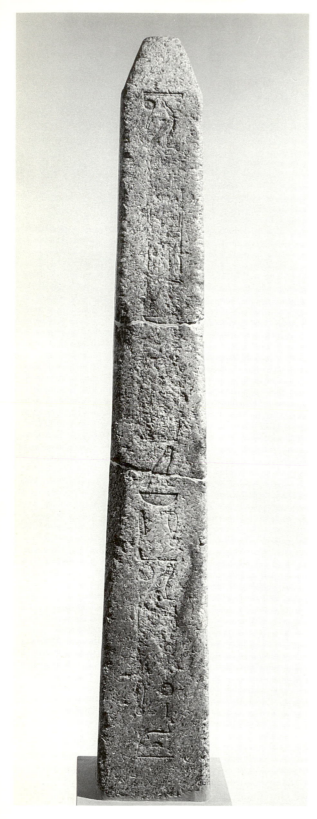

probably to promote the acculturation of their subjects. In some areas this eradication of local traditions seems to have been achieved thoroughly. Manifestations of the C-Group culture virtually disappeared in Lower Nubia, to be replaced by houses, graves and manufactures copying Egyptian models. In other areas the spread of Egyptian culture seems to have been resisted, and native burial customs were retained.

During the Eighteenth Dynasty towns and temples superseded fortresses as the main manifestation of the imperial presence. The towns, serving as administrative centres and bases for mining operations, were generally walled and a stone temple was a prominent feature. Some old-established settlements were renewed, while new towns were founded, such as those at Amara West and Sesebi. Two of the most imposing temples were erected at Soleb and Sedeinga and dedicated to the worship of Amenhotep III and Queen Tiy. A pair of red granite lions which originally stood in front of the temple of Soleb are now in the British Museum. Several rock-cut temples were built during the reign of Ramses II, the most celebrated of which are the 'Great Temple' at Abu Simbel, with its four immense seated figures of the king, and the smaller temple nearby, in which Queen Nefertari, identified with the goddess Hathor, is the main focus of attention. All these structures functioned both as cult-centres and as immense pieces of propaganda, designed to overawe the people of Nubia with the might of the Egyptian kings and gods.

During the last century of the New Kingdom Egyptian activity in Nubia declined. There appears to have been a major decrease in the population of Lower Nubia, perhaps due partly to adverse climatic conditions and over-exploitation of the region's human resources. Diminishing productivity in the goldfields, coupled with serious pressures on the Egyptian economy and threats to the country's security, led to the eventual abandonment of the Pharaonic settlements and the withdrawal of the provincial administration at the end of the Twentieth Dynasty.

The three centuries following the collapse of Egyptian authority constitute one of the most obscure phases of Nubia's history. During this period an indigenous state

159. LEFT *Red granite obelisk inscribed on one face with the names and epithets of Queen Hatshepsut. 18th Dynasty, c. 1479–1457 BC; from Qasr Ibrim. H. 1.83 m.*

160. OPPOSITE *Part of a wall-painting from the tomb-chapel of Sobekhotep, showing Nubians presenting the produce of the southlands to the Egyptian king. The items shown include gold rings, jasper, ebony logs, giraffe tails, a leopard skin and live baboons. 18th Dynasty, c. 1400 BC; from Thebes. H. 80 cm.*

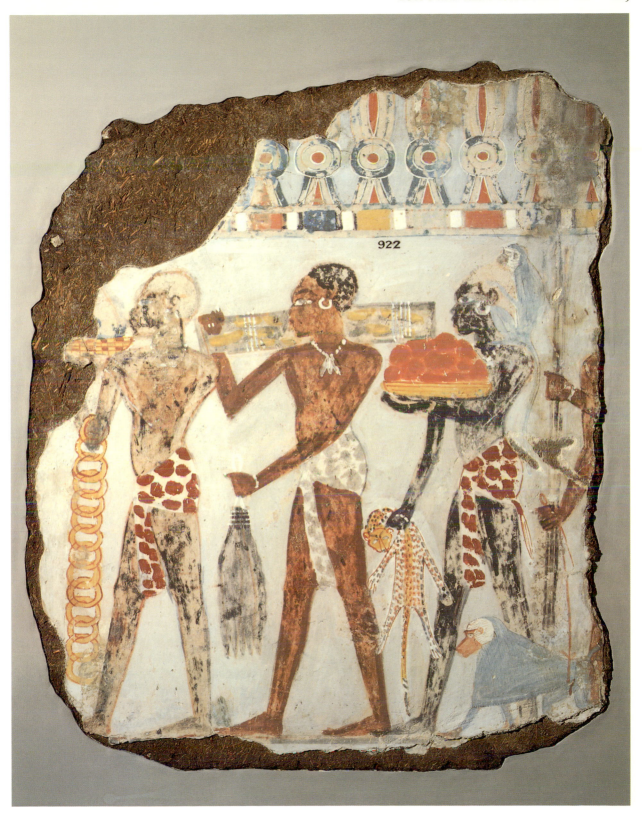

arose in Upper Nubia, but it is only in the eighth century BC that a clear picture of its character emerges from archaeological and inscriptional evidence. The native princes who ruled this state laid the foundations of an independent Nubian kingdom which was to endure for over a thousand years. Historians have been accustomed to recognise two phases in the kingdom's history, the Napatan Period and the Meroitic Period, although there appears to have been no significant break in continuity. The land south of Egypt was still generally referred to as 'Kush' by Egyptians and others at this time, and the adjective 'Kushite' is perhaps the most convenient one to describe the kingdom as a whole.

Inscriptions indicate that Napata, close to Gebel Barkal, was the most important religious centre from the early stages of the kingdom's rise to power, and probably for this reason the rulers were buried in the nearby cemeteries of Kurru and Nuri until the third century BC. The city of Meroe, in the Butana region far to the south, was also an important centre as early as the eighth century and minor members of the royal family were buried there. The remains of impressive temples testify to the importance of other sites such as Kawa and Argo Island, at this period.

The Kushite state apparently developed into a formidable power quite rapidly, and its rulers were able to take advantage of political weakness and disunity in Egypt. The Kushite king Piy, having gained the support or allegiance of the rulers of Thebes, launched a successful invasion of Egypt around 728 BC, ostensibly to halt the territorial ambitions of the dynast Tefnakht of Sais. After receiving the submission of the Egyptian local princes Piy returned to Nubia. A second invasion under Piy's successor Shabako (c. 716–702 BC) brought Egypt under permanent Kushite control, thus reversing the course of events which had led to Nubian subjection eight hundred years before. Shabako and his three successors Shabitko, Taharqo and Tanutamani, regarded themselves as legitimate Pharaohs of Egypt and were later reckoned as constituting the Twenty-fifth Dynasty. Besides adopting Pharaonic costume and titularies, and Egyptian royal burial practices, they used the Egyptian language for their monumental inscriptions. One of the most characteristic features of their regime was their constantly stressed devotion to the god Amun, whose worship at Gebel Barkal had possibly been maintained since the days of the Egyptian imperial presence.

During the half-century of their rule the Kushite kings brought much-needed peace and stability to Egypt. They imposed a strong government, pursued an active foreign policy and stimulated a revival of art, architecture and religious practices, turning to the monuments of the Old, Middle and New Kingdoms for inspiration. Whereas Memphis seems to have been the king's principal resi-

161

dence, Thebes, the religious capital, was placed under the authority of a celibate princess of the royal house, with the title 'God's Wife of Amun', a post which increased greatly in importance during the Twenty-fifth Dynasty. Each God's Wife adopted another young female member of the royal family as her successor, thereby ensuring that political power remained in the hands of the ruling dynasty. As an additional means of attaining a firm grip on Egypt the Kushite kings appointed fellow-countrymen to important posts in the religious and civil administration.

The reign of Taharqo (690–664 BC) marked the high-point of the Twenty-fifth Dynasty. Temple-building was actively pursued in his reign, particularly at Thebes, and in Nubia a series of imposing temples was constructed at Gebel Barkal, Sanam, Kawa and Tabo (on Argo Island), besides smaller works at Buhen, Semna and Qasr Ibrim. All these structures were purely Egyptian in their architectural design, plan and decoration, and were adorned with reliefs and sculptures which copied Pharaonic Egyptian models. Nonetheless, an 'African' element can be traced in the finest sculptures of the period, such as the granite sphinx of Taharqo from Kawa, in which the distinctive ethnic features of the ruler are placed within a traditional, yet vigorously carved, image of Egyptian kingship.

The Assyrian invasions between 674 and 663 BC eventually forced the Kushite rulers to withdraw from Egypt. Taharqo died in Nubia in 664 BC and an attempt by his successor Tanutamani to regain Egypt was short-lived. Tanutamani and his successors continued to rule their Kushite homeland, but through their use of the title 'King of Upper and Lower Egypt' they maintained the pretence of being the rightful rulers of Egypt as well. The Egyptian Pharaohs of the Twenty-sixth Dynasty evidently regarded the Kushite pretenders as a threat. In the reign of Psamtek II the names of the Kushite rulers were erased from Egyptian monuments and in 593 BC Egyptian forces invaded Nubia, defeating the army of the Kushite king in battle in the region of the Third Cataract.

Little is known of events in Nubia during the sixth to fourth centuries BC. The sequence of kings has been tentatively reconstructed from studies of their burial complexes and a few hieroglyphic inscriptions, but information on economic and cultural developments is very limited. Inscriptions set up by several kings, from Anlamani (c. 623–593 BC) to Nastasen (c. 335–315 BC) refer to conflicts with nomadic groups, particularly in Lower Nubia. This area was perhaps still sparsely populated and may have been politically unstable. Despite the hostilities in the reign of Psamtek II, trade with Egypt appears to have continued during the Twenty-sixth Dynasty and the Persian domination.

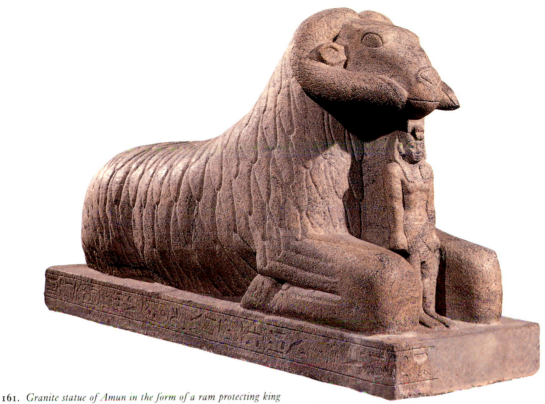

161. *Granite statue of Amun in the form of a ram protecting king Taharqo, whose figure stands between the paws. 25th Dynasty, c. 690–664 BC; from Kawa.* H. *1.06 cm.*

In the third century BC the Kushite kingdom entered upon a new phase of economic and cultural growth, probably due partly to increased contact with Egypt under the Ptolemies. The early Ptolemies apparently annexed the territory immediately south of Philae (the Dodekaschoinos or 'twelve mile strip'), enabling them to exploit the gold mines of the Wadi el-Allaqi and Wadi Gabgaba. Large quantities of gold, ebony, ivory tusks and live elephants are recorded entering Egypt at this time, clearly from Kush. That the traffic was reciprocal is indicated by the influx of Ptolemaic goods into Nubia and the Egyptian influences seen in Kushite art.

A notable increase in building activity in the Butana region occurred during this period, particularly at the site of Meroe, on the East Bank of the Nile between the Fifth and Sixth Cataracts. From this time until the collapse of the Kushite kingdom Meroe appears to have enjoyed exceptionally high status, and the term 'Meroitic Period' is often applied to this phase of the kingdom's history. There is evidence for significant economic expansion and industrialisation at the site as early as the eighth century (which may have contributed to the impetus which led to the sudden rise of the Kushite state

about this time). It was already at this date an important royal residence, and after about 300 BC most of the kingdom's rulers were buried there instead of in the cemeteries close to Napata. Smelting furnaces and great mounds of slag found at the site testify to the local production of iron, but probably more important in the city's prosperity was its strategic location, in a fertile area of grassland, suitable for agriculture and animal husbandry, and conveniently near to major trade routes linking central Africa and the Red Sea with the eastern desert and the Mediterranean.

Archaeological sources provide only an incomplete and unbalanced picture of the Kushite kingdom at this period. Evidence from Upper Nubia is biased towards religious structures and royal tombs, while material from the north yields more information about the burial practices of non-royal persons, and the development of pottery and other domestic objects. The kingdom is mentioned in the writings of several classical authors, and it is mainly from these that the little that is known of Meroe's relations with the Graeco-Roman world comes.

Throughout most of the kingdom's history royal authority was exercised by a king. On several occasions, however, beginning in the second century BC, a queen with the title *kandake* was sole ruler or shared the throne with the king. The exact circumstances under which

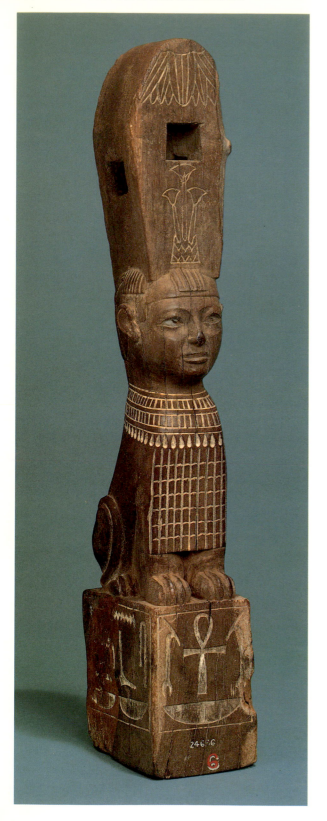

these female rulers obtained their position are in no case clear, and suggestions that matrilinear succession was in operation are not warranted by the available evidence. Funerary inscriptions and temple graffiti from Lower Nubia indicate that, as at some periods in Egypt, the main administrative and religious posts were hereditary in a number of important families. Details of the organisation and running of the economy and state institutions are lacking; that the priesthood wielded substantial influence is suggested from the stories preserved by classical authors, while there can be no doubt that the army continued to exercise a strong influence, as it had since the early centuries of the Kushite kingdom.

Relations between Meroe and Egypt remained generally amicable during the Ptolemaic Period (although the Meroites supported the Upper Egyptian rebels against Ptolemy IV and V, regaining control, for a time, of the Dodekaschoinos). Shortly after Egypt fell to Roman control, the Meroites launched a raid on the First Cataract region (23 BC). The Roman prefect of Egypt, Petronius, retaliated, defeating the Meroitic army and stationing a garrison of four hundred Roman troops at the outpost of Qasr Ibrim. After negotiations a permanent frontier between Meroe and Roman Egypt was established at Maharraqa (Hierasykaminos). This left the Dodekaschoinos region, with its access to the gold mines of the Wadi el-Allaqi, in Roman hands.

The conclusion of hostilities inaugurated a long period of peace, during which Meroe enjoyed profitable commercial relations with Rome. Both in Upper and Lower Nubia graves of this period contain pottery, bronzework, silverware and glass imported, not only from Roman Egypt, but from other centres as far afield as Pergamon, Rhodes and Algeria, and the influence of Mediterranean fashions left its mark on the culture of the southern kingdom. The Meroites, for their part, continued to export gold, ivory, ebony and live animals. As the kingdom flourished its sphere of influence grew. The southern limits of Meroitic control are unknown, but an outpost existed at Sennar on the Blue Nile. In the north, the extensive area of Lower Nubia was resettled. The exact date of this increase in population is debatable, but it may well have been a result of more land being brought under cultivation. In contrast to the Dodekaschoinos, where material culture was closely related to that of Egypt, the Lower Nubian territory from Maharraqa south to the Second Cataract was entirely Nubian in character. Civil and religious control there was in the

162. *Ornamental leg from a bed or chair, carved in the form of a sphinx. The eyes were originally inlaid and the decorative details were filled with a white pigment. The iconography suggests that the piece is of Nubian workmanship. 7th to 4th centuries BC; wood (probably ebony). H. 42.5 cm.*

163. *Ruined pyramids of Meroitic rulers in the northern cemetery at Meroe. Each pyramid had a stone-built funerary chapel fronted by a pylon-gateway and decorated with reliefs derived from Egyptian models. The northern cemetery was used from the 3rd century* BC *until the early 4th century* AD.

hands of a few Meroitic families, under the authority of the *pesato*, an official who functioned as a viceroy with Faras as his main administrative centre. The rest of the population appears to have been a mixture of Meroitic-speaking people from the south and other elements who perhaps moved into the Nile Valley from the regions to the east and west. Some of these newcomers, possibly the majority, spoke an ancestral version of the modern Nubian language.

From the second century BC the Meroites began to produce inscriptions in their native tongue rather than in Egyptian. Meroitic was written in two scripts, one using twenty-three signs adapted from Egyptian hiero-glyphs but with different sound-values, the other a short-hand form referred to by scholars as 'cursive'. Unlike Egyptian, Meroitic was syllabic (i.e. vowel-sounds were included) and words were divided first by triple and later

by double dots. The scripts were deciphered by the Egyptologist Francis Llewellyn Griffith (1862–1934). The 'key' was provided by a bilingual text on a stand for a divine barque, found at Wad Ban Naga. This gave the names of the royal dedicators in both Egyptian and Meroitic hieroglyphs, enabling Griffith to establish sound-values for the Meroitic signs. He was able to test his theory and to discover the values of the signs not present on the stand by a comparative study of funerary formulae on offering tables and stelae. Unfortunately bilingual inscriptions are rare and none are lengthy enough to provide the basis for a complete understanding of Meroitic grammar or to build up a vocabulary. The problem is exacerbated by the linguistic isolation of Meroitic; it appears to have no surviving relations in Africa and may have belonged to a self-contained group of languages now extinct. The British Museum possesses a number of texts in Meroitic on stone stelae and offer-ing tables, and a lengthy royal inscription on a sand-stone stela mentioning queen Amanirenas and prince Akinidad.

166

The problem of the inscriptions seriously limits any understanding of Meroitic religion. It is nonetheless clear that Egyptian deities were pre-eminent, the most import-

164. *Objects from a foundation deposit buried beneath the pyramid of king Senkamanisken, comprising tablets of copper, bronze, gold, jasper, lapis lazuli, chalcedony, faience and calcite, all inscribed with the king's cartouche. About 643–623 BC; from Nuri. H. of largest piece 5.5 cm.*

ant being Amun. His temples at Gebel Barkal were renovated and enlarged during this period, and new ones were built at Meroe and other centres. There is also evidence for strong popular devotion to the worship of Isis, whose temple at Philae became a major centre of pilgrimage, not only for Meroites but for other Nubian groups such as the Blemmyes. Several deities of purely Nubian origin were also worshipped, chief among which was the lion-god Apedemak. He has strong warlike associations and was depicted in statuary and relief at many of the major temples in the south of the kingdom.

Egyptian traditions retained a strong influence over the burial practices of the Meroitic rulers and the high-ranking officials. Continuing a tradition stretching back to the end of the eighth century BC, the kings were buried under small steep-sided pyramids. The adjacent chapels were decorated with reliefs reflecting Egyptian models of the afterlife. The British Museum possesses a wall

from the pyramid-chapel of a ruling queen (probably Shanakdakhete of the second century BC) showing the deceased enthroned, under the protection of the goddess Isis, and receiving offerings from rows of attendants. In the simpler graves of the ordinary people the body was often laid on a bed. Provisions for the dead included bronze vessels, pottery, cosmetic implements, jewellery and weapons.

The varied influences on Kushite culture in the Meroitic Period are nowhere more apparent, however, than in architectural forms and artistic products, which display an eclectic mixture of Pharaonic Egyptian, Graeco-Roman and African elements. The numerous temples constructed at Meroe, Naga and Wad Ban Naga clearly reflect Egyptian models, with pylon gateways and colonnaded courts leading to an axial sanctuary. Much more unconventional is the 'Great Enclosure' at Musawwarat el-Sufra, south of Meroe, a remarkable complex of structures incorporating several temples, courts, passages and other rooms, decorated with reliefs and statues. The function of the site is uncertain, various elements suggesting that it may be a religious centre or a royal palace complex.

Meroitic stone sculpture is notable for statues of gods and rulers, ranging in scale from life-size to colossal, and part-bird, part-human figures resembling Egyptian

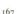

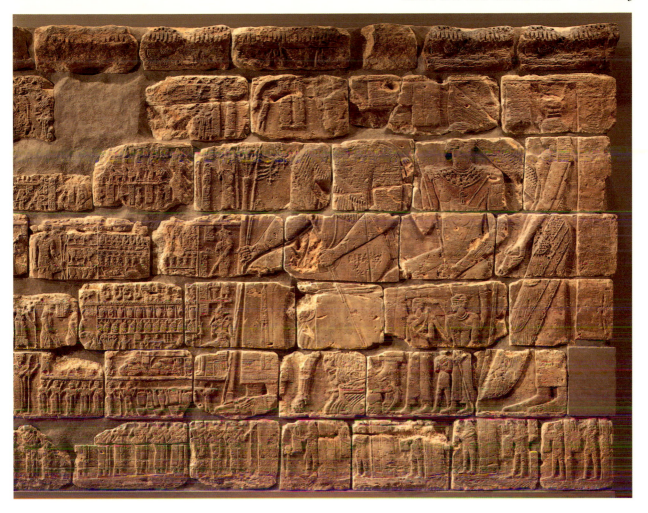

165. *South wall of the pyramid chapel of a female Meroitic ruler, probably Shanakdakhete. The queen is depicted enthroned, accompanied by a prince and protected by the wings of the goddess Isis. Facing the royal groups are rows of offering bearers and religious scenes including the weighing of the deceased's heart before Osiris. 2nd century* BC; *sandstone, from Meroe.* H. *2.52 m.*

depictions of the *ba*. These statues, an example of which is in the British Museum, were set up outside the tombs of high-ranking individuals. High-quality sculpture in metal was also produced, while the jewellery found in both royal and private graves testifies to the ability of local craftsmen in mastering the techniques of cloisonné work, granulation and embossing. Among the most celebrated products of Meroitic craftsmen are the ceramics. Particularly striking are the wheelmade fine wares –

bowls, vases and cups of surprisingly thin fabric, painted in several colours or impressed with small ornamental stamps. The decoration of these vessels is endlessly varied: vine leaf patterns, rosettes, crocodiles, frogs, snakes and giraffes feature prominently, while Egyptian motifs such as the *ankh* and *tyet* are recycled as decorative designs. Besides these attractive pieces there is a range of vessels decorated in a restrained manner, with simple bands on a plain ground.

The decline of the Meroitic state seems to have been a long and gradual one. The economic base of the kingdom was probably weakened by the emergence of other powers which syphoned off the lucrative Mediterranean commerce. Meroe's principal rival in this respect was the kingdom of Axum in northern Ethiopia; as Roman trade increasingly made use of Axum's Red Sea port of Adulis (giving access to the markets of India) Meroe probably suffered from decreasing revenues. The monarchical government seems to have collapsed in the fourth century AD, and the southern part of the kingdom

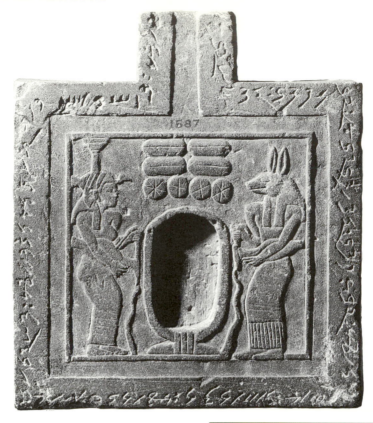

166. *Offering table from a Meroitic tomb at Faras, inscribed around the edge with a funerary formula in cursive script. The central scene depicts the Egyptian deities Nephthys and Anubis pouring libations for the benefit of the deceased.* H. *45.5 cm.*

was overrun by the nomadic tribes of the Noba, moving in from the lands west of the Nile.

The transition to a 'post-Meroitic' phase was probably accomplished with a minimum of upheaval, and the two centuries following the extinction of the old Kushite regime witnessed the rise of successor-states in north and south. The old Meroitic heartland of the Butana seems to have continued in the occupation of the Noba, but monumental art, architecture and writing died out. In Lower Nubia the transition to a new culture was accomplished more smoothly. The population here seems to have been a mixed one; apparently the Nubian-speaking peoples who had infiltrated the region during the preceding centuries eventually became the dominant element in the population. Two groups of these Nubian nomads can be distinguished: the Nobatae from west of the Nile, and the Blemmyes from the eastern desert. During the fourth to sixth centuries AD, when these groups were dominant, a new material culture (formerly known as the 'X-Group') becomes recognisable at sites

in Lower Nubia, taking its name from the important cemetery site of Ballana, near Faras. The tombs of the kings of this period, excavated at Ballana and Qustul, show a return to deeply-rooted African traditions in the practices of burial under earth tumuli, the placing of the corpse on a bed and the sacrificial killing of the ruler's retainers, horses and other animals. The rich embossed and inlaid silver crowns found in several of the graves, however, belong clearly to the tradition of Meroitic royal regalia.

Though little is known of events or political organisation in Nubia at this period, trade with Roman Egypt was clearly flourishing. Pottery, glassware and bronzes were again imported from the Mediterranean world in substantial quantities. There was a corresponding decline in the quality and variety of indigenous ceramic production, but other minor arts such as woodworking, leather working and textile manufacture persisted; a wide range of these products has been found in the excavations of the Egypt Exploration Society at Qasr Ibrim.

167. Group of Meroitic fine ware cups painted with friezes of floral and faunal motifs, including birds, frogs and mythical animals. 1st to 2nd century AD; from Faras. H. of tallest vessel 10.5 cm.

The post-Meroitic period was a crucial transitional phase in the development of religious beliefs in Nubia. Knowledge of Christianity filtered into Nubia from Egypt, and the new religion had probably gained a firm foothold by the early sixth century. In the same period the worship of the old 'pagan' deities declined. The temple of Isis at Philae was still a focal point for Nubian pilgrims in the fifth century, but the lack of serious opposition to its closure in about AD 540 may argue for a major diminution in its importance to the Nubian population.

By the sixth century three distinct kingdoms, Nobatia, Makuria and Alwa, had emerged in Nubia. These states were officially converted to Christianity by missionaries from Byzantium between AD 543 and AD 580. At the beginning of the eighth century Makuria absorbed Nobatia, creating a single large kingdom with its capital at Old Dongola. The adoption of Christianity throughout Nubia seems to have helped to consolidate the local societies. Attempts at invasion by the new Arab rulers of Egypt were repulsed, and were followed in AD 652 by a treaty guaranteeing the Nubians independence in return for an annual tribute of 360 slaves. This agreement, which remained in force for six hundred years, enabled the Nubian states to prosper and develop unhindered. The Christian era in Nubia was a period of growth and prosperity in both the political and cultural spheres.

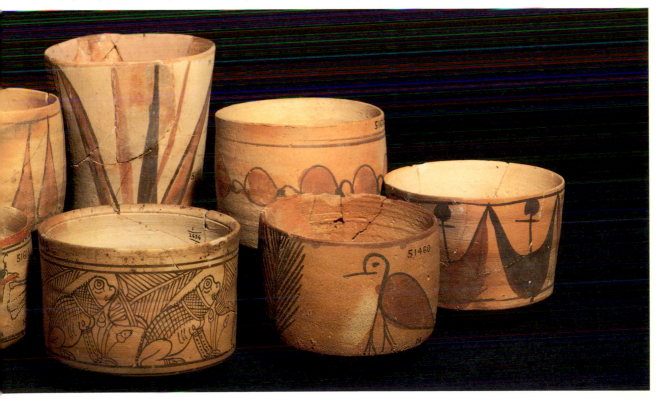

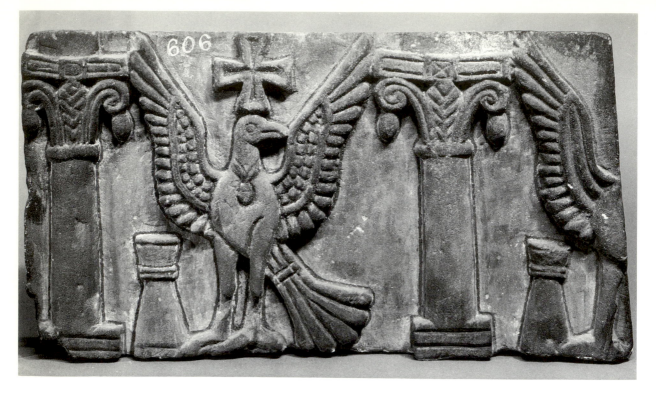

168. *Section of decorative frieze from the interior of the first cathedral at Faras. The bird probably represents a dove or an eagle, both of which were significant symbols in Christian iconography.*
7th century AD; sandstone, from Faras. H. 25 cm.

Information about the organisation of the land comes chiefly from Arab writers and relates mainly to the more accessible northern kingdom. Besides the king, and a number of vassal rulers of whom little is known, the most powerful official was the 'eparch', who acted as a viceroy for Lower Nubia. His rule involved supervising commercial relations with Islamic Egypt and defending the kingdom's northern frontier. The influence of Byzantine traditions is apparent in the robes and trappings of the Nubian kings, as depicted in paintings, and in the Greek titles of their officials.

The Nubian church was affiliated to that of Egypt, and the Coptic patriarch at Alexandria was acknowledged as its head. Religious activity within Nubia was controlled by the bishops, of whom the most prominent were those of Dongola and Faras. Many churches, monasteries and cathedrals were built, the model for most of the churches being the basilica-type usual in the Byzantine empire. While architectural embellishments were usually minimal, wall-paintings decorated the interiors even of quite small churches. The most celebrated series of Christian murals from Nubia are those from the cathedral at Faras, an immensely varied gallery of archangels,

saints, bishops, kings and eparchs which reflect the unique blend of Byzantine, Coptic, Syro-Palestinian and local influences created by the Nubian artists. Large-scale artistic production was otherwise limited mainly to carved column capitals, lintels, cornices and relief friezes installed in churches and cathedrals. Among the minor arts, pottery production underwent a revival. A series of bowls with stamped motifs or painted patterns on a white, cream or buff ground are characteristic of the northern kingdom, and contrast with the 'Soba ware' found at the site of the capital of Alwa, on the Blue Nile. The site of Qasr Ibrim has yielded copious evidence for the high standards of craftsmanship in metalworking, woodworking, basketry, leather working and textile production during the Christian period. Besides wool, which was widely used from the Ballana Period, the range of materials was augmented by the appearance of silk and by a revival in the popularity of cotton, which had been used in the Meroitic Period.

In keeping with the new attitudes to life after death, burials of the Christian period were very simple affairs. Funerary offerings were not provided, the body being wrapped in a shroud and laid in a simple pit grave covered with stones or a brick canopy. The main exceptions to the general rule of austerity were the burials of clerics, who were laid to rest in their ecclesiastical robes with symbols of their office. The British Museum possesses the episcopal robes and iron benedictional cross

of Bishop Timotheos of the late fourteenth century, whose undisturbed burial was found during excavations by the Egypt Exploration Society in the cathedral at Qasr Ibrim.

After the twelfth century conditions in Nubia became more unsettled. The authority of the kings was weakened by dynastic infighting, feudal warlords rose to prominence and Arab nomads from the eastern desert edge became a serious cause of disruption. The Mamelukes, who took over Egypt in the thirteenth century, adopted a more aggressive attitude towards Nubia than had their predecessors. The disruptions brought economic decline, while commerce and local industry seem to have dwindled almost to a halt. The disintegration of the northern kingdom in the late fourteenth-century left Nubia vulnerable to nomadic incursions and the aggression of the Islamic rulers of Egypt, while the southern kingdom of Alwa was conquered by the Moslem Funj in the early sixteenth century. By this date Christianity was practically extinct in Nubia. The inhabitants, under the influence of the numerous bedouin Arabs who had gained authority throughout much of the region, adopted the Islamic religion, which had already taken root in many parts of the land.

169. *A sketch of a baboon eating figs from a bowl on a cane table. The choice of baboon and monkey as pets underlines the African setting of Egyptian civilisation. New Kingdom, c. 1200 BC; limestone with red and black pigment, from Thebes. H. 10.5 cm.*

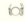

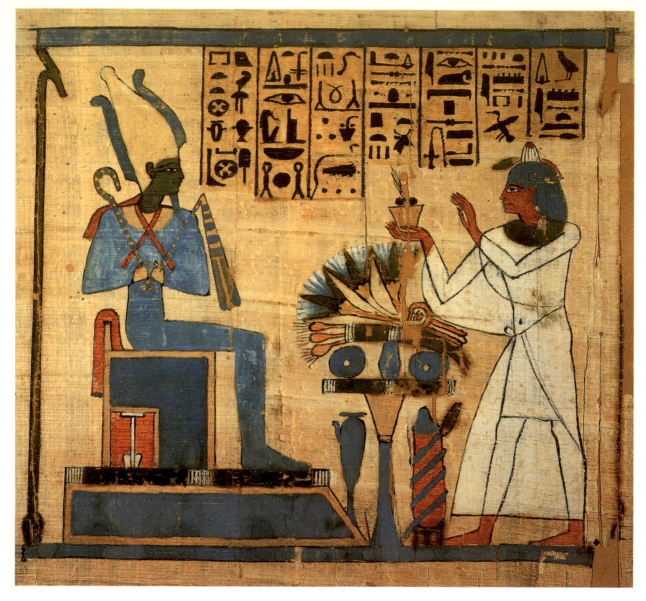

170. *Opening illustration for the* Book of the Dead *of Padiamenet, head baker of the Amun temple, showing the deceased offering incense to Osiris enthroned. A table of offerings and jars for water and wine stand between them. Third Intermediate Period, c. 950 BC; painted papyrus, from Thebes.*
H. *25.5 cm.*

SUGGESTIONS FOR FURTHER READING

CHAPTER ONE

J. Baines and J. Malek, *Atlas of Ancient Egypt*. London, 1979.

W. Butzer, *Early Hydraulic Civilization in Egypt*. Chicago and London, 1976.

W. Helck and E. Otto, *Lexikon der Äyptologie*. 7 vols, Wiesbaden, 1972–91.

T. G. H. James, *Pharaoh's People*. London, 1984.

J. and R. Janssen, *Growing Up in Ancient Egypt*. London, 1991.

B. J. Kemp, *Ancient Egypt. Anatomy of a civilization*. Cambridge, 1989.

L. Manniche, *Music and Musicians in Ancient Egypt*. London, 1991.

W. J. Murnane, *The Penguin Guide to Ancient Egypt*. Harmondsworth, 1983.

CHAPTER TWO

A. K. Bowman, *Egypt after the Pharaohs*. London, 1986.

S. Bowman, *Radiocarbon dating*. London, 1990.

A. H. Gardiner, *Egypt of the Pharaohs*. Oxford, 1961.

K. A. Kitchen, *Pharaoh Triumphant: the life and times of Ramesses II*. Warminster, 1982.

J. Malek and W. Forman, *In the Shadow of the Pyramids*. London, 1986.

Manetho, *Aegyptiaca*. Loeb Classical Library. London, 1940.

B. Trigger *et al.*, *Ancient Egypt, a social history*. Cambridge, 1983.

CHAPTER THREE

C. Aldred, *Akhenaten, King of Egypt*. London, 1988.

J. G. Griffith, *Apuleius of Madauros. The Isis Book. Metamorphoses Book XI*. Leiden, 1975.

J. G. Griffith, *Plutarch. De Iside et Osiride. Translation and Commentary*. Wales, 1970.

G. Hart, *A Dictionary of Egyptian Gods and Goddesses*. London and New York, 1986.

G. Hart, *Egyptian Myths*. London, 1990.

E. Hornung, *Conceptions of God in Ancient Egypt*. London, 1983.

S. Morenz, *Egyptian Religion*. London, 1983.

E. Otto, *Egyptian art and the cults of Osiris and Amun*. London, 1968.

D. B. Redford, *Akhenaten, the heretic king*. Princeton, 1984.

S. Sauneron, *The Priests of Ancient Egypt*. London, 1960, New York, 1969.

CHAPTER FOUR

T. G. Allen, *The Egyptian Book of the Dead*. Chicago, 1960.

C. A. R. Andrews, *Egyptian Mummies*. London, 1984.

E. A. T. W. Budge, *The Mummy*. 2nd edn, Cambridge, 1925.

R. O. Faulkner, *The Ancient Egyptian Book of the Dead*. Rev. edn by C. A. R. Andrews, London, 1985.

E. Hornung, *The Valley of the Kings*. New York, 1990.

C. N. Reeves, *The Complete Tutankhamun*. London and New York, 1990.

A. J. Spencer, *Death in Ancient Egypt*. London, 1982.

J. H. Taylor, *Egyptian Coffins*. Aylesbury, 1989.

CHAPTER FIVE

C. A. R. Andrews, *The Rosetta Stone*. London, 1982.

J. Černy, *Paper and Books in Ancient Egypt*. London, 1953.

W. V. Davies, *Egyptian Hieroglyphs*. London, 1987.

R. O. Faulkner, *A Concise Dictionary of Middle Egyptian*. Oxford, 1966.

A. H. Gardiner, *Egyptian Grammar*. 3rd edn, Oxford, 1957.

M. Lichtheim, *Ancient Egyptian Literature*. 3 vols, Berkeley, 1973–80.

R. B. Parkinson, *Voices from Ancient Egypt*. London, 1991.

G. Robins and C. Shute, *The Rhind Mathematical Papyrus*. London, 1987.

W. K. Simpson, R. O. Faulkner and E. Wente, *The Literature of Ancient Egypt*. London, 1972.

E. Wente, *Letters from ancient Egypt*. Atlanta, 1990.

CHAPTER SIX

C. Aldred, *Egyptian Art*. London, 1980.

D. Arnold, *Building in Egypt. Pharaonic stone masonry*. Oxford, 1991.

I. E. S. Edwards, *The Pyramids of Egypt*. London, 1978.

A. Fakhry, *The Pyramids*. Chicago and London, 1969.

T. G. H. James, *Egyptian Painting*. London, 1984.

T. G. H. James and W. V. Davies, *Egyptian Sculpture*. London, 1983.

G. Robins, *Egyptian painting and relief*. Aylesbury, 1986.

E. Russman, *Egyptian Sculpture: Cairo and Luxor*. London, 1991.

H. Shafer, *Principles of Egyptian Art*. English translation by J. R. Baines, Oxford, 1974.

CHAPTER SEVEN

C. Aldred, *Jewellery of the Pharaohs*. London, 1978.

C. A. R. Andrews, *Ancient Egyptian Jewellery*. London, 1990.

D. F. Grose, *The Toledo Museum of Art. Early Ancient Glass*. New York, 1989.

R. Hall, *Egyptian Textiles*. Aylesbury, 1986.

A. Lucas, *Ancient Egyptian materials and industries*. 4th edn, revised by J. P. Harris, London, 1962.

H. Tait (ed.), *Five Thousand Years of Glass*. London, 1991.

CHAPTER EIGHT

J. Boardman, *The Greeks Overseas*. Aylesbury, 1964.

J. B. Pritchard, *The Ancient Near East in pictures relating to the Old Testament*. 3rd edn, Princeton, 1974.

J. H. Taylor, *Egypt and Nubia*. London, 1991.

B. Trigger, *Nubia under the Pharaohs*. London, 1978.

LIST OF DYNASTIES

(Overlapping dates usually indicate coregencies. All dates given are approximate.)

FIRST DYNASTY

*c.*3100–2890 BC

Narmer
Aha
Djer
Djet
Den
Anedjib
Semerkhet
Qaa

SECOND DYNASTY

*c.*2890–2686 BC

Hotepsekhemwy
Raneb
Nynetjer
Peribsen
Khasekhem (Khasekhemwy)

THIRD DYNASTY

*c.*2686–2613 BC

Sanakht
Netjerkhet (Djoser)
Sekhemkhet
Huni

FOURTH DYNASTY

*c.*2613–2494 BC

Sneferu
Khufu (Cheops)
Radjedef
Khafra (Chephren)
Menkaura (Mycerinus)
Shepseskaf

FIFTH DYNASTY

*c.*2494–2345 BC

Userkaf
Sahura
Neferirkara Kakai
Shepseskara Isi
Raneferef
Nyuserra
Menkauhor Akauhor
Djedkara Isesi
Unas

SIXTH DYNASTY

*c.*2345–2181 BC

Teti
Userkara
Meryra (Pepy I)
Merenra
Neferkara (Pepy II)

SEVENTH/EIGHTH DYNASTIES

*c.*2181–2125 BC

NINTH/TENTH DYNASTIES

*c.*2160–2130 BC, *c.*2125–2025 BC

Meryibra Khety
Wahkara Khety
Merykara

ELEVENTH DYNASTY

*c.*2125–1985 BC

Mentuhotep I ⎤
Sehertawy Intef I ⎟ rulers of
Wahankh Intef ⎟ Thebes
Nakhtnebtepnefer Intef ⎦

Nebhepetra Mentuhotep
2055–2004 BC ⎤
Sankhkara Mentuhotep ⎟ Kings
2004–1992 BC ⎟ of
Nebtawyra Mentuhotep ⎟ Egypt
1992–1985 BC ⎦

TWELFTH DYNASTY

*c.*1985–1795 BC

Sehetepibra Amenemhat
1985–1955 BC
Kheperkara Senusret I
1965–1920 BC
Nubkaura Amenemhat II
1922–1878 BC
Khakheperra Senusret II
1880–1874 BC
Khakaura Senusret III
1874–1855 BC
Nymaatra Amenemhat III
1854–1808 BC
Maakherura Amenemhat IV
1808–1799 BC
Sobekkara Sobekneferu
1799–1795 BC

THIRTEENTH DYNASTY

*c.*1795–*c.*1650 BC

Sekhemrasewadjtawy Sobekhotep
Khaneferra Sobekhotep
Khasekhemra Neferhotep

FOURTEENTH DYNASTY

*c.*1750–*c.*1650 BC

FIFTEENTH DYNASTY

(Hyksos)

*c.*1650–1550 BC

Seuserenra Khyan
Aauserra Apepi

SIXTEENTH DYNASTY

*c.*1650–*c.*1550 BC

SEVENTEENTH DYNASTY

*c.*1650–1550 BC

Nubkheperra Intef
Seqenenra Taa
Wadjkheperra Kamose

EIGHTEENTH DYNASTY

*c.*1550–1295 BC

Nebpehtyra Ahmose I
1550–1525 BC
Djeserkara Amenhotep I
1525–1504 BC
Aakheperkara Thutmose I
1504–1492 BC
Aakheperenra Thutmose II
1492–1479 BC
Maatkara Hatshepsut
1479–1425 BC
Menkheperra Thutmose III
1479–1425 BC
Aakheperura Amenhotep II
1427–1400 BC
Menkheperura Thutmose IV
1400–1390 BC
Nebmaatra Amenhotep III
1390–1352 BC
Neferkheperura Amenhotep IV
(Akhenaten)
1352–1336 BC
Neferneferuaten
1338–1336 BC
Nebkheperura Tutankhamun
1336–1327 BC
Kheperkheperura Ay

1327–1323 BC
Djeserkheperura Horemheb
1323–1295 BC

NINETEENTH DYNASTY

*c.*1295–1186 BC

Menpehtyra Ramses I
1295–1294 BC
Menmaatra Sety I
1294–1279 BC
Usermaatra Ramses II
1279–1213 BC
Baenra Merenptah
1213–1203 BC
Menmira Amenmessu
1203–1200 BC
Userkheperura Sety II
1200–1194 BC
Saptah
1194–1188 BC
Tausret
1188–1186 BC

TWENTIETH DYNASTY

*c.*1186–1069 BC

Userkhaura Setnakht
1186–1184 BC
Usermaatra-meryamun, Ramses III
1184–1153 BC
Ramses IV
1153–1147 BC
Ramses V
1147–1143 BC
Ramses VI
1143–1136 BC
Ramses VII
1136–1129 BC
Ramses VIII
1129–1126 BC
Ramses IX
1126–1108 BC
Ramses X
1108–1099 BC
Ramses XI
1099–1069 BC

TWENTY-FIRST DYNASTY

*c.*1069–945 BC

Hedjkheperra Nesbanebded
(Smendes) *c.*1069–1043 BC
Aakheperra Pasebakhaenniut
(Psusennes) I *c.*1039–991 BC
Amenemope
*c.*993–984 BC
Saamun
*c.*978–959 BC
Pasebakhaenniut (Psusennes) II
*c.*959–945 BC

TWENTY-SECOND DYNASTY

*c.*945–715 BC

Hedjkheperra Sheshonq I
*c.*945–924 BC
Sekhemkheperra Osorkon I
*c.*924–889 BC
Takelot I
*c.*889–874 BC
Usermaatra Osorkon II
*c.*874–850 BC
Hedjkheperra Takelot II
*c.*850–825 BC
Usermaatra Sheshonq III
*c.*825–773 BC
Usermaatra Pimay
*c.*773–767 BC
Aakheperra Sheshonq V
*c.*767–730 BC

TWENTY-THIRD DYNASTY

*c.*818–715 BC

Usermaatra Padibast I
*c.*818–793 BC
Usermaatra Osorkon III
*c.*777–749 BC

TWENTY-FOURTH DYNASTY

*c.*727–715 BC

Tefnakht Bakenrenef (Bocchoris)

TWENTY-FIFTH DYNASTY

(Nubian or Kushite)

c.747–656 BC

Piy (Piankhi)
c.747–716 BC
Neferkara Shabako
c.716–702 BC
Djedkaura Shabitko
c.702–690 BC
Khunefertemra Taharqo
690–664 BC
Bakara Tanutamani
664–656 BC

TWENTY-SIXTH DYNASTY

(Saite)

664–525 BC

Wahibra Psamtek I
664–610 BC
Wehemibra Nekau II
610–595 BC
Neferibra Psamtek II
595–589 BC
Haaibre Wahibra (Apries)
589–570 BC
Khnemibra Ahmose II (Amasis)
570–526 BC
Ankhkaenra Psamtek III
526–525 BC

TWENTY-SEVENTH DYNASTY

(Persian Kings)

525–404 BC

Cambyses
525–522 BC
Darius I
522–486 BC
Xerxes

486–465 BC
Artaxerxes I
465–424 BC
Darius II
424–405 BC
Artaxerxes II
405–359 BC

TWENTY-EIGHTH DYNASTY

404–399 BC

Amyrtaeus
404–399 BC

TWENTY-NINTH DYNASTY

399–380 BC

Nefaarud (Nepherites) I
399–393 BC
Khnemmaatra Hakor (Achoris)
393–380 BC

THIRTIETH DYNASTY

380–343 BC

Kheperkara Nakhtnebef
(Nectanebo I)
380–362 BC
Djedhor (Teos)
362–360 BC
Snedjemibra Nakhtorheb
(Nectanebo II)
360–343 BC

PERSIAN KINGS

343–332 BC

Artaxerxes III Ochus
343–338 BC
Arses
338–336 BC
Darius III
336–332 BC

MACEDONIAN KINGS

332–305 BC

Alexander the Great
332–323 BC
Philip Arrhidaeus
323–317 BC
Alexander IV
317–305 BC

THE PTOLEMIES

305–30 BC

Ptolemy I Soter I
305–282 BC
Ptolemy II Philadelphus
284–246 BC
Ptolemy III Euergetes I
246–222 BC
Ptolemy IV Philopator
222–205 BC
Ptolemy V Epiphanes
205–180 BC
Ptolemy VI Philometor
180–145 BC
Ptolemy VII Neos Philopator
145 BC
Ptolemy VIII Euergetes II
170–116 BC
Ptolemy IX Soter II (Lathyros)
116–107 BC
Ptolemy X Alexander I
107–88 BC
Ptolemy IX Soter II (restored)
88–80 BC
Ptolemy XI Alexander II
80 BC
Ptolemy XII Neos Dionysos
(Auletes)
80–51 BC
Cleopatra VII Philopator
51–30 BC

NAMES OF THE PRINCIPAL KINGS OF EGYPT

(including the Roman Emperors)

During the Early Dynastic Period, the chief name (Horus-name) of the king was written in a rectangular frame called a *serekh*. The bottom part of the frame contained a design of panelling, and the whole was surmounted by a figure of a falcon–the god Horus. In the case of Peribsen of the Second Dynasty, the Seth-animal replaced the falcon, while the *serekh* of Khasekhemwy was surmounted by both falcon and Seth-animal. A second name sometimes accompanied the Horus-name, or was used independently; it was introduced by one or both of the two titles ⟨glyph⟩ King of Upper and Lower Egypt' and ⟨glyph⟩ 'The Two Ladies'.

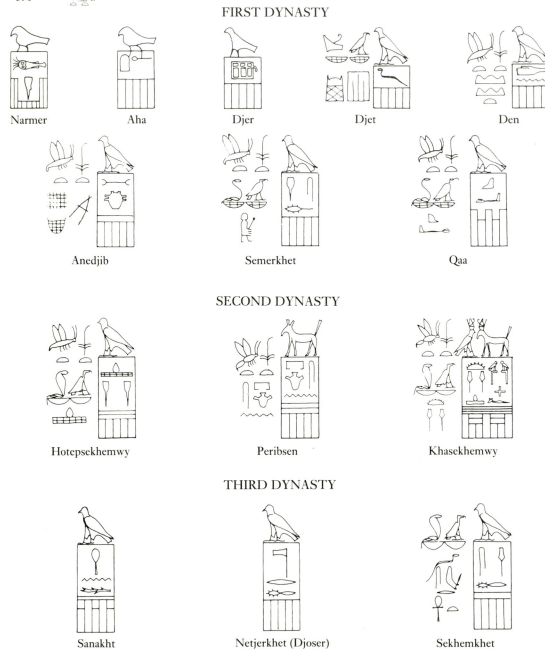

FIRST DYNASTY

Narmer Aha Djer Djet Den

Anedjib Semerkhet Qaa

SECOND DYNASTY

Hotepsekhemwy Peribsen Khasekhemwy

THIRD DYNASTY

Sanakht Netjerkhet (Djoser) Sekhemkhet

From the Old Kingdom the Egyptian king normally possessed five names: the Horus-name, the 'Two Ladies'-name, the Golden Horus-name (of uncertain origin), the prenomen (preceded by the title 𓆥, translated usually 'King of Upper and Lower Egypt') and the nomen (preceded by the title 𓅭 'Son of Re'). The nomen was first used by kings of the Fifth Dynasty who were specially devoted to the worship of Re. Prenomens and nomens were regularly enclosed within ovals called cartouches, which depict loops of rope with tied ends. By having his name so enclosed, the king possibly wishes to convey pictorially that he was ruler of all 'that which is encircled by the sun'. From the late Eighteenth Dynasty onwards additional epithets were regularly introduced into the cartouches. In times when the claim to the throne of all Egypt was disputed kings sometimes avoided the 𓆥-title and used 𓐙𓊹, 'the perfect god'. The names within cartouches are those by which a king is normally identified.

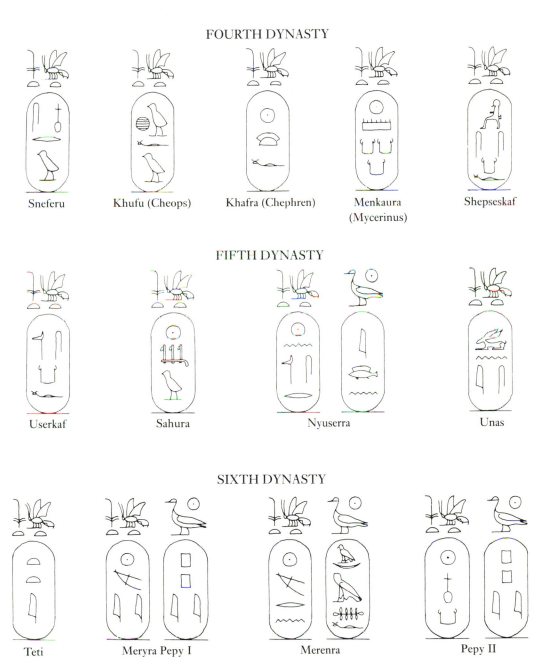

FOURTH DYNASTY

Sneferu Khufu (Cheops) Khafra (Chephren) Menkaura (Mycerinus) Shepseskaf

FIFTH DYNASTY

Userkaf Sahura Nyuserra Unas

SIXTH DYNASTY

Teti Meryra Pepy I Merenra Pepy II

ELEVENTH DYNASTY

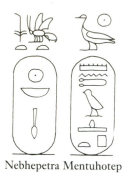

Nebhepetra Mentuhotep

Sankhkara Mentuhotep

Nebtawyra Mentuhotep

TWELFTH DYNASTY

Amenemhat I

Senusret I

Amenemhat II

Senusret II

Senusret III

Amenemhat III

Amenemhat IV

THIRTEENTH DYNASTY

Sekhemrasewadjtawy
Sobkhotep

Khaneferra Neferhotep

FIFTEENTH DYNASTY
(Hyksos)

Seuserenra Khyan

Aauserra Apepi

SEVENTEENTH DYNASTY

Nubkheperra Intef

Seqenenra Taa

Kamose

EIGHTEENTH DYNASTY

Ahmose I

Amenhotep I

Thutmose I

Thutmose II

Hatshepsut

Thutmose III

Amenhotep II

Thutmose IV

Amenhotep III

Akhenaten

Tutankhamun

Horemheb

NINETEENTH DYNASTY

Ramses I

Sety I

Ramses II

Merenptah

TWENTIETH DYNASTY

Ramses III

Ramses IV

Ramses IX

TWENTY-FIRST DYNASTY

Nesbanebdjed
(Smendes)

Pasebakhaenniut
(Psusennes) I

TWENTY-SECOND DYNASTY

Sheshonq I

Osorkon II

TWENTY-FIFTH DYNASTY

Piy (Piankhi)

Shabako

Taharqo

TWENTY-SIXTH DYNASTY

Psamtek I

Nekau II

Psamtek II

Wahibra (Apries)

Ahmose (Amasis) II

Psamtek III

TWENTY-SEVENTH DYNASTY

Cambyses

Darius

Xerxes

Artaxerxes

TWENTY-NINTH DYNASTY

Hakor (Achoris)

THIRTIETH DYNASTY

Nakhtnebef (Nectanebo I)

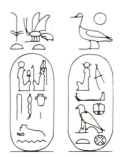

Nakhthoreb (Nectanebo II)

MACEDONIAN KINGS

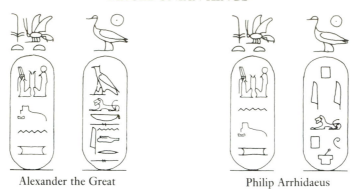

Alexander the Great

Philip Arrhidaeus

PTOLEMAIC DYNASTY

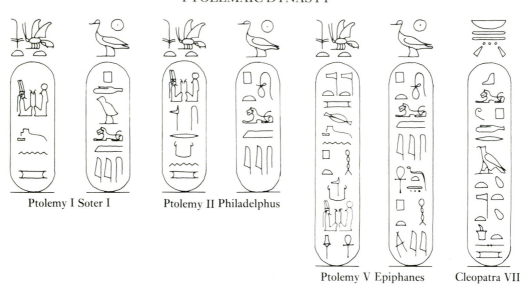

Ptolemy I Soter I

Ptolemy II Philadelphus

Ptolemy V Epiphanes

Cleopatra VII

ROMAN EMPERORS

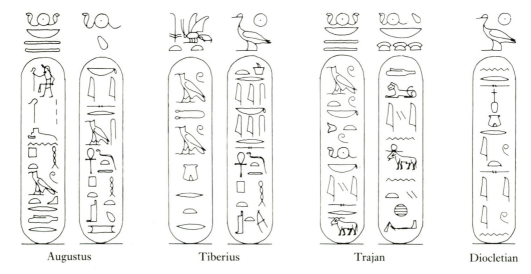

Augustus

Tiberius

Trajan

Diocletian

INDEX

References in *italic* refer to the pages on which illustrations appear.